D1068635

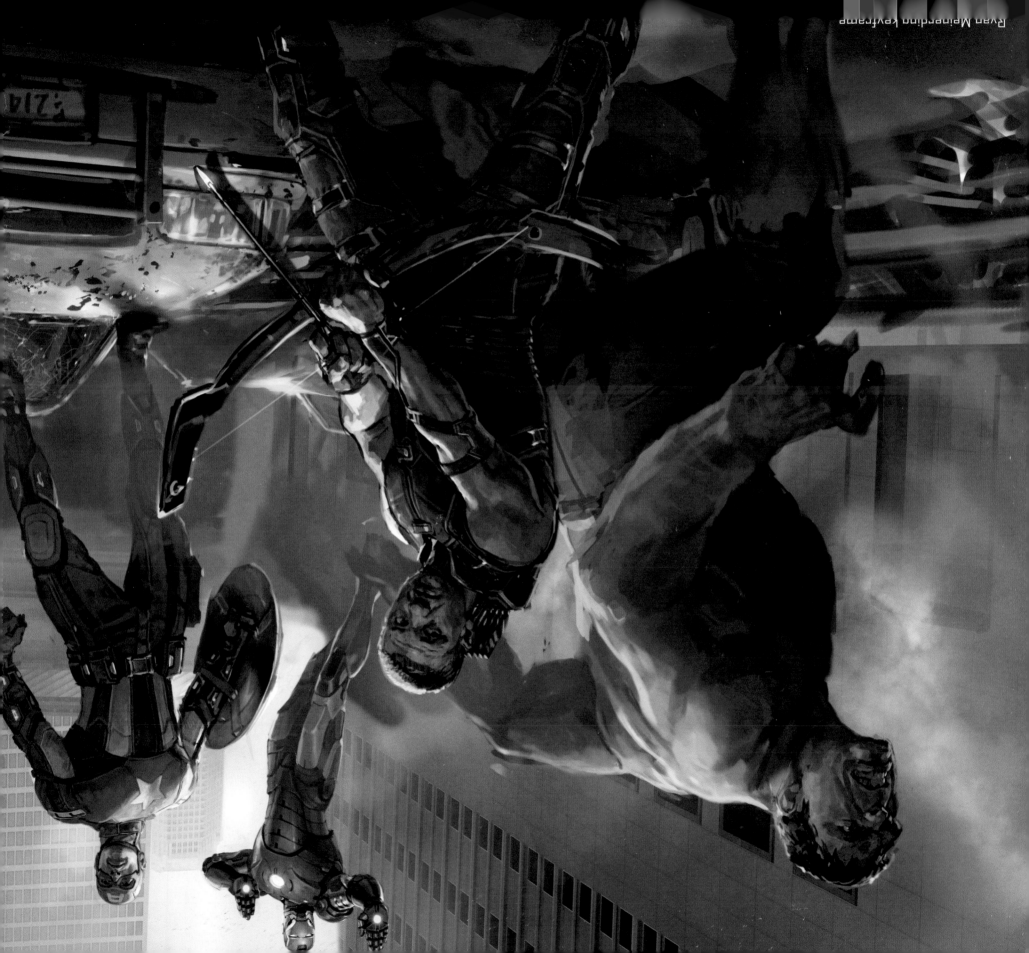

THE ART OF

MARVEL

AVENGERS
THE

WRITTEN BY
JASON SURRELL

BOOK DESIGN BY
JEFF POWELL

INTRODUCTION BY
RYAN MEINERDING & CHARLIE WEN

COVER ART BY
RYAN MEINERDING

ISBN# 978-0-7851-6234-6

Printed in the U.S.A.

Second printing 2012.
10 9 8 7 6 5 4 3 2

Published by MARVEL WORLDWIDE, INC., a subsidiary of MARVEL ENTERTAINMENT, LLC.
OFFICE OF PUBLICATION: 135 West 50th Street, New York, NY, 10020.

John Giang concept art

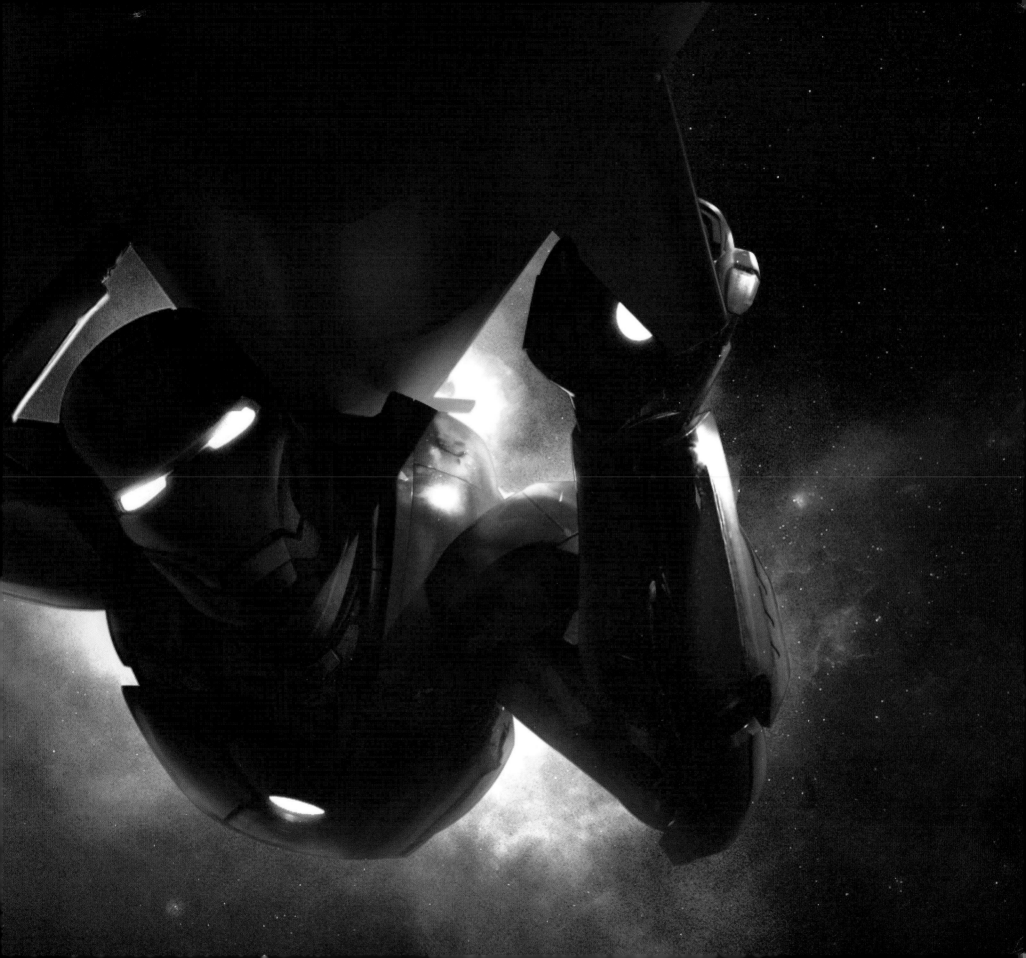

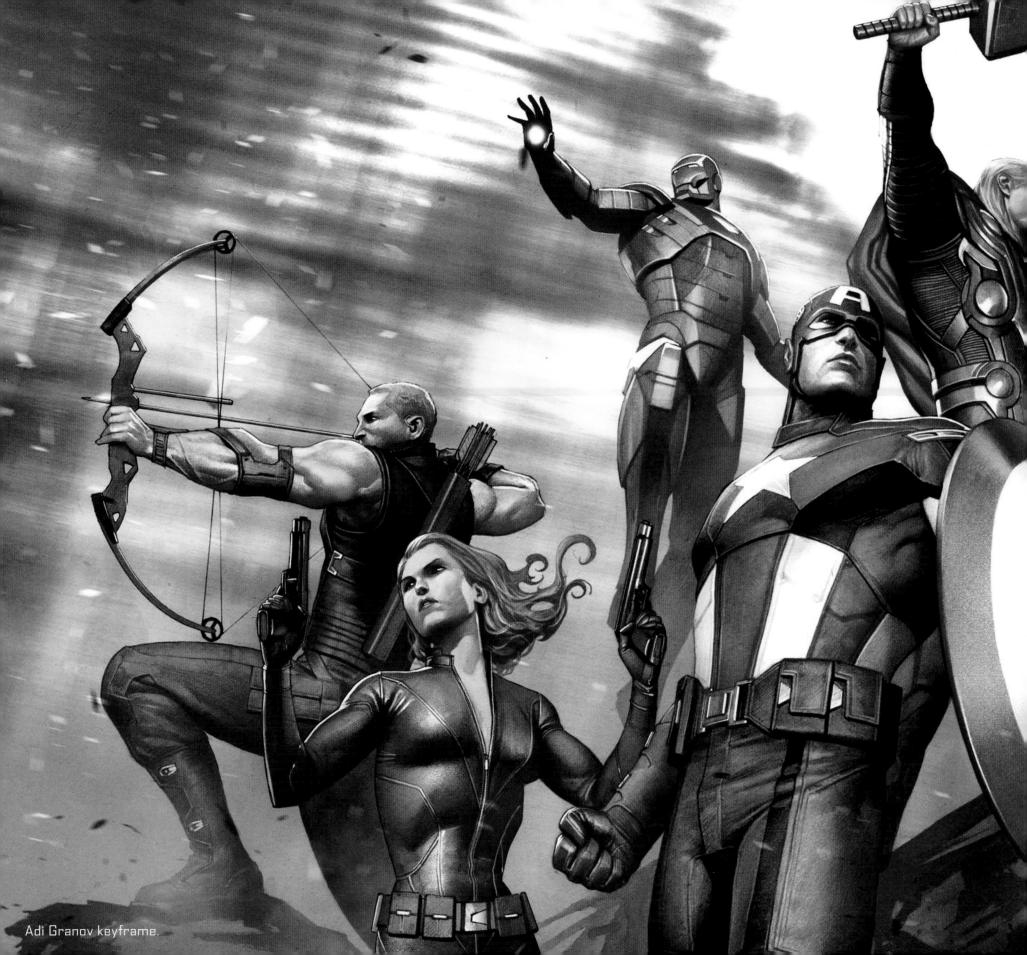

Adi Granov keyframe.

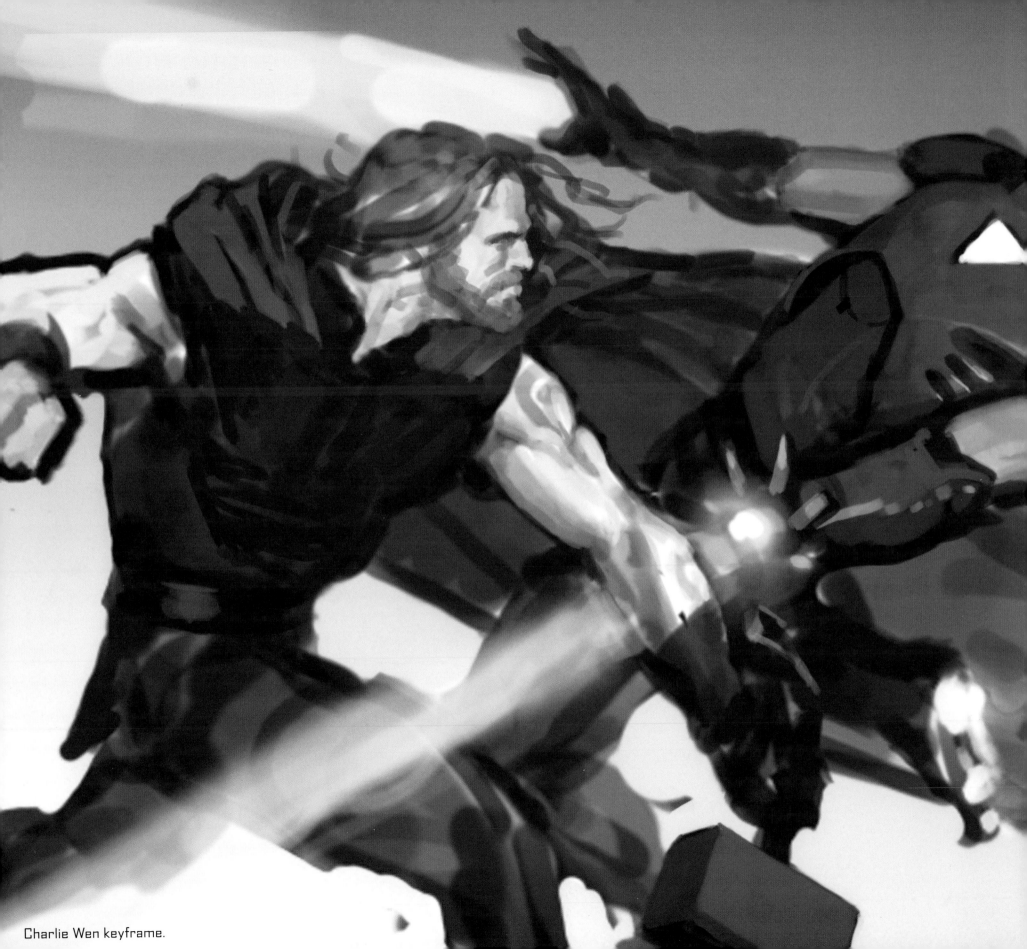

Charlie Wen keyframe.

The Marvel Cinematic Universe is a world whose foundation is based in art, or as we'd like to call it: an illustrator's dream. During the past few years, we have been given the opportunity to work with some of our own favorite heroes — from Iron Man, Captain America and Thor to Jon Favreau, Joe Johnston and Kenneth Branagh. It's a rare situation when artists can work directly with the director and producers — but we have had just that opportunity at Marvel, where Kevin Feige has entrusted us to assemble a team of artists whose passion for these Marvel icons would drive the design to a whole new level. Our team, the Visual Development department, is made up of a group of artists who had become experts in specific characters during the course of the previous Marvel films and would now come together to build *Marvel's The Avengers* under Joss Whedon's brilliant direction. To assemble Earth's Mightiest Heroes, it was going to take just that.

The process of working on a film for Marvel is slightly different than that of other films made in Hollywood. It all dates back to the way the Iron Man suits were first designed: Adi Granov, Phil Saunders and Ryan worked directly with Jon Favreau to make the best-looking concepts possible. Through weekly reviews — which carried over to *Marvel's The Avengers*, as well — the entire production team was always aware of where the concepts were headed. Once these designs were accomplished in illustration form, they were taken to Stan Winston Studios, where they built the suits in the computer under our direction, and then they were output to be realized in a cast and painted form. Seeing the Iron Man suit standing on set for the first time was a moment of utter awe in what we were all able to accomplish. The same could be said for the first time we were able to see the Warriors Three, Thor and Loki standing in the icy world of Jotunheim clad in their Asgardian garb Charlie had so intricately designed. The inspired result was due to a process that involved keeping the iconic Marvel heroes in the artists' hands from start to finish. Under the direction of the director and producers, each icon was brought to life remarkably well.

Since the first *Iron Man* film, this process for creating the characters has continually been about generating them in illustration form, and then allowing a master craftsman to build that design. Unfortunately, in the film business, it is generally hard for artists to take credit for their work. At Marvel, on the other hand, the directors and producers are in the trenches with the concept artists working hard to find the best solutions possible. There is a very clear line of authorship for each design done, and that in and of itself is a huge precedent in this business. If you look back through all the *Art of* titles from the Marvel films, you will find a remarkable continuity in the artists creating the Marvel Cinematic Universe. Kevin Feige has always been interested in creating a unity across this universe, and one of the ways he did that during the years following *Iron Man* was by making sure the same concept artists were responsible for these iconic characters. Phil Saunders and Adi Granov were the driving force behind Iron Man, Charlie was the source of design for Thor, and Ryan was responsible for Captain America. We would like to think the quality of character design in the Marvel films is evidence of the success of Kevin's plan.

When it came time for *Marvel's The Avengers* to become a reality, we had a core team of people — Andy Park, Rodney Fuentebella, Phil Saunders, Justin Sweet, Adi Granov and Jacob Johnston — each member with a specific focus. This team of amazing artists set forth to bring Joss' vision to life while staying true to each character. Like the directors we had worked with before, Joss was adamant about capturing what made these characters so unique. This time around, we were also handling an additional completely digital character: the Hulk. Joss had a very distinct vision for him; we worked closely with Joss, Visual Effects Supervisor Janek Sirrs, and Industrial Light & Magic to make sure we could do the character — as well as Joss' passion for him — justice. Legacy Effects (formerly Stan Winston Studio) did another great job with Iron Man, while Costume Designer Alexandra Byrne truly transcended our designs with what she created for the actors. And what would a set of heroes be without an epic backdrop, a world created from the mind of James Chinlund and his own brilliant team of artists: Steve Jung, Nathan Schroeder, Paul Ozzimo and many others.

In the book that follows, you will see all the work that went into creating *Marvel's The Avengers*. And once again, Marvel has allowed the artists to take credit for the designs they've done. Hopefully, it will be a fun journey from design to finished product, and you can feel the pride we all take in being part of the Marvel Cinematic Universe.

Ryan Meinerding & Charlie Wen

"Assemble."

That one word and the address of a bar in Albuquerque were the extent of a text message Chris Evans sent to his fellow Avengers once they had all arrived in the New Mexico desert to begin shooting the first film to feature Earth's Mightiest Heroes together on one bill. The newly ordained Captain America likely had no idea just how significant his simple text — and the unforgettable night of bonding that followed — would be in terms of film history. *Marvel's The Avengers* would not only mark the first time so many iconic comic-book characters, each one played by an A-list actor, appeared on-screen together, but also the culmination of a cinematic journey more than five years in the making.

The "big bang" that would ultimately create the Marvel Cinematic Universe took place in 2007, when Marvel Studios put into production the first film it would finance and produce completely independently. With *Iron Man*, Marvel Studios bucked the Hollywood tradition of chasing A-list movie stars and flavor-of-the-month filmmakers, instead hiring creative talent best suited to the material. Hence the relatively untested Jon Favreau — then best known for directing the Will Ferrell comedy *Elf* — slipped into the director's chair, and promptly lobbied for controversial choice Robert Downey Jr. to star as Tony Stark and his ironclad alter ego. The rest is movie history, and both actor and director are now household names and bankable box-office performers.

The expansion of this burgeoning cinematic universe continued two months later with the release of *The Incredible Hulk*, directed by Louis Letterier (*The Transporter, Transporter 2*). A visceral action-adventure epic, *The Incredible Hulk* featured the thrills of the green goliath running amok from Brazil to Harlem, while still capturing the pathos of Bruce Banner's fight to maintain control. The film made the Hulk fun again, a quality that was fast becoming a hallmark of Marvel Studios films.

But there was much more to the story than simply making a couple of summer blockbusters. Marvel Studios Producer Kevin Feige and his core creative team — including Louis D'Esposito, Victoria Alonso, Jeremy Latcham, Stephen Broussard and Craig Kyle — had a much more ambitious and elaborate endgame in mind.

"We started looking at the list of characters that we had: Iron Man, Hulk, Captain America, Thor, Hawkeye, Black Widow and all of the characters in the Marvel Universe that hadn't been taken by other studios," Feige said. "To be honest, our first priority was to make a great Iron Man film, introduce the character and start a new franchise. But in the back of my head, I thought, 'Isn't it interesting that all of these characters happen to form one of Marvel's most popular comic series: *Avengers*.'"

Up to that point, different studios had been making movies featuring Marvel characters that existed independently. But Marvel Studios would mirror what the legendary Stan Lee had done in the comics

and tell stories in which characters and continuity intersect to form one master mythology in the same cinematic universe, crossing over characters and the actors who played them — a practice that was and remains largely unheard of.

"These films take place in a much broader world and on a much bigger playing field," Feige said. "Our characters all inhabit the same world, and that had never been done on the big screen before."

"There has always been a Marvel Universe that exists in publishing," *Marvel's The Avengers* Executive Producer Louis D'Esposito said. "But now there's a Marvel Cinematic Universe, as well, that we have to track. We actually do a timeline for each film. What came first? How do they interact? How are they related? How does something that happened in *Thor* affect *Captain America* or *Iron Man*? It's not always easy — and some things we got lucky with, some things we had to correct, and some things were always part of a grand scheme."

"The idea for *Marvel's The Avengers* first surfaced during the production of *Iron Man*," *Marvel's The Avengers* Executive Producer Jeremy Latcham said. "Kevin Feige had a really strong notion that S.H.I.E.L.D. could be part of *Iron Man* and *The Incredible Hulk*, and we started thinking about the best way to plant the seeds and tease the audiences a bit."

With the one-two punch of *Iron Man* and *The Incredible Hulk* in the summer of 2008, Feige and his creative team began laying the foundation for this Marvel Cinematic Universe. Captain America's shield can be glimpsed amid the techno-clutter of Tony Stark's workshop, and Stark himself shows up in the final scene in *The Incredible Hulk* to inform General "Thunderbolt" Ross, "We're putting a team together." The frozen form of Captain America can even be seen — if you watch very closely — buried in the ice in one of *The Incredible Hulk*'s deleted scenes, referencing a major story point in a film then three years in the future.

Perhaps the single most significant development that summer was the introduction of Samuel L. Jackson as Nick Fury, who made his first appearance in *Iron Man*'s post-credits scene, an audible crowd-pleaser in which the shadowy director of S.H.I.E.L.D. pops in on Tony Stark to let him know he's not the world's only super hero. And it was in that moment Marvel Studios planted its flag and set its cinematic agenda for the years to come: "Mr. Stark, you've become part of a bigger universe," Fury says. "You just don't know it yet. I'm here to talk to you about the Avenger Initiative."

"When the idea of a Nick Fury cameo started coming up, we called Sam Jackson, and he thought it was a cool idea," Feige said. "It was his enthusiasm about it that led us to shoot that end-credit scene and what he says to Tony Stark in the scene was also Marvel telling that to the audience, as well.

"Audiences loved the cameo, and the buzz about Nick Fury began," Feige continued. "We did it again

two months later on *The Incredible Hulk* — and the reaction once again told us that the notion of making a movie out of *Marvel's The Avengers* had a lot of potential, and that audiences were interested in the idea. Our plan then became to build it one super hero at a time because it was really important that we introduced all of the characters first in their own franchises before putting them together in *Marvel's The Avengers.*"

Iron Man's worldwide gross of slightly less than $600 million, and the audience's overwhelmingly positive reaction to Fury and his cryptic reference, were the first real indications Marvel's all-star team would one day assemble on film.

The Marvel Cinematic Universe continued to expand two years later when Cap's shield made an encore appearance in Jon Favreau's *Iron Man 2*, offering a stronger hint at the Stark family's history with Steve Rogers and America's aborted Super-Soldier program. Sam Jackson also got more screen time to begin to build the uneasy alliance between Nick Fury and Tony Stark as they continue their collaboration on the growing Avenger Initiative. *Iron Man 2* also introduced Scarlett Johansson as Natasha Romanoff — better known in international espionage circles as Black Widow, agent of S.H.I.E.L.D. The sequel's post-credits sequence featured Clark Gregg as S.H.I.E.L.D. Agent Phil Coulson, an original character who had made his first appearance in *Iron Man*, as he arrives at a crater in the New Mexico desert. "Sir, we've found it," Coulson informs Fury — referring to Thor's hammer, Mjolnir, and setting the stage for one of the following summer's entries in the Marvel Cinematic Universe.

"We had to have a lot of confidence in the direction we were heading — but two of the four characters had not been introduced to audiences yet, and it was a bit of a leap of faith," Feige said. "A big part of the puzzle was introducing both Thor and Captain America in self-contained origin stories with very distinctive beginnings and endings that segued nicely into the storyline for *Marvel's The Avengers*. We also hired filmmakers on *Thor* and *Captain America* who were open to the idea that they were playing in a shared sandbox."

Thor — starring Australian newcomer Chris Hemsworth as the God of Thunder, and directed by veteran Shakespearean actor and filmmaker Kenneth Branagh — not only significantly expanded the Cinematic Universe, but also began to reveal the magnitude of the literal universe surrounding Earth in Marvel's more cosmic comic books.

IRON MAN

05.02.08

IronmanMovie.com

MARVEL

Thor begins in the most distant part of our universe," *Thor* Co-Producer Craig Kyle said. "It needs to make sense in Tony's world in *Iron Man*. They need to be able to sit on the couch in *Marvel's The Avengers* and talk about the universe and both be right."

And the actor playing the title role "just clicked," Kyle said. ""I think the last time Marvel was this successful in casting a relatively unknown actor in a lead role was when we cast Hugh Jackman as Wolverine."

At the film's center is an eminently relatable sibling rivalry between Thor and his jealous adopted brother, Loki (Tom Hiddleston), and a quest for the throne of Odin (Sir Anthony Hopkins). Thor's birthright and Loki's duplicity irrevocably fracture their relationship, pitting the siblings against each other in an epic power struggle that drives the film and would later come to a head in *Marvel's The Avengers*. Clark Gregg got more to do as Agent Coulson, and Jeremy Renner made a brief cameo as S.H.I.E.L.D. Agent Clint Barton, a.k.a. Hawkeye, to herald his more prominent role in *Marvel's The Avengers*. The climactic team-up film was by then a foregone conclusion thanks to the blockbuster success of the *Iron Man* films, and the significant investments in capital and creativity Marvel had made in *Thor* and the studio's other big summer 2011 release, *Captain America: The First Avenger*.

The post-credit scene focuses on one of Thor's earthly allies, Dr. Erik Selvig (Stellan Skarsgård), as Nick Fury offers him his first glimpse of the Tesseract, a source of unspeakable power that would go on to play a pivotal role in both *Captain America* and *Marvel's The Avengers*. Selvig is ultimately revealed to be possessed by a renegade Loki, who clearly has designs on the Tesseract — a strong hint at the identity of one of the Avengers' primary foes.

Captain America: The First Avenger — featuring Chris Evans in the title role and helmed by Joe Johnston, director of *The Rocketeer*, another fantastical vision of World War II — went further than any previous Marvel Studios production in building the Cinematic Universe and setting the stage for *Marvel's The Avengers*, yet still stands alone. The film formally introduced the Tesseract, an otherworldly power source the Red Skull (Hugo Weaving) intends to use as a weapon. The events of *Captain America* and Easter eggs in the *Iron Man* films suggest Howard Stark (Dominic Cooper) somehow manages to harness the mysterious energy source to develop the Arc Reactor Howard's son Tony later uses to save his own life and power his Iron Man armor. The Tesseract itself would ultimately become the MacGuffin driving much of the action in *Marvel's The Avengers*, pitting Loki and his alien allies against Thor and the newly assembled team of heroes in a cataclysmic battle for Earth.

"If you look at our other films, you see that we cast performers first," *Captain America* Co-Producer Stephen Broussard said. "We make sure that we cast actors with real talent, with real acting chops, and that's certainly going to be the case with a character like Steve Rogers. It's a very complex character. He starts in one place, ends up in a completely different place, both physically and emotionally. You need someone that can play the broad range of that. You also need someone that when we get to *Marvel's The Avengers* can go toe-to-toe with actors like Robert Downey Jr., can hold their own in a scene."

Making *Captain America* perhaps the most important stop on the road to *Marvel's The Avengers* was its final sequence, wherein Steve Rogers awakens to find himself alive and well in the 21st century after being exhumed from his icy tomb. And who is on hand to welcome Cap to the future? Nick Fury, of course. And as it turns out, America needs its legendary captain now more than ever.

Marvel's The Avengers builds upon the collective mythology created by *Iron Man, Iron Man 2, The Incredible Hulk, Thor* and *Captain America: The First Avenger*, continuing storylines and character arcs from all five films to fully and finally establish the Marvel Cinematic Universe — and set the stage for adventures to come. In many ways, the film is something of a cinematic dividing line between the movies that came before it and everything to come after it. Even if future productions are based on properties as seemingly disparate as Ant-Man or Dr. Strange, those characters will inhabit the same film world as Tony Stark, Bruce Banner, Steve Rogers and Thor — just as in the original comic books.

two months later on *The Incredible Hulk* — and the reaction once again told us that the notion of making a movie out of *Marvel's The Avengers* had a lot of potential, and that audiences were interested in the idea. Our plan then became to build it one super hero at a time because it was really important that we introduced all of the characters first in their own franchises before putting them together in *Marvel's The Avengers.*"

Iron Man's worldwide gross of slightly less than $600 million, and the audience's overwhelmingly positive reaction to Fury and his cryptic reference, were the first real indications Marvel's all-star team would one day assemble on film.

The Marvel Cinematic Universe continued to expand two years later when Cap's shield made an encore appearance in Jon Favreau's *Iron Man 2*, offering a stronger hint at the Stark family's history with Steve Rogers and America's aborted Super-Soldier program. Sam Jackson also got more screen time to begin to build the uneasy alliance between Nick Fury and Tony Stark as they continue their collaboration on the growing Avenger Initiative. *Iron Man 2* also introduced Scarlett Johansson as Natasha Romanoff — better known in international espionage circles as Black Widow, agent of S.H.I.E.L.D. The sequel's post-credits sequence featured Clark Gregg as S.H.I.E.L.D. Agent Phil Coulson, an original character who had made his first appearance in *Iron Man*, as he arrives at a crater in the New Mexico desert. "Sir, we've found it," Coulson informs Fury — referring to Thor's hammer, Mjolnir, and setting the stage for one of the following summer's entries in the Marvel Cinematic Universe.

"We had to have a lot of confidence in the direction we were heading — but two of the four characters had not been introduced to audiences yet, and it was a bit of a leap of faith," Feige said. "A big part of the puzzle was introducing both Thor and Captain America in self-contained origin stories with very distinctive beginnings and endings that segued nicely into the storyline for *Marvel's The Avengers*. We also hired filmmakers on *Thor* and *Captain America* who were open to the idea that they were playing in a shared sandbox."

Thor — starring Australian newcomer Chris Hemsworth as the God of Thunder, and directed by veteran Shakespearean actor and filmmaker Kenneth Branagh — not only significantly expanded the Cinematic Universe, but also began to reveal the magnitude of the literal universe surrounding Earth in Marvel's more cosmic comic books.

Thor begins in the most distant part of our universe," *Thor* Co-Producer Craig Kyle said. "It needs to make sense in Tony's world in *Iron Man*. They need to be able to sit on the couch in *Marvel's The Avengers* and talk about the universe and both be right."

And the actor playing the title role "just clicked," Kyle said. ""I think the last time Marvel was this successful in casting a relatively unknown actor in a lead role was when we cast Hugh Jackman as Wolverine.""

At the film's center is an eminently relatable sibling rivalry between Thor and his jealous adopted brother, Loki (Tom Hiddleston), and a quest for the throne of Odin (Sir Anthony Hopkins). Thor's birthright and Loki's duplicity irrevocably fracture their relationship, pitting the siblings against each other in an epic power struggle that drives the film and would later come to a head in *Marvel's The Avengers*. Clark Gregg got more to do as Agent Coulson, and Jeremy Renner made a brief cameo as S.H.I.E.L.D. Agent Clint Barton, a.k.a. Hawkeye, to herald his more prominent role in *Marvel's The Avengers*. The climactic team-up film was by then a foregone conclusion thanks to the blockbuster success of the *Iron Man* films, and the significant investments in capital and creativity Marvel had made in *Thor* and the studio's other big summer 2011 release, *Captain America: The First Avenger*.

The post-credit scene focuses on one of Thor's earthly allies, Dr. Erik Selvig (Stellan Skarsgård), as Nick Fury offers him his first glimpse of the Tesseract, a source of unspeakable power that would go on to play a pivotal role in both *Captain America* and *Marvel's The Avengers*. Selvig is ultimately revealed to be possessed by a renegade Loki, who clearly has designs on the Tesseract — a strong hint at the identity of one of the Avengers' primary foes.

Captain America: The First Avenger — featuring Chris Evans in the title role and helmed by Joe Johnston, director of *The Rocketeer*, another fantastical vision of World War II — went further than any previous Marvel Studios production in building the Cinematic Universe and setting the stage for *Marvel's The Avengers*, yet still stands alone. The film formally introduced the Tesseract, an otherworldly power source the Red Skull (Hugo Weaving) intends to use as a weapon. The events of *Captain America* and Easter eggs in the *Iron Man* films suggest Howard Stark (Dominic Cooper) somehow manages to harness the mysterious energy source to develop the Arc Reactor Howard's son Tony later uses to save his own life and power his Iron Man armor. The Tesseract itself would ultimately become the MacGuffin driving much of the action in *Marvel's The Avengers*, pitting Loki and his alien allies against Thor and the newly assembled team of heroes in a cataclysmic battle for Earth

If you look at our other films, you see that we cast performers first," *Captain America* Co-Producer Stephen Broussard said. "We make sure that we cast actors with real talent, with real acting chops, and that's certainly going to be the case with a character like Steve Rogers. It's a very complex character. He starts in one place, ends up in a completely different place, both physically and emotionally. You need someone that can play the broad range of that. You also need someone that when we get to *Marvel's The Avengers* can go toe-to-toe with actors like Robert Downey Jr., can hold their own in a scene."

Making *Captain America* perhaps the most important stop on the road to *Marvel's The Avengers* was its final sequence wherein Steve Rogers awakens to find himself alive and well in the 21st century after being exhumed from his icy tomb. And who is on hand to welcome Cap to the future? Nick Fury, of course. And as it turns out, America needs its legendary captain now more than ever.

Marvel's The Avengers builds upon the collective mythology created by *Iron Man, Iron Man 2, The Incredible Hulk, Thor* and *Captain America: The First Avenger*, continuing storylines and character arcs from all five films to fully and finally establish the Marvel Cinematic Universe — and set the stage for adventures to come. In many ways, the film is something of a cinematic dividing line between the movies that came before it and everything to come after it. Even if future productions are based on properties as seemingly disparate as Ant-Man or Dr. Strange, those characters will inhabit the same film world as Tony Stark, Bruce Banner, Steve Rogers and Thor — just as in the original comic books.

"The release of *Marvel's The Avengers* is the realization of a dream that began long before I was born when Stan Lee, Jack Kirby and everyone in the Marvel Bullpen had the brilliant idea to put all these characters together in one comic book to deal with one big mega-event," Feige said. "When we became our own studio, our endgame was to one day combine them all."

The mega-event in question is an all-out assault on Earth motivated by Loki's thirst for power and insatiable desire to occupy a throne — any throne — even if it means lording that power over humans, a race "made to be ruled" in his estimation. He can't do it alone, of course, even with the Tesseract, so the trickster forges an uneasy alliance with the Chitauri, an alien race that serves as his invading force.

"It was a very unique challenge in figuring out what material to adapt into the screenplay for *Marvel's The Avengers*," Latcham said. "For all of the previous films, we could look at the comics for a jumping-off point. But with *Marvel's The Avengers*, we said let's see what we've established in our previous films. It's really about, 'How do we pay off this cinematic universe that we've established? How do we give fans of the movies what they want while still honoring and giving fans of the comics what they want, as well?'"

Continuing their tradition of hiring creative talent best suited to the material, Marvel Studios enlisted fan favorite and self-proclaimed fanboy Joss Whedon — who co-wrote the original *Toy Story*; created and ran the cult TV classics *Buffy the Vampire Slayer*, *Angel* and *Firefly*; and enjoyed his own critically acclaimed and wildly popular comic-book run with *Astonishing X-Men*. Feige felt the genre veteran was the perfect choice to write and direct *Marvel's The Avengers*. "We needed somebody who could take a big story and a big idea, and execute it without ever letting the characters get lost amongst all the spectacle," Feige said.

"The challenge is making sure all these different types of super heroes feel like they belong together as a team — and not as misfits — to the viewer," *Marvel's The Avengers* Executive Producer Victoria Alonso said. "And that's what you get: a team of people that could go to battle together."

And so there came a day, a day unlike any other, when Earth's Mightiest Heroes found themselves united against a common threat. On that day the Avengers were born.

"It really was a special moment seeing everyone together for the first time," Feige said. "*Marvel's The Avengers* is a cornerstone of Marvel Comics, and to bring it to the big screen is quite an accomplishment. And it was something the entire cast recognized in the moment and were all very excited. I know I was giddy in the moment watching at the monitor."

Whedon started work on his script with a few key creative parameters. "They knew they wanted Loki to be the primary villain," Whedon said. "They wanted all the heroes to come together in a way that made sense, and they wanted the film to end with an alien invasion of New York. That's basically your three-act structure right there." The film's storyline is also a nod to *Avengers #1*, published in 1963, which likewise featured Loki as its antagonist.

"In the very first issue of the *Avengers* comic, it's Loki who is causing trouble, and it brings them all together," Feige said. "So it not only worked into the order in which we were telling these stories in our movies; it also has its own origins in the very first issue of the comic."

Even Loki's alliance with the Chitauri emerged organically. "One guy against six hugely powerful heroes really didn't seem fair to me," Whedon said. "So it made sense to give him an alien army to help him out." But both Loki and his alien co-conspirators are being unwittingly manipulated by a shadowy figure revealed in the film's post-credits scene, one instantly familiar to Marvel comic-book fans. Much as *Marvel's The Avengers* serves as the culmination of a five-film series that began with *Iron Man*, this brief but pivotal epilogue helps set the stage for future films and what will effectively become a second act of the Marvel Cinematic Universe.

"*Iron Man* was the dawn of the Marvel Studios age, the establishment of the Marvel Cinematic Universe and the beginning of that continuity," Feige said. "*The Avengers* is the next big step. Once all these characters come together, it's the culmination of everything that has come before and launches a new era in the history of our films. It also renews each of these characters and launches them into their own franchises, beginning with *Iron Man 3*. Thor will set off on new adventures, and Captain America will continue to explore the modern world. We hope that holds true for all of the characters in *The Avengers* — Black Widow, Hawkeye, Nick Fury and S.H.I.E.L.D. All of them are more than capable of carrying their own films."

The expansion of the Marvel Cinematic Universe won't be limited to just this particular team of Avengers and the characters featured in the studio's first five films. The comic books have long featured an ever-changing roster of Avengers, and some of those other members could join or even replace Iron Man, Cap, Thor, Hulk and the agents of S.H.I.E.L.D. in future installments of the film series. And then there's the infinite Marvel Universe beyond just waiting to make the transition from comic-book page to film screen. "We've got a lot of other characters that we're preparing for their film debuts," Feige said. "The world of martial arts, these great cosmic space fantasies, Dr. Strange and the magical side of the Marvel Universe — with more than 8,000 characters in our stable, there are many, many stories to bring to the moviegoers for years to come."

And so *Marvel's The Avengers* is at once an ending and a new beginning for the Marvel Cinematic Universe — one that, like our own, is destined to continue expanding far into the future. The film is the realization of one dream and the promise of many others to come, a rich and complex world that took hundreds of visionary artists and skilled craftsmen countless hours to realize. And their journey is every bit as compelling as the one Earth's Mightiest Heroes undertake on-screen, as you are about to experience.

It seems only fitting to begin this exploration of *The Art of Marvel's The Avengers* with the same call to action as Chris Evans' fateful text message to his fellow teammates:

"Assemble."

 Jotunheim invades Midgard/Earth (Tonsberg, Norway), Odin defeats Laufey and the Jotuns and captures the Casket of Ancient Winters (*THOR*)

Johann Schmidt invades Tonsberg, Norway and steals the Tesseract (*CAPTAIN AMERICA: THE FIRST AVENGER*)

 Stark Industries unveils the first Arc Reactor (*IRON MAN*)

Captain America defeats Johann Schmidt (The Red Skull) and crashes the suborbital bomber into the Arctic (*CAPTAIN AMERICA: THE FIRST AVENGER*)

Tony Stark is kidnapped by the Ten Rings, invents a miniaturized Arc Reactor to keep shrapnel out of his heart and the Iron Man Mark I armor to escape (*IRON MAN*)

 S.H.I.E.L.D. monitors Bruce Banner, Tony Stark, and Jane Foster

Banner "Hulks" out at a bottling plant while chased by General Ross and Emil Blonsky in Rochina, Rio de Janeiro (*THE INCREDIBLE HULK*)

After a botched mission involving a Hammer Industries prototype, General Ross is confronted by Iron Man (*IRON MAN 2: PUBLIC IDENTITY*)

1000 years BIM

600 years BIM

67 years BIM

64 years BIM

45 years BIM

33 years BIM

5 years BIM

9 mo BIM

1 day BIM

POINT OF ORIGIN: "I AM IRON MAN"

1/2 day AIM

3 mo AIM

6 mo AIM

BEGIN "FURY'S BIG WEEK"

Odin leaves the Tesseract on Earth

Steve Rogers becomes Project: Rebirth's first and only successful super-soldier (*CAPTAIN AMERICA: THE FIRST AVENGER*)

Howard Stark works with Anton Vanko on the development of the Arc Reactor (*IRON MAN 2*)

Bruce Banner is bombarded with gamma radiation, changes into the Hulk, and escapes (*THE INCREDIBLE HULK*)

Iron Man battles the Iron Monger on the Howard Stark Memorial Freeway (*IRON MAN*)

Nick Fury approaches Tony Stark about the Avengers Initiative (*IRON MAN*)

Tony is attacked by Ivan Vanko's Whiplash suit at the Monaco Historical Grand Prix and defeats him by using the Mark V "suitcase suit" (*IRON MAN 2*)

BIM = Before Tony Stark declares "I am Iron Man" AIM = After Tony Stark declares "I am Iron Man"

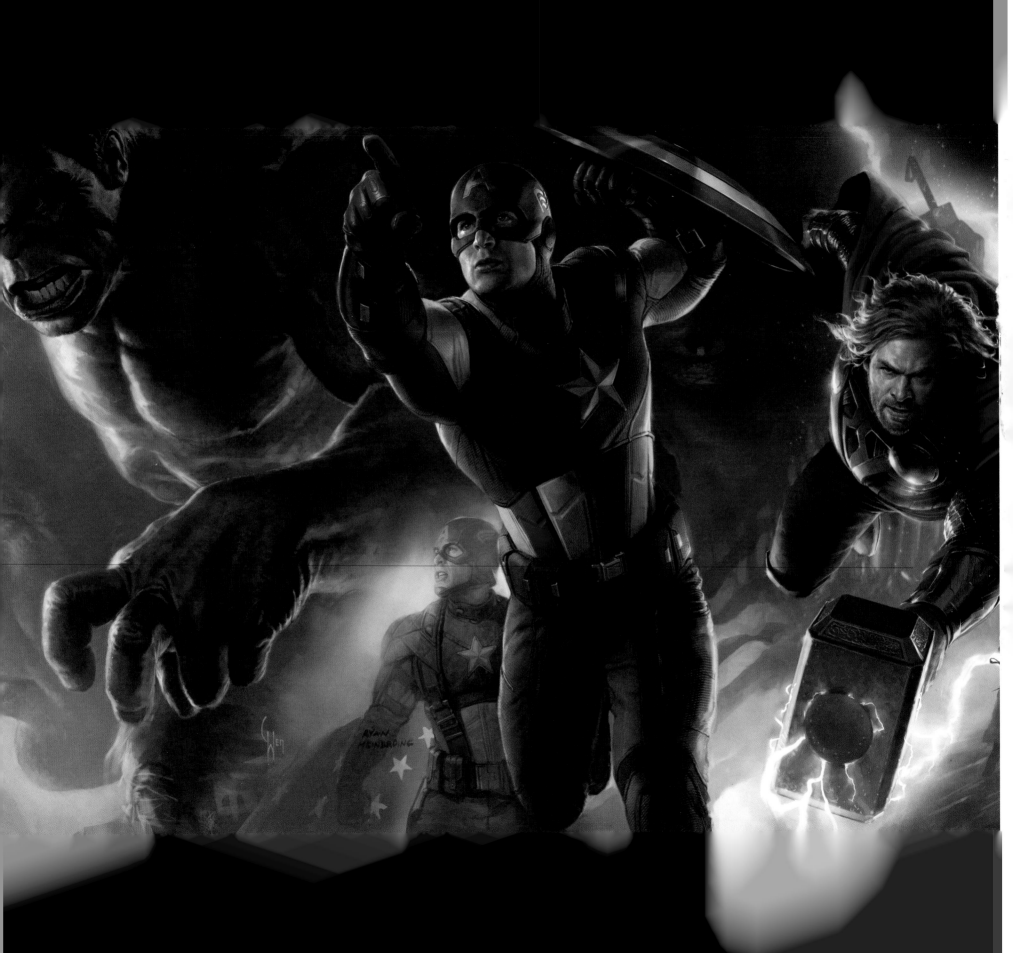

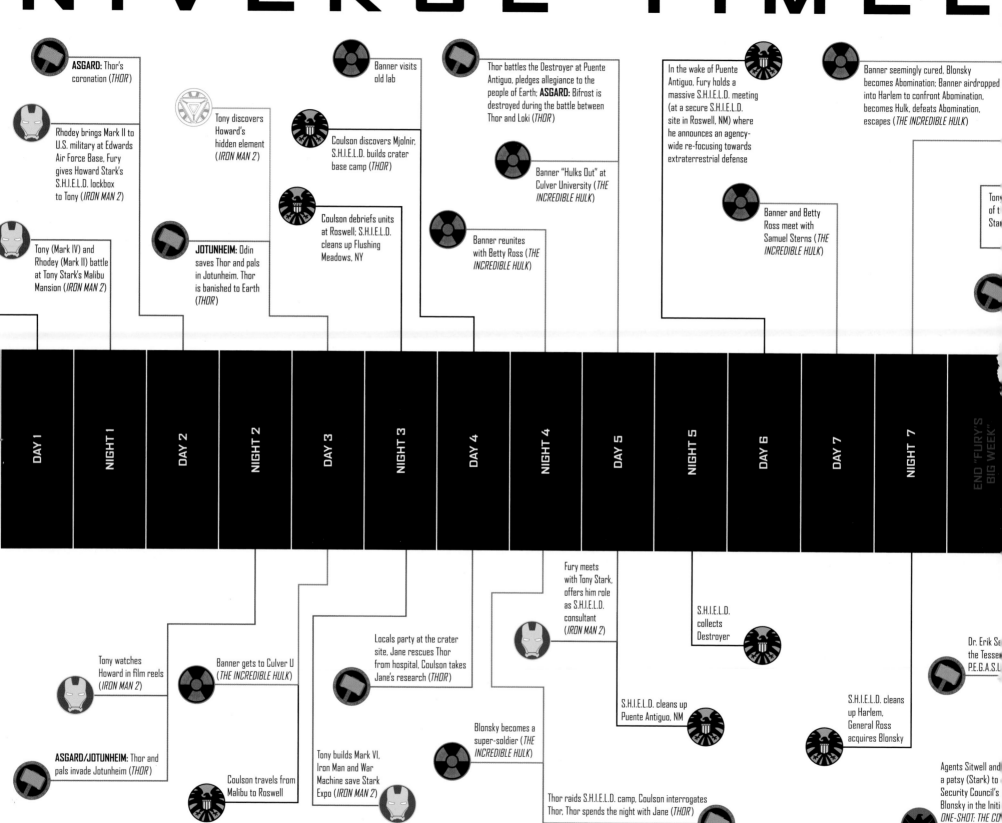

NIVERSE TIMEL

ASGARD: Thor's coronation (*THOR*)

Rhodey brings Mark II to U.S. military at Edwards Air Force Base, Fury gives Howard Stark's S.H.I.E.L.D. lockbox to Tony (*IRON MAN 2*)

Tony (Mark IV) and Rhodey (Mark II) battle at Tony Stark's Malibu Mansion (*IRON MAN 2*)

Tony discovers Howard's hidden element (*IRON MAN 2*)

JOTUNHEIM: Odin saves Thor and pals in Jotunheim. Thor is banished to Earth (*THOR*)

Banner visits old lab

Coulson discovers Mjolnir, S.H.I.E.L.D. builds crater base camp (*THOR*)

Coulson debriefs units at Roswell; S.H.I.E.L.D. cleans up Flushing Meadows, NY

Thor battles the Destroyer at Puente Antiguo, pledges allegiance to the people of Earth; **ASGARD:** Bifrost is destroyed during the battle between Thor and Loki (*THOR*)

Banner "Hulks Out" at Culver University (*THE INCREDIBLE HULK*)

Banner reunites with Betty Ross (*THE INCREDIBLE HULK*)

In the wake of Puente Antiguo, Fury holds a massive S.H.I.E.L.D. meeting (at a secure S.H.I.E.L.D. site in Roswell, NM) where he announces an agency-wide re-focusing towards extraterrestrial defense

Banner and Betty Ross meet with Samuel Sterns (*THE INCREDIBLE HULK*)

Banner seemingly cured, Blonsky becomes Abomination; Banner airdropped into Harlem to confront Abomination, becomes Hulk, defeats Abomination, escapes (*THE INCREDIBLE HULK*)

Ton of t Stan

| DAY 1 | NIGHT 1 | DAY 2 | NIGHT 2 | DAY 3 | NIGHT 3 | DAY 4 | NIGHT 4 | DAY 5 | NIGHT 5 | DAY 6 | DAY 7 | NIGHT 7 | END "FURY'S BIG WEEK" |

Fury meets with Tony Stark, offers him role as S.H.I.E.L.D. consultant (*IRON MAN 2*)

S.H.I.E.L.D. collects Destroyer

Tony watches Howard in film reels (*IRON MAN 2*)

Banner gets to Culver U (*THE INCREDIBLE HULK*)

Locals party at the crater site, Jane rescues Thor from hospital, Coulson takes Jane's research (*THOR*)

Dr. Erik Se the Tesse P.E.G.A.S.U

S.H.I.E.L.D. cleans up Harlem, General Ross acquires Blonsky

ASGARD/JOTUNHEIM: Thor and pals invade Jotunheim (*THOR*)

Coulson travels from Malibu to Roswell

Tony builds Mark VI, Iron Man and War Machine save Stark Expo (*IRON MAN 2*)

Blonsky becomes a super-soldier (*THE INCREDIBLE HULK*)

S.H.I.E.L.D. cleans up Puente Antiguo, NM

Thor raids S.H.I.E.L.D. camp, Coulson interrogates Thor, Thor spends the night with Jane (*THOR*)

Agents Sitwell and a patsy (Stark) to Security Council's Blonsky in the Initi *ONE-SHOT: THE CO*

INE

Banner manages to refrain from "Hulking Out" as he travels from British Columbia to Calcutta (After *THE INCREDIBLE HULK*)

Stark begins construction e Arc Reactor-powered k Tower (After *IRON MAN 2*)

Loki arrives on Earth

BEFORE THE AVENGERS

lvig works with act at Project: S. (After *THOR*)

Captain America is discovered in the Arctic (*CAPTAIN AMERICA: THE FIRST AVENGER*)

Coulson call in quell the World lans to include ative (*MARVEL NSULTANT*)

AVENGERS ASSEMBLE

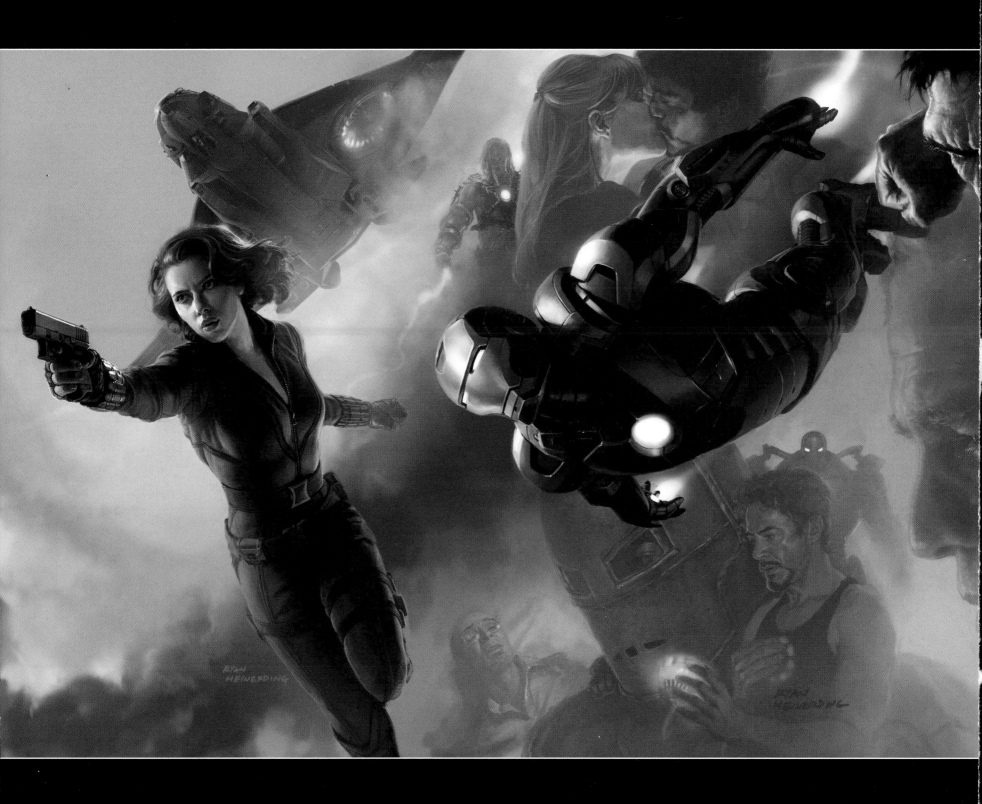

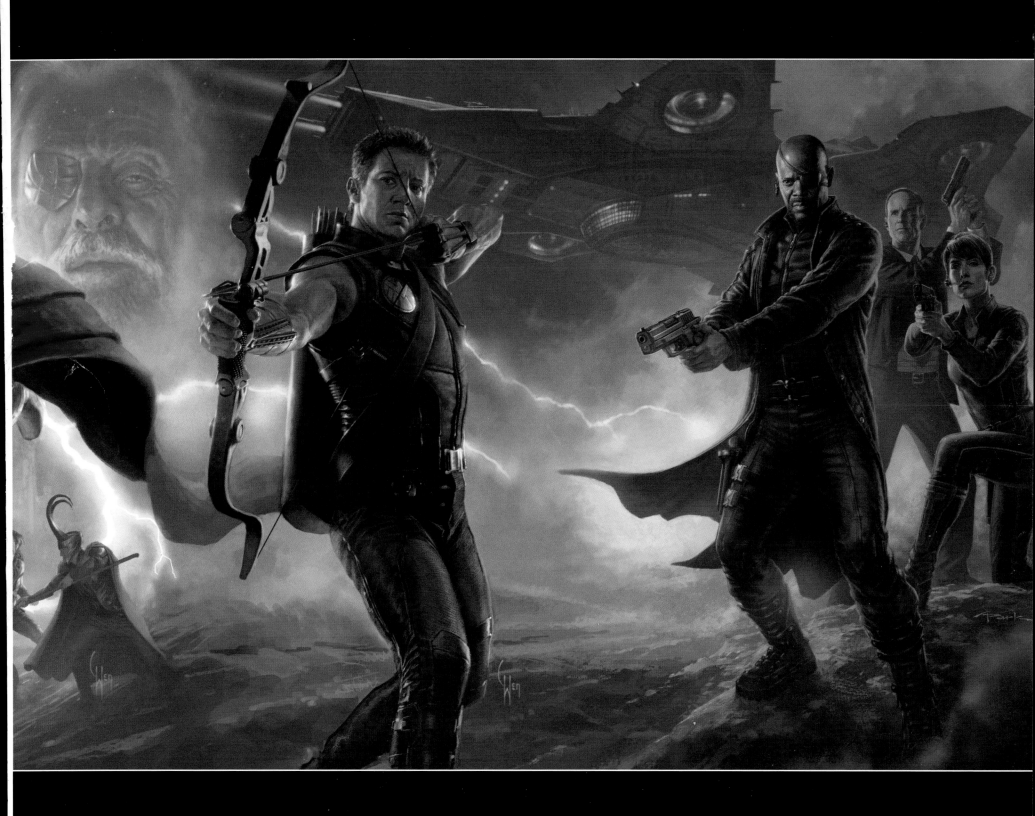

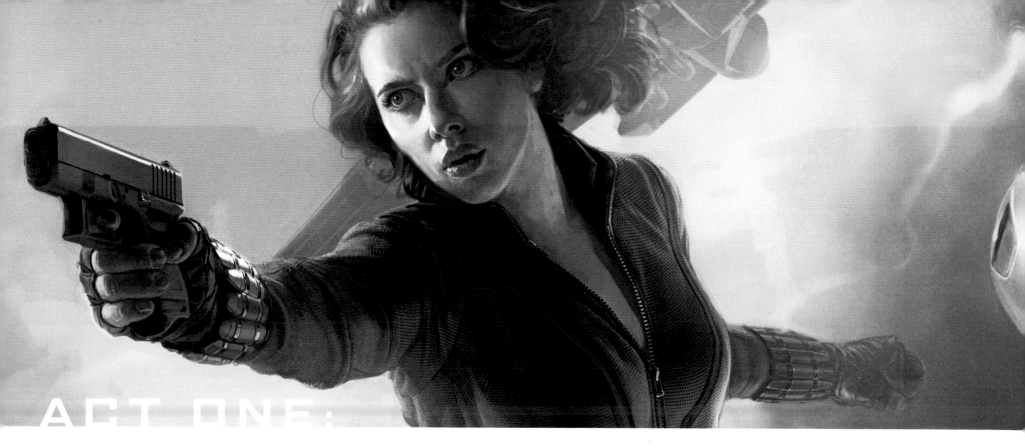

INCIDENT IN THE DESERT

Art by Ryan Meinering.

PROJECT: P.E.G.A.S.U.S.

Project: P.E.G.A.S.U.S. is a clandestine quest to unlock the secrets and harness the power of the Tesseract, ostensibly to create a new and unlimited clean energy source — "a warm light for all mankind to share," as Loki derisively refers to it. But as with most matters involving S.H.I.E.L.D., there's more to P.E.G.A.S.U.S. than meets the eye. A much smaller group within S.H.I.E.L.D. is already deep into Phase 2, a top-secret program under the direct command of Nick Fury (Samuel L. Jackson). Howard Stark (Dominic Cooper), one of S.H.I.E.L.D.'s founders, fished the Tesseract out of the icy waters of the Arctic while searching for Steve Rogers (Chris Evans) at the end of *Captain America: The First Avenger*. S.H.I.E.L.D. has sought to unlock its secrets ever since — recruiting Dr. Erik Selvig (Stellan Skarsgård), whom we first met in *Thor*, to study this strange Cosmic Cube and attempt to harness its intergalactic dark energy.

As *Marvel's The Avengers* begins, Selvig and his team of scientists are sequestered in a cavernous chamber at Project: P.E.G.A.S.U.S. under the watchful eyes of agents Clint Barton, a.k.a. "Hawkeye" (Jeremy Renner), and Maria Hill (Cobie Smulders). But when the Tesseract inexplicably "turns itself on" and Selvig notices an ominous surge of dark energy, Fury must chopper in to assume control of a rapidly deteriorating situation.

"Throughout the entire prep period of *The Avengers*, the S.H.I.E.L.D. facility was a constantly evolving set of puzzle pieces as we had several locations that came and went," Production Designer James Chinlund said. "We literally did a nationwide search looking for just the right spaces, with the requisite grandeur to contain the action of the opening sequence. In the end, we wound up with a group of locations literally spread across four states.

"As Fury arrives initially at the S.H.I.E.L.D. facility, he lands at a high-school location in the desert outside Albuquerque," Chinlund continued. "At this location, we installed a helipad and — with Victor Zolfo, our set decorator — did a tremendous amount of augmentation to make this feel like a high-security government facility."

Zolfo had the task of balancing story needs with practical concerns. "Turning an operating high school's campus into the S.H.I.E.L.D. facility — complete with helipad — required many custom rigs for on-camera lighting containing thousands of LEDs," he said. "They had to be able to withstand rotor wash from the choppers."

Because filmmakers used multiple locations — from a New Mexico high school to an underground mine in Pennsylvania to the world's largest vacuum chamber in Ohio — to realize the S.H.I.E.L.D. facility, portability also was a key component. "We painted and applied S.H.I.E.L.D. graphics to hundreds of military cases purchased from salvage yards across the Southwest; they became part of our enormous S.H.I.E.L.D. package that we traveled with to all the locations," Zolfo said.

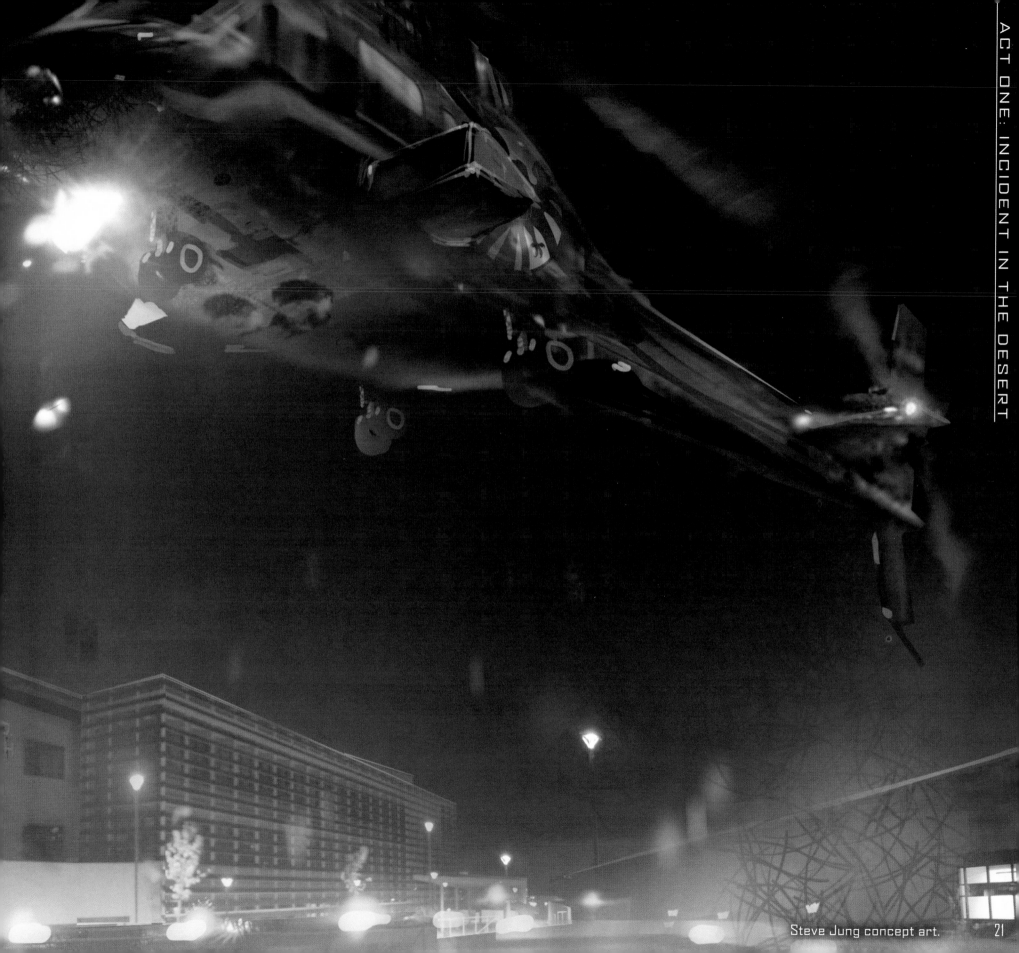

Steve Jung concept art.

21

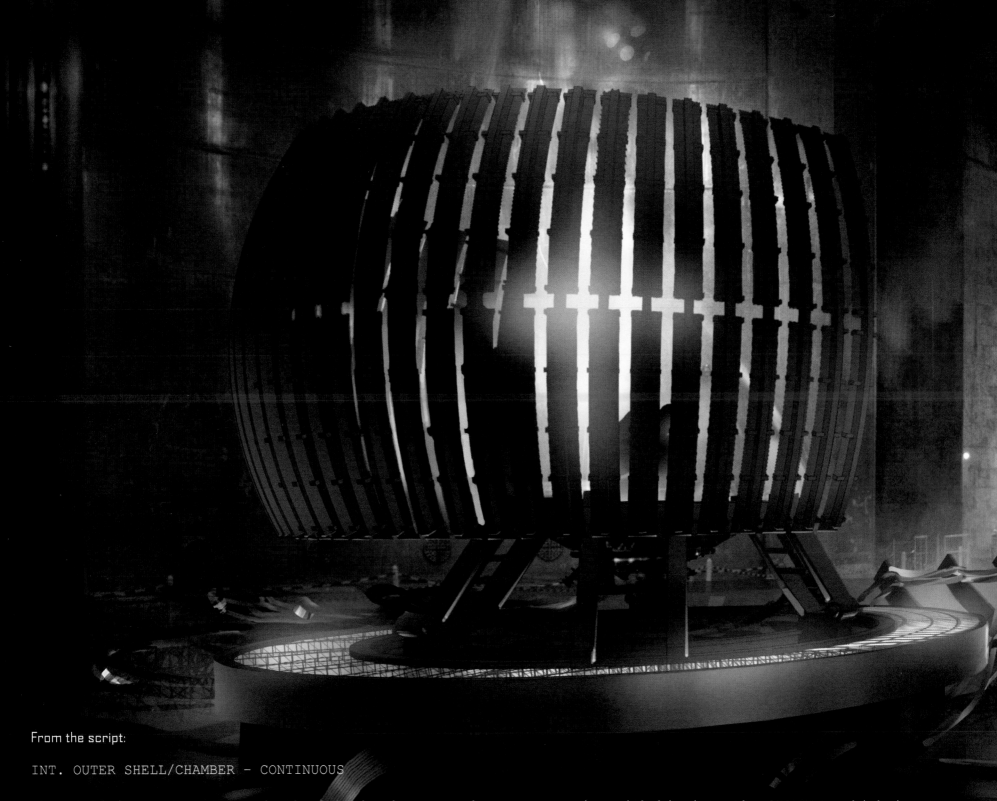

From the script:

INT. OUTER SHELL/CHAMBER - CONTINUOUS

They fall in as Fury proceeds through the doorway, the camera moving with him into the CHAMBER, which is, to put it mildly, vast. Eighty feet high, gleaming and domed like the inside of a bullet. The room is empty but for a receptor platform that faces a small machine glowing blue in the center.

Steve Jung concept art.

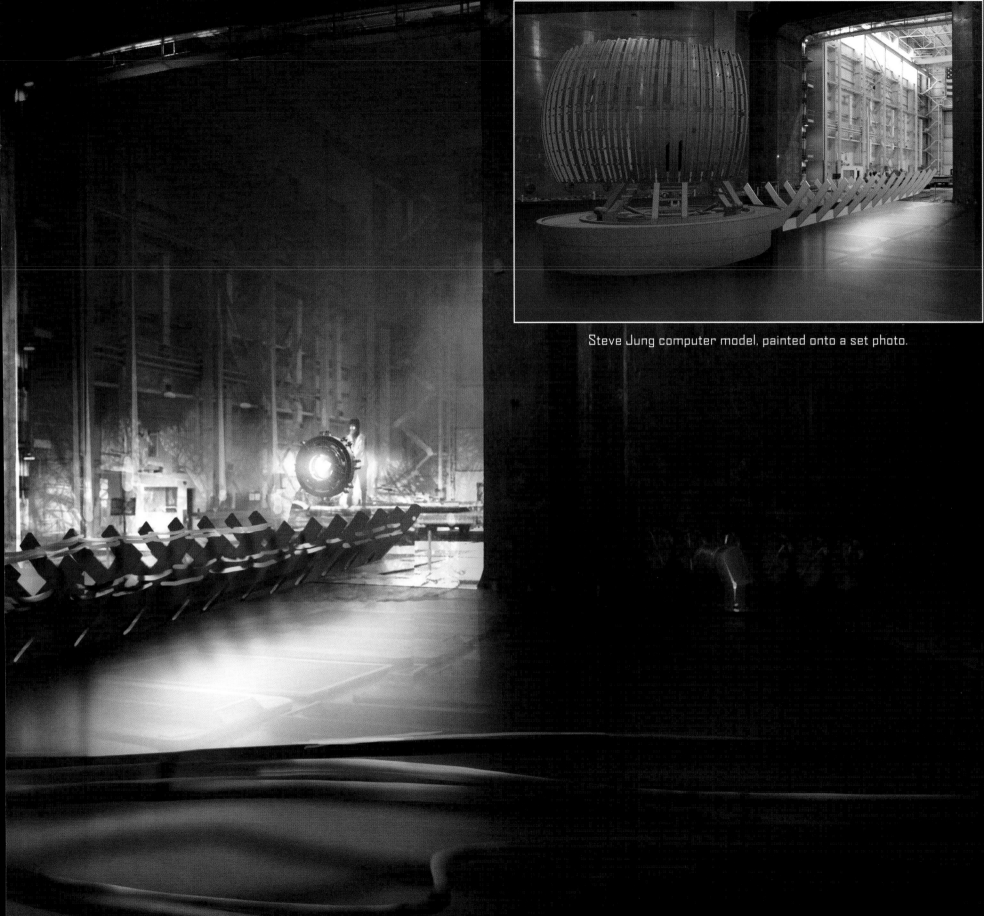

Steve Jung computer model, painted onto a set photo.

NICK FURY

Samuel L. Jackson made his first on-screen appearance as Nick Fury in the post-credits sequence of *Iron Man* (2008), a cameo met by thunderous applause and widespread excitement for what the future might hold for both the character and his cryptic reference to "the Avengers Initiative." Fury returned in *Iron Man 2* (2010) — primarily to tell Tony Stark (Robert Downey Jr.) that his father, Howard (played in that film by John Slattery of *Mad Men* fame) was one of the founders of S.H.I.E.L.D., and that Tony's new personal assistant Natalie Rushman (Scarlett Johansson) is actually undercover agent Natasha Romanoff, a.k.a. Black Widow. Fury also made post-credits cameo appearances in *Thor* (2011) and *Captain America: The First Avenger* (2011), recruiting Dr. Erik Selvig to study the Tesseract in the former and welcoming an understandably rattled Steve Rogers to the 21st century in the latter.

But it is in *Marvel's The Avengers* that Earth must finally confront the "common threat" Fury has been anticipating and dreading for years. And so Sam Jackson at last gets to take center stage as the architect of Earth's last line of defense. Writer/director Joss Whedon told Jackson up front he wanted to see the weight of the world on Fury's shoulders as the man "who is supposed to be in control of the most powerful beings on the planet, the weight on somebody who has to run an organization like S.H.I.E.L.D. and the sheer gravity of that situation."

But Fury remains the picture of grit under fire, even when it's coming at him from every quarter: the World Security Council, an invading alien force led by a megalomaniacal demigod and even the Avengers themselves, who can often be just as much a hindrance as a help. And that's because, at the end of the day, he has a job to do. "Nick is a soldier," Jackson said. "He's a rational battlefield technician. He's a pro, the guy you bring in when things turn bad. He knows this collective is the only thing that can save the Earth, and he fully believes in them."

Fury's determination and self-confidence shone through in all aspects of the production. "I felt that Nick Fury should be a statement of effortless authority," Costume Designer Alexandra Byrne said. "Combine this with Samuel L. Jackson's great style and innate ability to wear clothes, and the task is not difficult. Less is more was a clear way forward."

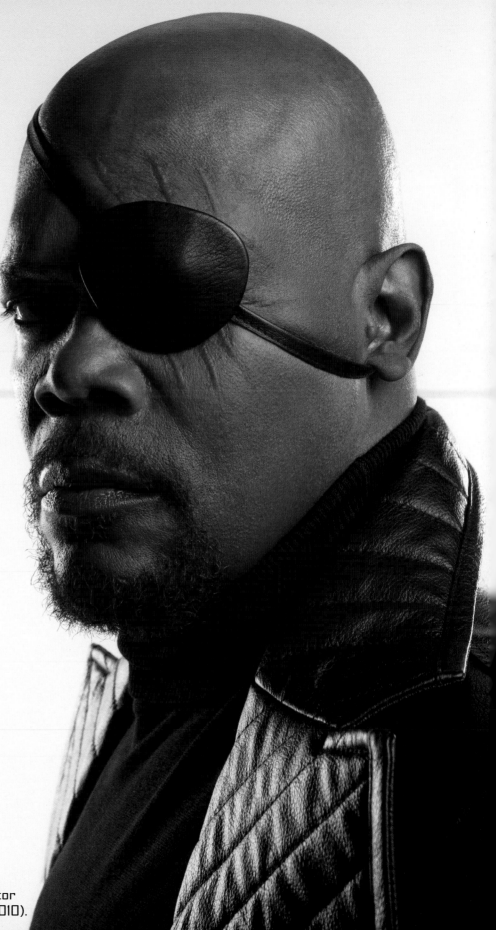

Samuel L. Jackson as Nick Fury, director of S.H.I.E.L.D., as seen in *Iron Man 2* (2010).

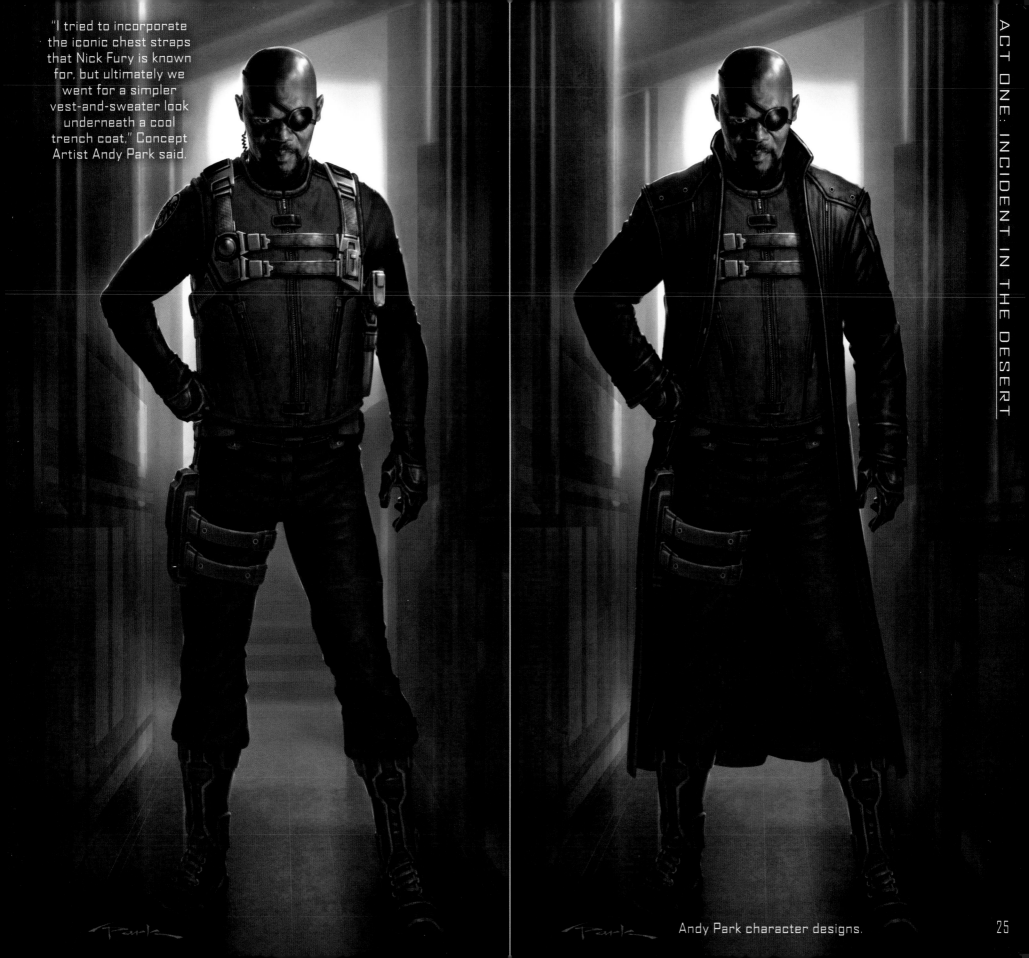

"I tried to incorporate the iconic chest straps that Nick Fury is known for, but ultimately we went for a simpler vest-and-sweater look underneath a cool trench coat." Concept Artist Andy Park said.

Andy Park character designs.

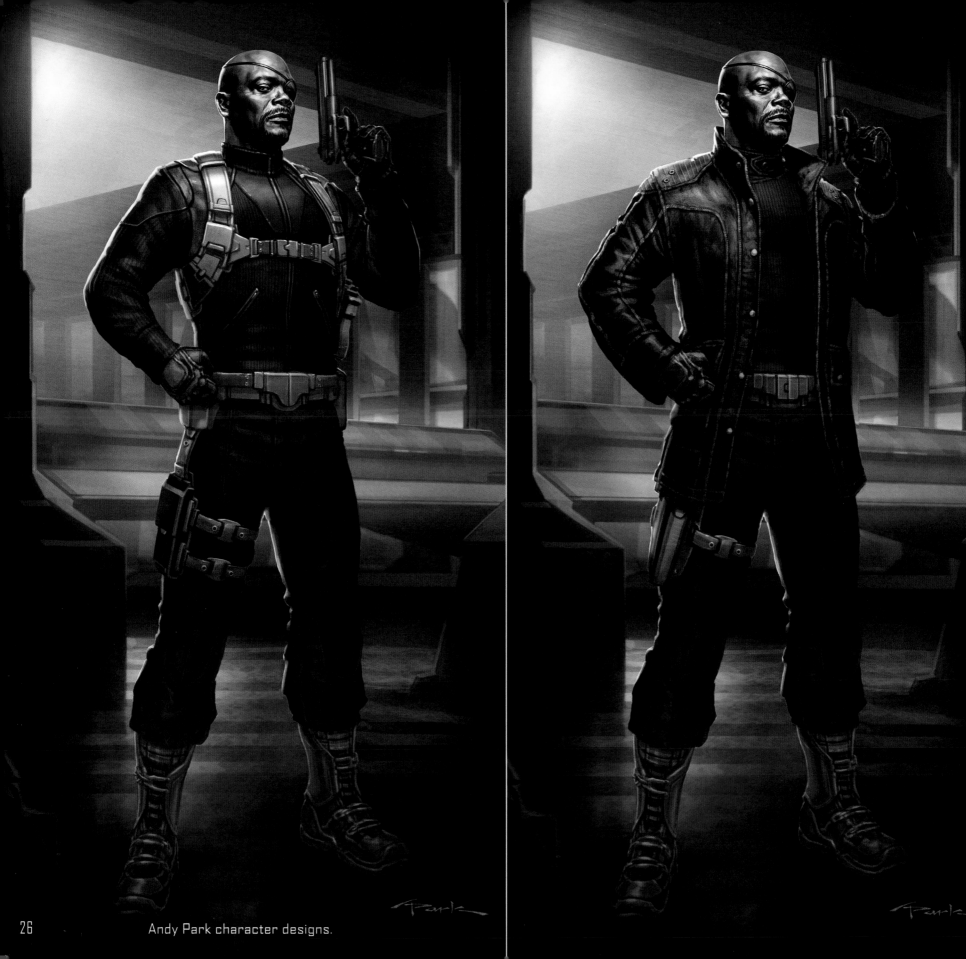

Andy Park character designs.

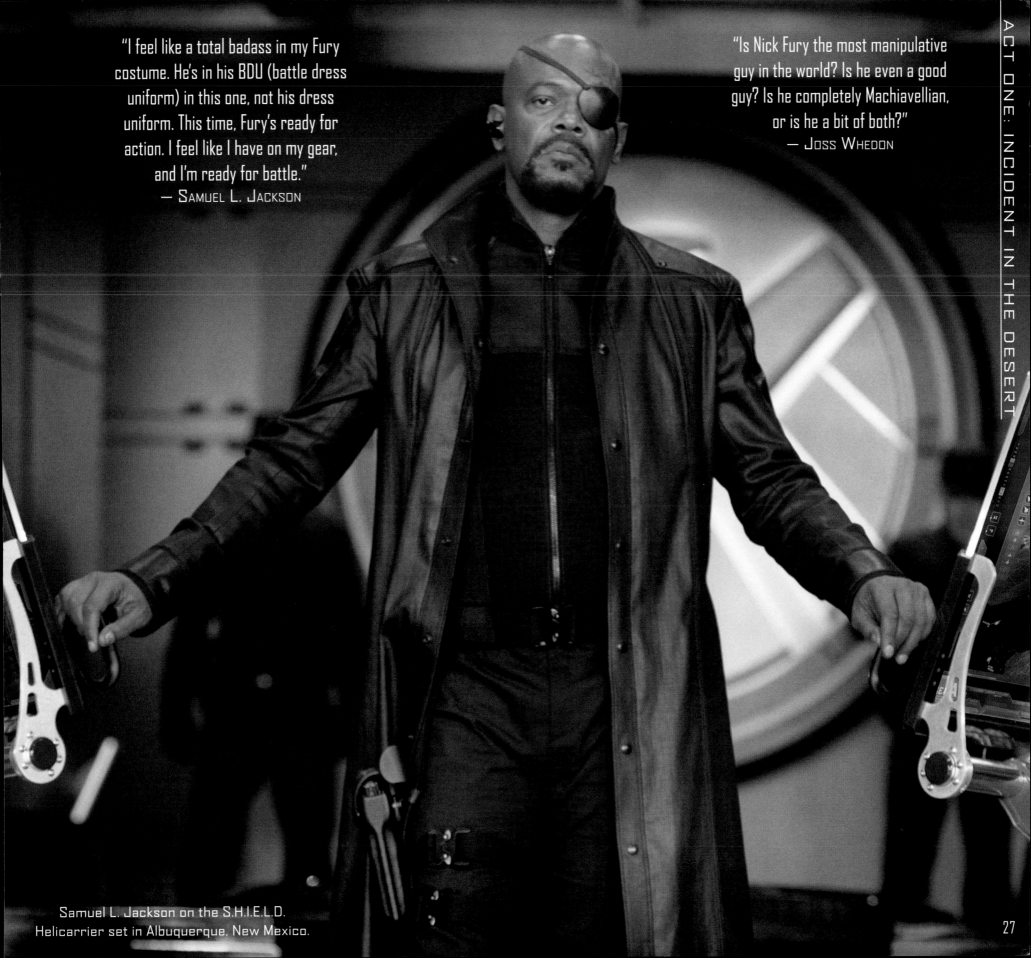

"I feel like a total badass in my Fury costume. He's in his BDU (battle dress uniform) in this one, not his dress uniform. This time, Fury's ready for action. I feel like I have on my gear, and I'm ready for battle."
— SAMUEL L. JACKSON

"Is Nick Fury the most manipulative guy in the world? Is he even a good guy? Is he completely Machiavellian, or is he a bit of both?"
— JOSS WHEDON

Samuel L. Jackson on the S.H.I.E.L.D. Helicarrier set in Albuquerque, New Mexico.

AGENTS OF S.H.I.E.L.D.

The acronym has changed throughout Marvel history — but in the Marvel Studios films, S.H.I.E.L.D. stands for Strategic Homeland Intervention, Enforcement and Logistics Division. The agents of S.H.I.E.L.D. expand their presence significantly in *Marvel's The Avengers*, a far cry from the small role played by Agent Phil Coulson (Clark Gregg) and Nick Fury's post-credits cameo in *Iron Man*. The fighting force got a bit more to do in *Thor*, when they mobilized following Mjolnir's crash landing in the New Mexico desert — but this time around, we get to see an entire army of S.H.I.E.L.D. agents and soldiers in action at the research compound and later aboard their iconic Helicarrier. The challenge for Joss Whedon and his creative collaborators was to design a look for S.H.I.E.L.D. personnel that stayed true to their comic-book origins, but passed for realistic military uniforms and functional battle armor on screen.

"Of course the look of all the characters was inspired by their source material, the comic books themselves," Andy Park said. "The Marvel line of movies has a more real-world feel to them and lent to being heavily influenced by Bryan Hitch's work on *The Ultimates*. The S.H.I.E.L.D. agents and Maria Hill were designed to keep that militaristic yet sleek look S.H.I.E.L.D. is known for in the comic books."

"There are many variations of S.H.I.E.L.D. uniforms drawn in the comics with the challenge of seemingly white boots and webbings," Alexandra Byrne added. "Joss was very specific about webbings and pouches. He would always want to know what went in each and every pouch — and if there wasn't an answer, the pouch would go. I felt the costume challenge was to support the level of technology and science within S.H.I.E.L.D., but to also give a sense of real life on the Helicarrier. There is a clear sense of uniform, but a breadth of style and dress code appropriate to task. The practical challenge was knowing that casting could and would come in many shapes and sizes."

S.H.I.E.L.D. agents operate the Helicarrier from a high-tech bridge under Nick Fury's watchful eye.

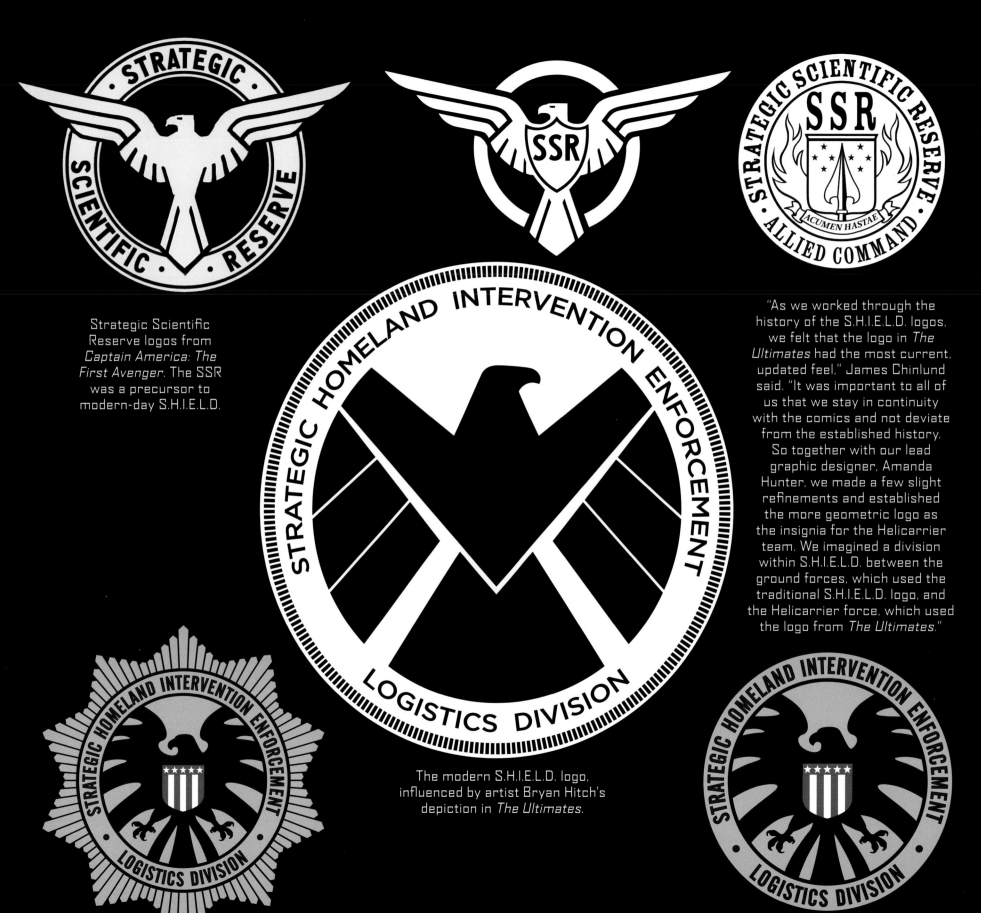

Strategic Scientific Reserve logos from *Captain America: The First Avenger*. The SSR was a precursor to modern-day S.H.I.E.L.D.

"As we worked through the history of the S.H.I.E.L.D. logos, we felt that the logo in *The Ultimates* had the most current, updated feel," James Chinlund said. "It was important to all of us that we stay in continuity with the comics and not deviate from the established history. So together with our lead graphic designer, Amanda Hunter, we made a few slight refinements and established the more geometric logo as the insignia for the Helicarrier team. We imagined a division within S.H.I.E.L.D. between the ground forces, which used the traditional S.H.I.E.L.D. logo, and the Helicarrier force, which used the logo from *The Ultimates*."

The modern S.H.I.E.L.D. logo, influenced by artist Bryan Hitch's depiction in *The Ultimates*.

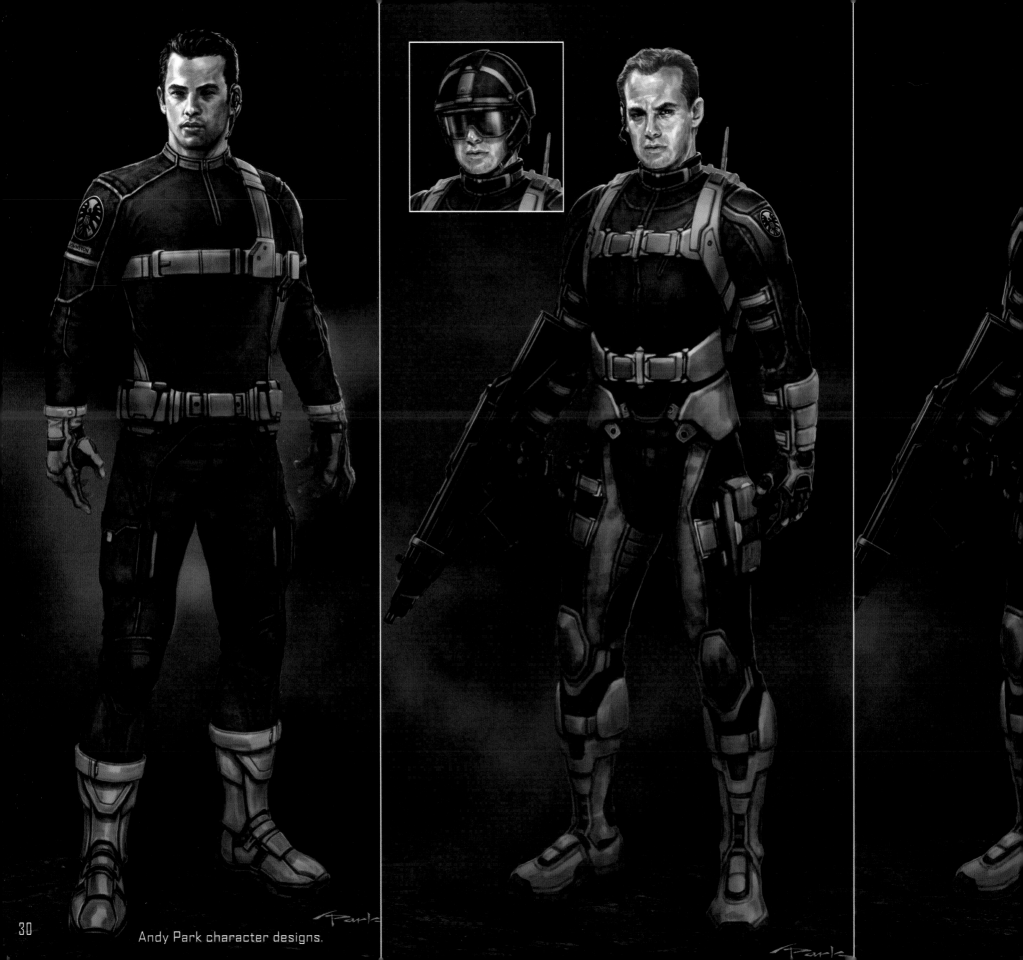

Andy Park character designs.

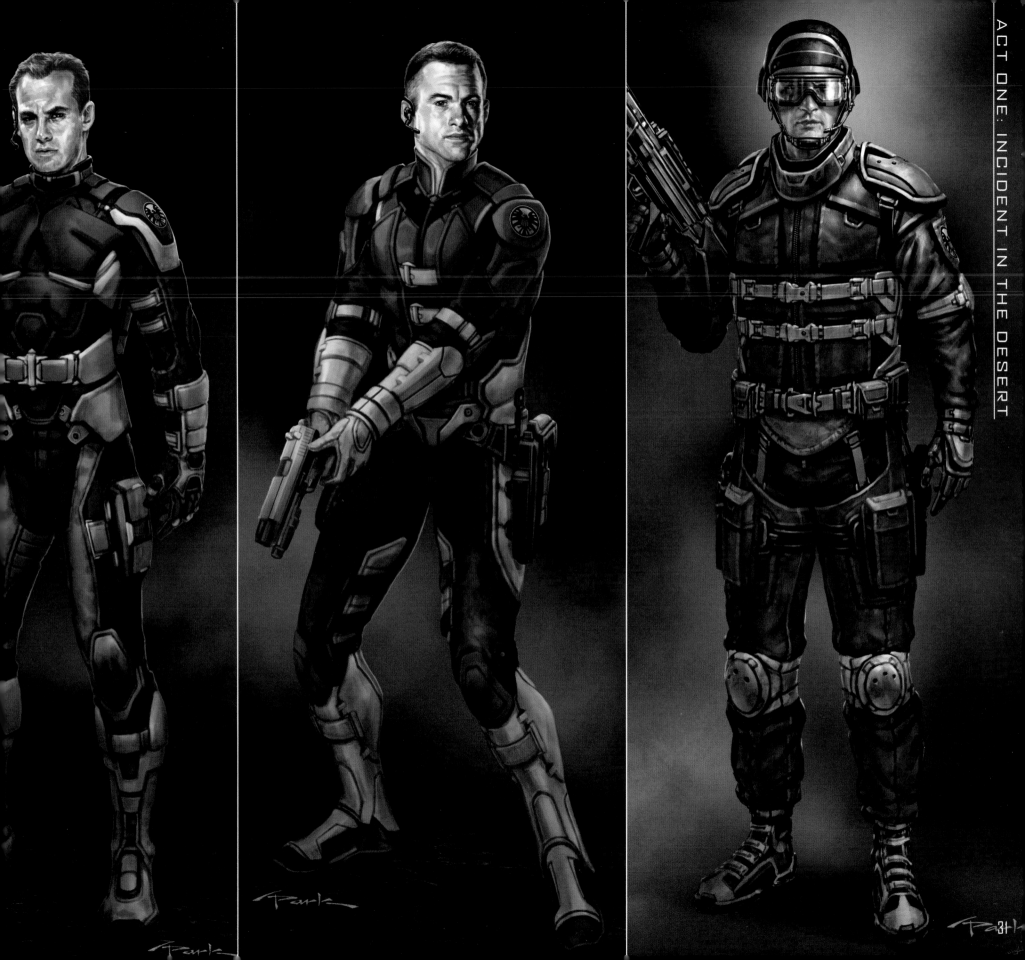

AGENT PHIL COULSON

Clark Gregg returns for his largest role yet as Agent Phil Coulson, a character Jon Favreau created and cast for the Marvel Cinematic Universe in *Iron Man*. He reprised his role in *Iron Man 2* and *Thor* before going on to star in a series of short films — Marvel One Shots — that appeared as special features on the home-video releases of *Thor* and *Captain America: The First Avenger*. The Coulson shorts, *The Consultant* and *A Funny Thing Happened on the Way to Thor's Hammer* — much like the popular post-credits sequences — serve as narrative connective tissue between the Marvel Studios films and help further establish the Marvel Cinematic Universe.

Coulson has emerged as something of an everyman in the Marvel films, a human character with whom audiences can readily identify that acts as a window into this fantastical world of gods and monsters. In *Marvel's The Avengers*, as Loki sets Earth on its collision course with destiny, Coulson has perhaps the most important job of all: assembling Earth's Mightiest Heroes. He calls Natasha Romanoff back to active duty, primarily to give her the unenviable task of bringing in Dr. Bruce Banner (Mark Ruffalo); makes the pilgrimage to Stark Tower in Manhattan to deliver a mission brief to a typically uncooperative Tony Stark; and escorts his childhood hero, Steve Rogers, via Quinjet to the Helicarrier, where the once and future Captain America joins Banner and Black Widow for a meeting with Nick Fury.

"Coulson is the evolving piece of the Marvel puzzle," Gregg said. "He's the only character who wasn't in the comics. He was designed to really be the 'disguised' face of S.H.I.E.L.D. in *Iron Man*. As that role evolved, the character evolved in a really interesting way for me as an actor and as a comic-book fan because with each new script and director both the audience and I got to find out more about who the guy was and what his job was.

"He's a force to be reckoned with; the part I loved was finding out that this is a guy who was hiding in plain sight as a kind of testy bureaucrat who had to work with Tony Stark," Gregg continued. "And the big reveal was that he represented a very, very formidable operation that transcended any national government and was tasked with protecting the world from malevolent forces

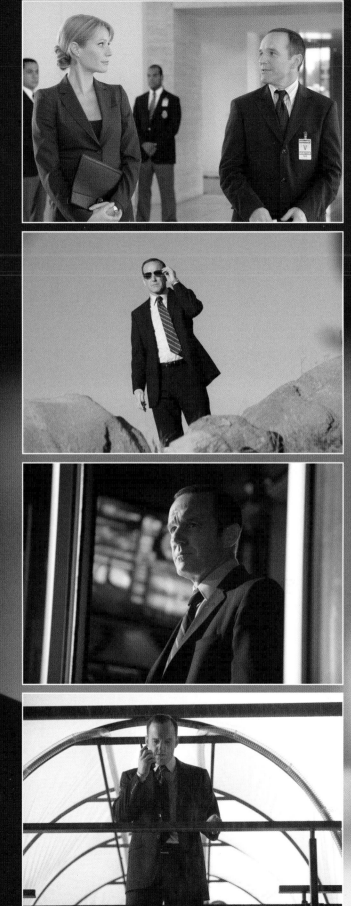

"His costume is actually part of his disguise. By the time I was doing some combat in the Marvel One Shots — wearing my black Dolce & Gabbana suit, which is actually really flexible and breathable — my costume really started to feel like my uniform. It's not the same as the Mark V Iron Man suit or Hawkeye's amazing S.H.I.E.L.D. gear, but it really is Coulson's uniform. And when I put on that suit and shirt and tie, and sometimes my sunglasses, I kind of feel like I'm back home again. When I put on my costume and walked onto the set of *The Avengers*, and walked into a room on the Helicarrier with everybody else in their uniforms, I felt like one of the super heroes who is part of the Avengers — and my uniform just happens to be very expensive black material."

— CLARK GREGG

Insets: Agent Coulson as he appeared in *Iron Man* and *Thor*.

AGENT MARIA HILL

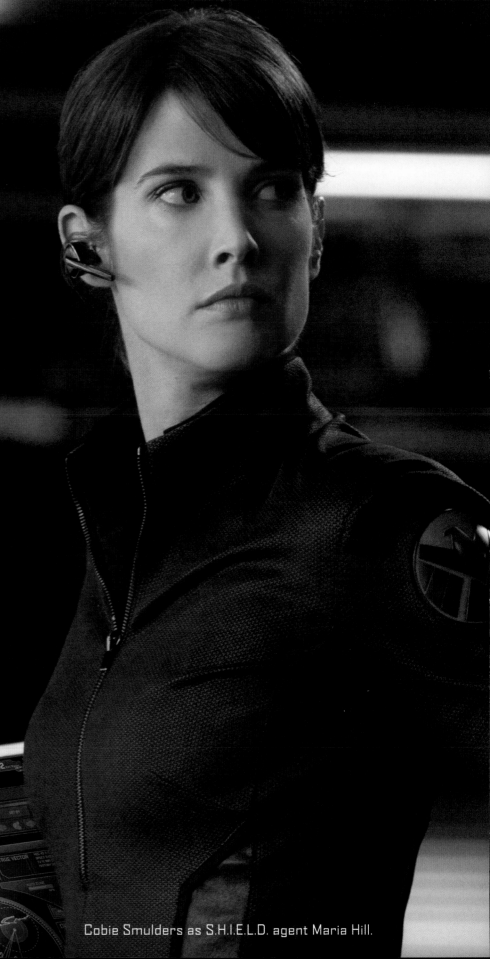

Maria Hill is a S.H.I.E.L.D. agent who rose to prominence during the late 2000s in Marvel events such as *Civil War* and *Secret Invasion*. In *Marvel's The Avengers*, she is played by Cobie Smulders (*How I Met Your Mother*) and puts a face to S.H.I.E.L.D.'s divisive internal views on Nick Fury's vision for Earth's Mightiest Heroes. Hill doesn't necessarily trust Fury — and she certainly doesn't trust his band of argumentative, lethal misfits who, as Joss Whedon puts it, "have no business being on the same team."

Hill is a tough woman, and she has to be in the Marvel Cinematic Universe just to keep pace with the apocalyptic events unfolding around her. Smulders embraced that side of the character — along with her more vulnerable, human side, which Joss Whedon didn't want her to let get lost in the shuffle. "She is the epitome of the strong, independent woman," Smulders said, "the way she carries herself with such strength and grace in a tough, tough world. I was immediately drawn to her tough, female exterior. Having Joss Whedon as your director is always a big bonus, but especially in character development because he works really closely with the actors. We explored the strength of this woman and what she has to deal with on a day-to-day basis. You get to see the more sensitive, human side of her, as well.

"The script has a great arc from not trusting Nick Fury and maybe going behind his back a bit — Maria is very much a rule-abider — but in the end she sees the method to his madness and trusts him," Smulders continued. "She thinks working with the Hulk in *any* capacity is dangerous. She doesn't see them working together and doesn't think they're reliable. But over the course of the film she sees that they can come together, and we need them to. There is no option other than to have these people save us."

Cobie Smulders as S.H.I.E.L.D. agent Maria Hill.

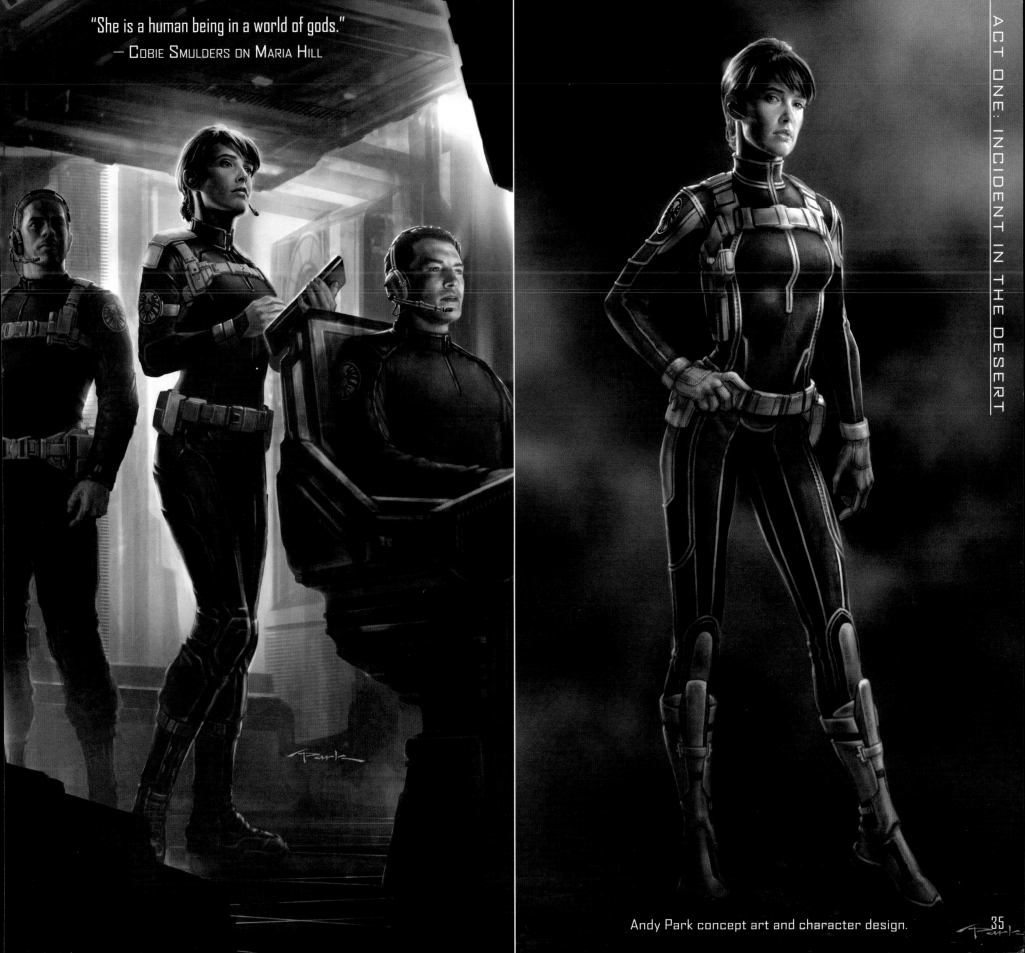

"She is a human being in a world of gods."
— COBIE SMULDERS ON MARIA HILL

Andy Park concept art and character design.

HAWKEYE

Clinton "Clint" Francis Barton, a.k.a. Hawkeye, first appeared in *Tales of Suspense #57* (September 1964), by writer Stan Lee and artist Don Heck. Hawkeye joined Earth's Mightiest Heroes in *Avengers #16* (May 1965) and has been a member of the team in its many incarnations in the years since. In the Marvel Cinematic Universe, Barton is a S.H.I.E.L.D. agent known for his prowess with a bow and arrow. As in his comic-book origins, he has a special bond with Natasha Romanoff, or Black Widow — a story point that figures prominently in *Marvel's The Avengers*.

Barton also has one of the more interesting story arcs of any character in the film due to the fact he spends half of it fighting alongside Loki against the Avengers. As the film opens, Hawkeye is in his perch watching over Dr. Erik Selvig as he attempts to unlock the secrets of the Tesseract; and that puts him squarely in the firing line when Loki uses the Cosmic Cube to cross the dimensions and enter our world. Loki touches his scepter to Barton's heart and uses dark energy to take control of the agent in a sort of interdimensional possession.

Hawkeye's costume is on full view for the first time in *Marvel's The Avengers*. "His weapons and fighting style were big influences," Alexandra Byrne said. "Jeremy is also extremely agile and wanted to achieve a clean silhouette. Our first fittings helped to evolve style and detail. Jeremy's stance for drawing the bow string threw his neck tall and straight, but in a crouch position his neck came forward — so we developed a center back detail in the stand collar made with woven elastics. This meant the collar could stretch back with Jeremy as he drew the bow and not be left poking out as he bent forward."

Andy Park sought inspiration in the character's comic-book roots. "I'm a huge *West Coast Avengers* fan, so it was a pleasure to be able to design Hawkeye," Park said. "But I knew going in that most likely we would need to design it more along *The Ultimates* line rather than the traditional purple Hawkeye look. After all, this film version of Hawkeye is a S.H.I.E.L.D. agent. It's hard to imagine an all-purple S.H.I.E.L.D. agent with a pointy mask running around, though it would have been fun to design."

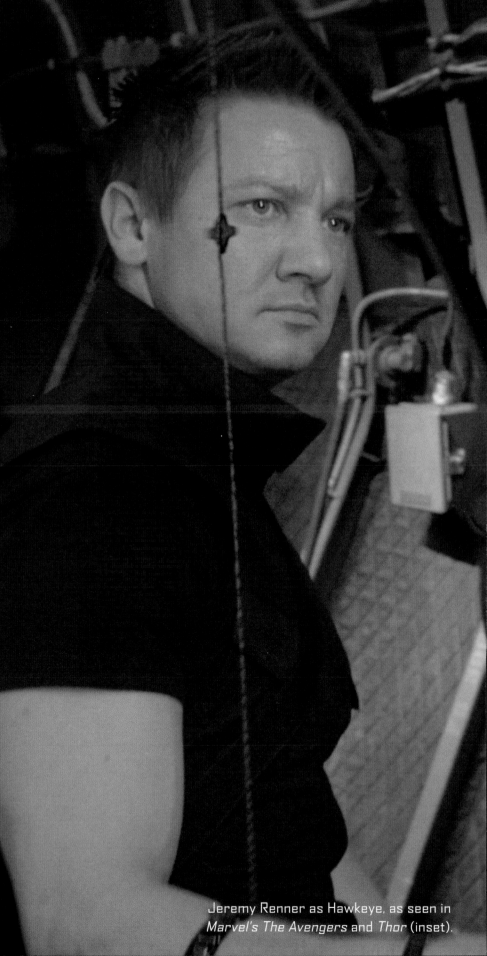

Jeremy Renner as Hawkeye, as seen in *Marvel's The Avengers* and *Thor* (inset).

"I practiced with Olympic archers," Renner said. "I learned the basics and the proper positions, and that really helped. There has to be consistency in how you draw back the bow, and that's tough to do when drawing fast — so I wanted to slow it down a bit and take aim, just for precision. I also took a lot of stunt training in how to use the bow as a weapon. It's not part of archery, rather like using the bow as a staff."

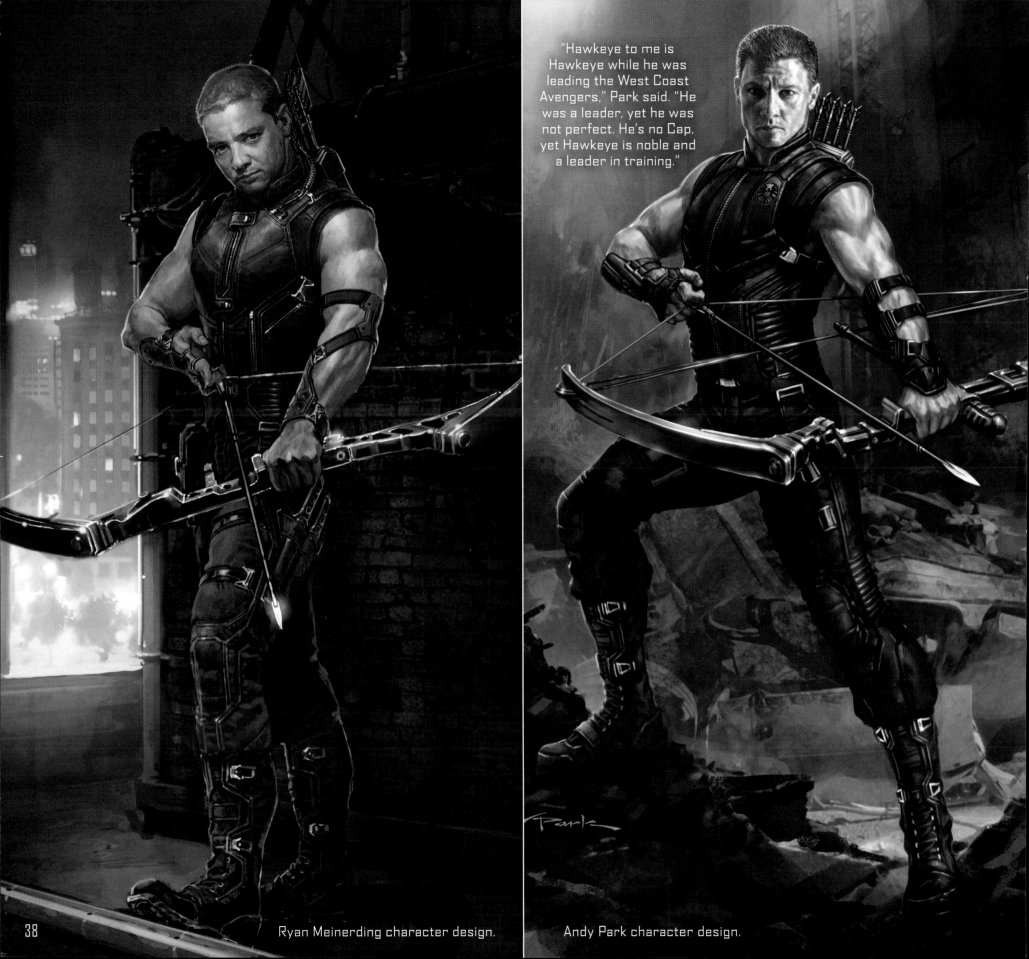

"Hawkeye to me is Hawkeye while he was leading the West Coast Avengers," Park said. "He was a leader, yet he was not perfect. He's no Cap, yet Hawkeye is noble and a leader in training."

Ryan Meinerding character design.

Andy Park character design.

Ryan Meinerding character design.

Andy Park character design.

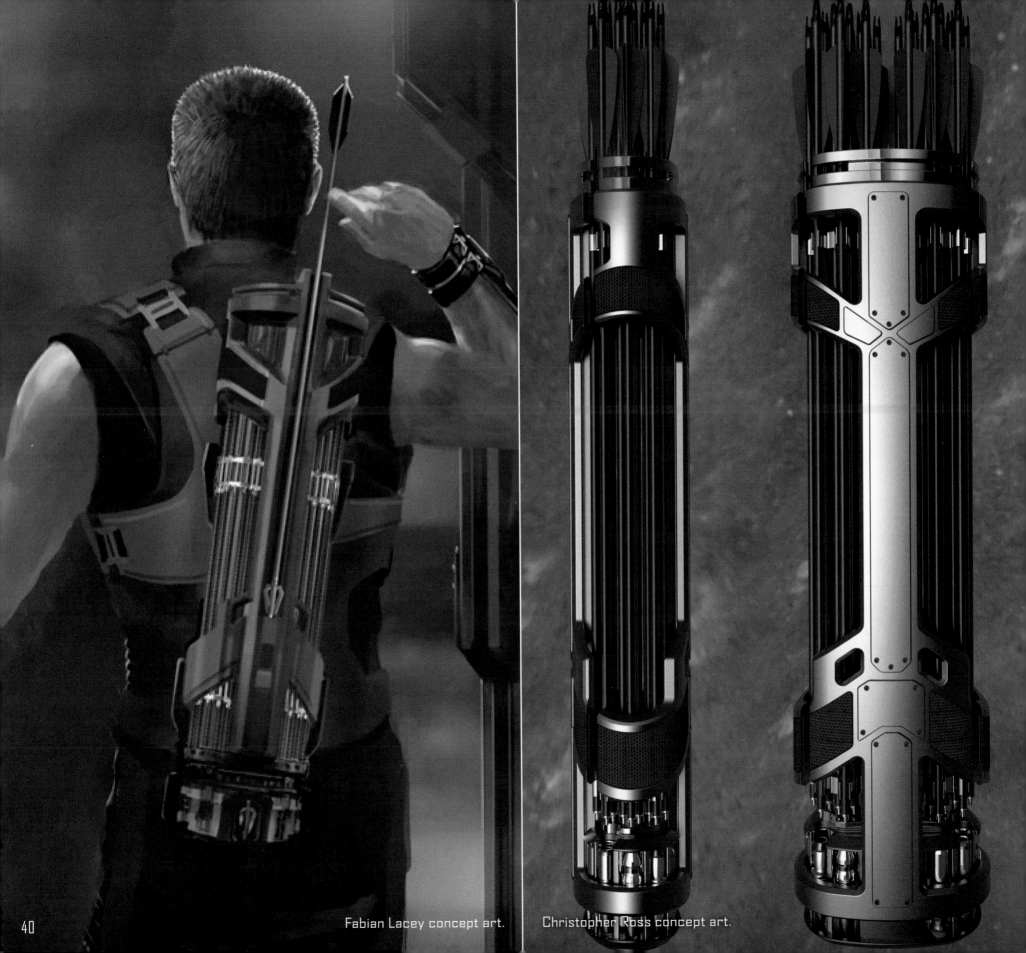

Fabian Lacey concept art. Christopher Ross concept art.

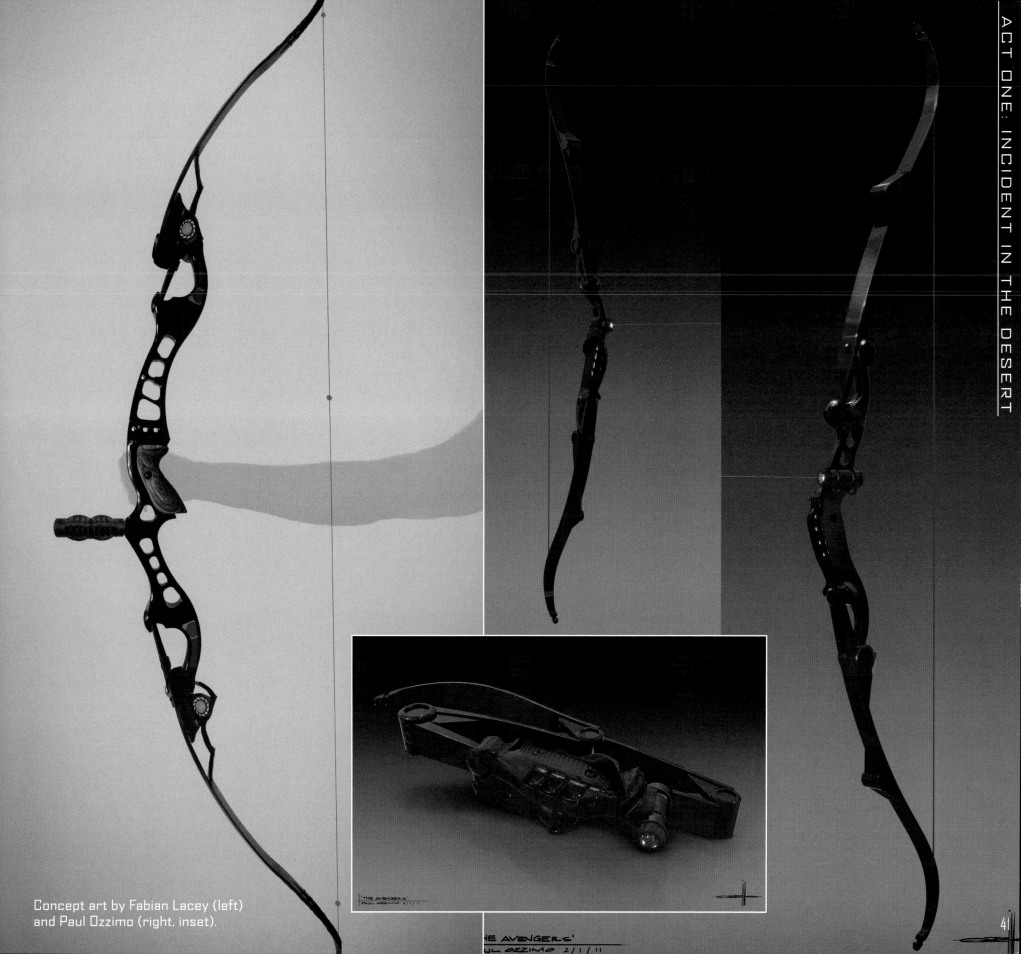

Concept art by Fabian Lacey (left)
and Paul Ozzimo (right, inset).

'THE AVENGERS'
PAUL OZZIMO 2/1/11

41

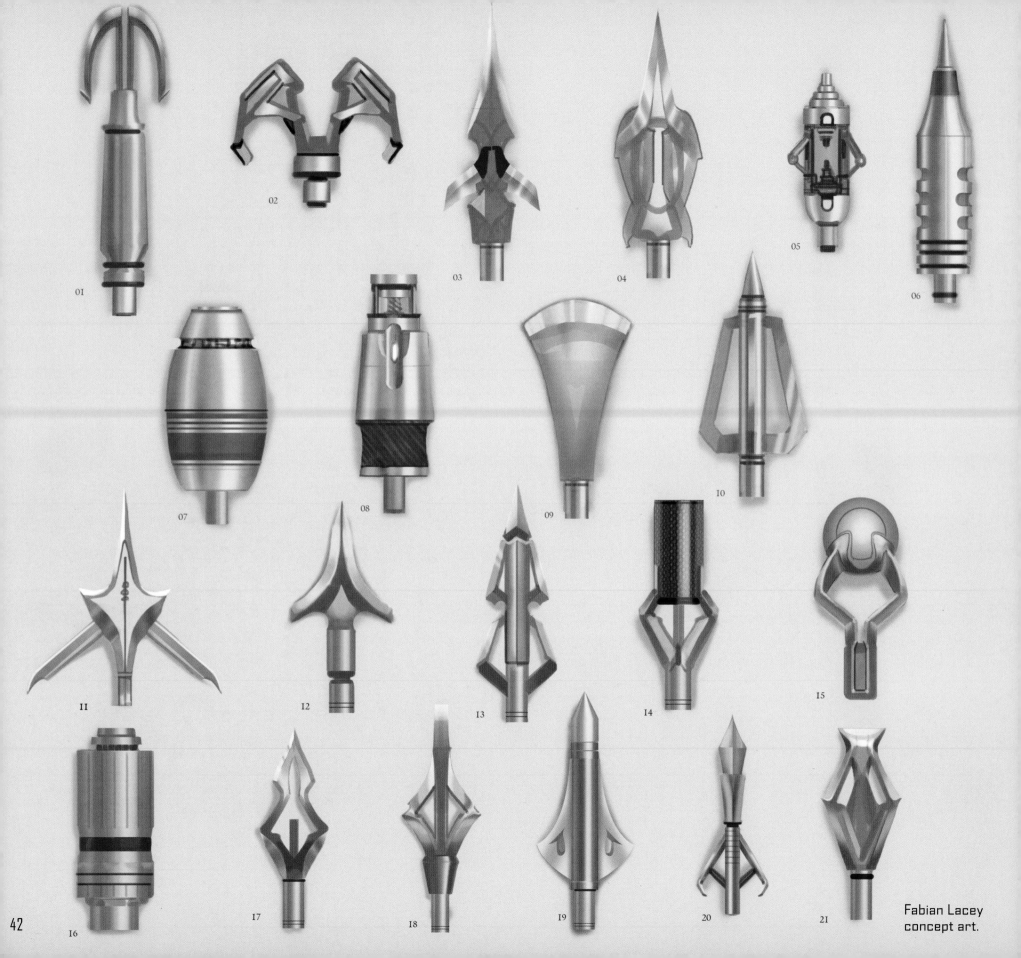

01

02

03

04

05

06

07

08

09

10

11

12

13

14

15

16

17

18

19

20

21

Fabian Lacey
concept art.

Fabian Lacey concept art.

① ② ③ ④ ⑤ ⑥

Paul Ozzimo grappling-arrow concept art;
right: Christopher Ross virus-arrow concept art.

THE AVENGERS

43

HE TESSERACT

In the Marvel Universe, there is no more compelling MacGuffin than the Cosmic Cube. An otherworldly device that could transform any wish into reality, the Cube made its first appearance in *Tales of Suspense #79* (July 1966).

In the Marvel Cinematic Universe, the Cosmic Cube has been dubbed the Tesseract, a source of unspeakable power and a key that unlocks doors to myriad worlds across multiple dimensions. "Let's face it, 'The Tesseract' is just a much cooler name," Joss Whedon noted wryly. Audiences got their first glimpse of it in the post-credits sequence of *Thor*, when Nick Fury unveils it to Erik Selvig, unknowingly under the thrall of Loki. The cube plays a larger role in *Captain America: The First Avenger*, in which the Red Skull (Hugo Weaving) uses its power to develop weapons of mass destruction for Hydra to deploy against an unsuspecting and unprepared world. The cube ultimately zaps Red Skull into dimensions unknown and is recovered by Howard Stark, who uses it to develop the Arc Reactor that will one day save his son Tony's life and pave the way for Iron Man.

In *Marvel's The Avengers*, Loki harnesses the Tesseract's dark energy to cross the dimensions and arrive on Earth as the rightful king he believes himself to be. But for Loki, the Tesseract is merely a means to an end — a kingdom for him to rule following his expulsion from Asgard — and the bargaining chip with which he will acquire his invasion force. We will soon discover Loki is a pawn in a much larger game, manipulated by forces far more interested in the Tesseract's vast and heretofore untapped potential.

"The power extractor was one of the first design challenges Drew (Petrotta) and I were confronted with when we began work on *The Avengers*," James Chinlund said. "Early on, we decided it was important to us that the device be active, moving as it focussed its energy in various directions. Working with concept artists Tani Kunitake and Christopher Ross, we churned through many variations on this idea until we landed on a design that satisfied the requirements of the many scenes and looks that the extractor appeared in. As with most of the design in the film, we were hoping for something that felt suitably impressive and commanding, and simultaneously plausible and grounded. It was important to all of us that the audience could see the device functioning, that it not just be a mystery box with a ray coming out of it. We spent a lot of time looking at various laser devices, optical machinery and particle colliders for inspiration. The build was a tremendous challenge as we were asking for a fair amount of practical articulation from the device on camera. It was executed to perfection under the supervision of Prop Master Drew Petrotta and Lewis Doty at Studio Art and Technology."

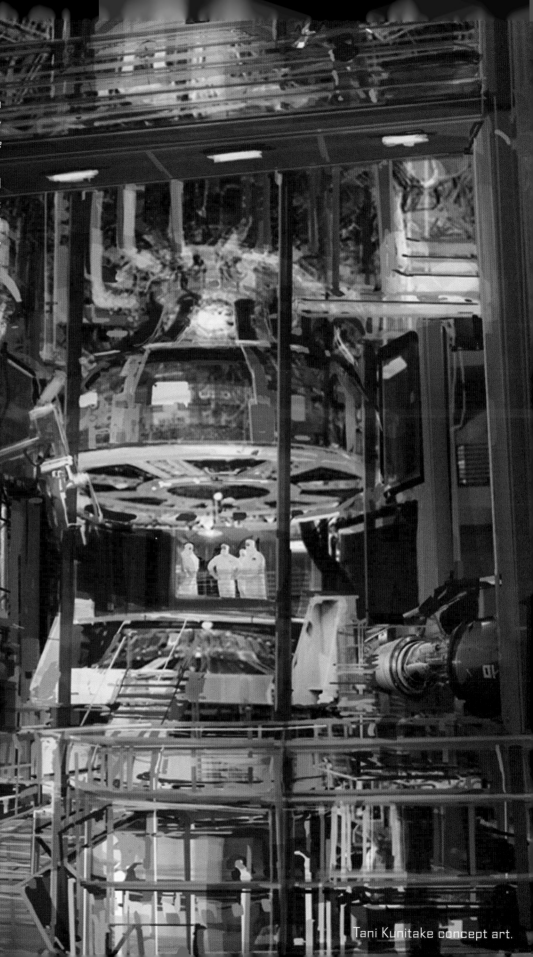

Tani Kunitake concept art.

"Prop Master Drew Petrotta designed the Cube 'suitcase' for the end-credits scene in *Thor*, and then we used it throughout *The Avengers* as the Cube goes from the S.H.I.E.L.D. facility to Loki's hideout before ending up on the roof of Stark Tower," Executive Producer Jeremy Latcham said. "We see it in Central Park in Stark's hands after the Avengers saved the city and the world from its destructive power."

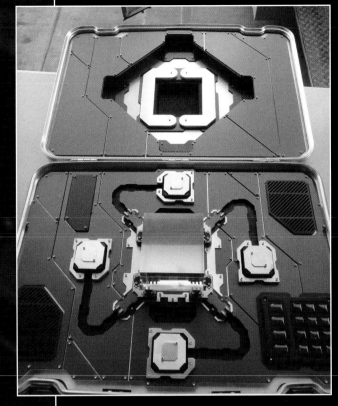

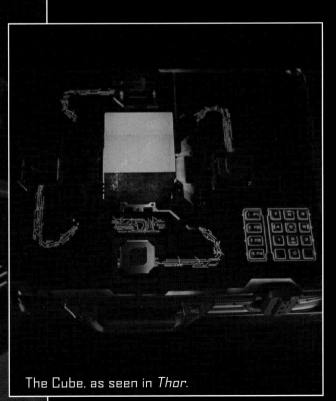

The Cube, as seen in *Thor*.

The Cube suitcase, as seen in *Marvel's The Avengers* (above, top inset).

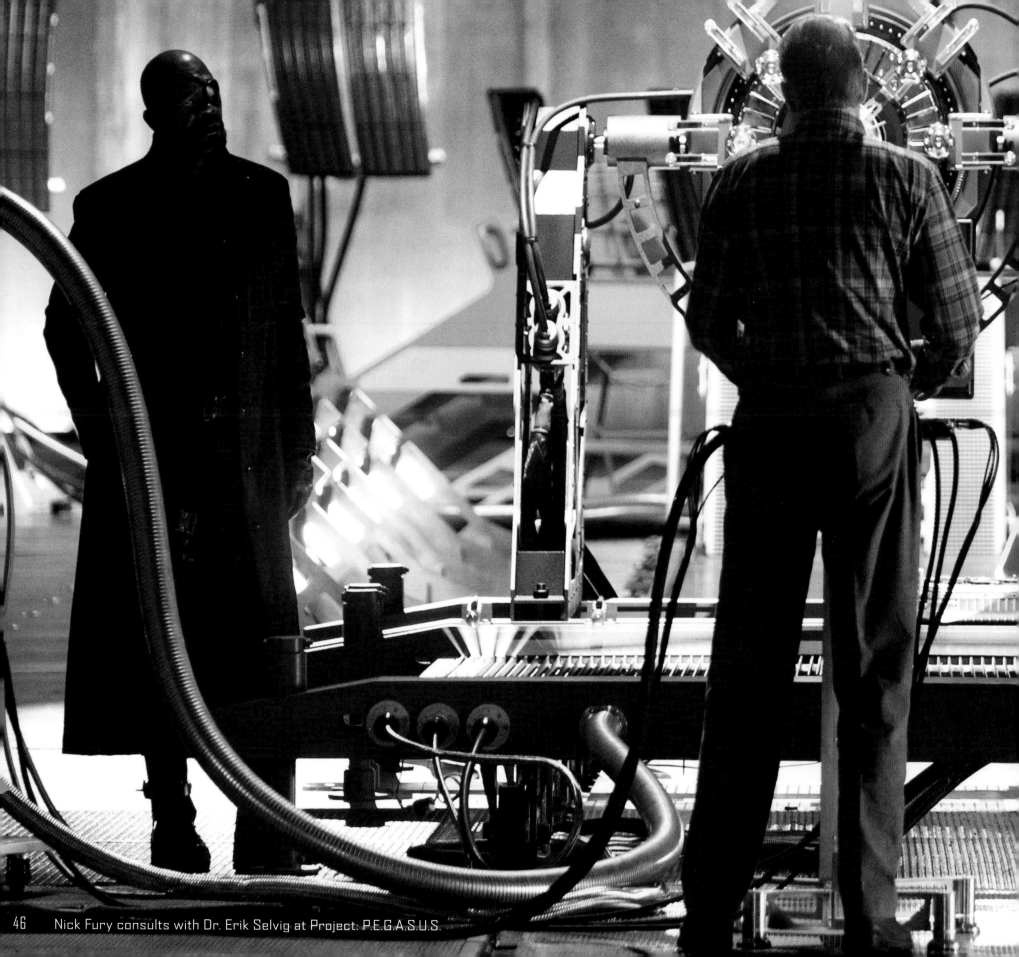

46 Nick Fury consults with Dr. Erik Selvig at Project: P.E.G.A.S.U.S.

"'As Fury moves below ground, we pick up the action in...Sandusky, Ohio, at a facility that houses the world's largest vacuum chamber," Chinlund said. "This space was built in the fifties as scientists were exploring the idea of nuclear-powered spacecraft. So not only is it a vacuum chamber, but it's surrounded by concrete walls eight feet thick to prevent nuclear accidents. This is one of the most impressive spaces I have ever encountered, and it was a tremendous honor to be able to shoot there. It made the ideal test facility for Selvig's work with the Tesseract."

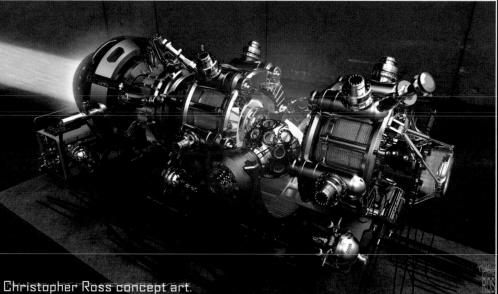

Christopher Ross concept art.

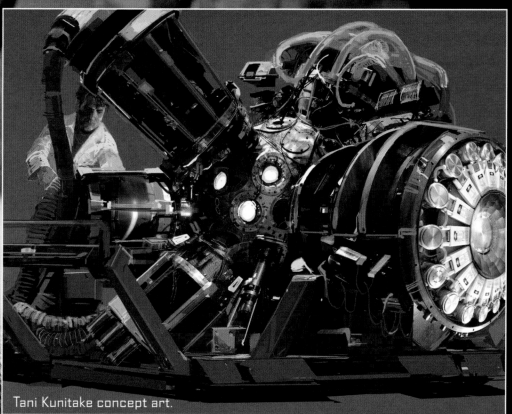

Tani Kunitake concept art.

THE PORTAL

The Tesseract begins to spin wildly out of control. The cube emits a piercing beam of blue energy that appears to rip a hole in the very air of the chamber, revealing the endless stars of deep space beyond. A small crystal in the center of this expanding portal catches the energy beam — a crystal at the end of a long staff clutched by a dark shape crouched on the chamber floor.

The portal begins to expand, causing explosions and blasting S.H.I.E.L.D. agents to the ground. The connection between the Tesseract and the crystal is broken, but both continue to glow an identical shade of blue as cosmic energy arcs and bounces throughout the chamber.

S.H.I.E.L.D. agents, led by Barton, draw their weapons and advance on the dark form, quickly revealed to be Loki clutching his scepter. The Asgardian blasts away with his scepter, and the agents open fire as Barton tackles Fury to protect him. Barton fires on Loki, clipping his head before dodging a scepter blast.

"You...have heart," Loki tells Barton as he touches the scepter to the agent's chest. The pulsing blue glow slips off the tip of the scepter and into Barton's chest. Barton's eyes glow briefly blue before hardening to a stone-cold black that quickly dissipates. Barton belongs to Loki.

Fury uses Loki's momentary preoccupation with Barton to attempt to slip the Tesseract into a metal case and escape. "I still need that," Loki warns Fury, his voice betraying audible strain as dark energy continues to build in the chamber.

"We have no quarrel with your people," Fury says.

"An ant has no quarrel with a boot," Loki replies.

Loki similarly converts Selvig to his cause as Fury tries to stall the Asgardian, knowing full well the complex is about to blow sky high — but the possessed Barton points out the tactic before shooting Fury in the chest and leading Loki, Selvig and a second possessed S.H.I.E.L.D. agent out of the chamber.

Andy Park keyframe with production still.

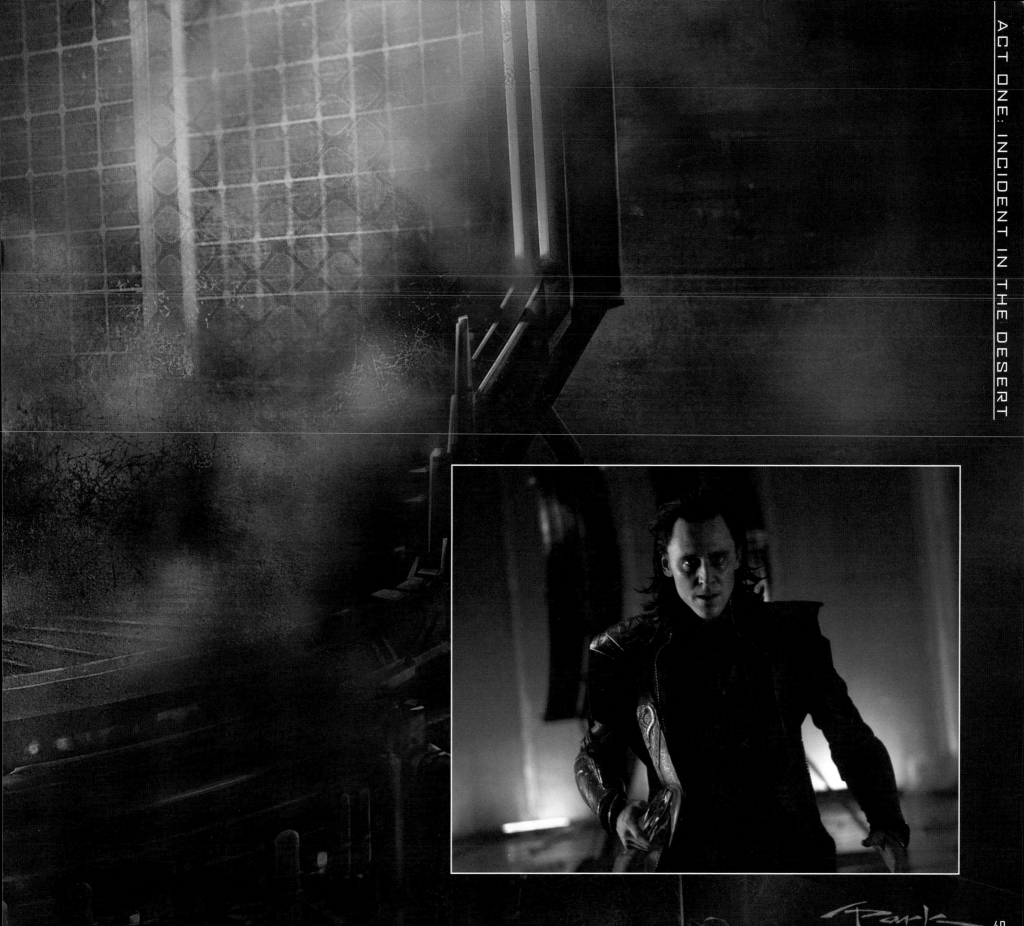

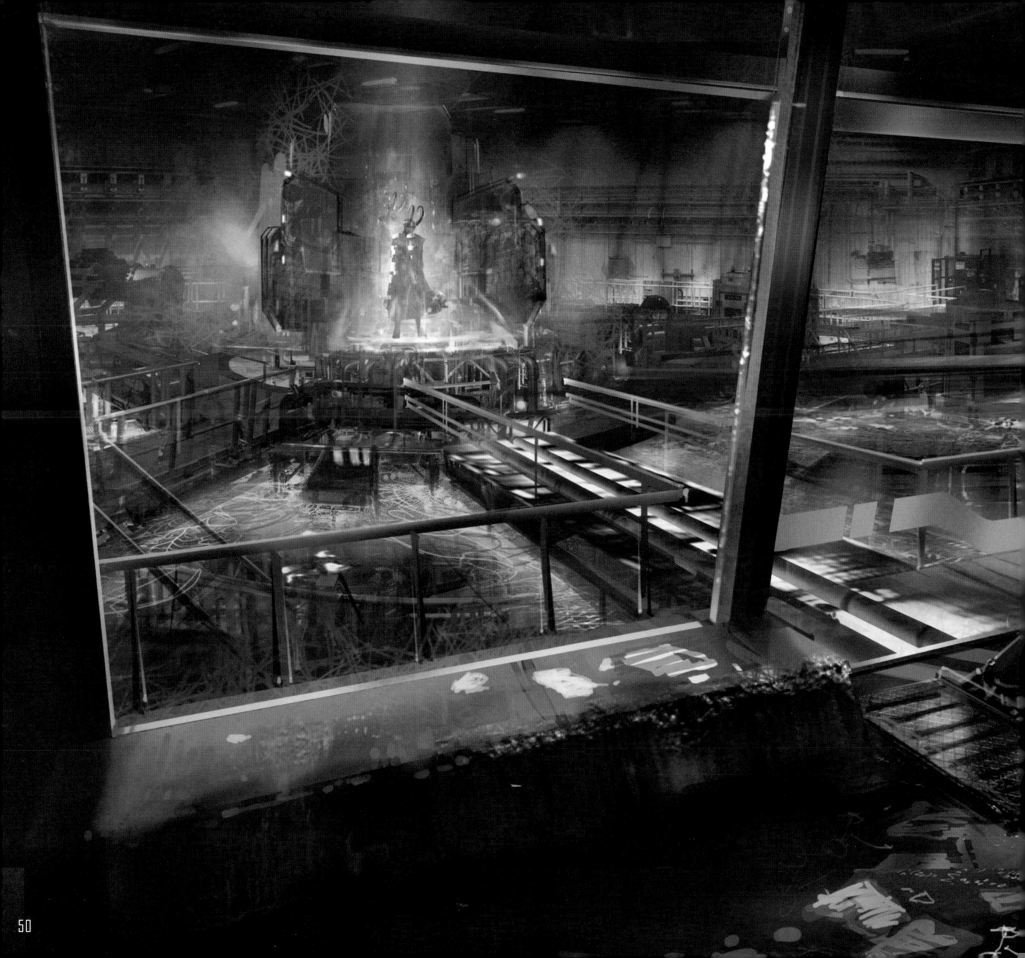

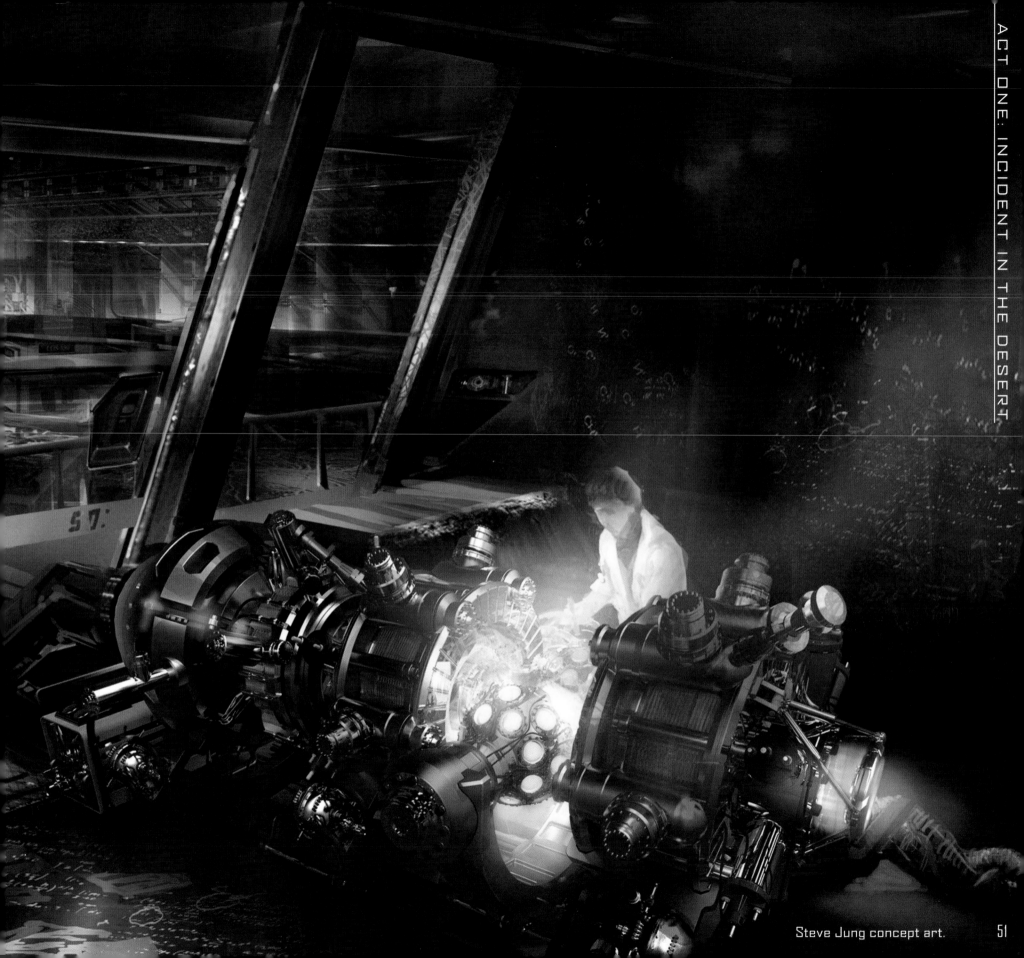

Steve Jung concept art.

LOKI

After he fails to take Odin's throne and rule over Asgard and the rest of the Nine Realms, Loki (Tom Hiddleston) the spiteful trickster returns in *Marvel's The Avengers* to wreak havoc on Earth and seek vengeance upon his adopted brother, Thor (Chris Hemsworth), in the process. But his ambition to rule comes at a great price to not only the human race, but also, ultimately, himself.

"At the end of *Thor*, Loki lets go of that spear and falls into a wormhole," Hiddleston said. "And the question in the audience's mind, one hopes, is what happens to Loki in that moment? And in the time between the end of *Thor* and the beginning of *The Avengers*, Loki has explored the shadowy highways and byways of the universe — and he's met some terrible, terrible people and probably had some awful experiences, which he has survived and overcome. So by the time he arrives in *The Avengers*, he knows the extent of his power — and he's unafraid to use it. And more importantly, he's unafraid to enjoy it."

In *Marvel's The Avengers*, Loki sets out to remake Earth as his personal kingdom. "That's his motivation," Hiddleston said. "Thor has his own kingdom in Asgard. Why shouldn't Loki have his own? As Loki sees it, planet Earth is a world at war with itself. All of these races and tribes are fighting each other. And if they were united in the reverence of one king, there would be peace. It's not that he plans to attack Earth. It's that he plans to 'restructure' it as a new kingdom of which he will be the head. Loki feels that it's his birthright. He feels that he was born to rule. And he sees the human race as an incredibly weak people who actually were made to be ruled. And, in his mind and in his opinion, the human race functions better under rule."

Thor, newly humbled by his time on Earth, disagrees. "In *The Avengers*, Thor's presence is because he's come back to collect his brother and help bring him back to the light — to bring him back from the darkness," Hiddleston said. "And there's a huge amount of emotional investment for Thor, as well, because he's taken the time and the energy to come down to Earth and stop the damage that Loki is doing and reconcile his brother back into the fold of the family in Asgard."

Hiddleston's wardrobe helped bring out his inner god of mischief. "When I put on the costume for the first time, it was made of leather and metal and chain mail and green felt, essentially — and it weighed thirty pounds," Hiddleston said. "The costume designer, Alexandra Byrne asked me, 'Is that going to be OK for you every day? Do you want it to be lighter?' And I said, 'No, keep the weight.' There are ways they can make things look heavy, but not feel heavy. But even in those early incarnations, it was fantastic that the costume gave me a size and a stature that I didn't have to perform, in a sense. The costume makes you feel godly."

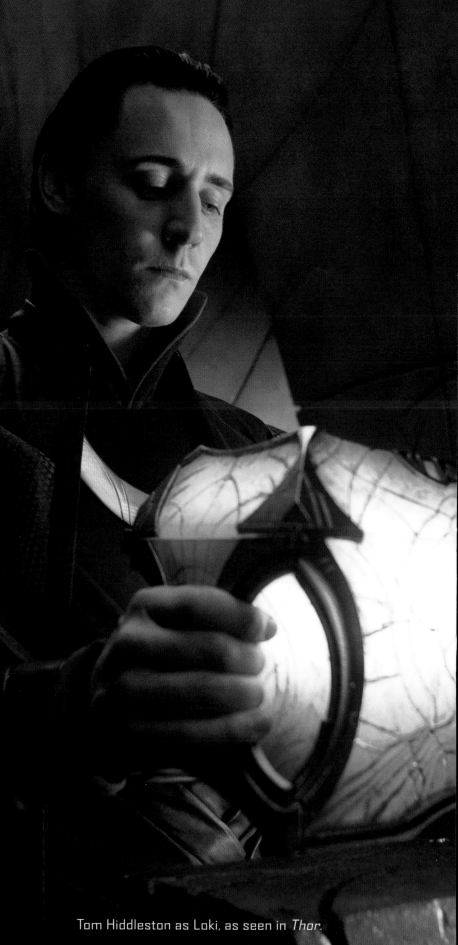

Tom Hiddleston as Loki, as seen in *Thor*.

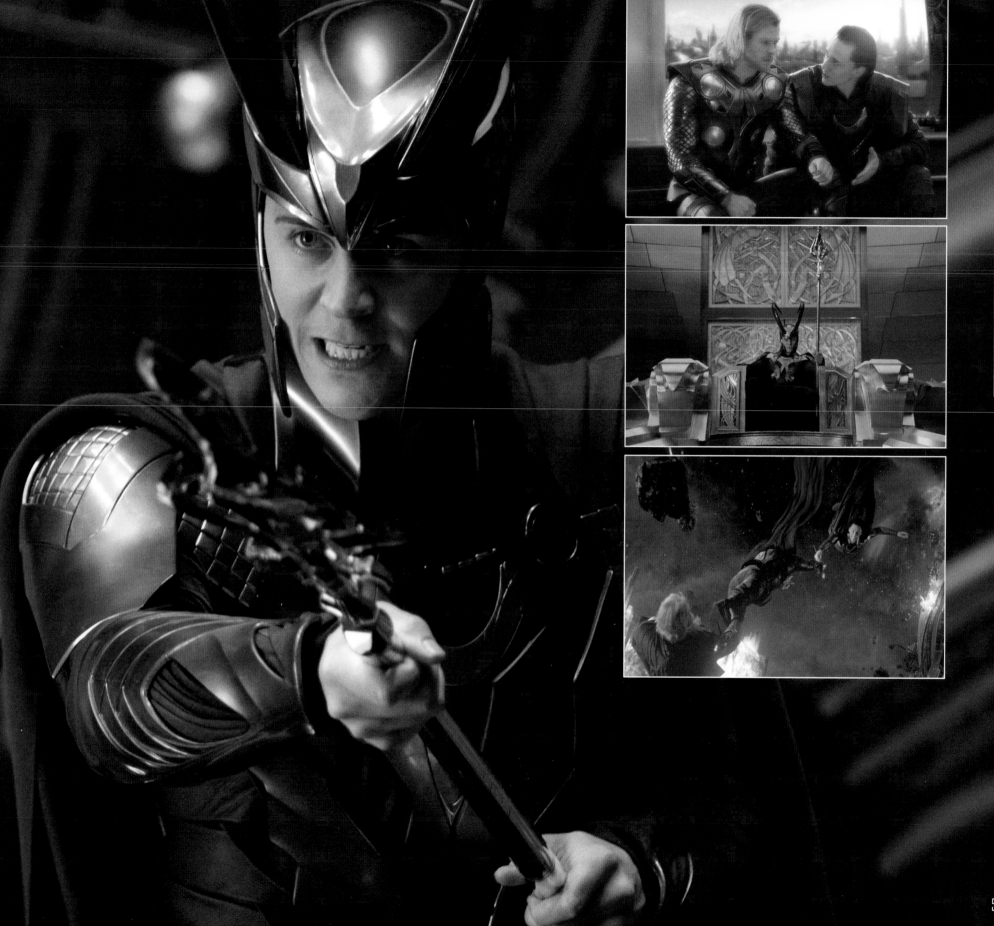

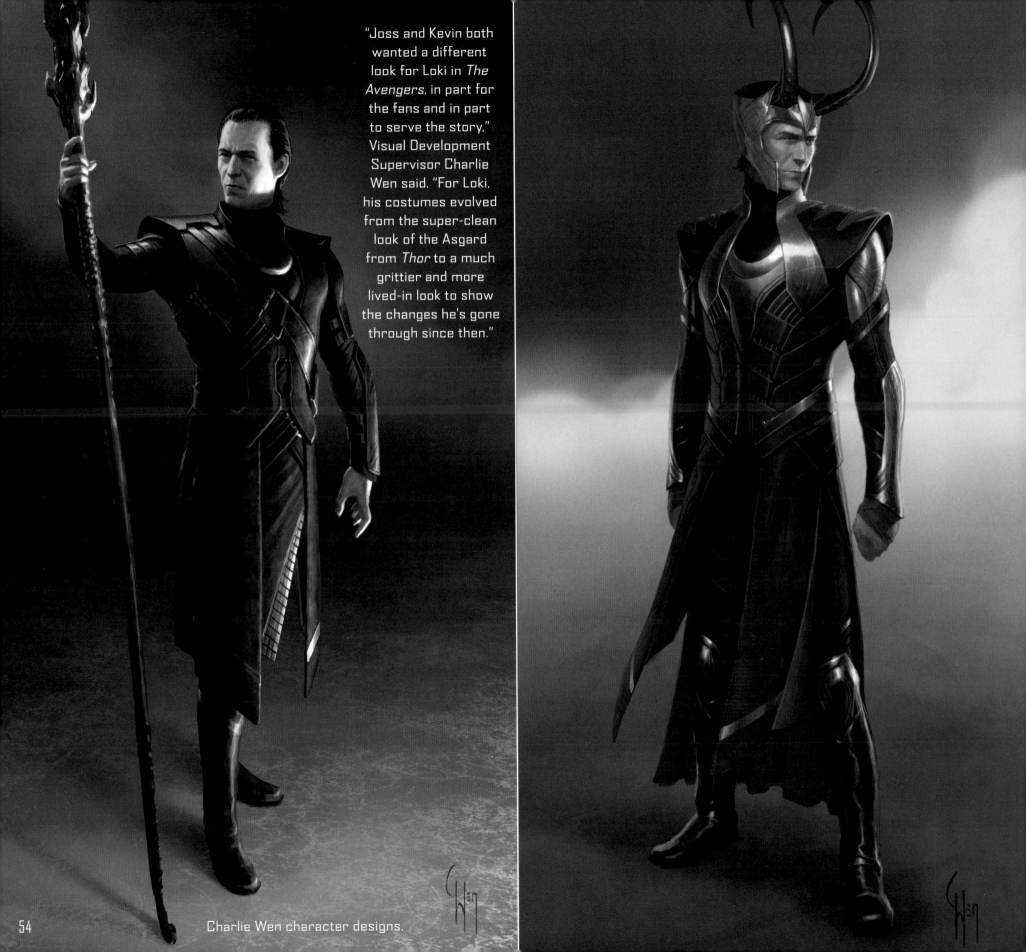

"Joss and Kevin both wanted a different look for Loki in *The Avengers*, in part for the fans and in part to serve the story," Visual Development Supervisor Charlie Wen said. "For Loki, his costumes evolved from the super-clean look of the Asgard from *Thor* to a much grittier and more lived-in look to show the changes he's gone through since then."

Charlie Wen character designs.

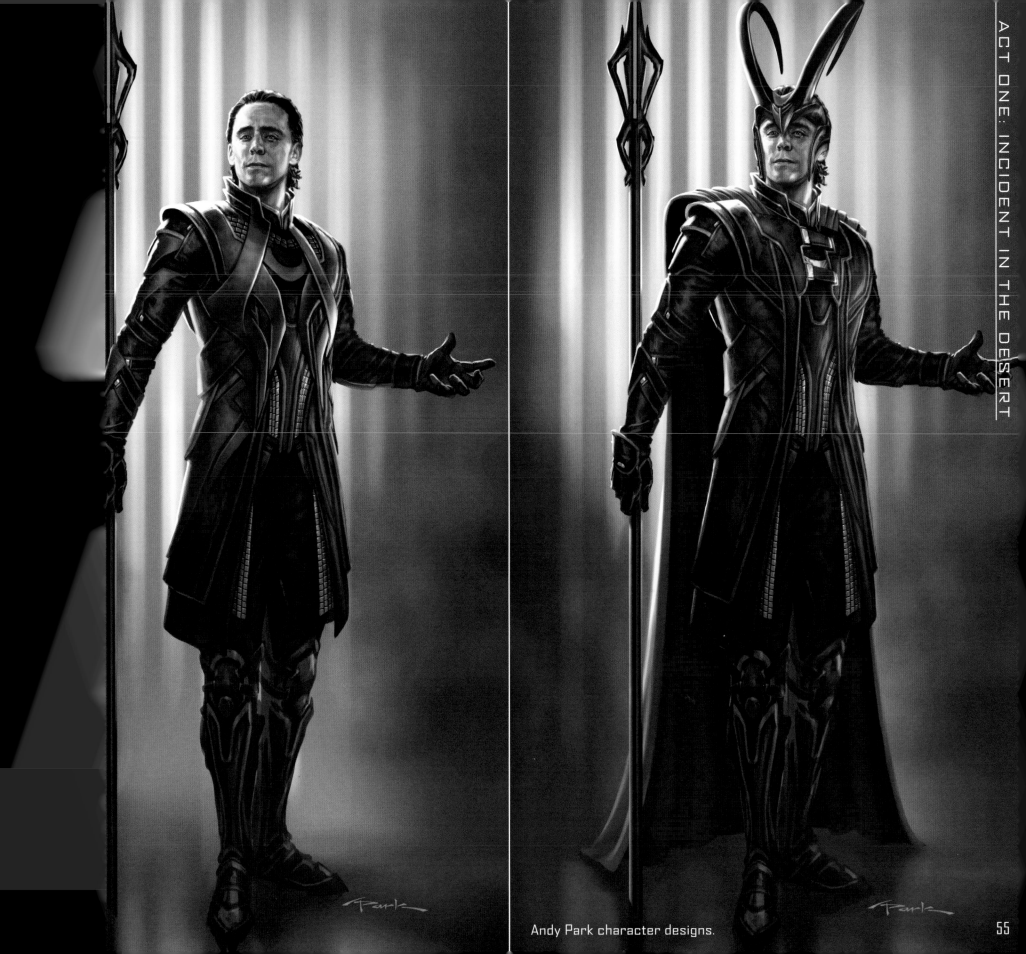

Andy Park character designs.

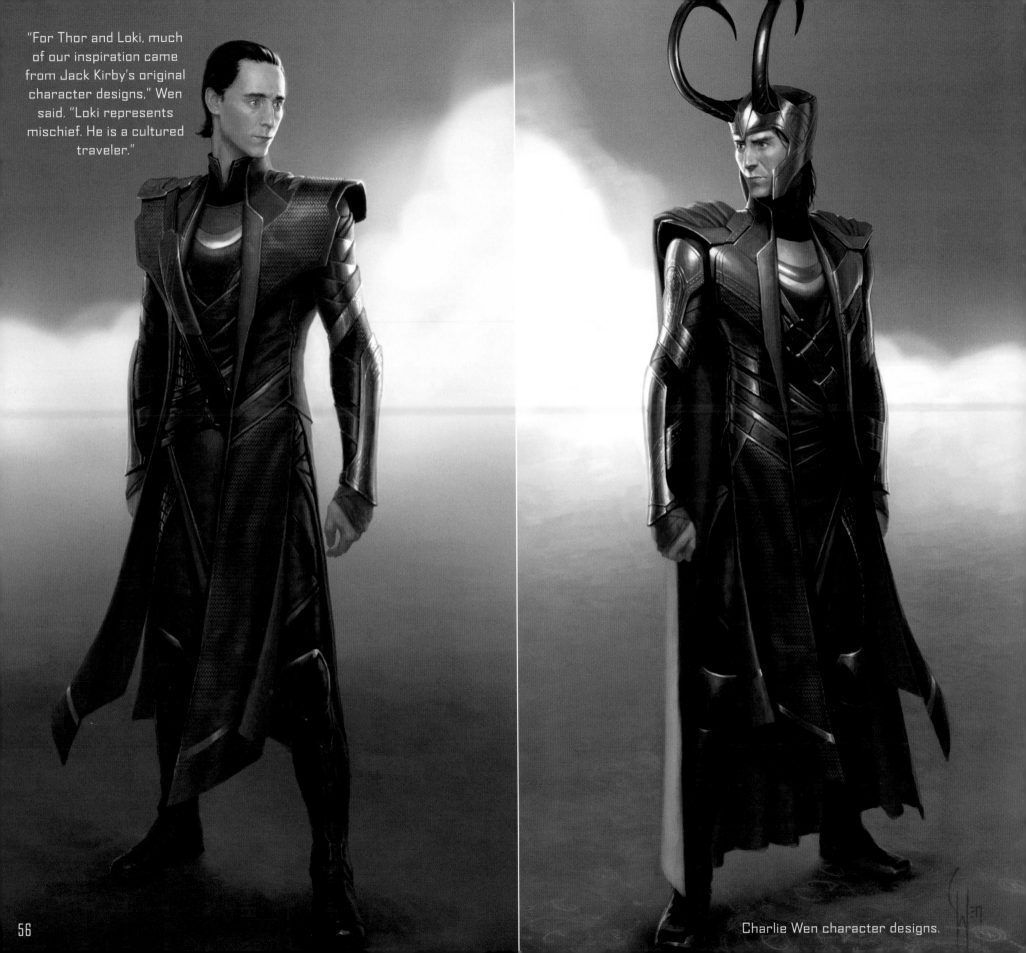

"For Thor and Loki, much of our inspiration came from Jack Kirby's original character designs." Wen said. "Loki represents mischief. He is a cultured traveler."

56

Charlie Wen character designs.

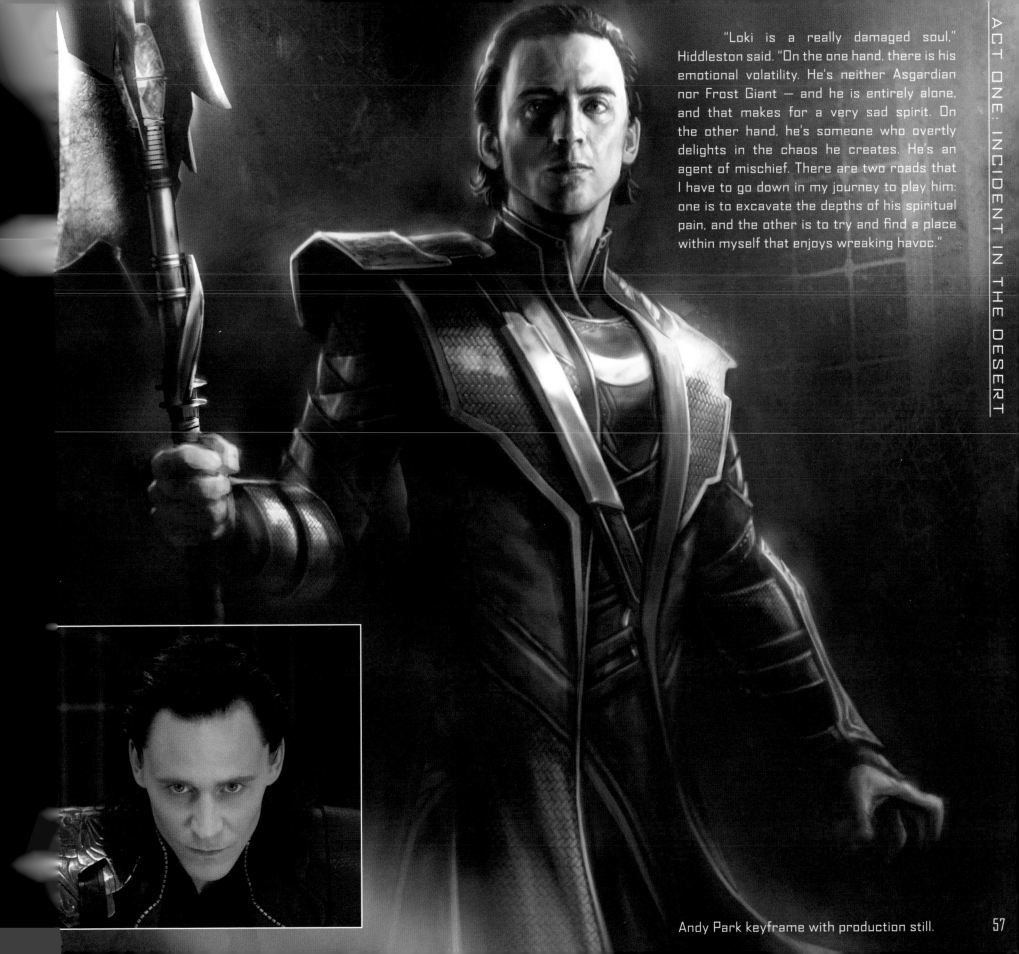

"Loki is a really damaged soul," Hiddleston said. "On the one hand, there is his emotional volatility. He's neither Asgardian nor Frost Giant — and he is entirely alone, and that makes for a very sad spirit. On the other hand, he's someone who overtly delights in the chaos he creates. He's an agent of mischief. There are two roads that I have to go down in my journey to play him: one is to excavate the depths of his spiritual pain, and the other is to try and find a place within myself that enjoys wreaking havoc."

Andy Park keyframe with production still.

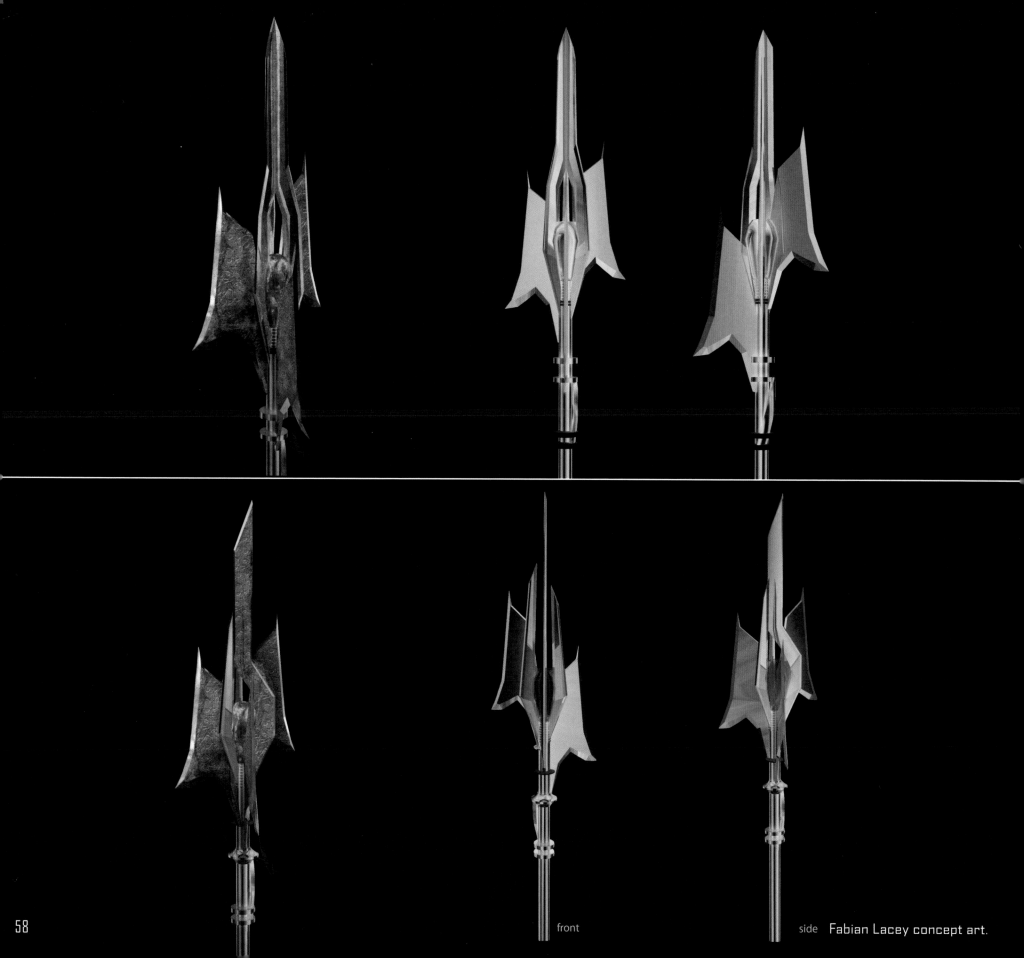

front side Fabian Lacey concept art.

Stills of the finished prop.

Barton leads his small band of fugitives to an underground loading dock, where he commandeers a truck and a sedan from an unsuspecting Agent Hill, who does not yet know about the attack in the chamber. The second agent jumps into the sedan, and Barton helps a visibly weakened Loki into the back of the truck. Fury alerts Hill to the situation over the radio, and she barely has time to dive for cover as Barton opens fire on his former comrade. Hill dodges the gunfire, jumps into a jeep and pursues the small enemy convoy into the tunnels deep beneath the mesa. A white-knuckle chase ensues, replete with gunfire and scepter blasts, culminating as dark energy consumes the entire compound in a blinding whiteout.

"As Loki makes his escape, the action picks up again in the loading-dock area of the Albuquerque Convention Center, which gave us some interesting tunnels and passageways and created the perfect bridge to get us to...a massive underground tunnel complex in Pennsylvania, where most of the chase action took place," James Chinlund said. "As Loki shoots out of the tunnels, we pick up the action

Nick Cross computer diagram.

"As you can see it was a huge undertaking piecing all of these parts together, and required an incredibly disciplined eye to find the elements that would join them all together and form a seamless whole," Chinlund said. "Victor (Zolfo) and his team did an amazing job creating the whole that is the Dark Energy Research Facility of S.H.I.E.L.D."

Steve Jung concept art.

S.H.I.E.L.D. AIRCRAFT AND VEHICLES

"Our car partner, Acura, provided us with a ton of vehicles that we modified to be tricked-out S.H.I.E.L.D. vehicles for use in the tunnel chase," Jeremy Latcham said.

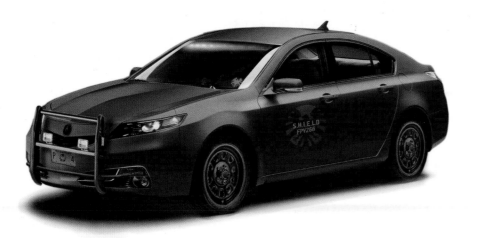

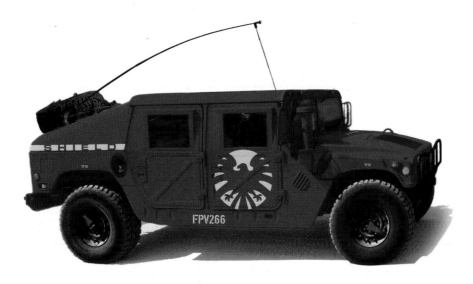

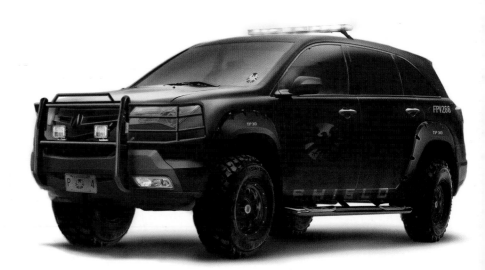

Ben Edelberg concept art.

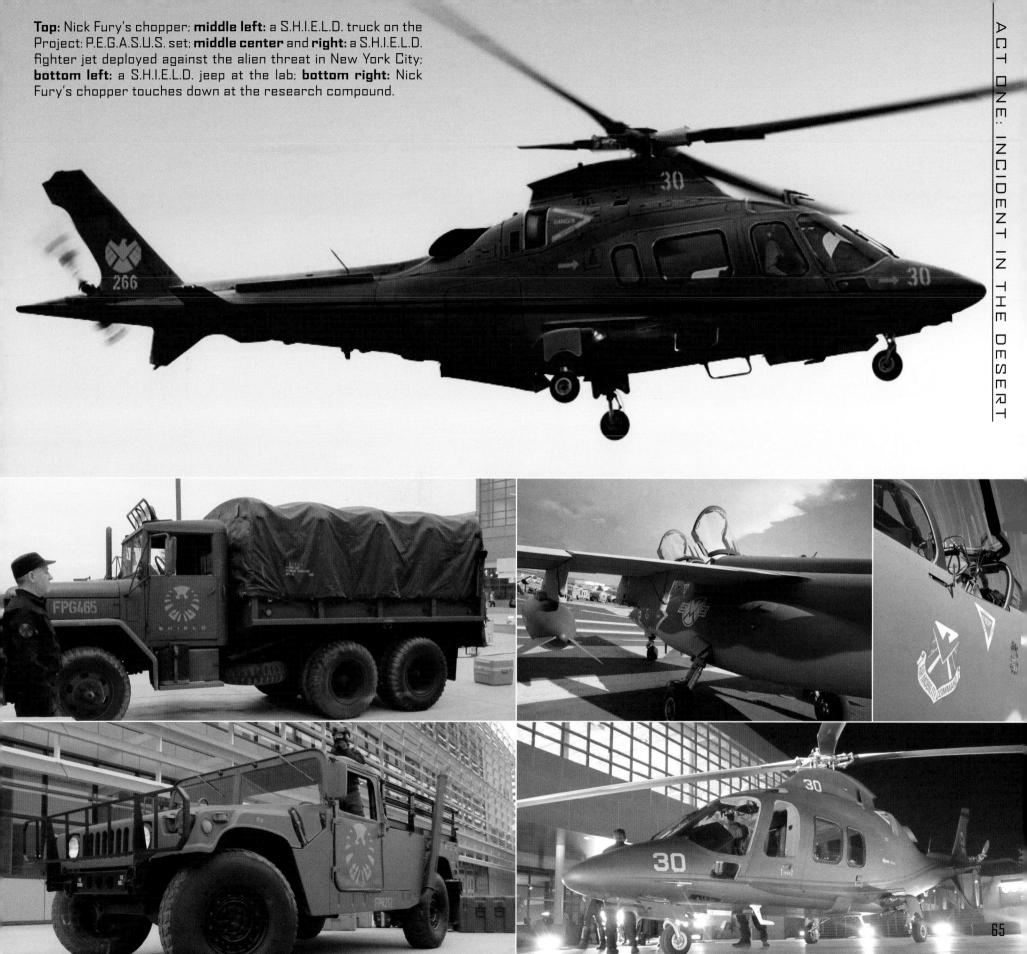

Top: Nick Fury's chopper; **middle left:** a S.H.I.E.L.D. truck on the Project: P.E.G.A.S.U.S. set; **middle center** and **right:** a S.H.I.E.L.D. fighter jet deployed against the alien threat in New York City; **bottom left:** a S.H.I.E.L.D. jeep at the lab; **bottom right:** Nick Fury's chopper touches down at the research compound.

AVENGERS ASSEMBLE!

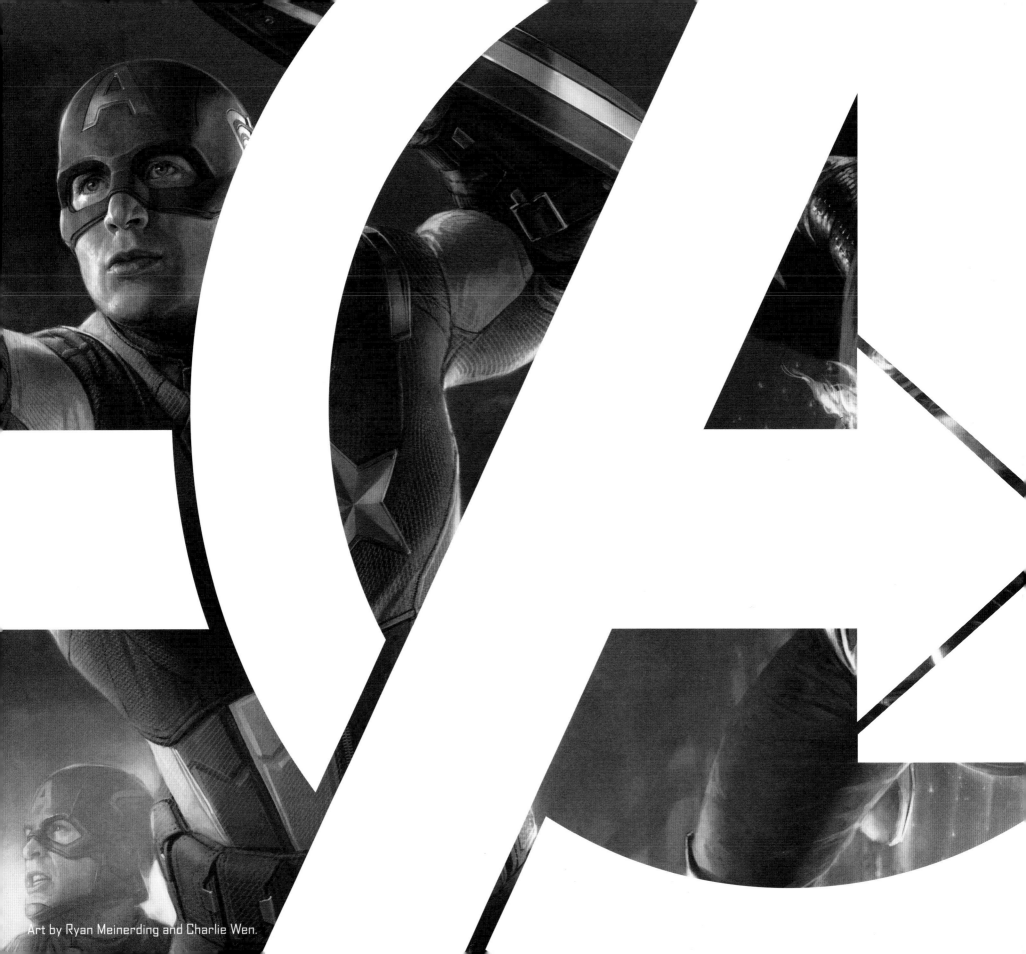

Art by Ryan Meinerding and Charlie Wen.

CONDEMNED RUSSIAN FACTORY

Natasha Romanoff appears to be in peril when we're reintroduced to her in *Marvel's The Avengers* — shackled to a chair in a condemned factory in Russia, seemingly under interrogation by three decidedly unsavory former Soviet Union types. When Natasha receives a call from Agent Coulson, the thugs quickly discover who was really under interrogation. Natasha cleans up after herself — and a number of bruises and broken Russian bones later, returns to active duty with S.H.I.E.L.D. and sets off in search of Dr. Bruce Banner.

"As we meet all of the Avengers, it was important to Joss that we feel an international scope to the team," Production Designer James Chinlund said. "As we encounter Widow for the first time, we find her in the middle of a mission in Russia. As with many of the locations on the film, we went through many options and changes before landing in the location that became the 'Russian Warehouse,' which actually was an old Westinghouse factory in Cleveland. Joss took advantage of the practical opportunities the location provided, shooting the live rail tracks that were adjacent to the space. With the help of Victor Zolfo, we created a scene that showed the den of this arms-smuggling operation. He did an amazing job bringing the textures of the old world into this 20th-century space."

S. JUNG '10

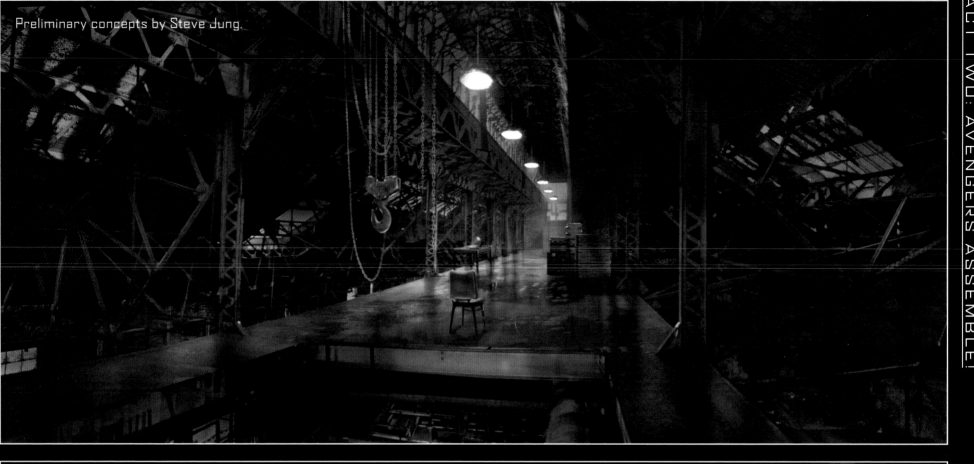

Preliminary concepts by Steve Jung.

BLACK WIDOW/NATASHA ROMANOFF

Natasha Romanoff, a.k.a. Black Widow, first appeared as Natalia Alianova Romanova in *Tales of Suspense #52* (April 1964) — written by Stan Lee and Don Rico, and illustrated by Don Heck. She made her first big-screen appearance in *Iron Man 2* (2010). Romanoff went undercover as Natalie Rushman at Stark Industries on behalf of S.H.I.E.L.D., which didn't score her many points with Tony Stark.

Natasha's backstory is a morally murky one, as she hints at and Loki flat-out declares. We get the sense her loyalty to Nick Fury and S.H.I.E.L.D. stem from her intense desire to somehow make up for past misdeeds. "Natasha has a mutual respect for Fury," Scarlett Johansson said. "She works under his command and follows his direction willingly. She knows that Fury understands more about her past than anyone else in her life other than Hawkeye."

Clint Barton and Natasha Romanoff's mutual understanding of one another drives a number of pivotal story points in the film and informs both characters' motivations.

Natasha's debt to Clint runs deep, owing to his refusal to obey an order to assassinate her and instead recruit her to S.H.I.E.L.D. "I got red in my ledger. I'd like to wipe it out," as Romanoff says to both Loki and Barton in the film, albeit for different reasons and with different results in each case.

We get a much better sense of who Natasha Romanoff is and what drives her in *Marvel's The Avengers*, and this gradual immersion into the character is a big part of what attracted Johansson to the role in the first place. "I signed on to play the Widow in the hopes that audiences would want to explore her story arc," Johansson said. "She has a complex history and a dark past. I love that she's never a damsel in distress or just a pretty girl in a super-hero suit. The Widow isn't afraid to get blood on her hands."

Although Black Widow had appeared on-screen previously, the filmmakers weren't content to rest on their laurels. "The mandate for these characters was to update their look," Concept Artist Andy Park said. "Marvel was happy with how they looked in the previous films, so they didn't want to deviate too far from that. Black Widow originally was going to have 'Widow Stingers' that coursed throughout her whole costume, so I incorporated that look to help sell that she's wearing essentially a powered-up suit — and by 'suit' I mean cat-suit, of course."

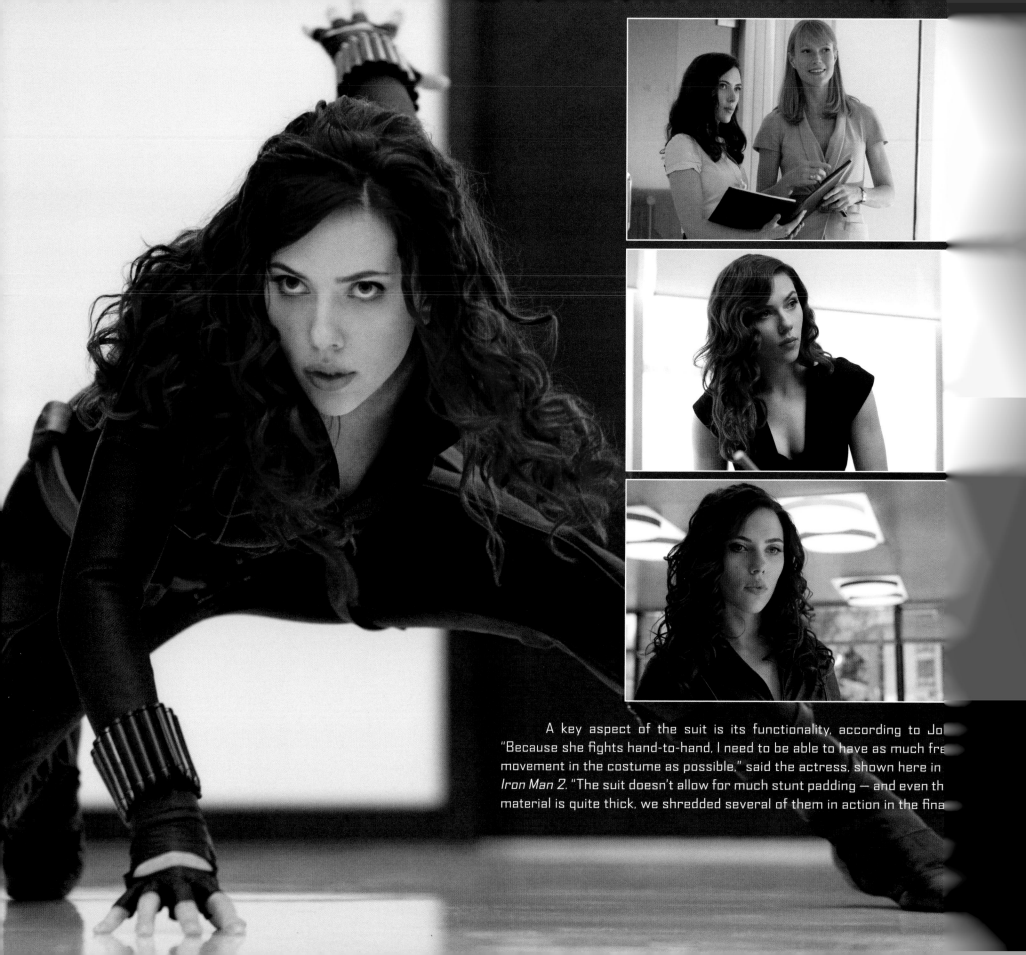

A key aspect of the suit is its functionality, according to Jo
"Because she fights hand-to-hand, I need to be able to have as much fre
movement in the costume as possible," said the actress, shown here in
Iron Man 2. "The suit doesn't allow for much stunt padding — and even th
material is quite thick, we shredded several of them in action in the fina

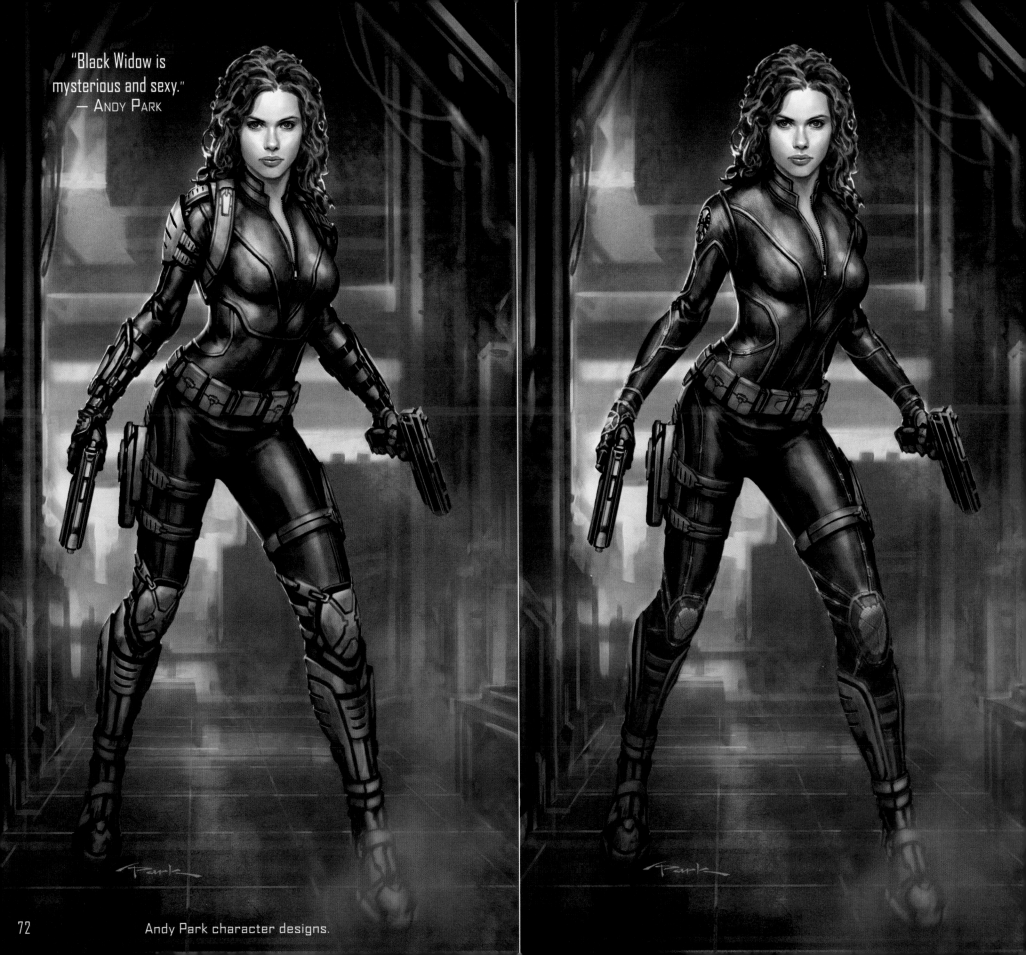

"Black Widow is mysterious and sexy."
— ANDY PARK

Andy Park character designs.

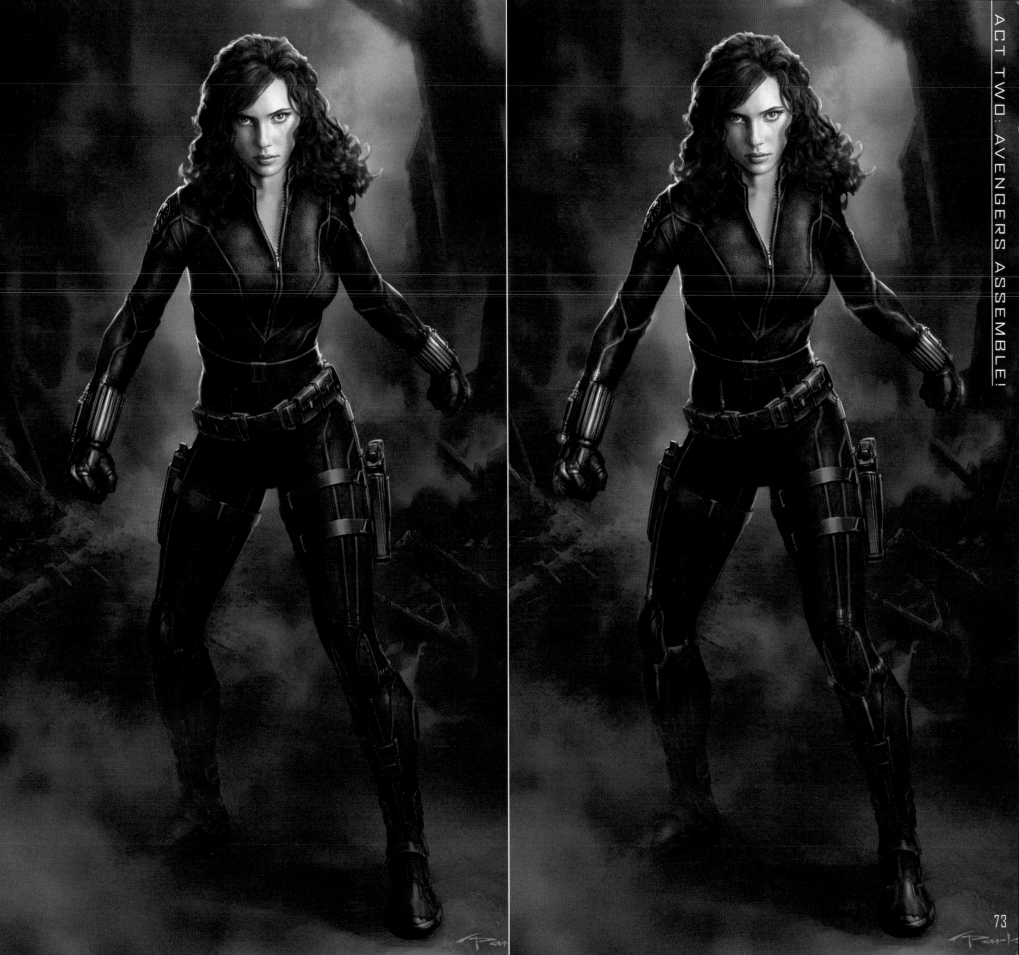

SHORT RANGE TAZER

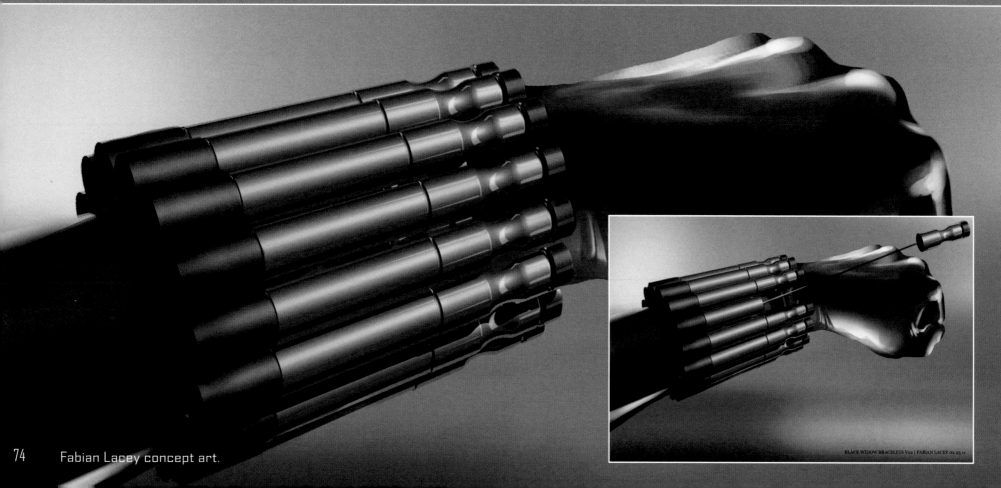

Fabian Lacey concept art.

BLACK WIDOW BRACELETS V02 | FABIAN LACEY 02.25.11

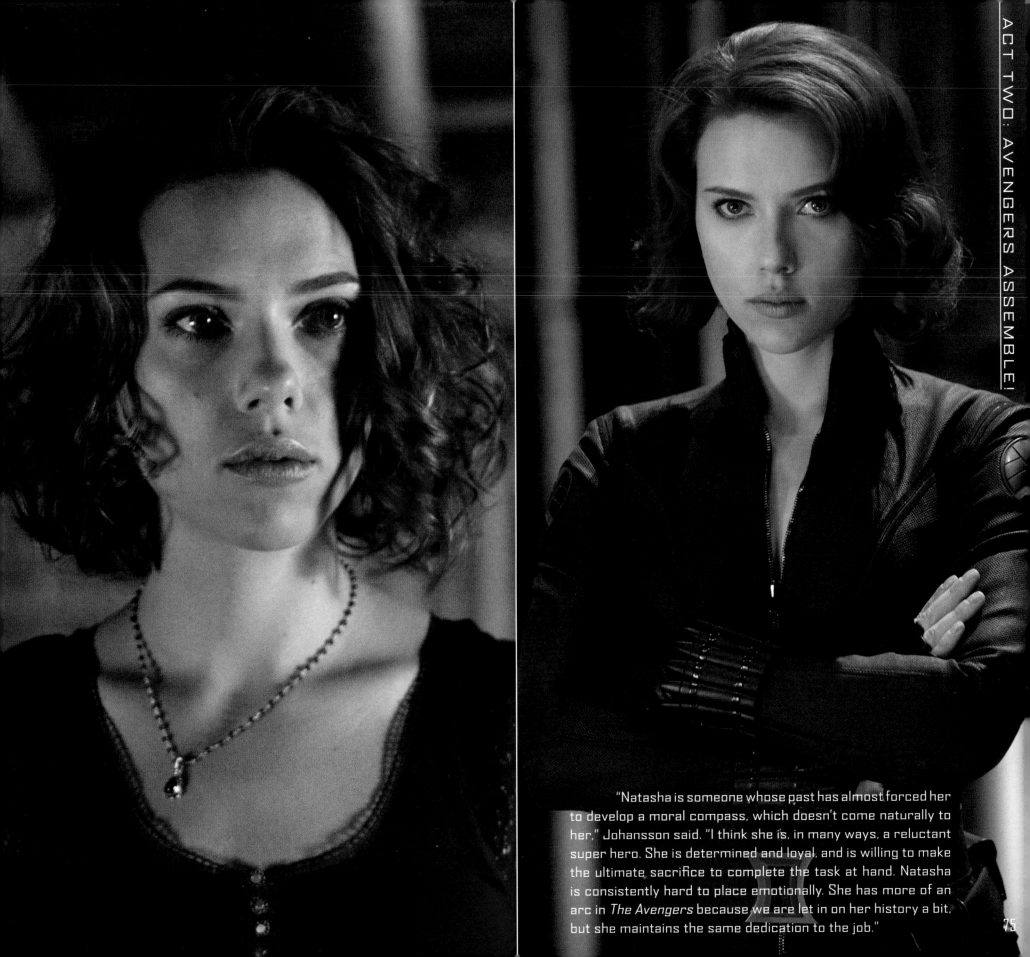

"Natasha is someone whose past has almost forced her to develop a moral compass, which doesn't come naturally to her," Johansson said. "I think she is, in many ways, a reluctant super hero. She is determined and loyal, and is willing to make the ultimate sacrifice to complete the task at hand. Natasha is consistently hard to place emotionally. She has more of an arc in *The Avengers* because we are let in on her history a bit, but she maintains the same dedication to the job."

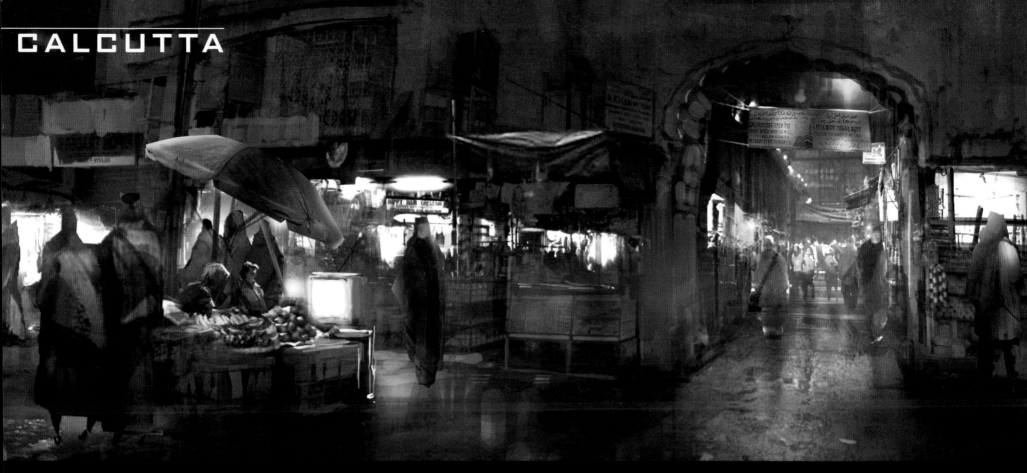

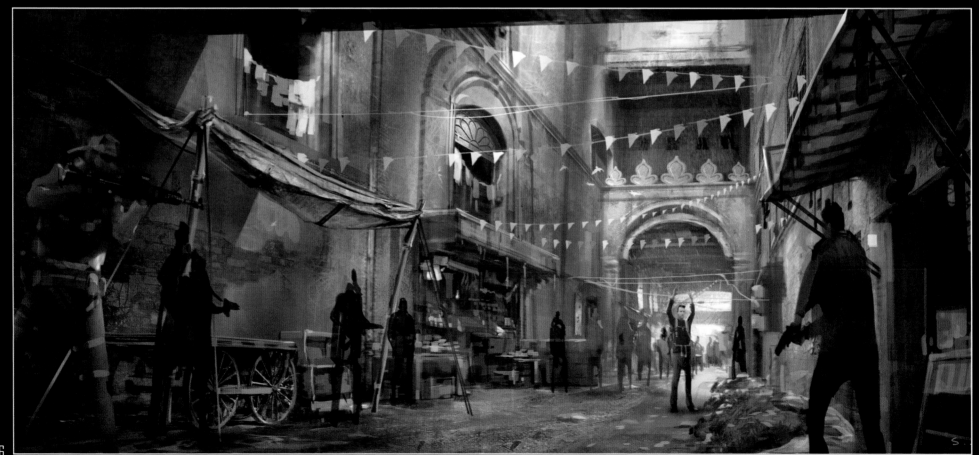

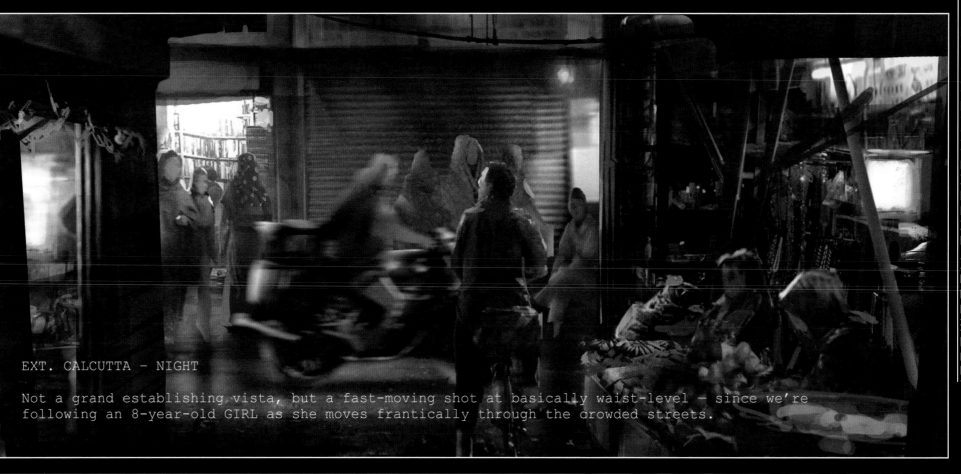

EXT. CALCUTTA - NIGHT

Not a grand establishing vista, but a fast-moving shot at basically waist-level — since we're following an 8-year-old GIRL as she moves frantically through the crowded streets.

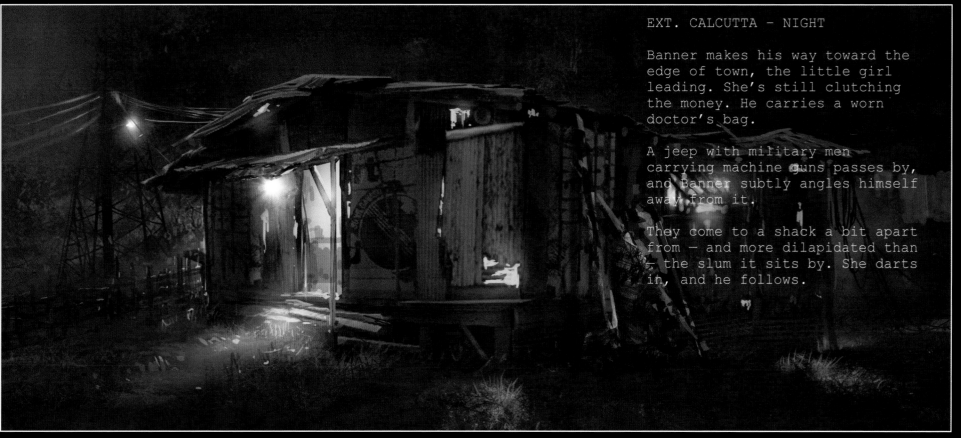

EXT. CALCUTTA - NIGHT

Banner makes his way toward the edge of town, the little girl leading. She's still clutching the money. He carries a worn doctor's bag.

A jeep with military men carrying machine guns passes by, and Banner subtly angles himself away from it.

They come to a shack a bit apart from — and more dilapidated than — the slum it sits by. She darts in, and he follows.

"Practicalities dictated that we shoot the scenes where we find Banner in India in our home base: Albuquerque, New Mexico," James Chinlund said. "As a production designer, we live for these challenges. How could we create a street scene that felt dense and alive here in the desert in America? Again, I turned to the capable hands of Victor Zolfo, who did an absolutely mind-blowing job helping us convert an alley in an abandoned train yard into a bustling piece of Calcutta. His attention to detail was jaw-dropping as he reached back to India and filled several shipping containers with just the right pieces to make the place pop. Our graphics department, led by Amanda Hunter, also did an awesome job bringing all of the textures and layers that make a place like India feel so foreign and rich. The shack where Banner has his conversation with Widow was built on a soundstage. And again, Victor and his team came through — bringing life to an empty stage. He thought through every aspect: where water was collected, how food was prepared, the sleeping habits of these people. Every decision was beautifully motivated. This is one of my favorite scenes in the film, and it was such a pleasure to bring the rich contrast of a world like India to the hyper-tech world of *The Avengers*. These are the contrasts that ground the look of the movie and allow us to believe what we are seeing is really there."

Steve Jung concept art.

"What was fun and surprisingly challenging was blending the different visual worlds inhabited by each of the heroes into one cohesive and consistent universe," Set Decorator Victor Zolfo said. "We were very conscious of the scale of the set dressing and furnishings relative to each character as to not overpower them or feel too diminutive. When you meet each character, there are small nods to their Marvel mythologies and backstories in their environments — from previous films in the series and from the pages of the comics themselves. We first meet Bruce Banner in a poor family home in bustling Calcutta (seen below as constructed on a New Mexico soundstage). When he turns to face the camera, there is a green light bulb in the socket above the sink where he washes his hands. It made sense with the set dressing — India is so colorful — and I think Joss got a kick out of it, too. And Steve Rogers' apartment has lovely framed pictures of Peggy throughout, as well as several American flags and 1940s boxing memorabilia peppered about."

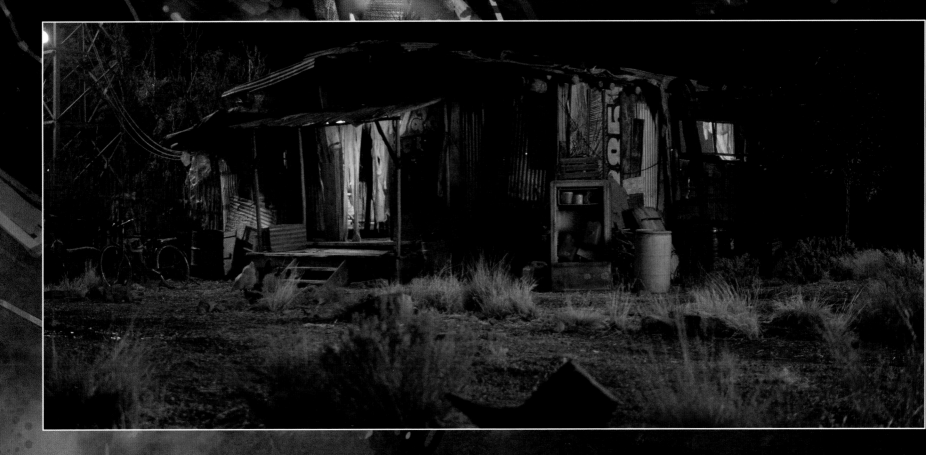

BRUCE BANNER

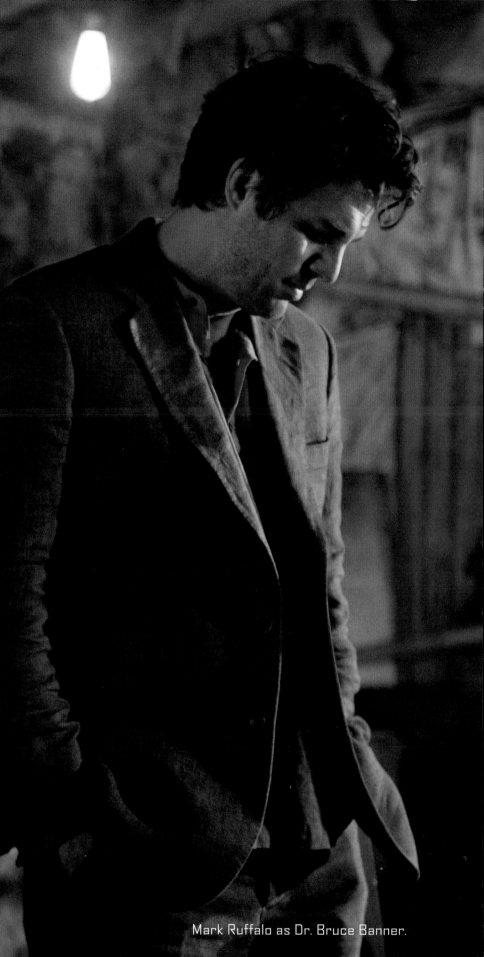

Marvel's The Avengers introduces audiences to a new Bruce Banner, Mark Ruffalo, and a corresponding incarnation of his gamma-irradiated alter ego, the Hulk. Following the events of *The Incredible Hulk* (2008) and the not-so-jolly green giant's climactic confrontation with the Abomination (Tim Roth) — an ultra-heavyweight bout in which he "broke Harlem," as Banner so eloquently puts it — the good doctor has been traveling the world in search of people in need, an homage to the 1970s TV series starring Bill Bixby.

"Joss and I both knew that we wanted to build on the shoulders of what had come before out of deference and respect to the other Hulks. We also wanted to get back to the spirit of the television show," Ruffalo said. "What appealed to us about that was that Banner was kind of a common man. He had this kind of world-weary charm to him and, in a strange way, a sense of humor about his situation. And building off the last Hulk we saw, you also get a sense that Banner might have become a master of it or have some control over the behemoth."

Following her orders from Agent Coulson, Natasha Romanoff catches up with Banner in Calcutta, the latest stop on his lonely global trek. S.H.I.E.L.D. has been tracking his movements, she explains, and has "even kept other interested parties off your scent" — a reference to General Thaddeus E. "Thunderbolt" Ross and the U.S. military complex. But now, they're facing a potential global catastrophe and need him to help trace the Tesseract's unique gamma signature. In other words, they're after his expertise, not "the other guy."

"He's in India, where there's so much suffering around him that it's just impossible to get angry at anything in life because he's afraid, he doesn't want to turn into the Hulk," Ruffalo said. "During that time, he's also beginning to think that integration is the answer: instead of running away from it, turning towards it. As you get older — and this is just where I'm coming from as a 43-year-old man — you start to know what your limitations are, but you are also aware of your capabilities. Then you come to accept those things. And because you can accept those things, you're actually able to use them in a much more efficient way. And so Joss and I sort of riffed on that idea: that this is the next, 43-year-old version of Bruce Banner — who's more mature, who's done plenty of suffering and soul-searching in this dilemma that he finally has to say, 'OK, this is what it is, and how am I going to figure out a way to live my life with it?' And so there's this kind of iconic world-weariness and playfulness that we see in Bruce Banner.

"And so he's in Calcutta," Ruffalo continued. "He's administering to the sick. He's being of service. I imagine that he's been able to cobble together some semblance of a life in the time that he's been there. And so we have him administering to some sick, and a little girl shows up and says, 'My father, he's ill, please come, he's sick!' And of course, he can't say 'no.' So he follows her through the streets and into the countryside of Calcutta, and he sees that the little girl has led him into this shack. And there he is, trapped with the Black Widow."

Mark Ruffalo as Dr. Bruce Banner.

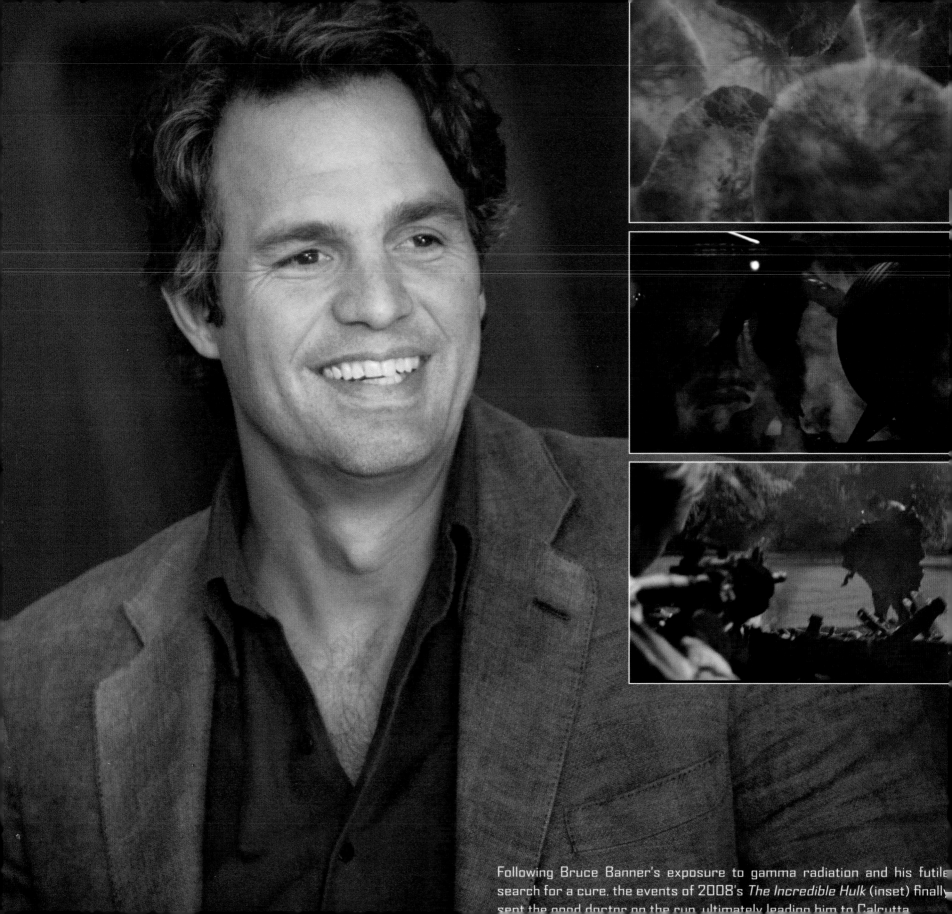

Following Bruce Banner's exposure to gamma radiation and his futile search for a cure, the events of 2008's *The Incredible Hulk* (inset) finally sent the good doctor on the run, ultimately leading him to Calcutta.

WORLD SECURITY COUNCIL CHAMBER

Even the formidable Nick Fury must answer to somebody — and in *Marvel's The Avengers*, that would be the World Security Council. Its members are decidedly less than supportive of the Avengers Initiative, and their concern only grows after the incident in the desert that imploded Project: P.E.G.A.S.U.S. and Loki's theft of the Tesseract.

COUNCILMAN
You're running the world's greatest
covert security network, and you're gonna
leave the fate of the human race to a
handful of freaks.

FURY
I'm not leaving anything to anyone. I
need a response team. These people may
be isolated, even unbalanced. I believe,
with the right push, they can be exactly
what we need.

COUNCILWOMAN
You "believe"?

COUNCILMAN
War isn't won by sentiment, director.

FURY
No. It's won by soldiers.

Jackson Sze concept art.

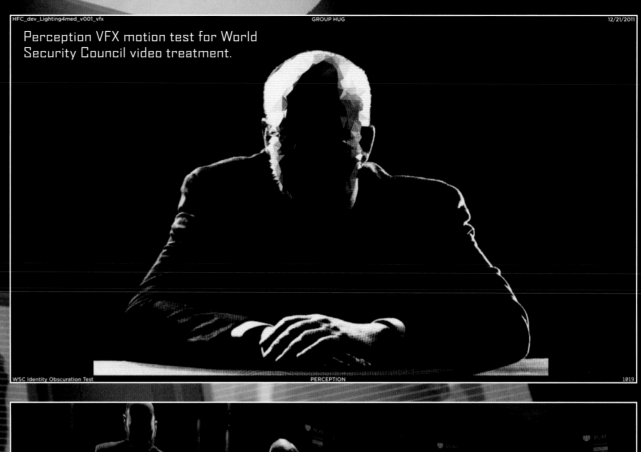

HFC_dev_Lighting4med_v001_vfx GROUP HUG 12/21/2011

Perception VFX motion test for World
Security Council video treatment.

WSC Identity Obscuration Test PERCEPTION 1019

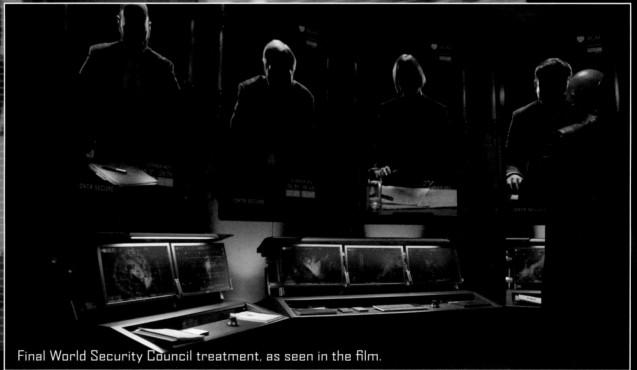

Final World Security Council treatment, as seen in the film.

STEVE ROGERS

Steve Rogers is a man out of time. Most of his friends and allies are dead. But true to his nature, he's trying to remain positive and make the best of it. Steve spends much of his time working out in a gym that looks almost as out of place in the modern world as he does. And that's where Nick Fury finds him following the incident in the desert. The once and future Captain America knocks his punching bag clean off the chain and across the gym, and Steve is about to replace it when the director of S.H.I.E.L.D. comes calling.

"Steve Rogers is still the same man," Chris Evans said. "What makes him Captain America to begin with is that he is a selfless person. So even though he has things to adjust to and a certain degree of conflict in his life, I think the fact that he's willing to handle the challenge is what makes him who he is. So even though there is struggle, even though there is an acceptance that everyone you know in the world is dead — that you've missed seventy years of life, that you're completely alone — there's options. You can either pout, or you can suck it up and deal with it. And I think that's just the nature of who Steve Rogers is. So it's not the best time in his life, but he's coping.

"He's adjusting — but thankfully a big part of Steve Rogers is his good nature, high morals and strong values," Evans continued. "Those morals and values were created in a time when people treated each other really differently. The level of interaction was a bit deeper. Everything feels one step apart with all of the technology we have now. Even if you ask a girl out on a date, you can virtually do it without ever saying a word to her. That's not the way it used to be in Steve's world, so I think there's a lot to get used to for him. A lot of the things that he believed in, stood for and loved have changed. They're not gone, they're just different. He's trying to find his footing in a modern world.

"When he's called upon to help his country, he puts his country's problems before his own. I think there's a subtle part of him that's looking to get back in the suit. I think that's where he feels he has purpose, and I think that's where he feels he has comfort. So despite the fact that he's having a difficult time adjusting, I think deep down what he really wants to do is do what he used to do best, which is defend and help."

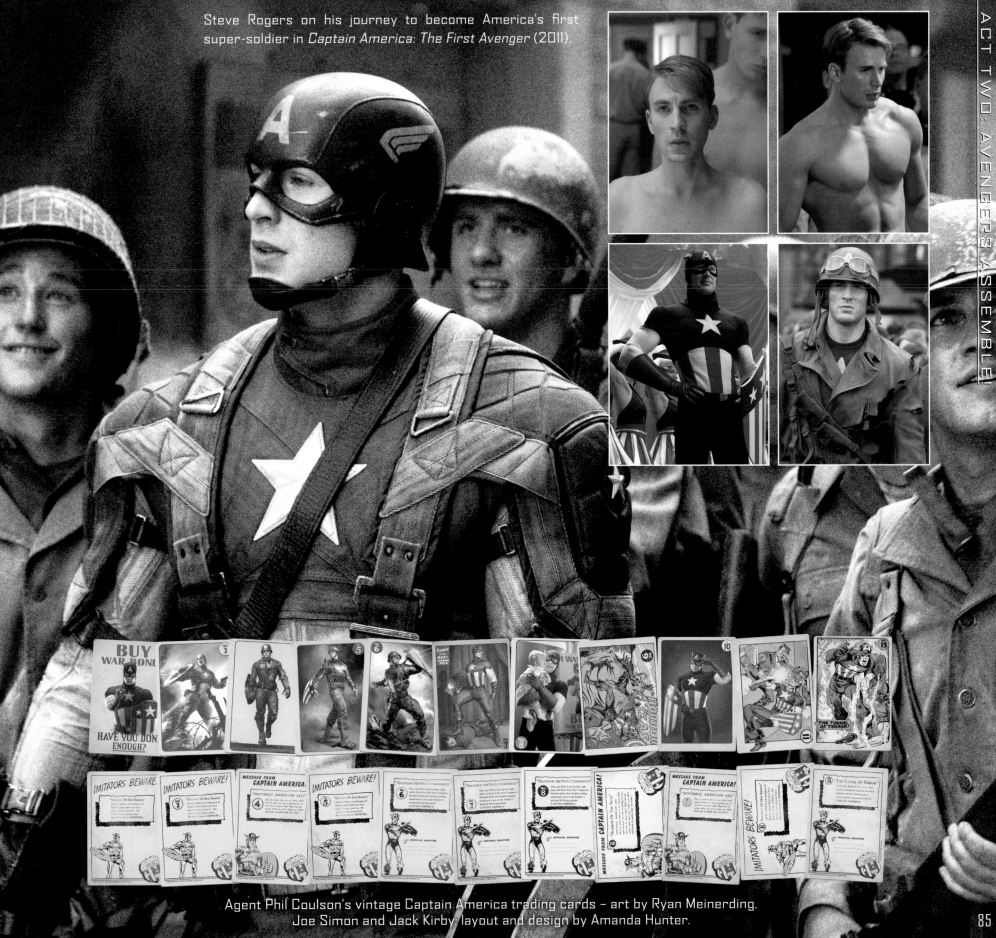

Steve Rogers on his journey to become America's first super-soldier in *Captain America: The First Avenger* (2011).

Agent Phil Coulson's vintage Captain America trading cards – art by Ryan Meinerding, Joe Simon and Jack Kirby; layout and design by Amanda Hunter.

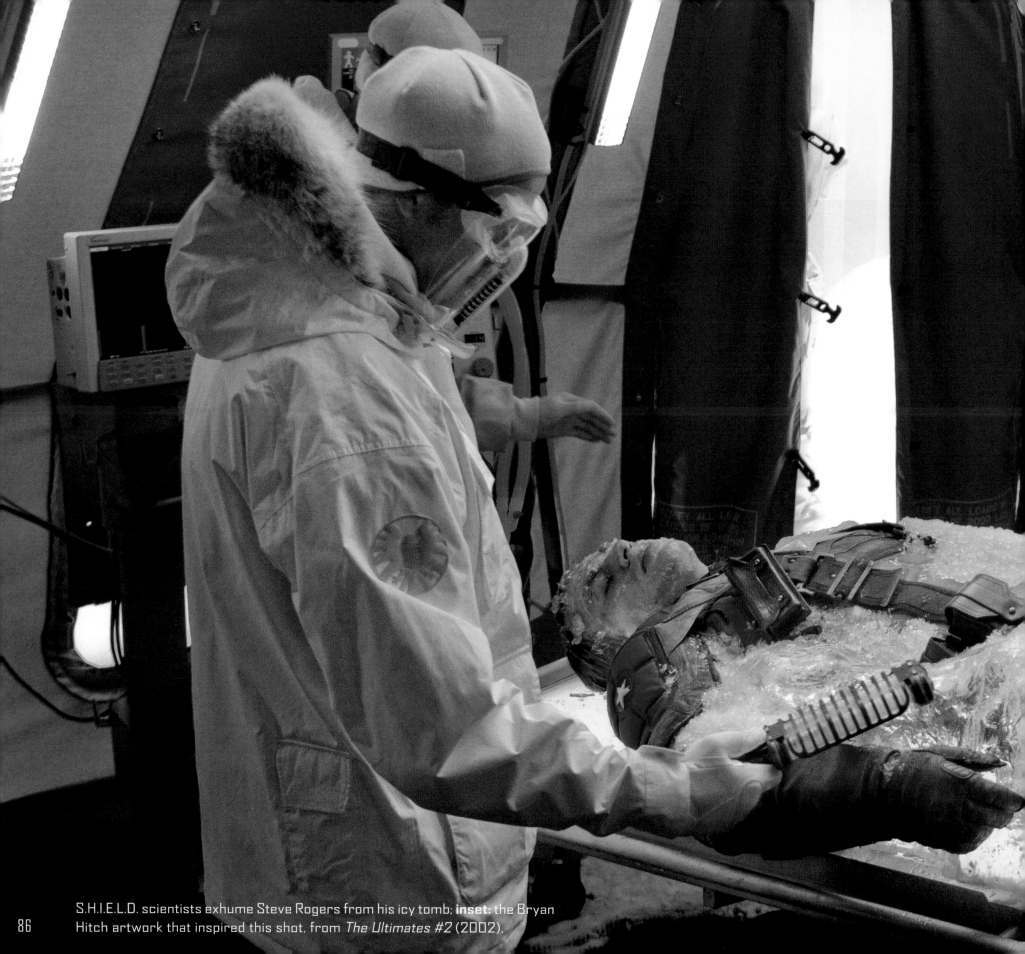

S.H.I.E.L.D. scientists exhume Steve Rogers from his icy tomb; **inset:** the Bryan Hitch artwork that inspired this shot, from *The Ultimates #2* (2002).

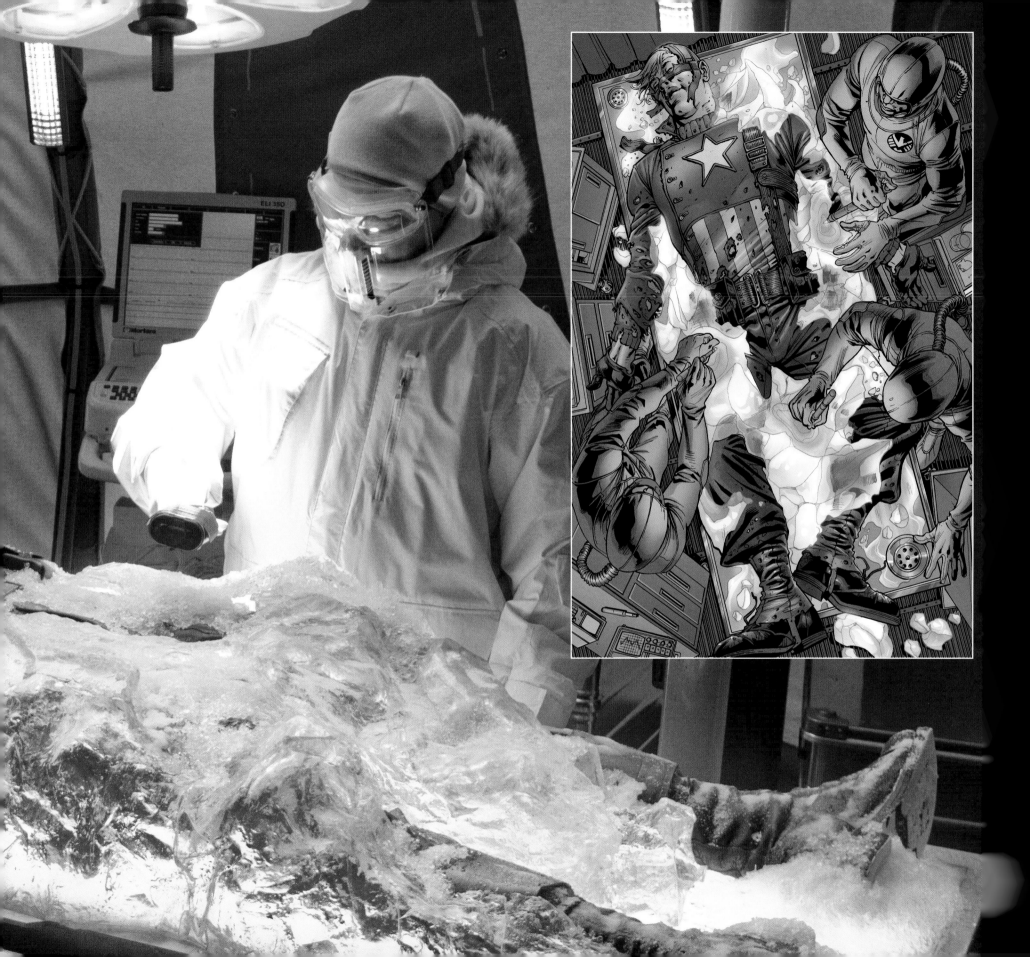

STEVE ROGERS' GYM

INT. OLD GYM - NIGHT

...Steve BREAKS the bag — knocks the stuffing right out of it as it
rips off the chain and sails across the room.

WIDEN to see that Steve has six more bags lined up on the floor. HE
grabs one with one hand, hooks it onto the chain. As he does so,
Fury steps into frame.

 FURY
 Trouble sleeping?

 STEVE
 I slept for 70 years, sir. I think I've
 had my fill.

 FURY
 Then you should be out, celebrating —
 seeing the world.

 STEVE
 I've seen some.

 FURY
 Lotta change. Takes some getting used to,
 even if you've lived through it.

 STEVE
 I went under, country was at war. I wake up,
 they say we won. They didn't say what we'd lost.

 FURY
 We've made a few mistakes along the way.
 Some very recently.

 STEVE
 You here with a mission, sir?

 FURY
 I am.

 STEVE
 Trying to get me back in the world?

 FURY
 Trying to save it.

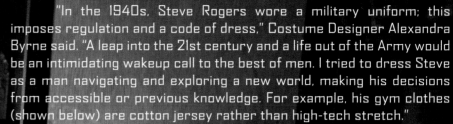

"In the 1940s, Steve Rogers wore a military uniform; this imposes regulation and a code of dress," Costume Designer Alexandra Byrne said. "A leap into the 21st century and a life out of the Army would be an intimidating wakeup call to the best of men. I tried to dress Steve as a man navigating and exploring a new world, making his decisions from accessible or previous knowledge. For example, his gym clothes (shown below) are cotton jersey rather than high-tech stretch."

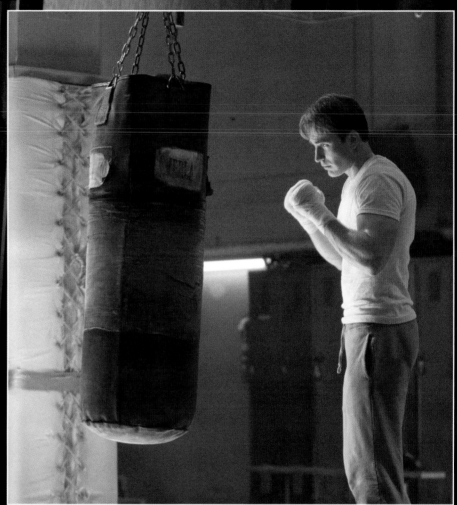

Steve Jung concept art.

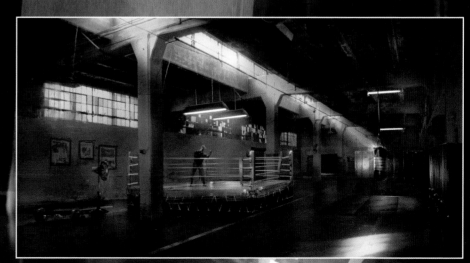

TONY STARK/IRON MAN

When we first encounter Tony Stark, Iron Man is at the bottom of the New York Bay disconnecting the HVDC transmission lines, physically taking Stark Tower off the grid. Seconds later Tony's girlfriend, Pepper Potts (Gwyneth Paltrow), fires up the Arc Reactor that will act as a self-sustaining, clean energy source for the monolithic building.

Iron Man returns to Stark Tower just in time to meet Agent Coulson, who briefs Tony on every aspect of the present danger and Nick Fury's planned response to it — from Loki and Thor to the Tesseract and the newly thawed Captain America. Tony is still clearly bitter about his failure to qualify for the Avengers Initiative, which he believes to have been scrapped. Yet he quickly finds himself completely immersed in the briefing materials, and there's little question as to whether or not he's in the game.

In many ways, the events of *Marvel's The Avengers* prove to be the ultimate test for Tony Stark. "I'm volatile, self-obsessed, and I don't play well with others," he says, citing his S.H.I.E.L.D. psychological profile. Stark has always been his own man — and he's always gone his own way, even when it wasn't in his best interest to do so. But with the looming global threat posed by Loki and his mysterious alien co-conspirators, this "genius billionaire playboy philanthropist" — as he refers to himself — will have to learn to put his innate egocentricity aside and function as part of a team, even one of which he may not necessarily be the head. And according to the actor who plays him, Tony is ready for this pivotal next step of his hero's journey.

"If you look at the evolution of Tony Stark in the two *Iron Man* films, he is growing toward being able to do something like *The Avengers*," Robert Downey Jr. said. "The first film is his origin story, and he has an epiphany and redemption of sorts. The second film is about making space for others in his insular world and dealing with certain legacy issues. Now, if Tony Stark was at home and Thor walked in, he'd think it was hilarious. He knows that his dad was into some trippy stuff — but as an engineer and a scientist, as someone who thinks in terms of all the possibilities, he would think, 'You know, this just might be possible. It's outside my realm of normal experience, but it just might be possible.'"

Robert Downey Jr. as Tony Stark.

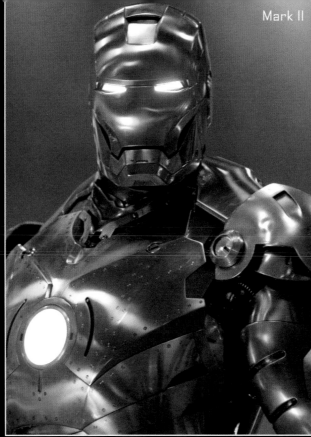
Mark II

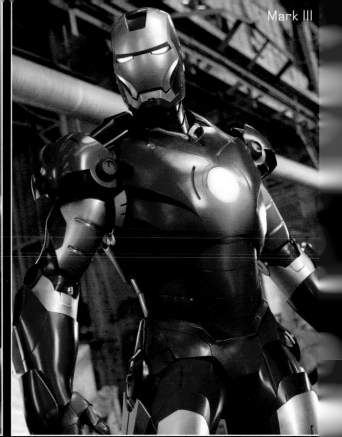
Mark III

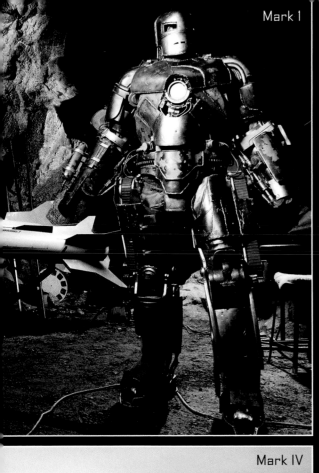
Mark IV

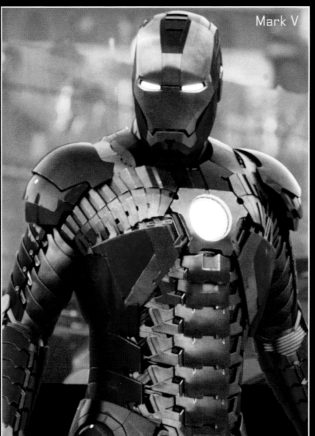
Mark V

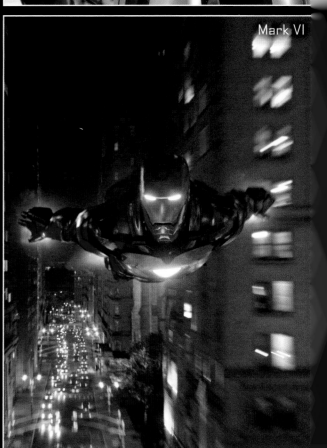
Mark VI

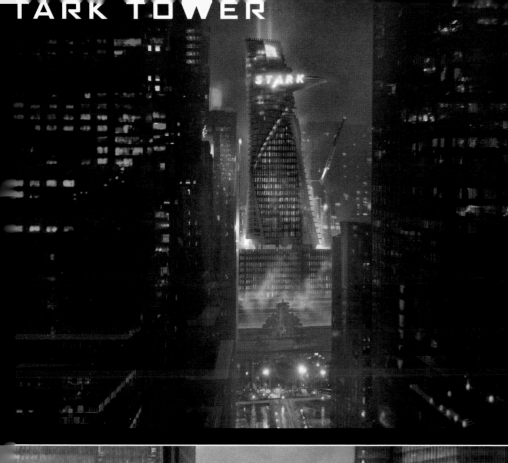

TARK TOWER

framework for the look of the movie, I continually came back to the same idea of trying to blend these futuristic technologies with a 20 world with a full range of histories and textures," James Chinlur said. "Throughout the film, we looked for opportunities where w could represent these ideas, ideally right next to each other the same frame. The Stark Tower was the ultimate representatic of this idea, where Tony Stark bought the iconic MetLife Buildir — formerly the Pan Am Building — and ripped off the top, addir his own piece of parasitic architecture to the top. The height arrogance and the essence of Stark! As a production designe this was the most fun set by far for me having grown up in Ne York and looking at that building every day for my whole life — t be able to affect its history, forever, was an amazing opportunit In choosing the MetLife location, we were also recognizing the ric topography of the streets below, which is a unique arrangemer in New York — with the viaduct over 42nd Street and the tunne behind Grand Central Terminal, not to mention Grand Centr itself — the ultimate conflagration of rich histories and futurist ideas. Art Director William Hunter was the catalyst for all of th work, coming up with some early models that cracked the back the design challenges and together with Set Designer Luis Hoyc brought Stark Tower to life in the physical build."

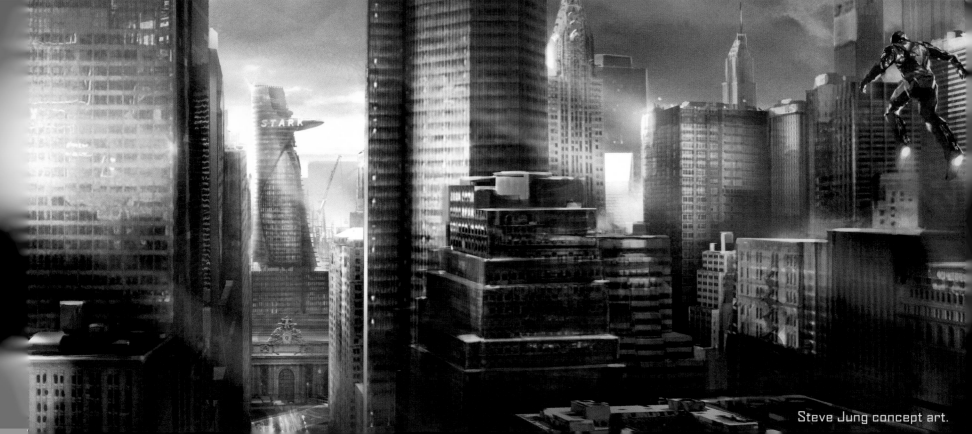

Steve Jung concept art.

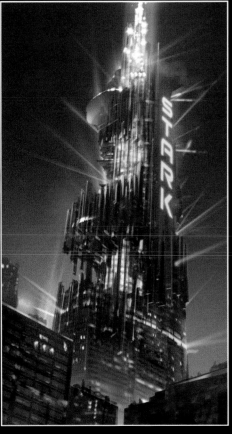
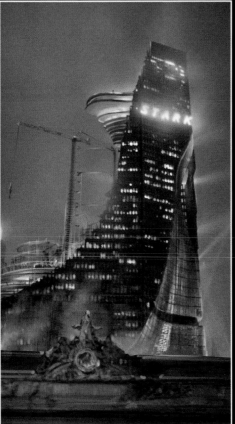
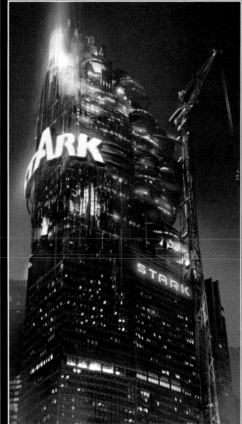
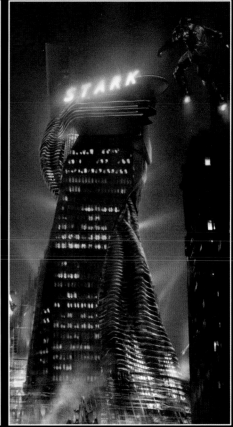

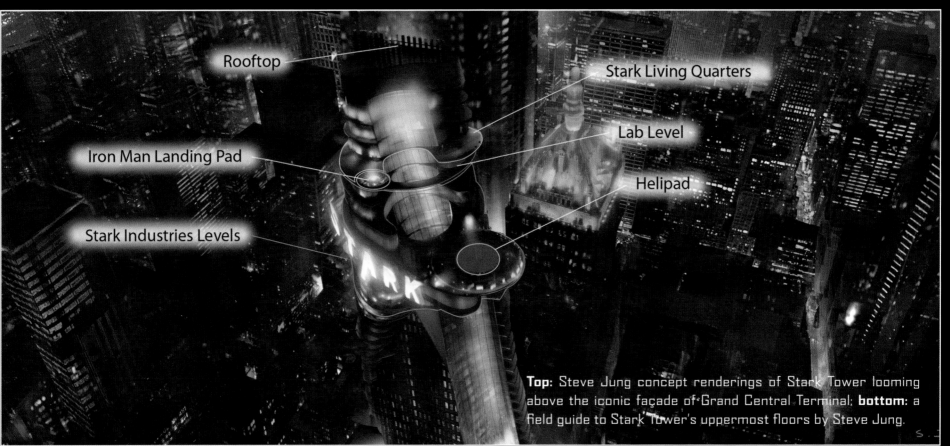

Rooftop

Stark Living Quarters

Iron Man Landing Pad

Lab Level

Helipad

Stark Industries Levels

Top: Steve Jung concept renderings of Stark Tower looming above the iconic façade of Grand Central Terminal; **bottom:** a field guide to Stark Tower's uppermost floors by Steve Jung.

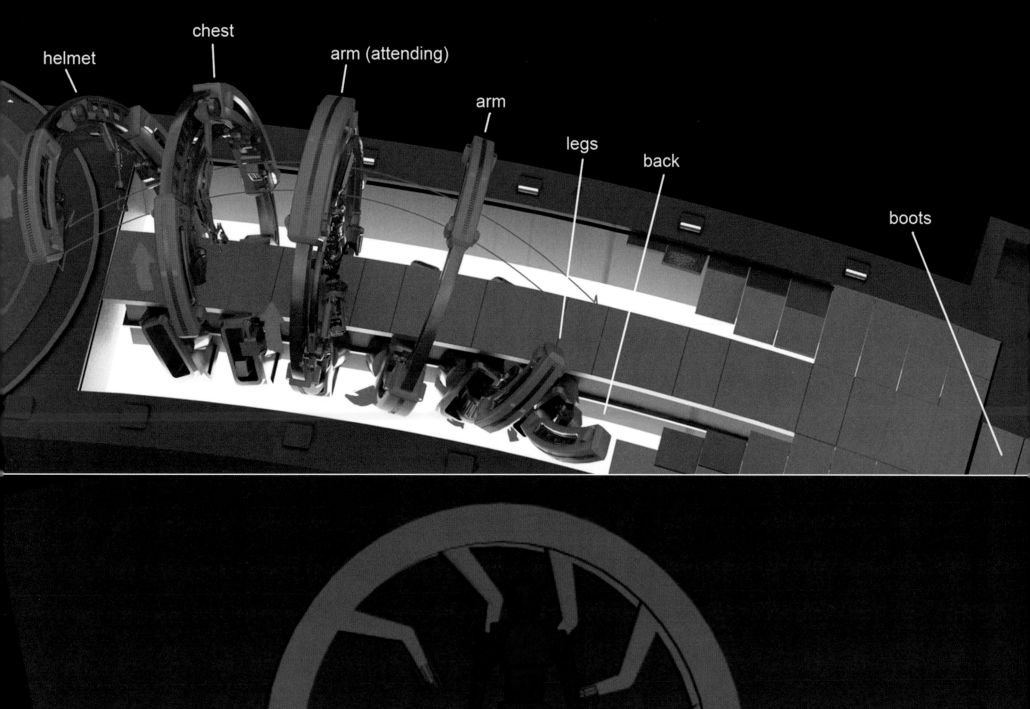

helmet

chest

arm (attending)

arm

legs

back

boots

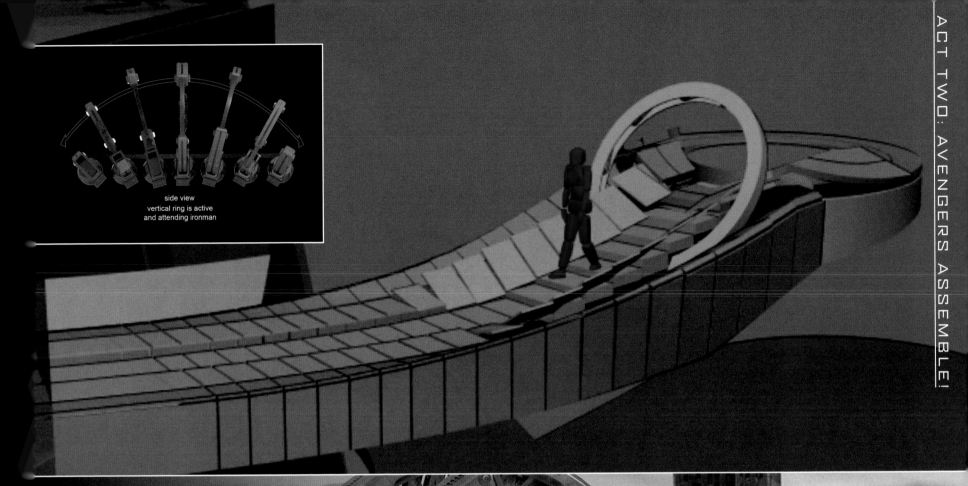

side view
vertical ring is active
and attending ironman

We tried to conceive of the whole
…t as a machine, starting with
…ng pad known as the 'car wash,'"
… said. "This was a concept that
…rked in his first draft of the script
…ched on to with both hands. The
… Tony is now designing his world
…ne Iron Man tech, it makes sense he
…corporate it into the architecture
…ace. A lot of energy went into the
… his workstations, as well — trying
…porate all of the elements into the
…nction of the space. The space was
…ly designed around his initial arrival
…p Park Avenue through the canyons
…ork, arriving upon the twisting form
… Tower, landing on the pad, gliding
…e balcony through the doors and
…y arriving at his workspace. For a
…ction, it's as efficient as it gets."

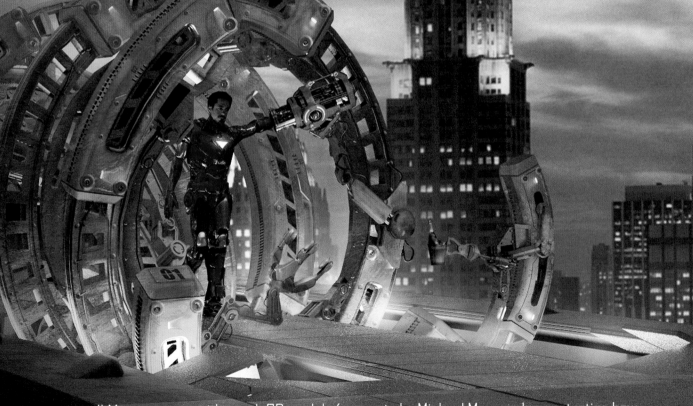

ILM concept art with rough 3D models/concepts by Michael Meyers demonstrating how
a large metal ring encircles and follows Tony as mechanical arms remove his Iron Man
armor "car-wash style," according to Joss Whedon's script.

HE QUINJET

The Quinjet figures in a number of the film's most memorable action sequences, including Thor's return to Earth and bsequent "rescue" of Loki, and a crash landing on Park Avenue in New York City after taking alien laser fire.

"The Quinjet was a tricky piece to work out," James Chinlund said. "The requirements of the script necessitated an craft that was capable of carrying up to nine people at supersonic speeds, and had vertical takeoff and landing capabilities. e larger payload pushed the form away from most fighter-jet forms, and the supersonic requirements made it not a licopter form. So we were hoping for a hybrid form that could change its overall look based on the requirements of the given uation. As it was going to be utilized in an urban battle, I thought it was important that it have a tough face, more chopper- e, but could then streamline its form into more of a jet as it moved into higher-speed modes. As with the Helicarrier, it was itical that it pass the sniff test and look like a plausible current-day piece of military tech. Tani Kunitake did some incredible ork on the visualization of this craft, with some real breakthrough renderings of the exterior and interior. Phil Saunders and chael Meyers both did some beautiful modeling and animations that revealed the form changes that the Quinjet was capable Art Director Ben Edelberg shepherded the entire build, both digital and practical, through the choppy waters and helped eate the amazing final result."

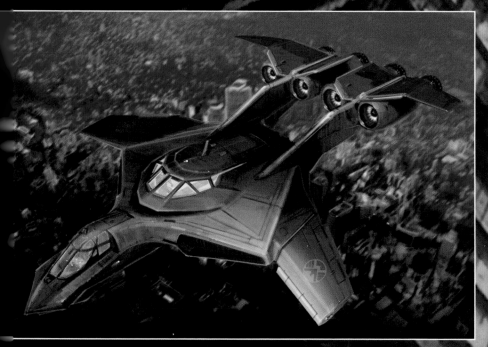

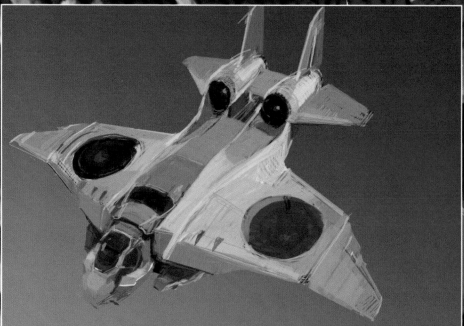

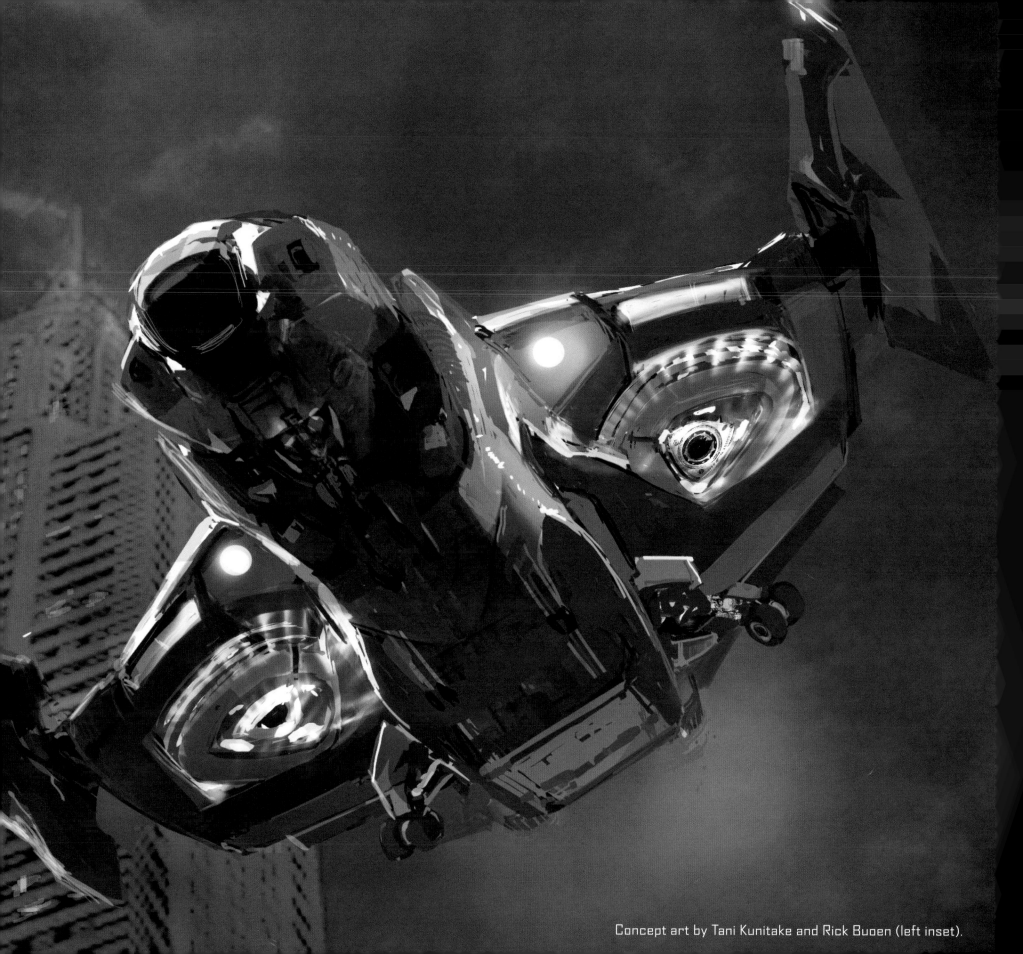

Concept art by Tani Kunitake and Rick Buoen (left inset).

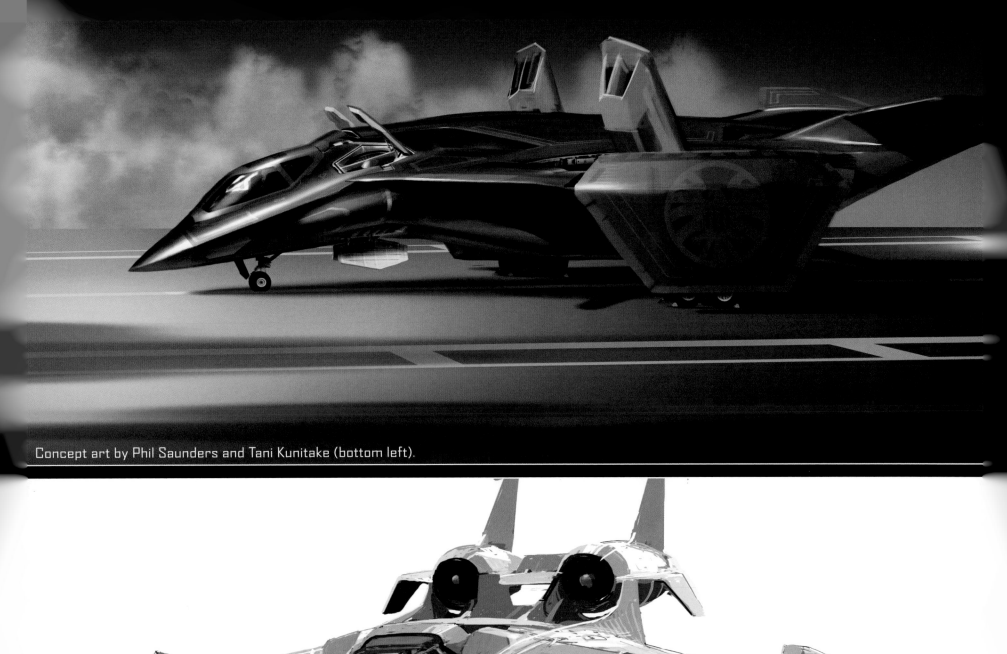

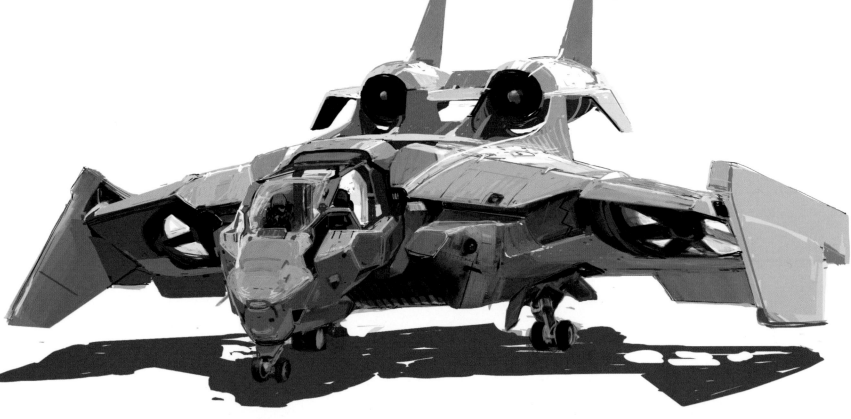

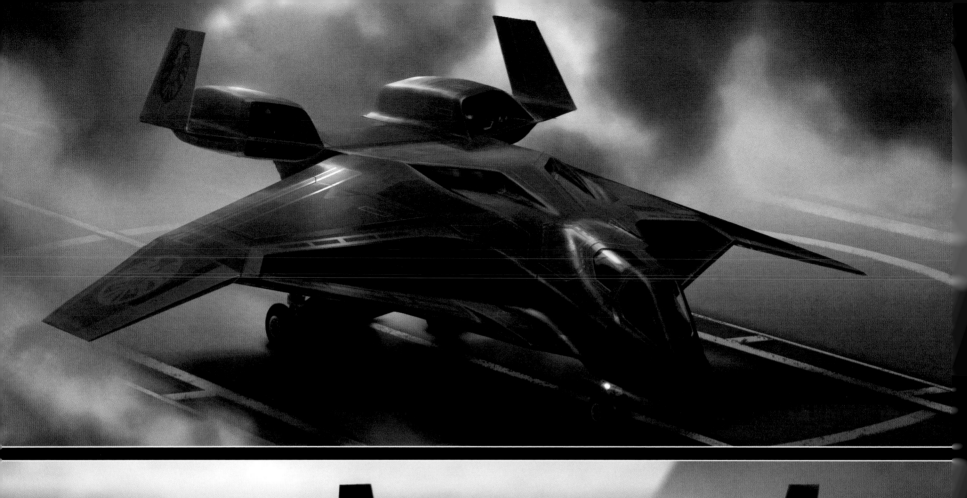
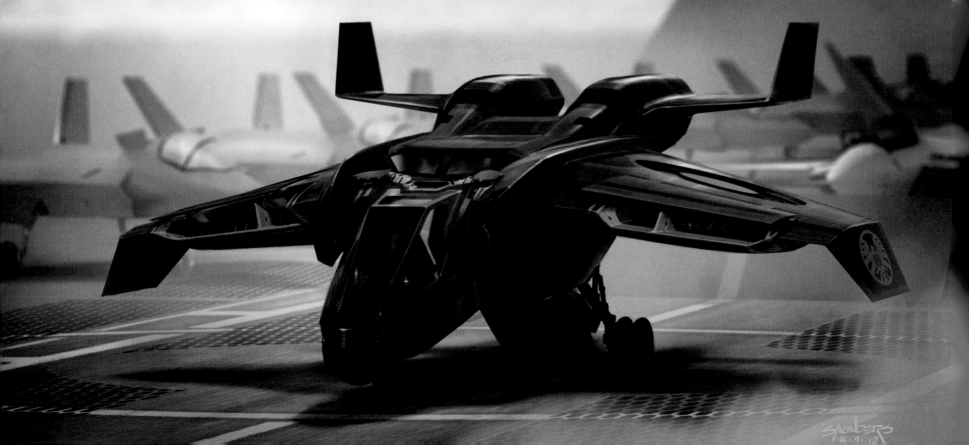

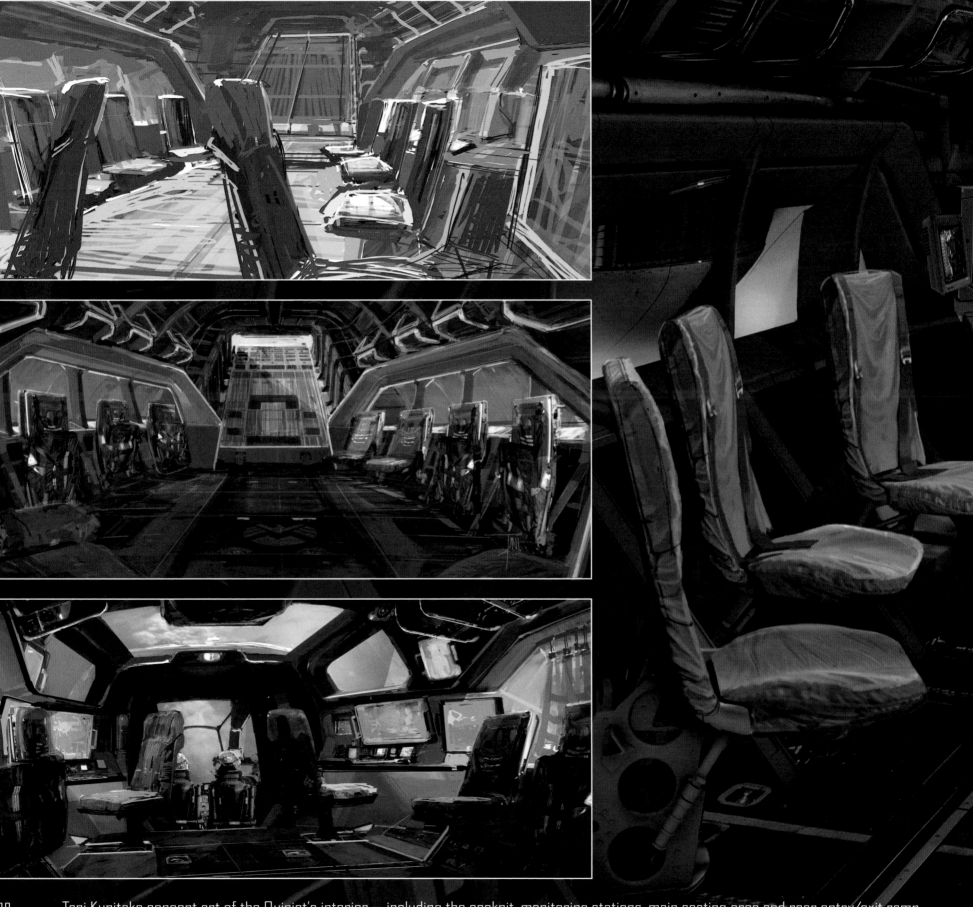

Toni Kunitaka concept art of the Quinjet's interior — including the cockpit, monitoring stations, main seating area and rear entry/exit ramp.

"The Quinjet had a number of constraints as originally envisioned in the script," Concept Artist Phil Saunders said. "First, it had to be a troop transporter large enough to carry the six Avengers members, including a potential Hulk-out,, as well as a couple of S.H.I.E.L.D. pilots. It needed to have vertical takeoff ability to land on the Helicarrier and in tight New York streets, which also necessitated a pretty small landing footprint. At the same time, it needed to be convincing as a craft that could cross long distances at supersonic speeds. Mike Meyers and I each spent a lot of time working out believable variable-geometry systems in 3D that would transform the craft from a compact, hawk-like VTOL setup to a sleeker supersonic configuration that actually lengthened the craft as a whole. Ultimately, Joss and James opted for a more fixed geometry with sliding panels in the wings that exposed the ducted fans for vertical takeoff and landing."

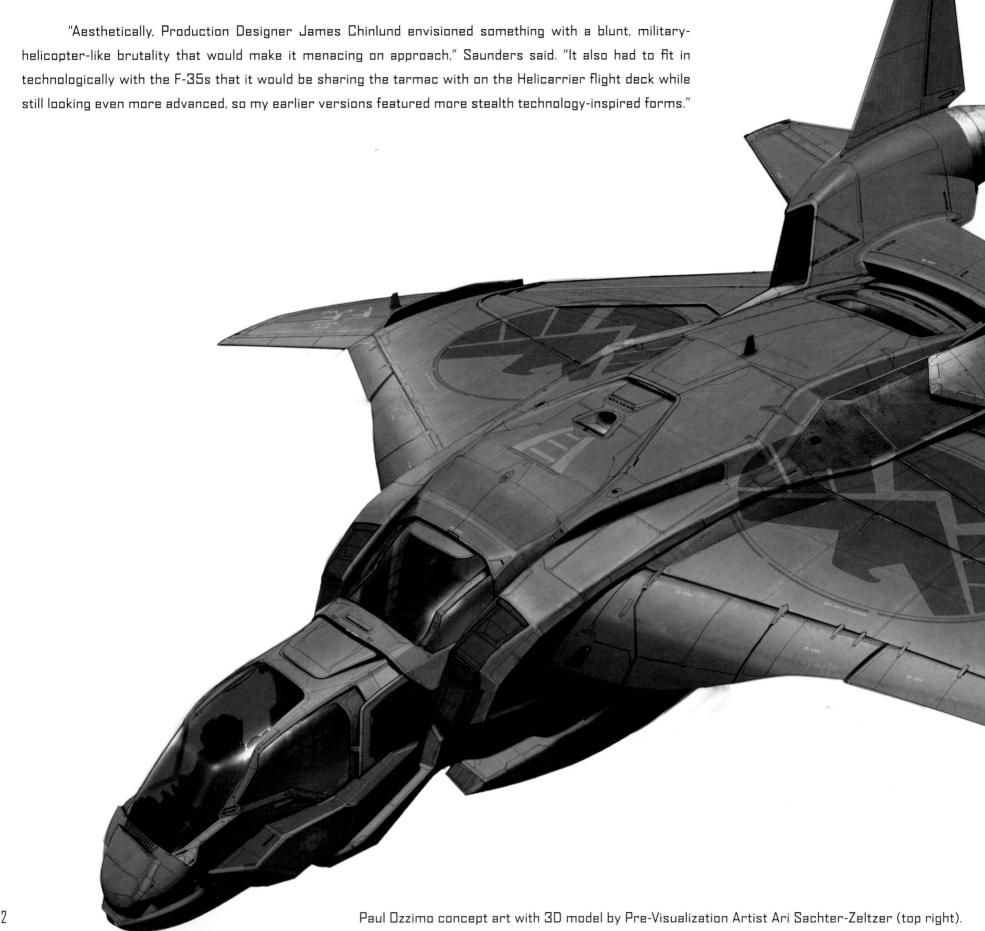

"Aesthetically, Production Designer James Chinlund envisioned something with a blunt, military-helicopter-like brutality that would make it menacing on approach," Saunders said. "It also had to fit in technologically with the F-35s that it would be sharing the tarmac with on the Helicarrier flight deck while still looking even more advanced, so my earlier versions featured more stealth technology-inspired forms."

Paul Ozzimo concept art with 3D model by Pre-Visualization Artist Ari Sachter-Zeltzer (top right).

S.H.I.E.L.D. HELICARRIER

Like the Quinjet, the S.H.I.E.L.D. Helicarrier has a long history in the comic books. To all outward appearances, the mighty vessel is a standard aircraft carrier. But once its four massive turbine engines have been deployed, the Helicarrier becomes a flying war machine — the flagship of the S.H.I.E.L.D. fleet. The legendary Jack Kirby first rendered the Helicarrier for the Nick Fury feature in *Strange Tales #135* (August 1965). In the comics, the Helicarrier was designed by Tony Stark, the Fantastic Four's Reed Richards and the X-Men's Forge, and then built by Stark Industries. In addition to housing a wing of fighters and other aircraft, the Helicarrier bristles with advanced weaponry, including an intercontinental ballistic missile. The Helicarrier has been redesigned a number of times through the years, including the version in *The Ultimates* that informed the ship's look in the film, but its function as a mobile headquarters for S.H.I.E.L.D. has remained largely consistent.

"It's basically an aircraft carrier in the sky," Joss Whedon said. "Throughout the years, the look of Helicarrier has evolved in the comics, but it was always the idea of this floating fortress. It was part of the bargain in writing the script that it had to be included, and I wasn't about to say 'no.' We had a lot of discussions on figuring out how to make it work. But the streamlined design that our production designer, James Chinlund, came up with was very sleek and cool — but it also towed the line between fantasy and reality very well.

"The Helicarrier had to be state of the art and visually stunning because it elevates S.H.I.E.L.D. to something other than a bunch of guys in a cave with banks and banks of computers," Whedon continued. "A good portion of the movie takes place on the Helicarrier, and it's the only place that makes sense in having all of the Avengers there."

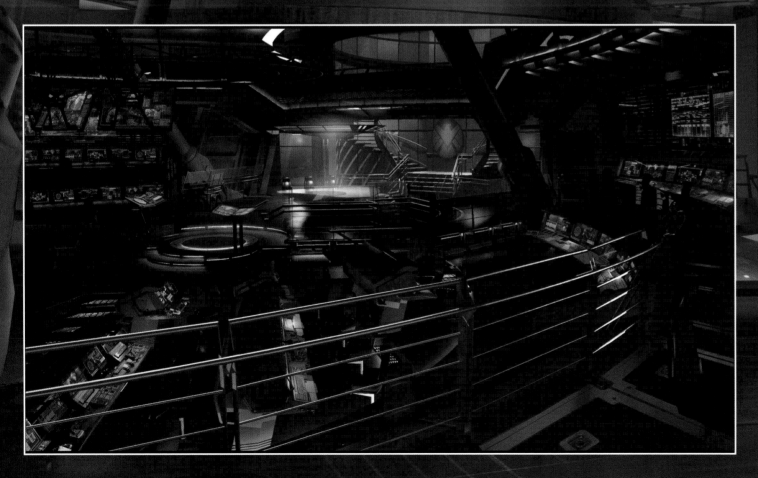

Concept art by Steve Jung and Nathan Schroeder (inset).

For reasons of plausibility, the film version of the Helicarrier had to be functional in the air during crisis situations and on the water as S.H.I.E.L.D. monitors world safety. "One of the things that was bumping for us early on was the idea that the Helicarrier had been flying around the whole time in the film," Kevin Feige said. "If there's an object the size of an aircraft carrier floating above Manhattan, I think the world would know about it, and I think Nick Fury would have acknowledged it in our earlier films."

"It was a tremendous challenge bringing together all of the various ideas and iterations of the Helicarrier that have occurred throughout Marvel history and creating a cohesive, plausible piece of military hardware that viewers could accept without their suspension of disbelief being pushed off the precipice," Chinlund said. "I think everyone involved was focused on making this 1,500-foot-long monster battle station look like something that looked like it could be sailing over Manhattan and not crashing to earth in a ball of badly designed flames. During our research, we looked at all sorts of historical/current/conceptual military vehicles, particularly naval vessels — the literal ships — and stealth aircraft, in addition to all of the versions from the Marvel pantheon. We tried to distill from these something that the fans would recognize as the iconic craft and people unfamiliar with the history could accept. I went through many forms and form changes with many different designers who all had a hand in the final product — but the key designer on the piece was Nathan Schroeder, who was elbow deep for several months helping bring the ship to life. Early on, we were excited about the idea of having an upper deck that was slightly higher than the lower deck, which would give us a dynamic space below the upper deck for staging action and also a plausible storage area. In the end, the carrier scaled out to approximately 1,300 feet long, roughly the size of a Nimitz-class aircraft carrier."

"The bridge of the carrier was the first set we started on, knowing that the ship would need a gathering place for all of the heroes," Chinlund said. "As the main command center of this massive battle station, I knew we would have to deliver a space sufficiently impressive. My biggest fear was that after the first look at the carrier, we would wind up in an interior space that didn't match its majesty. The design for most of the interior spaces was organized around the idea that all of the interior chambers on the ship were suspended from the decks — that the engines were lifting from the deck level, and that all of the spaces below were 'hanging' from the decks above. This involved an intricate series of pipes and hangers that ran throughout the ship. This helped us develop the architectural signature for the look of the ship. The struts and 'ribs' that are seen throughout all reference back to this original idea. On the bridge, this idea is most evident in the massive struts on either side of the main viewing window and at the back of the space by the Avengers' table. There is some artwork in *The Ultimates*, with Nick Fury at a giant viewing window that was incredibly inspiring to me. I felt that S.H.I.E.L.D., this international intelligence-gathering organization, should have the ultimate 'eye in the sky' — and Fury as its leader should have the catbird seat. So I decided to push the window a step further and have him standing on a porthole window actually looking directly down on the earth. Joss and I pushed around several different arrangements, where the porthole was in the middle of the set before landing on the final position where it is part of the larger viewing window. This presented an incredible engineering challenge that our construction coordinator, John Hoskins, executed flawlessly to create a seamless piece of glass that swept along these compound curves and could support the weight of an actor (and a camera and a dolly and...). In the end, we had the perfect spot for Fury to lead the team from."

Concept art by Nathan Schroeder and Steve Jung (insets).

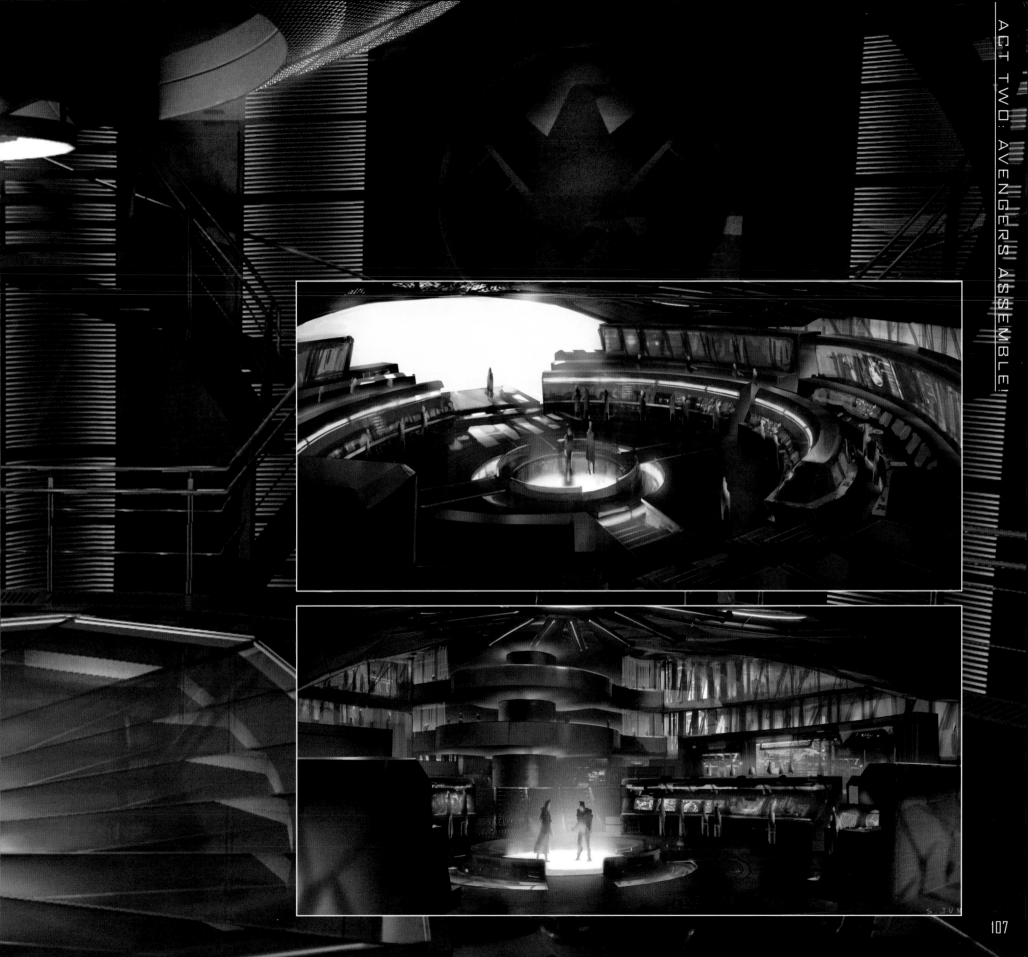

It's an amazing set, although it still wasn't completely 360 degrees as there was some green screen on the top and out the windows," Executive Producer Louis D' Esposito said. "When you walk on the set of that size, and you can see and feel the environment, the actors really appreciate it. Every cast and crew member who was on set was impressed when they saw it, and James Chinlund and his team did a fantastic job."

Steve Jung concept art with set photo.

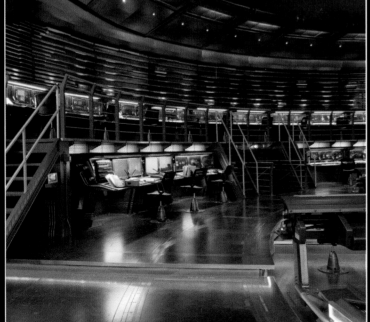

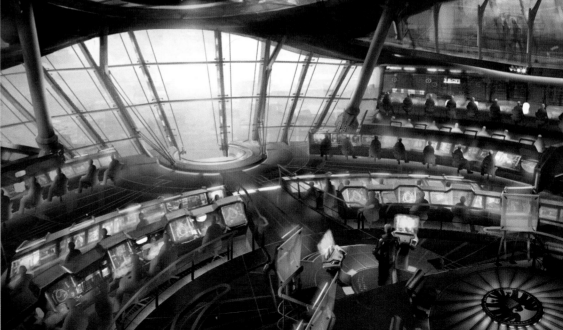

"It's such a beautiful set to work with," Director of Photography Seamus McGarvey said. "And Joss really wanted to explore the architecture of this set, as well as the placement with the lighting design. We also tried to give him as much freedom and movement as possible to accommodate all of the cast as they interacted on the Helicarrier. The set was predominantly lit with a lot of practical sources, a lot of LEDs and a lot of Kino Flo's. All of the technician areas are accented with lights on the consoles and a bit of architectural accents along the outer edges."

"The Bridge is a fantastic set conceived by James Chinlund and Steve Jung — a sprawling multi-leveled space with raised walkways, sunken command stations and hanging galleries," Concept Artist Nathan Schroeder said. "Because of the shape of the room — with its huge curved window, pitched upper gallery and problematic architectural conditions — many talented set designers spent countless hours bringing this set to completion."

Concept art by Nathan Schroeder and Steve Jung (inset). 109

Concept art by Steve Jung, Amanda Hunter (top inset)
and Nathan Schroeder (bottom inset).

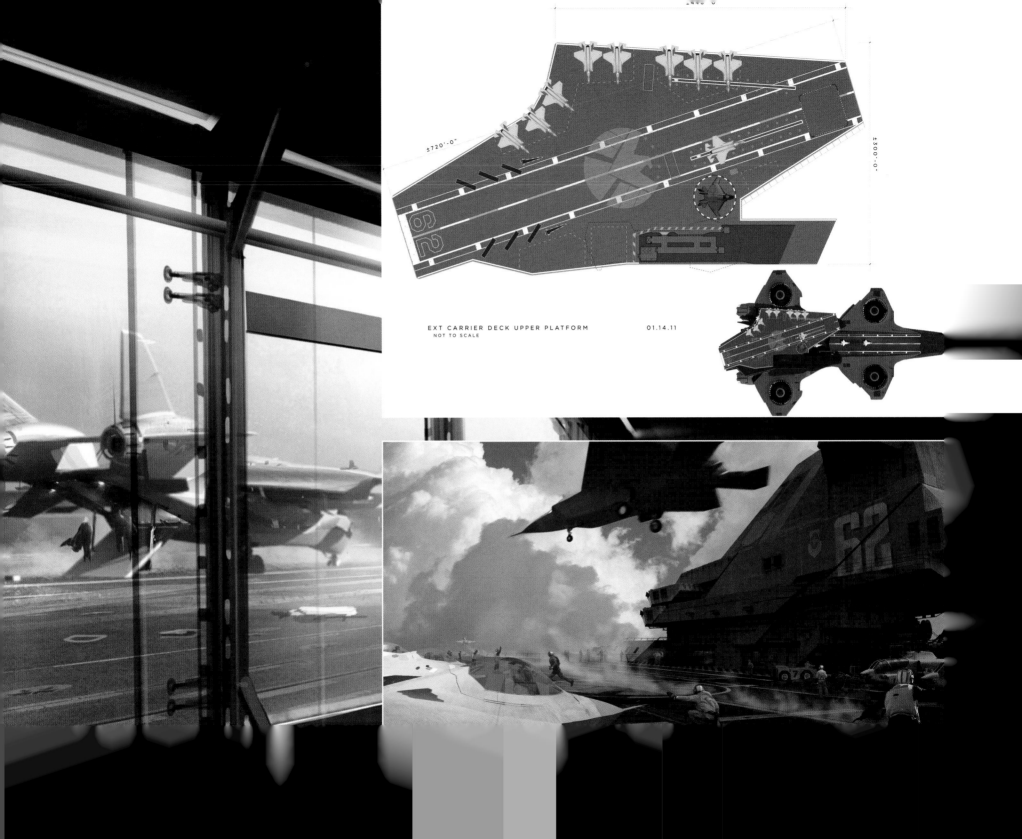

EXT CARRIER DECK UPPER PLATFORM

NOT TO SCALE

01.14.11

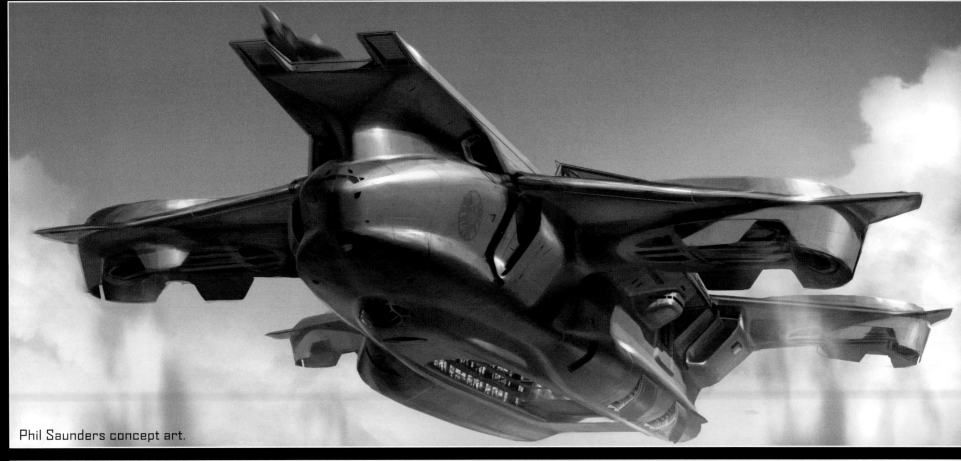

Phil Saunders concept art.

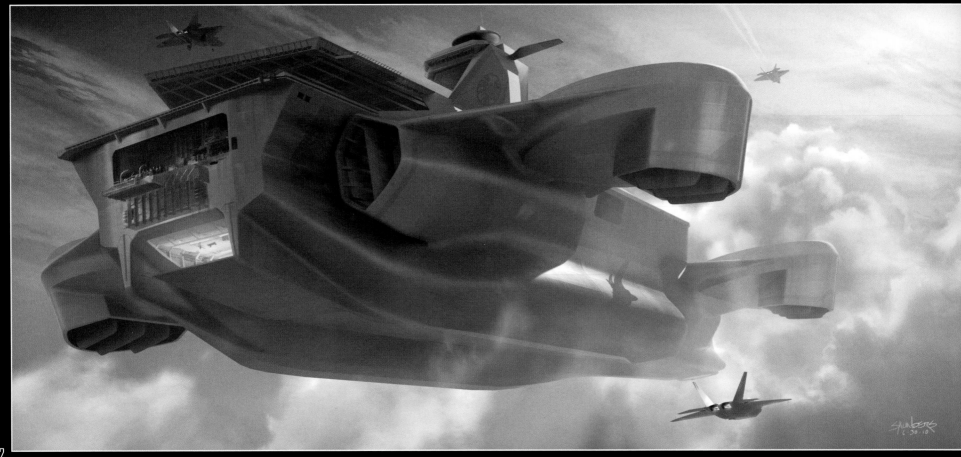

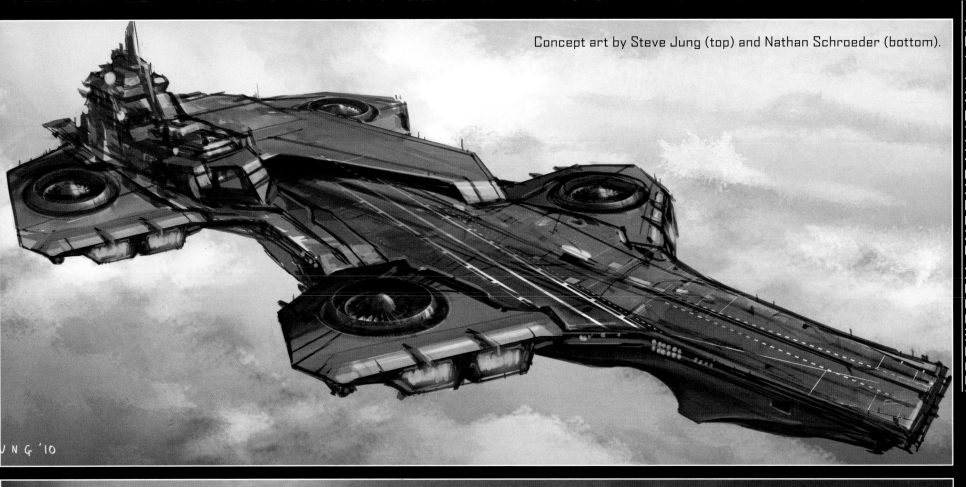

Concept art by Steve Jung (top) and Nathan Schroeder (bottom).

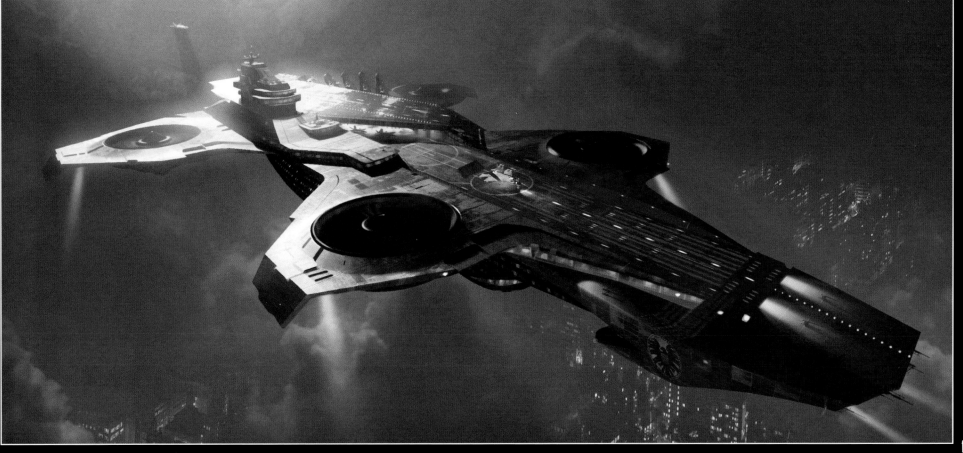

"There's already so much we're throwing at the audience with the idea of S.H.I.E.L.D., the idea of Loki and Thor in Manhattan, the idea of invading evil forces," Feige said. "So we can't just say, 'Oh and on top of that, this whole time there has been this large ship flying around in the sky keeping track of everything.' So we decided S.H.I.E.L.D. is a crisis-response team, and we should see the Helicarrier rise up out of the water in a big moment in the film."

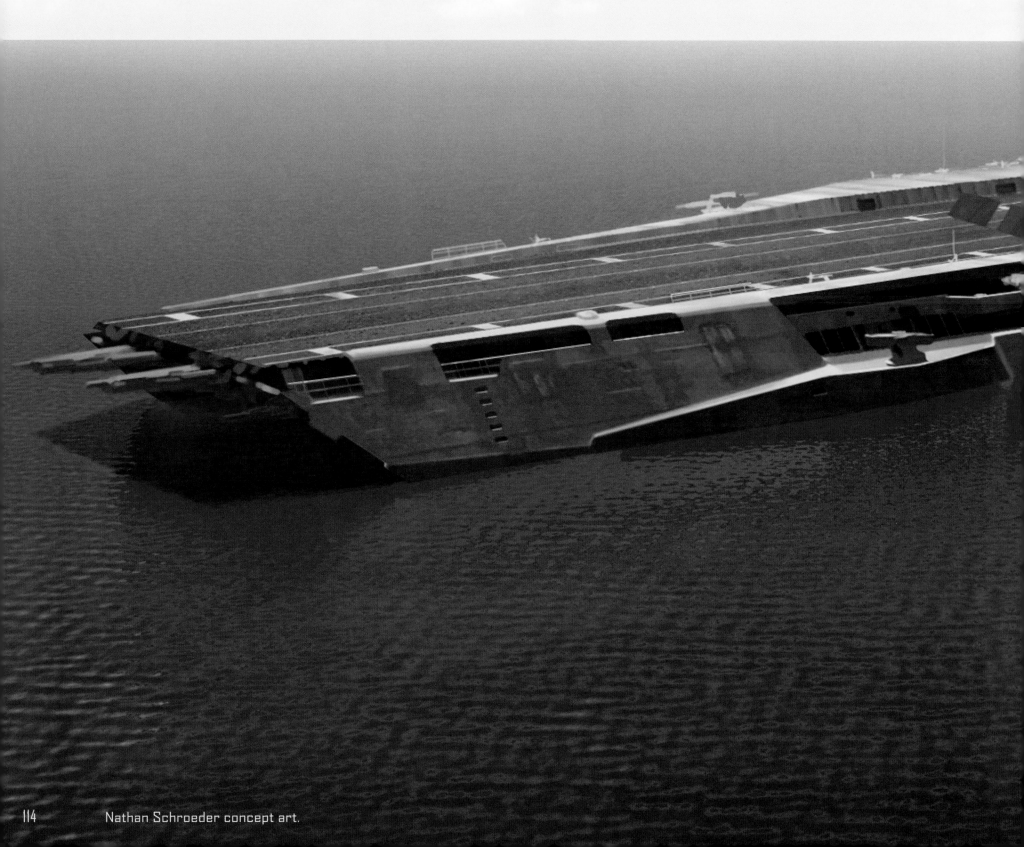

Nathan Schroeder concept art.

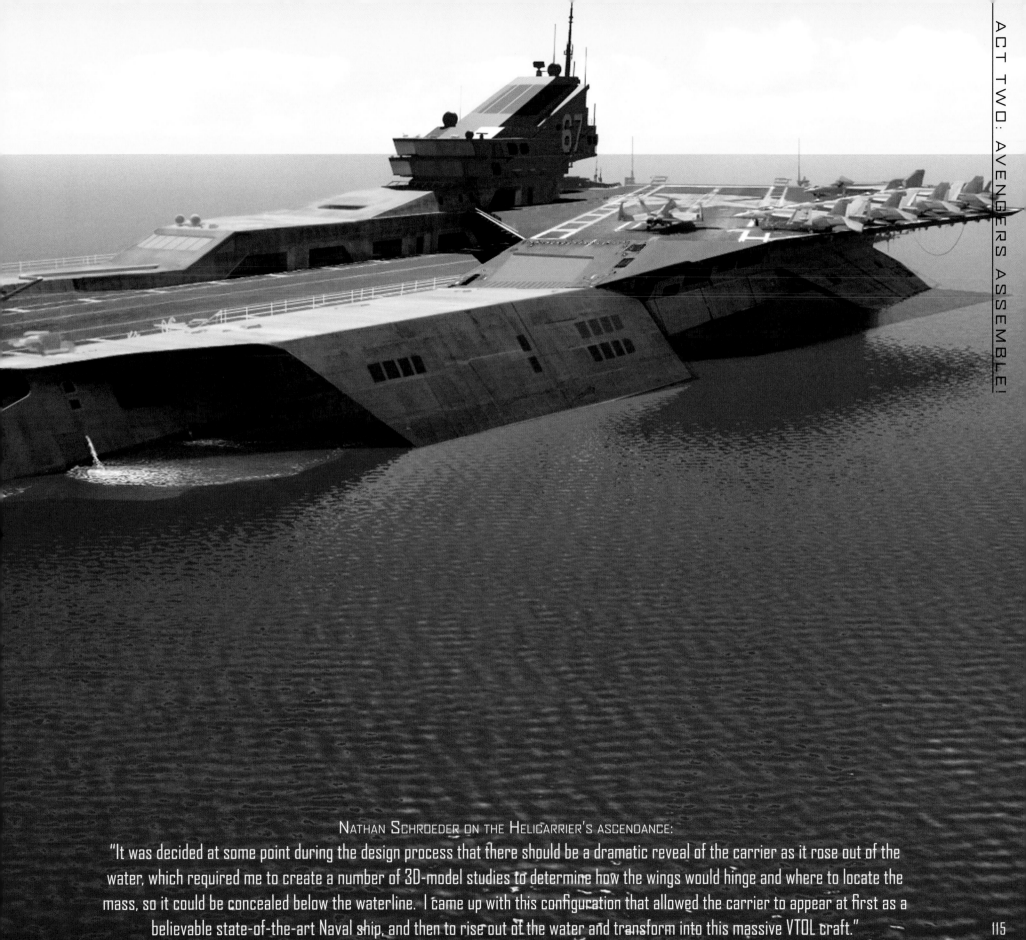

NATHAN SCHROEDER ON THE HELICARRIER'S ASCENDANCE:
"It was decided at some point during the design process that there should be a dramatic reveal of the carrier as it rose out of the water, which required me to create a number of 3D-model studies to determine how the wings would hinge and where to locate the mass, so it could be concealed below the waterline. I came up with this configuration that allowed the carrier to appear at first as a believable state-of-the-art Naval ship, and then to rise out of the water and transform into this massive VTOL craft."

"The Helicarrier was envisioned by James Chinlund to be a dramatic realization of futuristic technology that needed to satisfy a number of criteria: It should not be too dissimilar to current aircraft-carrier vernacular; it should be light enough to fly, but also strong and aggressive — with a nod to a design history rooted in the comic books, but also maintain an identity as a military vessel," Schroeder said. "While the topside of the ship coalesced rather quickly, the underside required much more attention. It needed to have the aesthetic of a nautical hull, and yet not appear too heavy to fly. The ship's bridge had to locate on the underside and correspond to the practical set built on stage. James had a vision of a great wishbone hallway that would be open to the sky and provide dramatic vistas from inside — and in a specific story beat, would allow for an airborne attack on the Medlab. The four massive vertical turbines were conceived to be of some sort of supercooled maglev technology — one of which becomes damaged in the story, necessitating a dramatic repair by Iron Man."

Nathan Schroeder concept art.

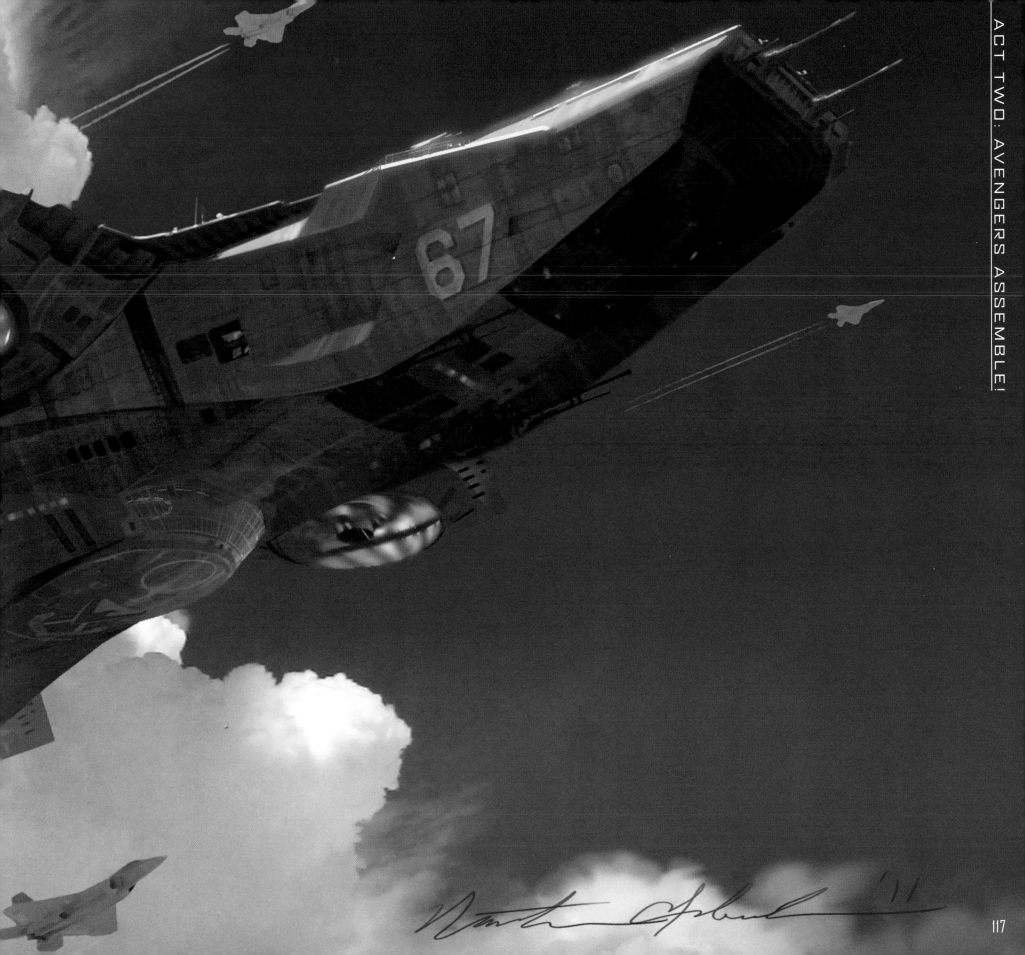

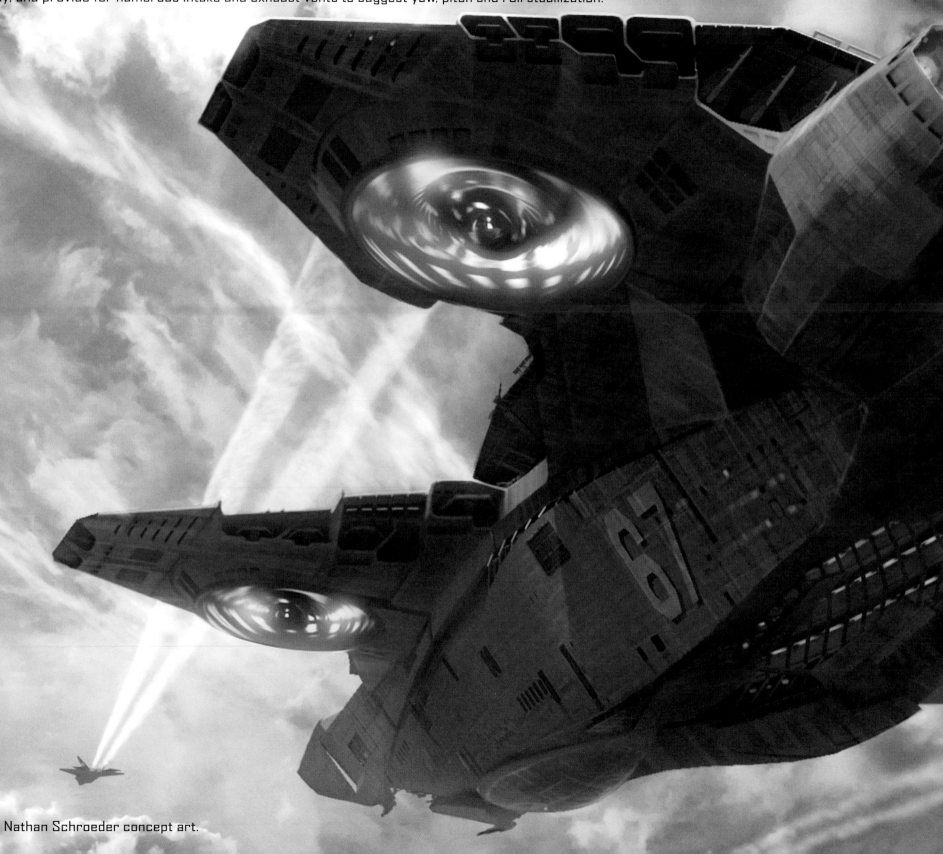

"The development of the stern was the most problematic and the last part of the ship's design to be fully refined, since it bore the burden of resolving a number of technical and design issues," Schroeder said. "We had to define the shape of the hull to both integrate the wishbone hallway and the lower hangar decks, and suggest a launch area for the Quinnjet, without leaving the ship feeling too open and vulnerable – note the moveable blast panels. We needed to properly locate and describe the massive engines that provided forward propulsion; aesthetically integrate the wings into the body; and provide for numerous intake and exhaust vents to suggest yaw, pitch and roll stabilization."

Nathan Schroeder concept art.

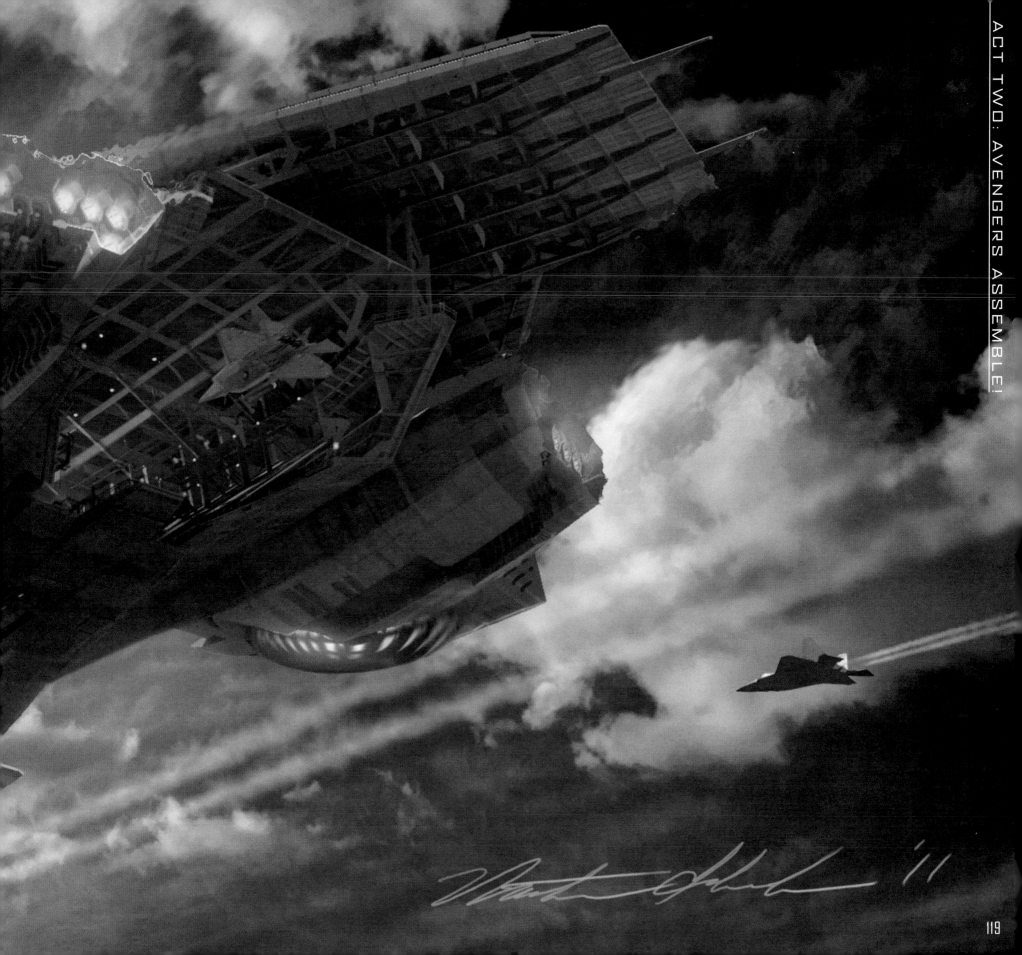

"We spent a lot of time trying to distill the essence of the Helicarrier from the various versions throughout the Marvel Universe," Chinlund said. "Ultimately, the goal was to create a ship that was simultaneously believable as a vehicle that might actually exist, and completely mind-blowing and overwhelming in its scale — a real challenge to say the least. At the end of the day, the main guideline was to create something that looked like it could fly, that could actually exist in today's military.

"The deck was executed at a closed airstrip at the Albuquerque International Sunport," Chinlund continued. "We built only a small portion of the conning tower, but it was critical to have a large runway area to match the footprint of the upper deck. It was truly mind-blowing standing on the runway and imagining the area of the total ship, a real monster. As with all of the interiors we built for the ship, we were trying to find the balance between an impressive space and scale, and something the audience could believe was actually flying through space."

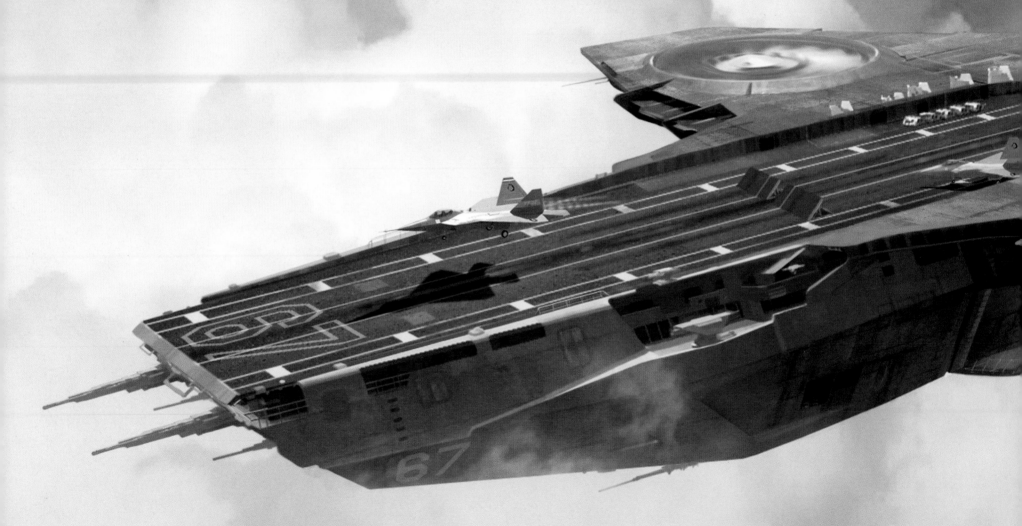

120 Nathan Schroeder concept art.

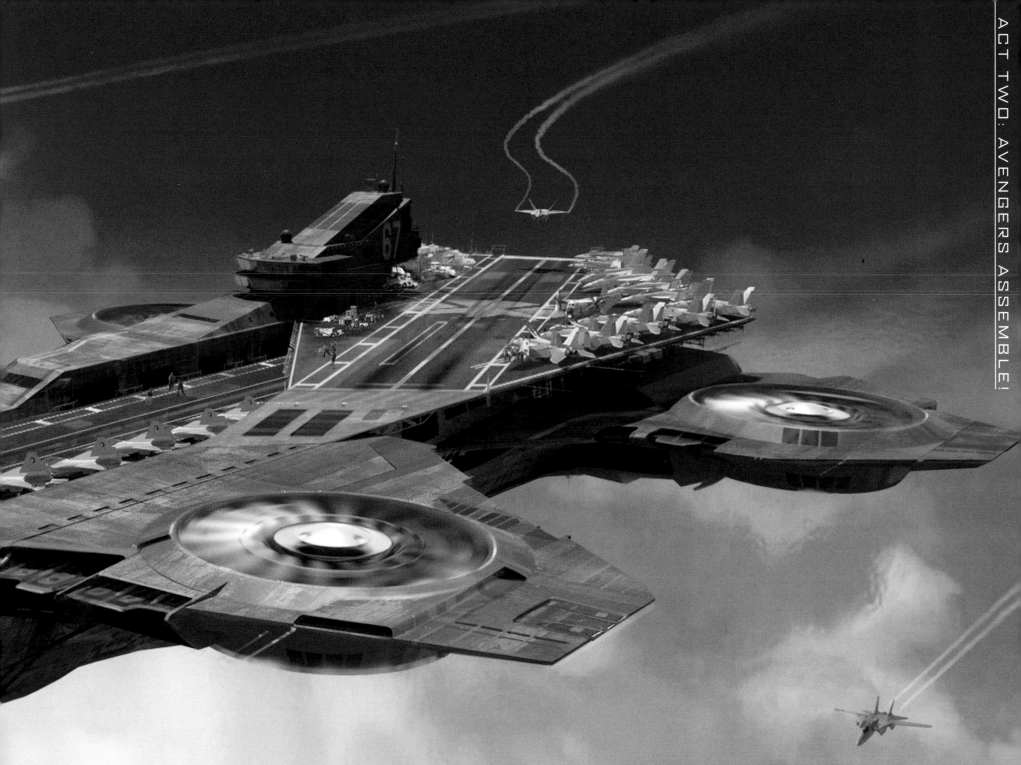

"From the beginning, James Chinlund had some very specific ideas about the ship's configuration, and I was originally tasked with developing those ideas," Schroeder said. "The final design of the carrier proved to be an exhaustive process, during which a number of talented artists explored various alternatives. Ultimately, though, we came back to a concept very close to James' original vision as illustrated here – with split launch decks, turbines mounted on wings and an asymmetrical control island. We were also quite liberal in referencing contemporary carrier-deck layout and detail, so that the audience would willingly accept the ship as a plausible vehicle."

'11

Christopher Ross computer models of the weapon S.H.I.E.L.D. has been developing to combat a potential Asgardian threat in the wake of the events of *Thor* (2011).

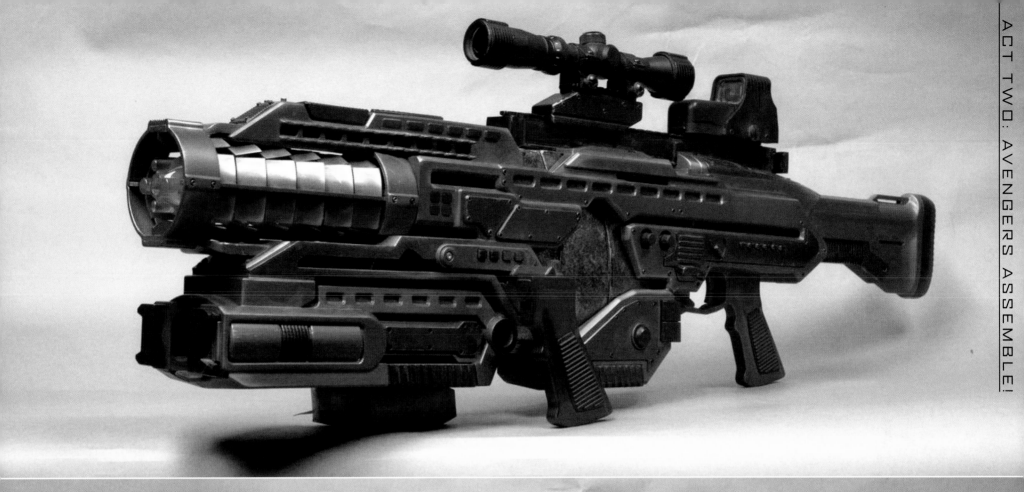

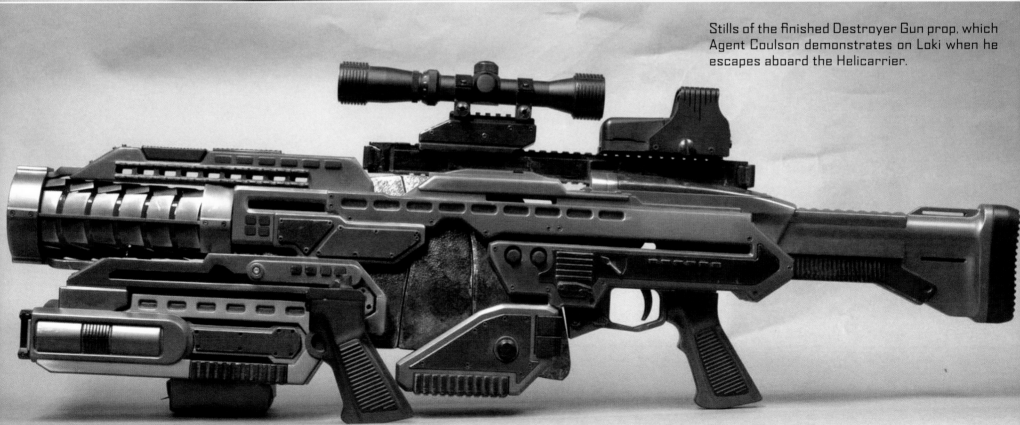

Stills of the finished Destroyer Gun prop, which Agent Coulson demonstrates on Loki when he escapes aboard the Helicarrier.

CAPTAIN AMERICA'S READY ROOM

"I had designed all three of Cap's costumes in *The First Avenger*," Visual Development Supervisor Ryan Meinerding said. "The hero costume for that film was directly focused on trying to blend the comic version of his costume with a tough-looking soldier's war uniform. We were trying to preserve as much of the icon as we could while still hitting things that hit an athletic soldier archetype. The task for Cap's *Avengers* costume was very different. It was a very unique challenge in a comic-book movie. Most characters' costumes don't change that much from movie to movie — but Steve wakes up 70 years in the future, and we needed the suit to visually represent this time passing. I was excited to try and make the *Avengers* costume feel like something very different than the World War II costume. Joss was very interested in a much more tight-fitting costume than the World War II version, and the result was a very lithe silhouette. With the World War II suit, we had started with the baggier uniforms of the period and slimmed them down. But with the *Avengers* suit, we started with a skintight suit and added bulk where we could. Because we weren't tied to hitting as much of the 'soldier' archetype, it allowed us to stay a little closer to his comic look as well. We changed his boots and gloves to red, and lost some of the military webbing from the World War II suit. We took some of the visual cues from the *Ultimates* costume, and then worked them into Cap's original Kirby costume. The few nods to a sense of practicality were the soldier's pouches on his belt, and turning the top of the costume into a jacket and his cowl into a helmet."

Ryan Meinerding concept art.

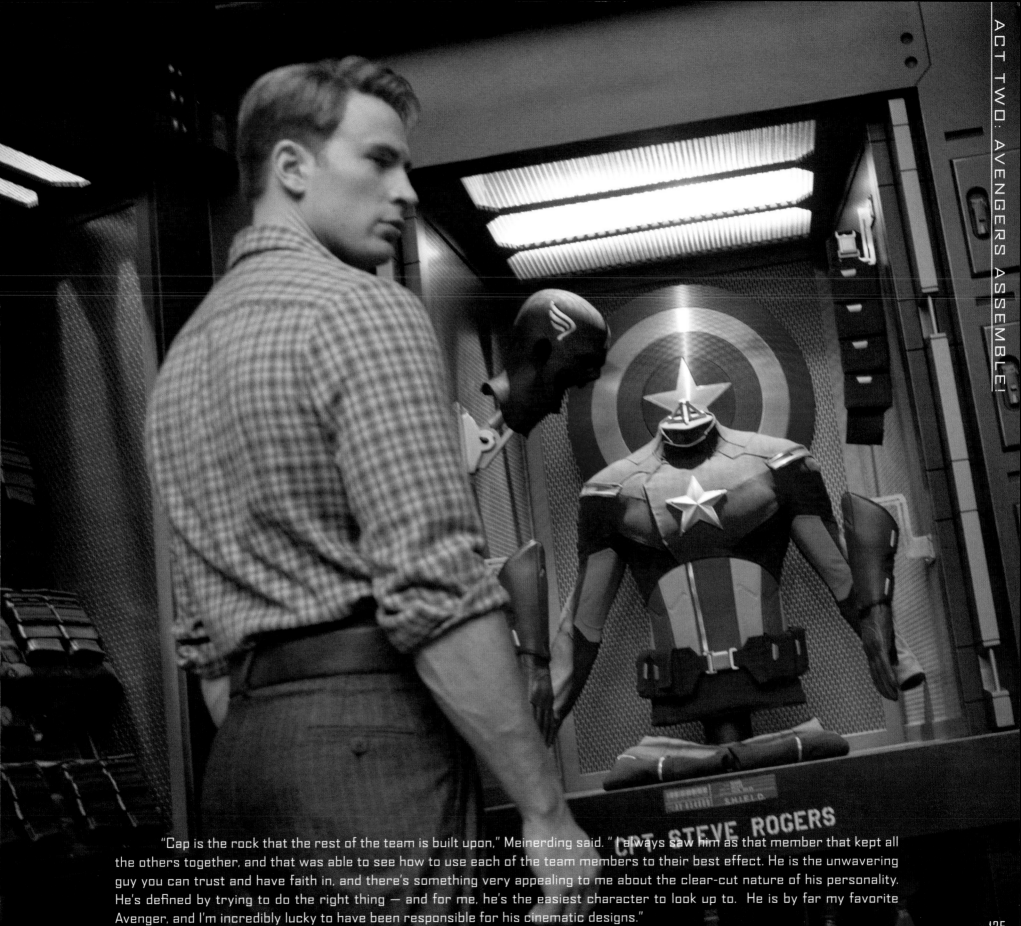

CPT. STEVE ROGERS

"Cap is the rock that the rest of the team is built upon," Meinerding said. "I always saw him as that member that kept all the others together, and that was able to see how to use each of the team members to their best effect. He is the unwavering guy you can trust and have faith in, and there's something very appealing to me about the clear-cut nature of his personality. He's defined by trying to do the right thing — and for me, he's the easiest character to look up to. He is by far my favorite Avenger, and I'm incredibly lucky to have been responsible for his cinematic designs."

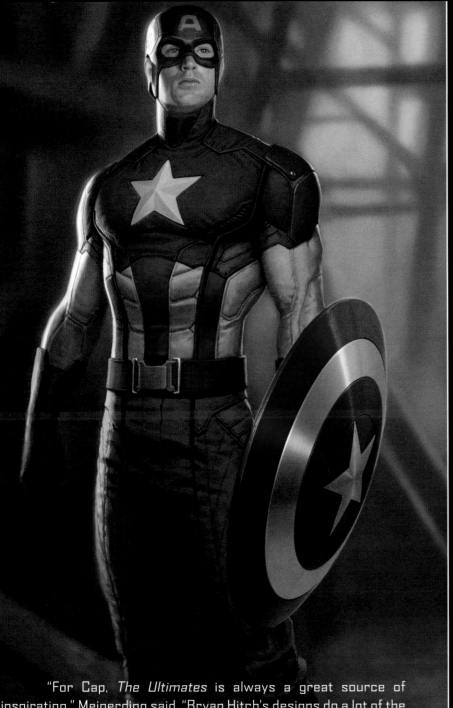

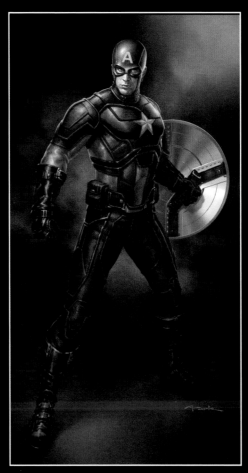

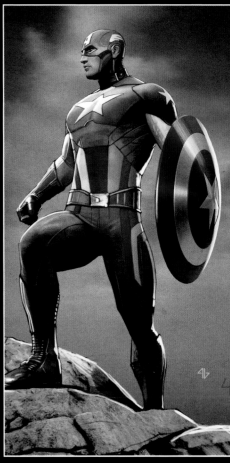

"For Cap, *The Ultimates* is always a great source of inspiration," Meinerding said. "Bryan Hitch's designs do a lot of the same things that we try and do: add 20 percent more reality to the classic costumes. We were trying to combine those practical concepts with the classic Kirby Cap.

"The best research is usually to reread some of the comics," Meinerding continued. "I reread *The Ultimates* and the *Captain America Omnibus* that features Ed Brubaker's run. There are a lot of great Cap moments in each volume. From a practical costume-design point of view, we looked at a lot of military clothes that are commercially available. There are undershirts and cargo/military pants being designed for military applications that are fantastic sources of inspiration for a group like S.H.I.E.L.D. or for a costume like Cap's."

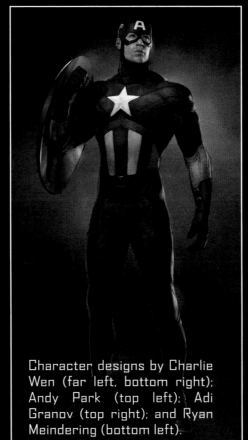

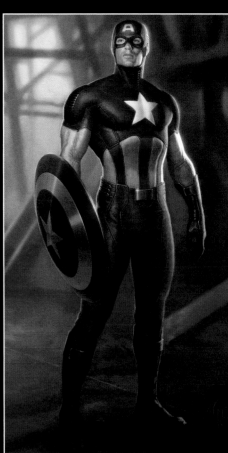

Character designs by Charlie Wen (far left, bottom right); Andy Park (top left); Adi Granov (top right); and Ryan Meindering (bottom left).

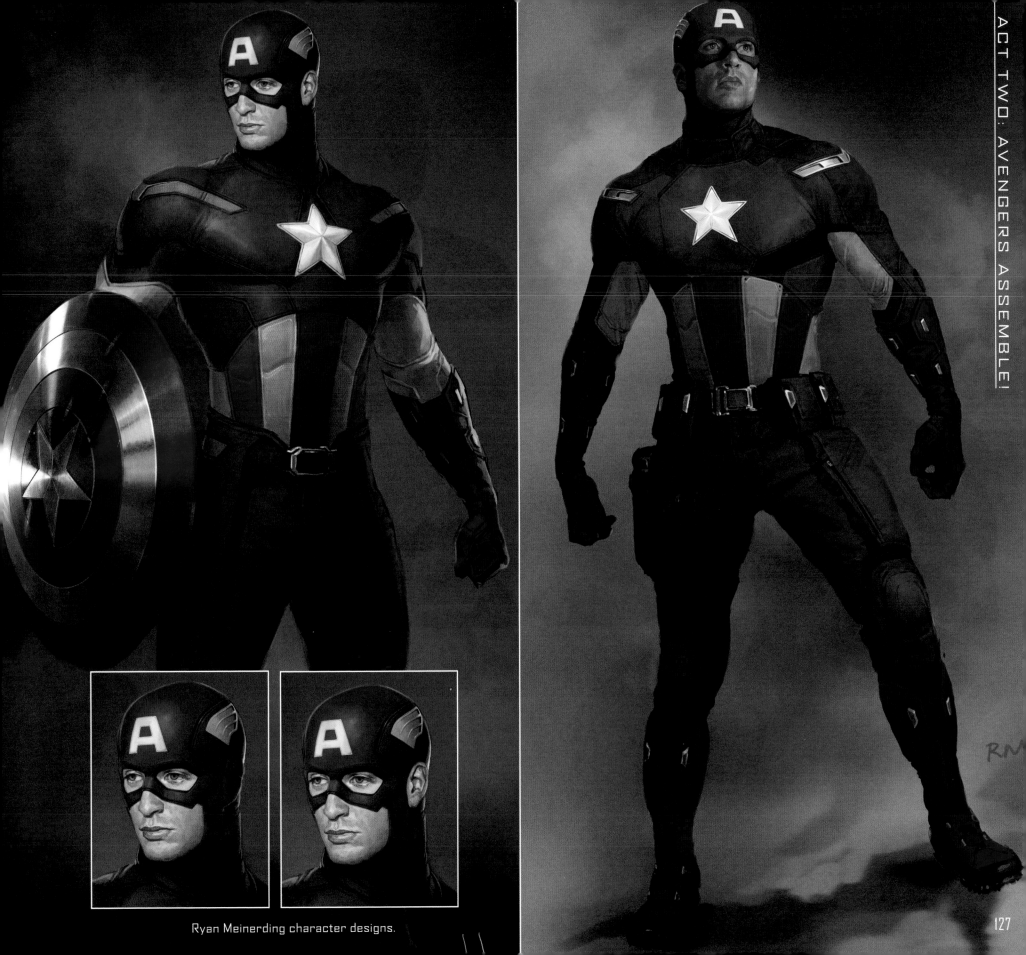

Ryan Meinerding character designs.

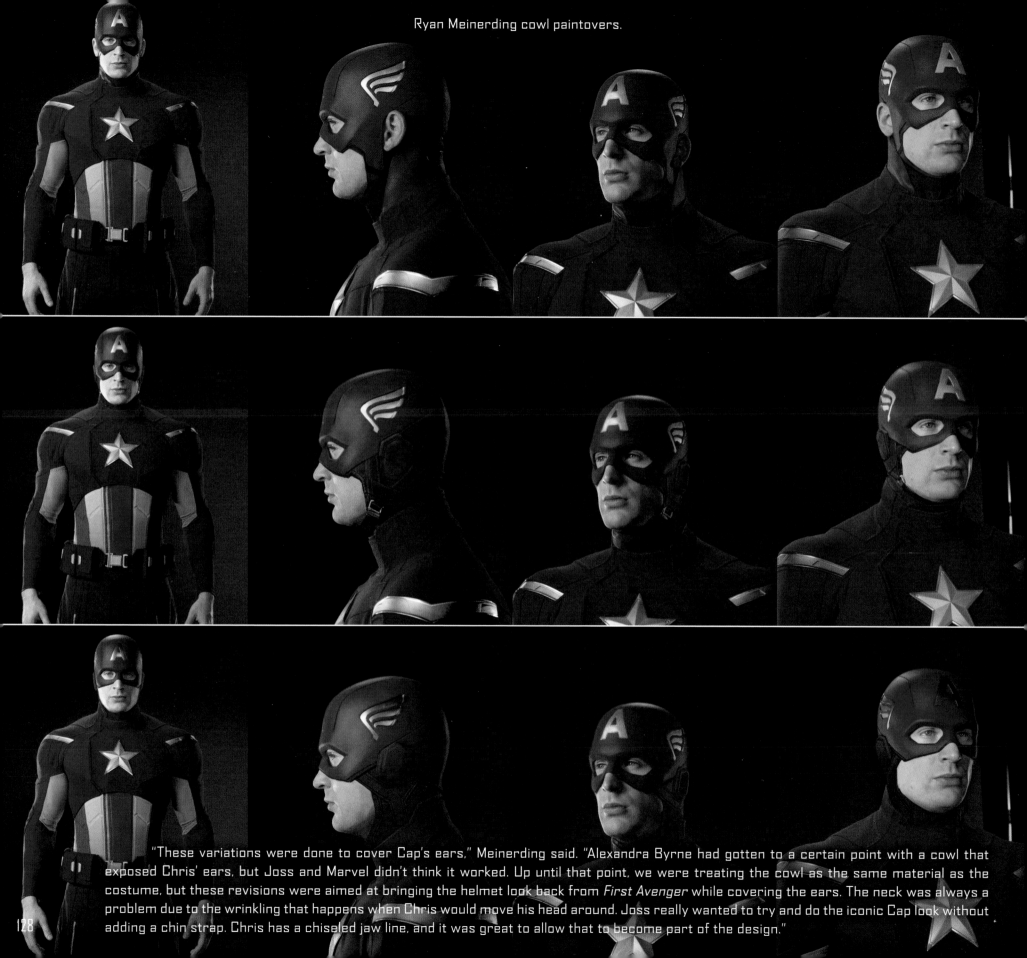

"These variations were done to cover Cap's ears," Meinerding said. "Alexandra Byrne had gotten to a certain point with a cowl that exposed Chris' ears, but Joss and Marvel didn't think it worked. Up until that point, we were treating the cowl as the same material as the costume, but these revisions were aimed at bringing the helmet look back from *First Avenger* while covering the ears. The neck was always a problem due to the wrinkling that happens when Chris would move his head around. Joss really wanted to try and do the iconic Cap look without adding a chin strap. Chris has a chiseled jaw line, and it was great to allow that to become part of the design."

Captain America costume is that all the latest S.H.I.E.L.D. technology would be available," Byrne said. "And unlike the 1940s, this includes the potential of stretch fabrics. We wanted to keep the influence of military clothing. I referenced some current tactical samples and prototypes; there are some very sophisticated design solutions to both practical and protective requirements. The biggest challenge on *The Avengers* was how to deliver each individual super hero, but also a coherent lineup of heroes able to relate and converse. Any one of the heroes designed in isolation may well have looked different."

Evans said of Cap's new look. "The first outfit had more of a utilitarian feel. It was something that would actually serve a purpose in battle. It looked like you could actually wear it in World War II and get away with it. The current costume has more of a comic-book feel and looks like it came out of *The Ultimates*."

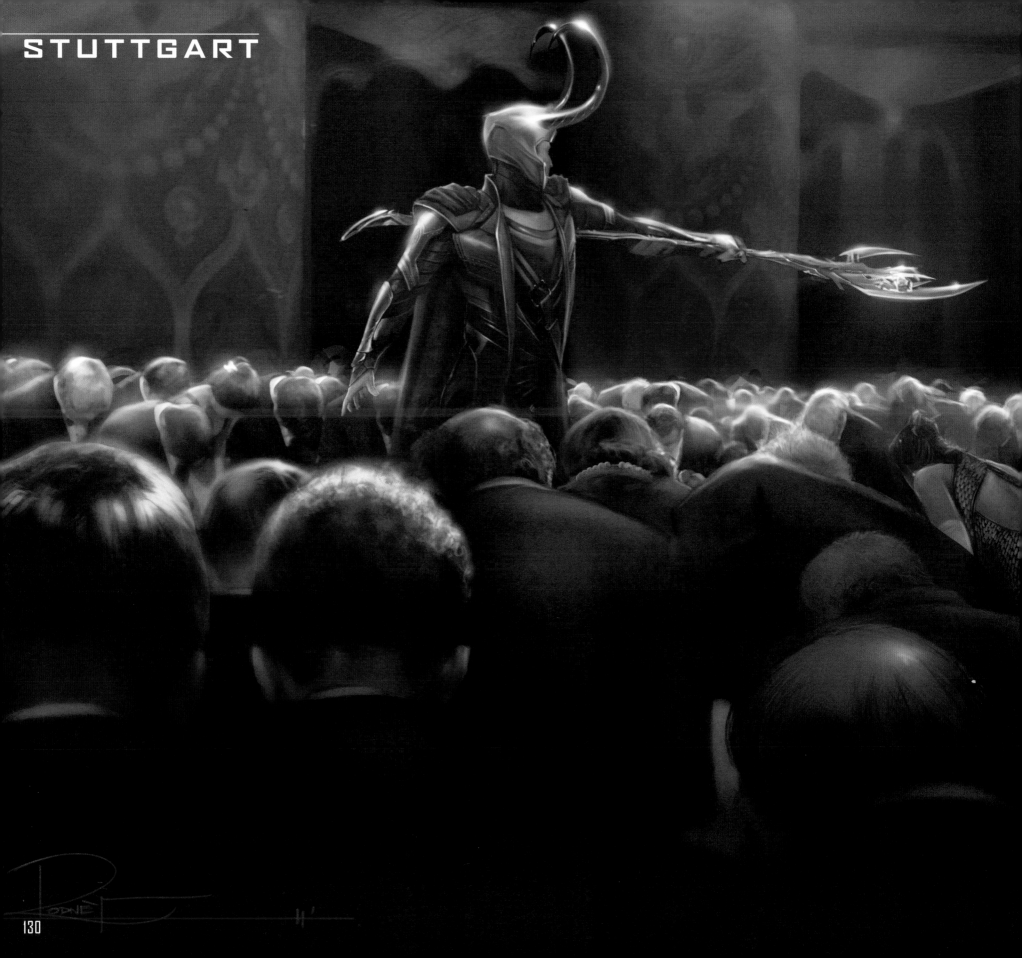

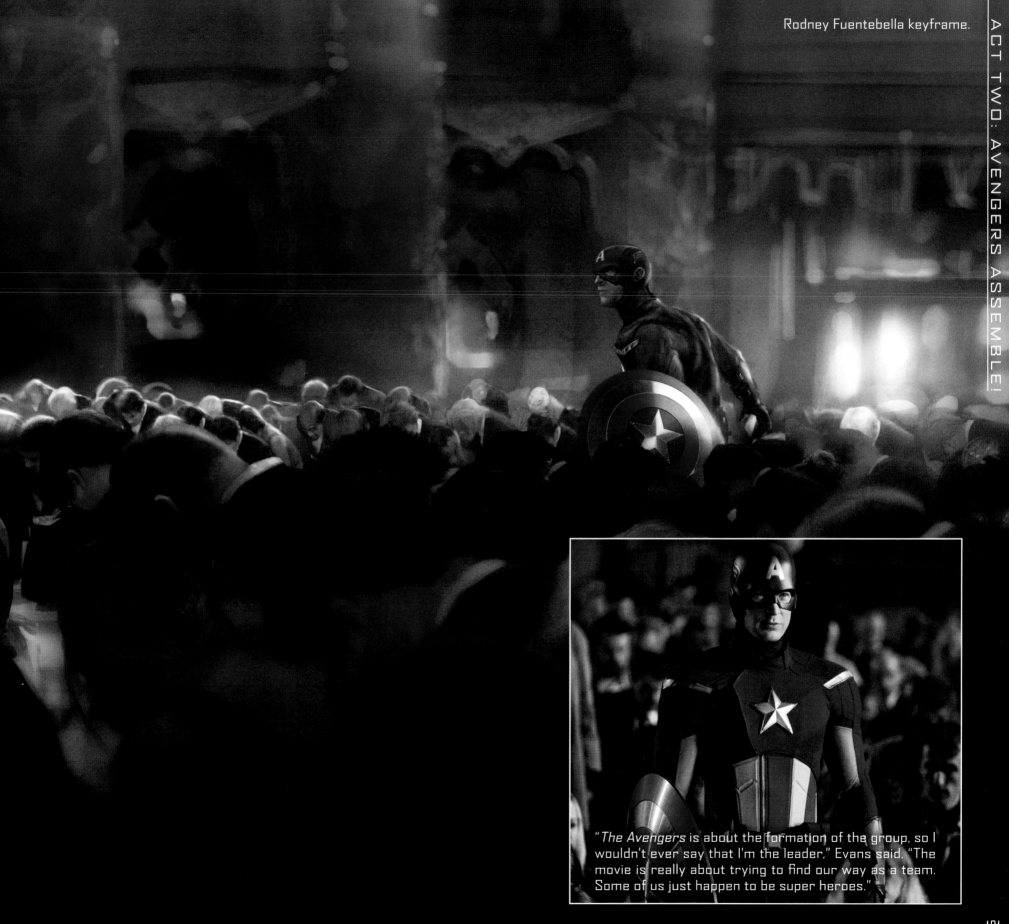

"*The Avengers* is about the formation of the group, so I wouldn't ever say that I'm the leader," Evans said. "The movie is really about trying to find our way as a team. Some of us just happen to be super heroes."

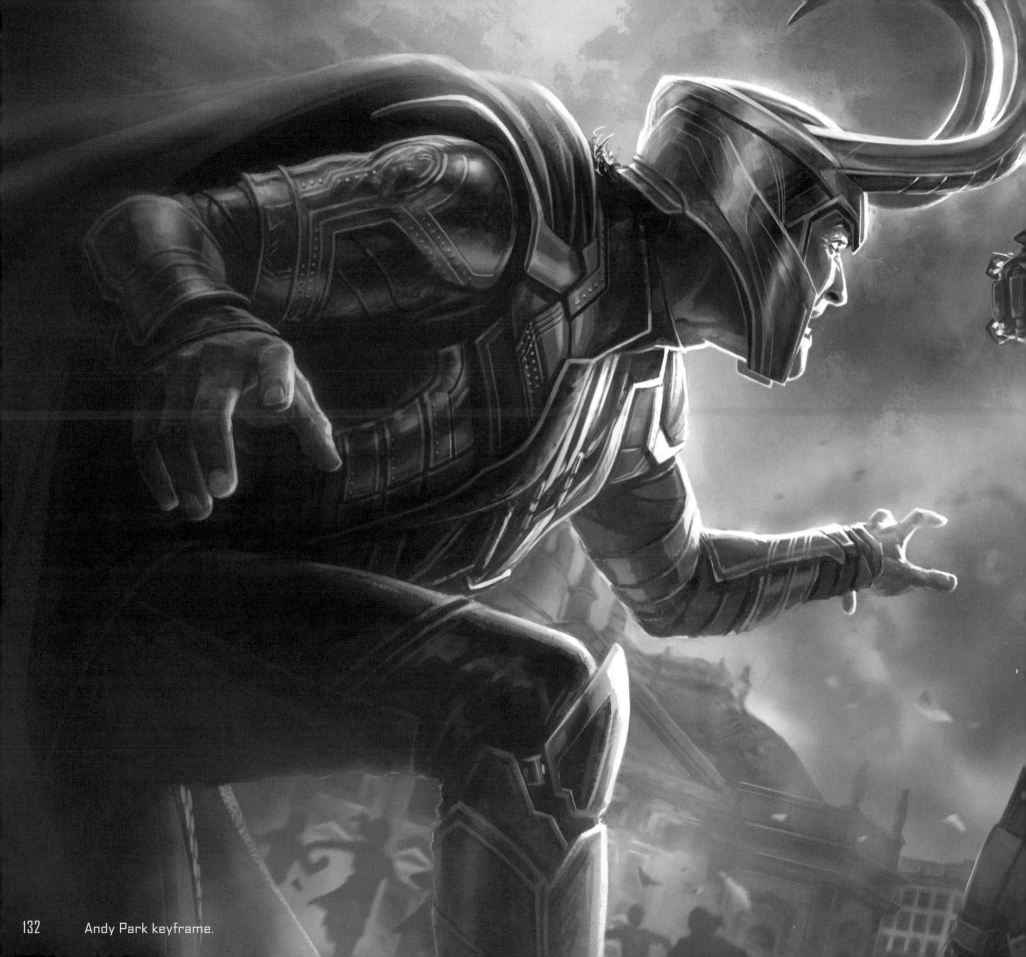

Andy Park keyframe.

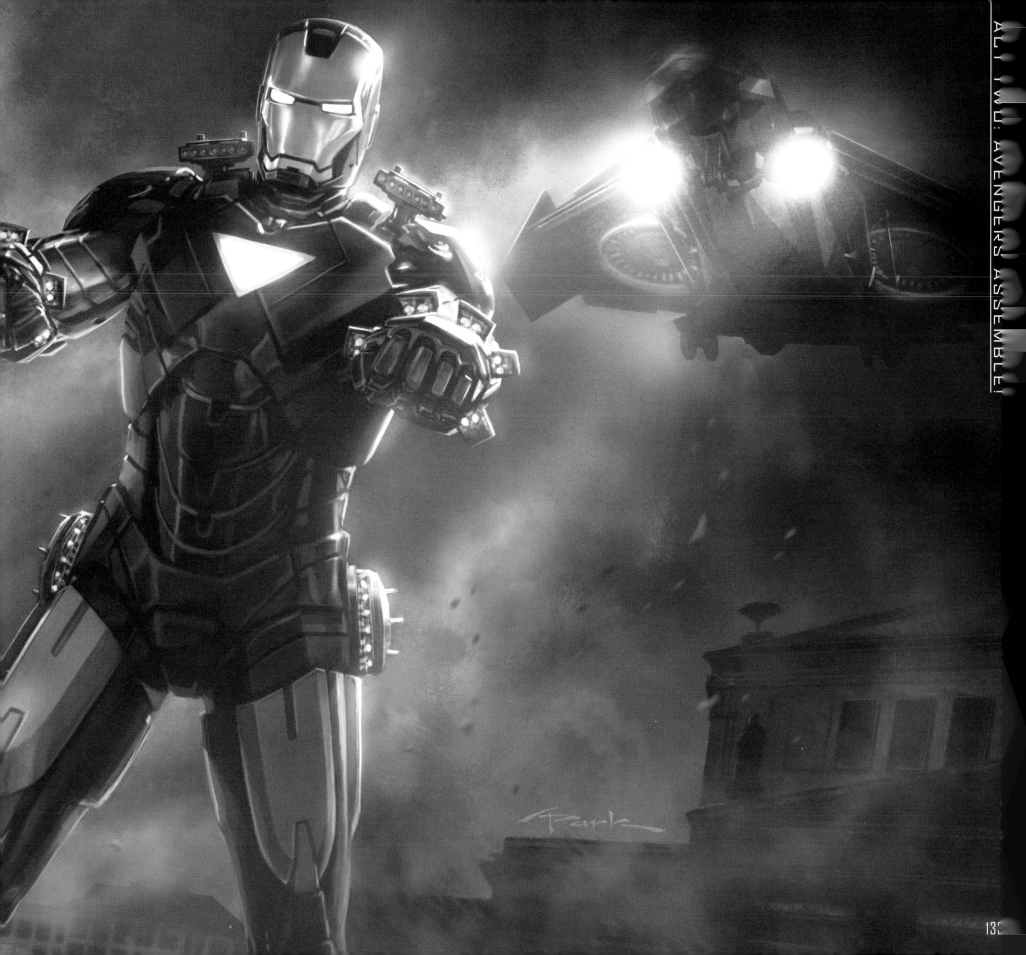

THOR

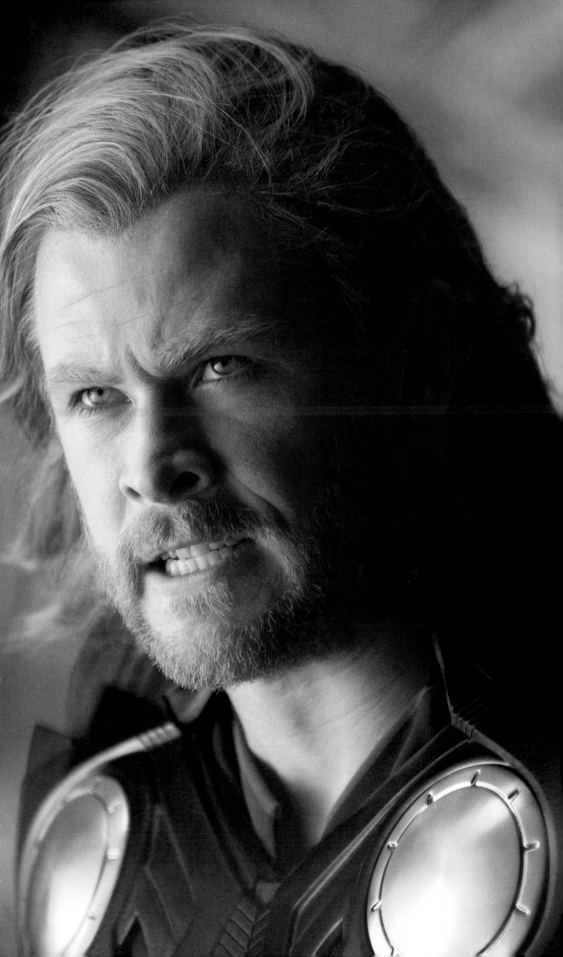

The God of Thunder returns to the Earth he swore to protect at the end of *Thor* (2011) to thwart another attack by his wayward adopted brother. The stakes are decidedly higher this time, as the Avengers and the rest of the world are about to discover, with an alien invasion force replacing the solitary Destroyer that Loki sent to kill a then-mortal Thor the last time the brothers came to blows. But even in the wake of Loki's deceit and betrayal, Thor remains conflicted. He is clearly torn between the human beings for whom he feels a deep compassion and kinship thanks to his time among them; and a stubborn, almost involuntary loyalty to and familial bond with Loki — whom Thor still considers an Asgardian, even now. This cosmic sibling rivalry sets the two brothers on a collision course that inevitably will play out on an earthly battlefield, with the fate of a planet hanging in the balance.

"I think Thor has more of a personal investment in what's happening than the other super heroes because Loki is his brother," Chris Hemsworth said. "Loki isn't just some bad guy he needs to take care of. For Thor, the problem the Avengers are facing is a member of his family. And I think his attitude in the beginning is, 'I'll take care of this and teach him a lesson.' Of course, the bigger conflict for him is that he's trying to protect the greater good, but he has some deep questions about what is going on with his brother. 'Why is Loki doing what he's doing?' This is the first time that Thor has seen Loki since the last movie. He sees his brother again, and it's against the backdrop of this chaos, and there are a bunch of feelings that come up."

One challenge the filmmakers faced early on was humanizing the God of Thunder. "The reason we cast Chris Hemsworth is we didn't want Thor to just be a one-dimensional, Adonis-like character," Kevin Feige said. "What makes a character a Marvel character is you can relate to them, and recognize your own flaws and struggles in the character's flaws and struggles. In *Thor*, the character has to earn the lesson of humility, and Chris was able to bring that in a very likeable way despite the fact that he comes from another world."

As the son of Odin has evolved from *Thor* to *Marvel's The Avengers*, so has his costume. "Visually, this is led by story and character," Alexandra Byrne said. "I also had the advantage of having worked closely with Chris and Tom through one production, and could capitalize on what I learned from them both in performance and movement. There was also benefit in what I learned through building the costumes for *Thor*. The costumes are very complex, and there were inevitably decisions and building choices that I wanted to refine. It can be that an early technical decision impacts time and time again through the building process — and although it was the right decision at that point in the process, as the costume comes near completion, a better solution becomes obvious. It could be as simple as where to place a zipper, or where to make an articulation in a piece of armor."

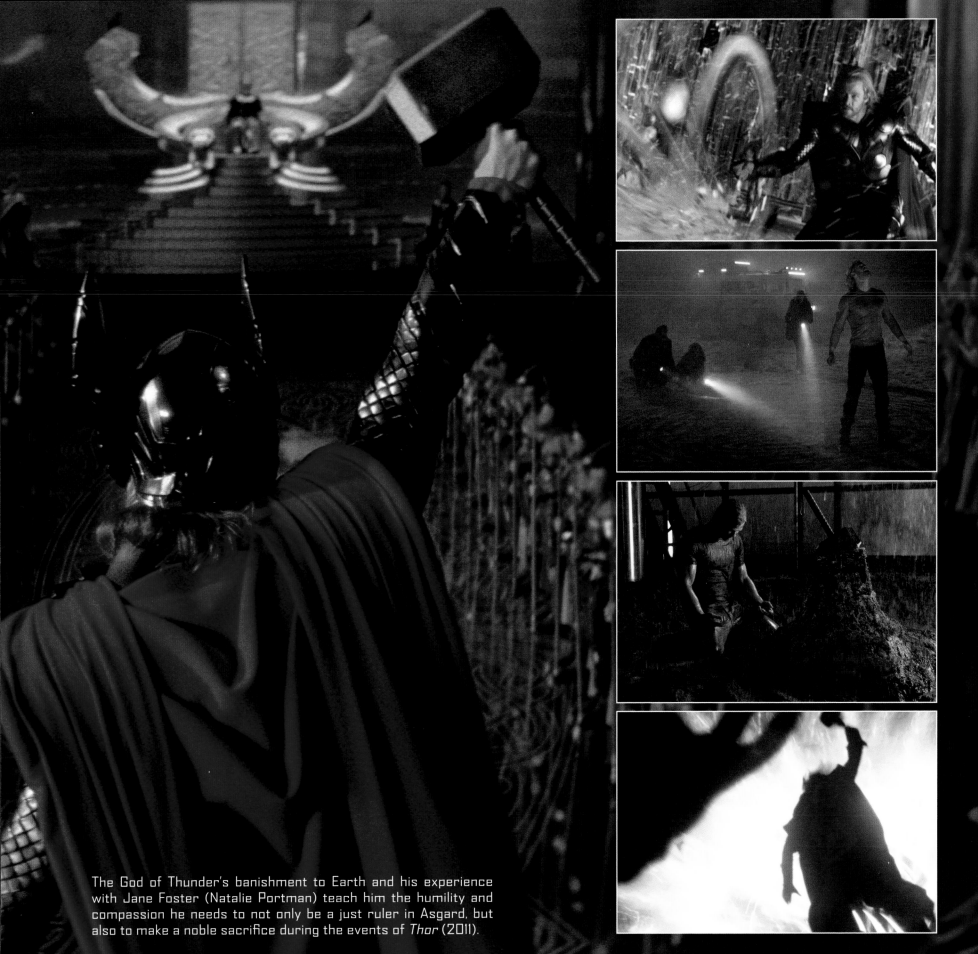

The God of Thunder's banishment to Earth and his experience with Jane Foster (Natalie Portman) teach him the humility and compassion he needs to not only be a just ruler in Asgard, but also to make a noble sacrifice during the events of *Thor* (2011).

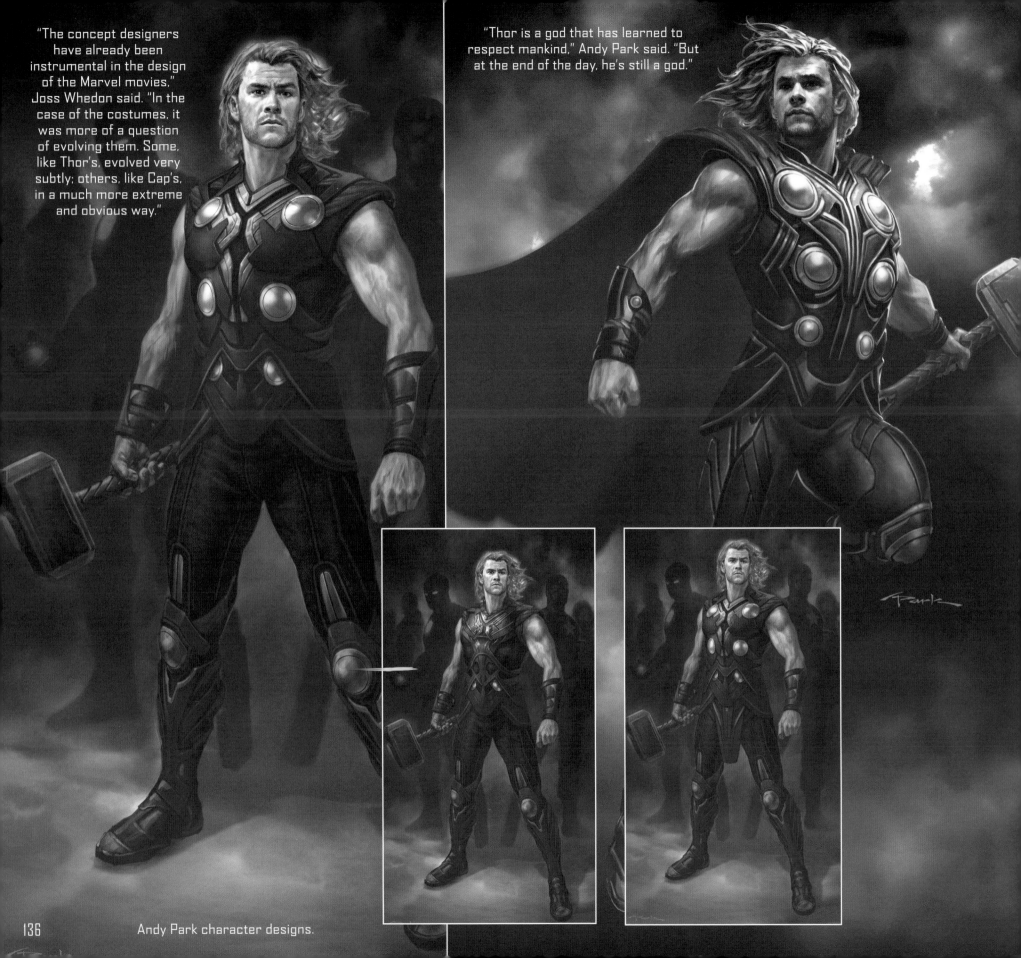

"The concept designers have already been instrumental in the design of the Marvel movies," Joss Whedon said. "In the case of the costumes, it was more of a question of evolving them. Some, like Thor's, evolved very subtly; others, like Cap's, in a much more extreme and obvious way."

"Thor is a god that has learned to respect mankind," Andy Park said. "But at the end of the day, he's still a god."

Andy Park character designs.

Charlie Wen character designs.

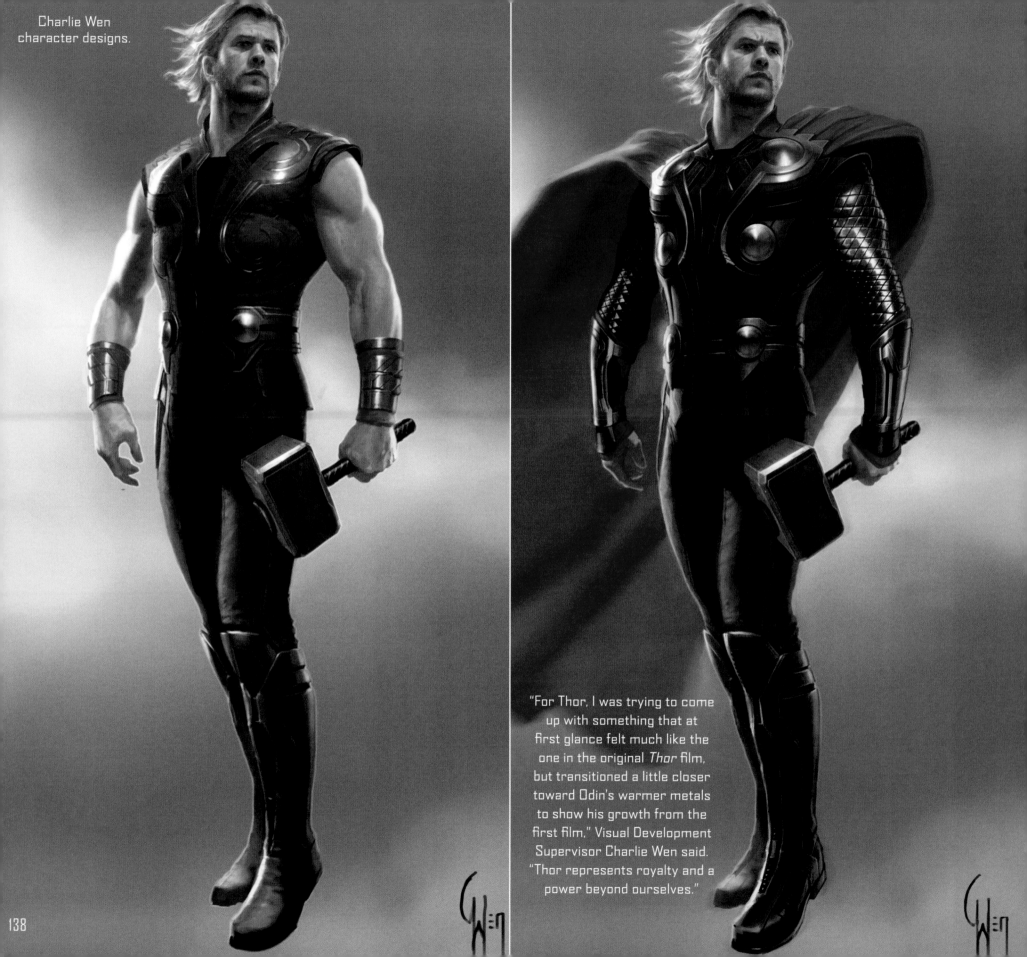

Charlie Wen
character designs.

"For Thor, I was trying to come
up with something that at
first glance felt much like the
one in the original *Thor* film,
but transitioned a little closer
toward Odin's warmer metals
to show his growth from the
first film," Visual Development
Supervisor Charlie Wen said.
"Thor represents royalty and a
power beyond ourselves."

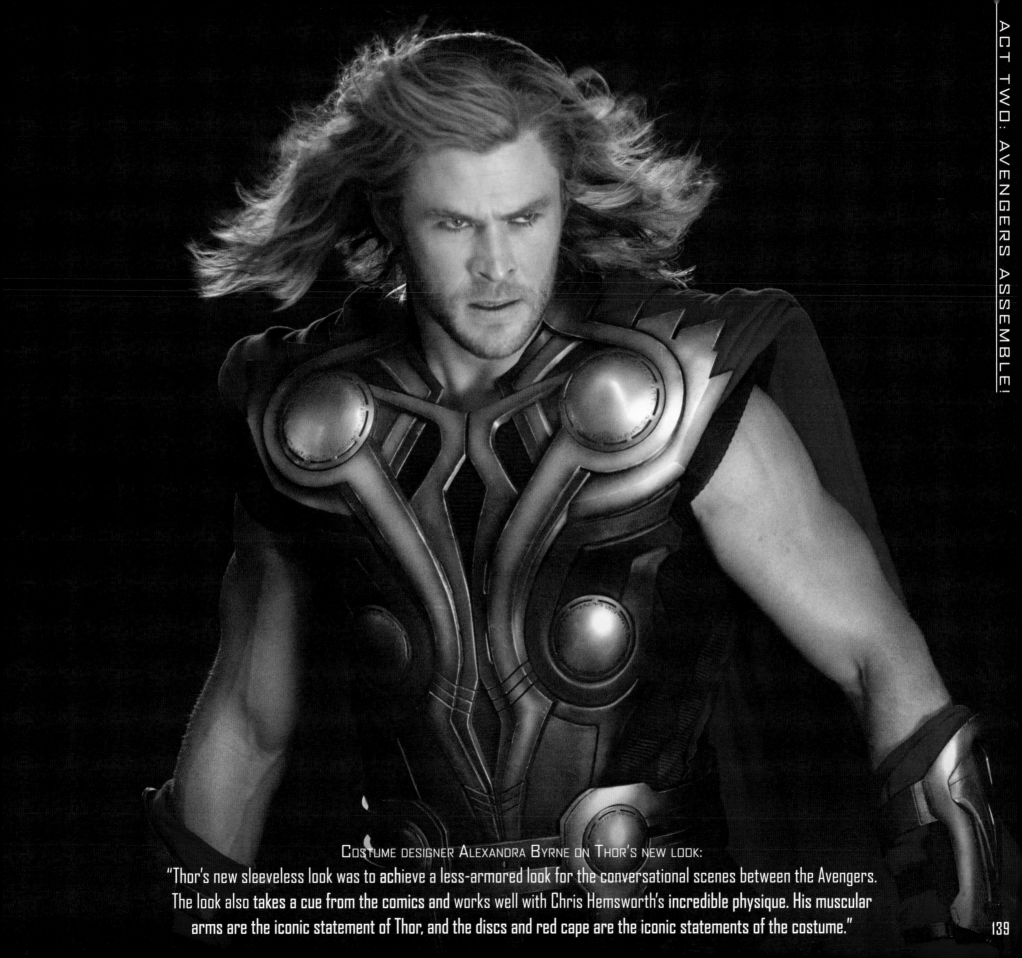

Costume designer Alexandra Byrne on Thor's new look:
"Thor's new sleeveless look was to achieve a less-armored look for the conversational scenes between the Avengers. The look also takes a cue from the comics and works well with Chris Hemsworth's incredible physique. His muscular arms are the iconic statement of Thor, and the discs and red cape are the iconic statements of the costume."

BATTLE IN THE WOODS: STORYBOARDS

"The fight is spectacular, and it's also quite funny because Tony Stark is having a lot of fun messing with Thor and the outfit he's wearing," Louis D'Esposito said. "So he's not only jabbing him with repulsor technology — he's also taking verbal jabs at him, as well. Captain America arrives and tries to convince them that they shouldn't be fighting."

Unimpressed by the super-soldier's appeal to reason, Thor brings down his hammer on Cap's shield — creating a shockwave that levels the mountaintop and surrounding forest.

"Thor arrives a little late to the party after the Avengers have captured Loki, and he tears the place apart, grabs Loki and disappears," Chris Hemsworth said. "Once they get to the mountaintop, he attempts to have a heart-to-heart with Loki. But that doesn't end well. And Iron Man shows up, and they're feeling each other out in an incredibly aggressive way. Thor is surprised by the strength of Iron Man and Captain America's shield, and it ends up being a pretty epic battle that basically wipes out the entire mountaintop and forest."

Shooting the battle in the woods also marked the first big fight scene for Chris Evans in the film — and the first time he saw Robert Downey Jr. and Chris Hemsworth in full costume as Iron Man and Thor. "We were shooting nights on this beautiful wooded mountaintop, and Iron Man and Thor are duking it out; Captain America being the peacekeeper that he is tries to break them up," Evans said. "It was the first time I saw Chris Hemsworth in his full costume with the long red cape, which was impressive. I was looking at him and thinking, 'Damn, the God of Thunder is standing right next to me. That's pretty cool.' And then Robert Downey walks onto set in his full Iron Man armor, and I am talking to him and thinking, 'Is this really happening? Because this is beyond cool.' Suddenly, the Captain America outfit that I was wearing felt much better on me standing next to these guys. It was one of my favorite moments on the production."

Rodney Fuentebella keyframe with production still.

EXT. QUINJET — NIGHT

The clouds are thick and textured, lightning
highlighting sections of them. We move towards the jet
from above…

He lands on top of the jet — a blur of feet and hands
scrambling for purchase.

INT. QUINJET — CONTINUOUS

Everyone is jolted by the bump from above —

EXT. QUINJET — CONTINUOUS

And THOR stands atop the jet, cape whipping behind him.
Lightning behind him silhouettes him momentarily — then
lightning in front paints him bright as day.

Storyboard Artist Bryan Andrews: "Working with Joss on the mountaintop battle was a blast. It's great when it's so early in the process, and he knows this epic scuffle will occur, but the details really haven't been figured out yet. All you have to begin with is, 'Mountaintop, Iron Man and Thor fight — go!' Which is rad. I mean, it's a throwdown between Iron Man and Thor, with a bit of Cap thrown in for good measure. The imagery that comes to mind with that is ridiculous. It has to be rad. Hopefully, we achieved the awesomeness."

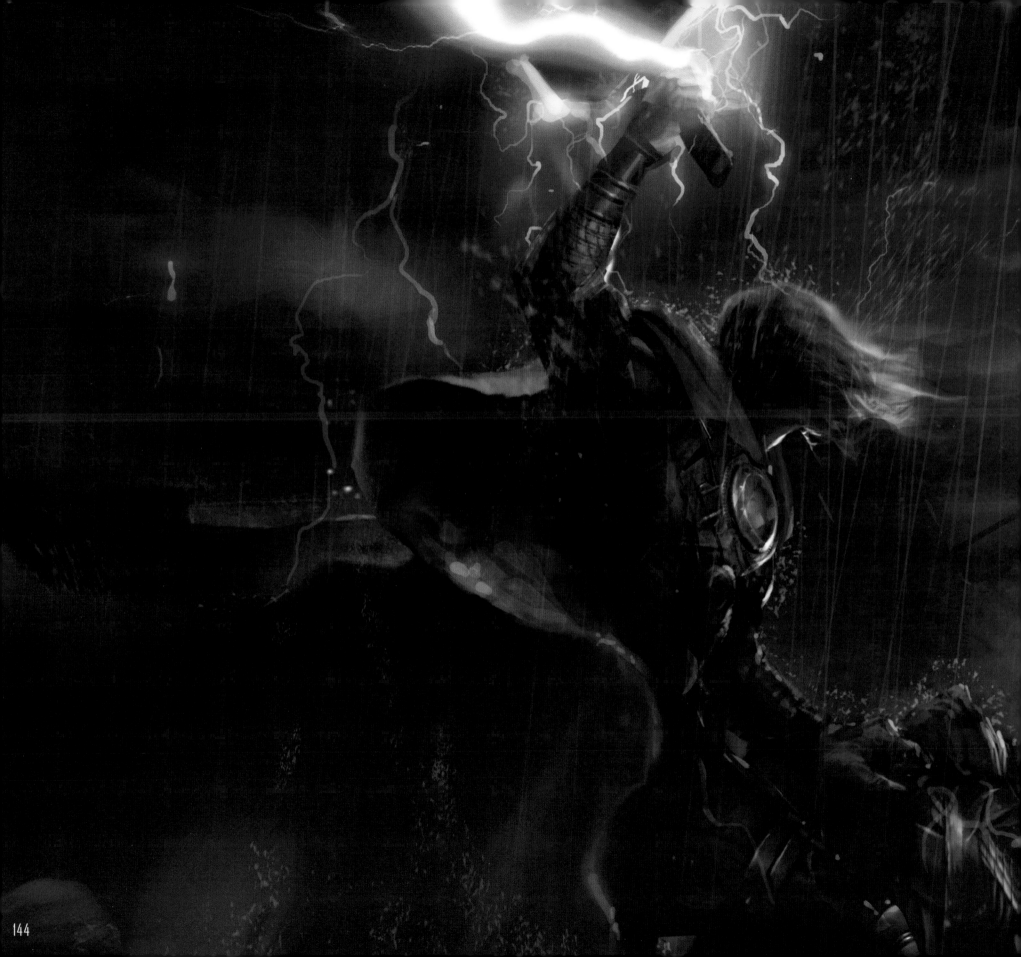

Steve Jung keyframe.

S.JUNG '10

Andrews: "It starts with a broad pitch of all the various gags, beats and bits of brutality that I would want to see in a matchup this epic. Then Joss wades through it all, picking out his favorite nuggets of rad and adding some awesomesauce of his own. It's great how what I pitch in the early stages can inspire an idea in him that he bounces back at me — a fun idea that in turn inspires me to come up with some stuff that leads into and out of that idea. Next thing you know, it's taking shape. The flow of events, the escalation of combat, the character bits — it all starts coming together. In the end, you want something that feels like a Marvel comic come to life — or more."

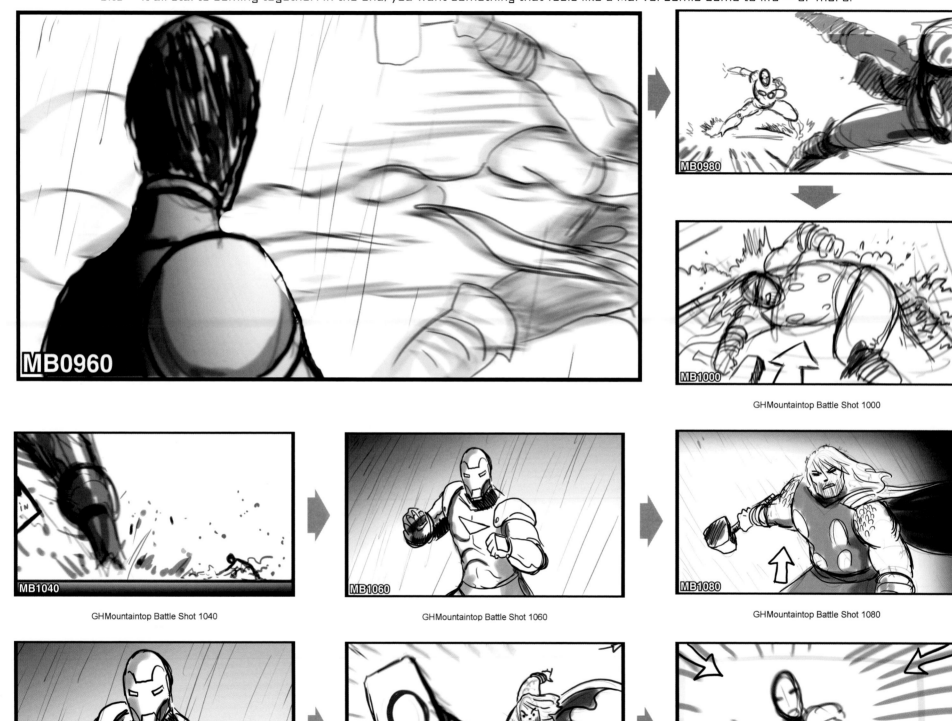

GHMountaintop Battle Shot 1000

GHMountaintop Battle Shot 1040

GHMountaintop Battle Shot 1060

GHMountaintop Battle Shot 1080

GHMountaintop Battle Shot 1100

GHMountaintop Battle Shot 1120

GHMountaintop Battle Shot 1140

GHMountaintop Battle Shot 1160

GHMountaintop Battle Shot 1180

GHMountaintop Battle Shot 1240

GHMountaintop Battle Shot 1280

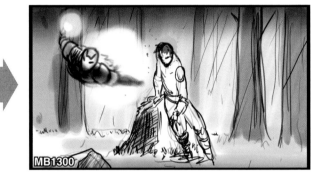

GHMountaintop Battle Shot 1300

GHMountaintop Battle Shot 1340

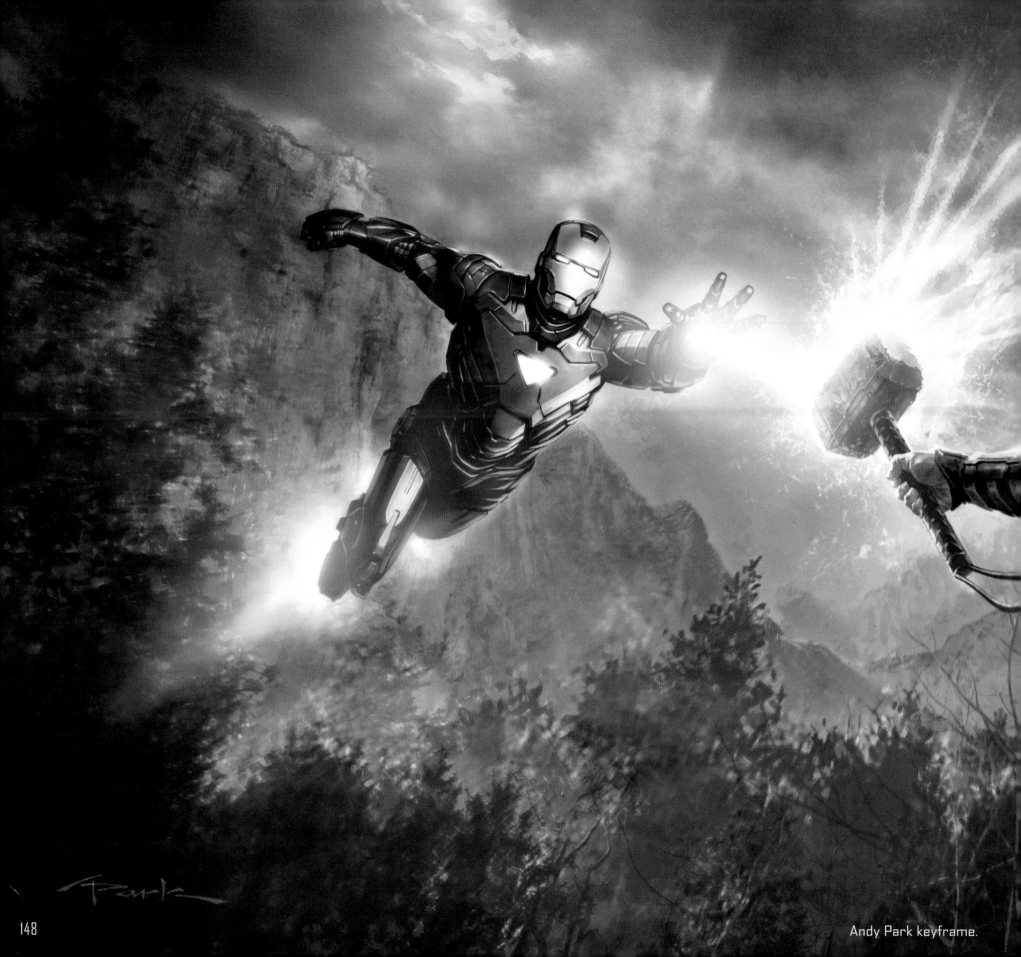

Andy Park keyframe.

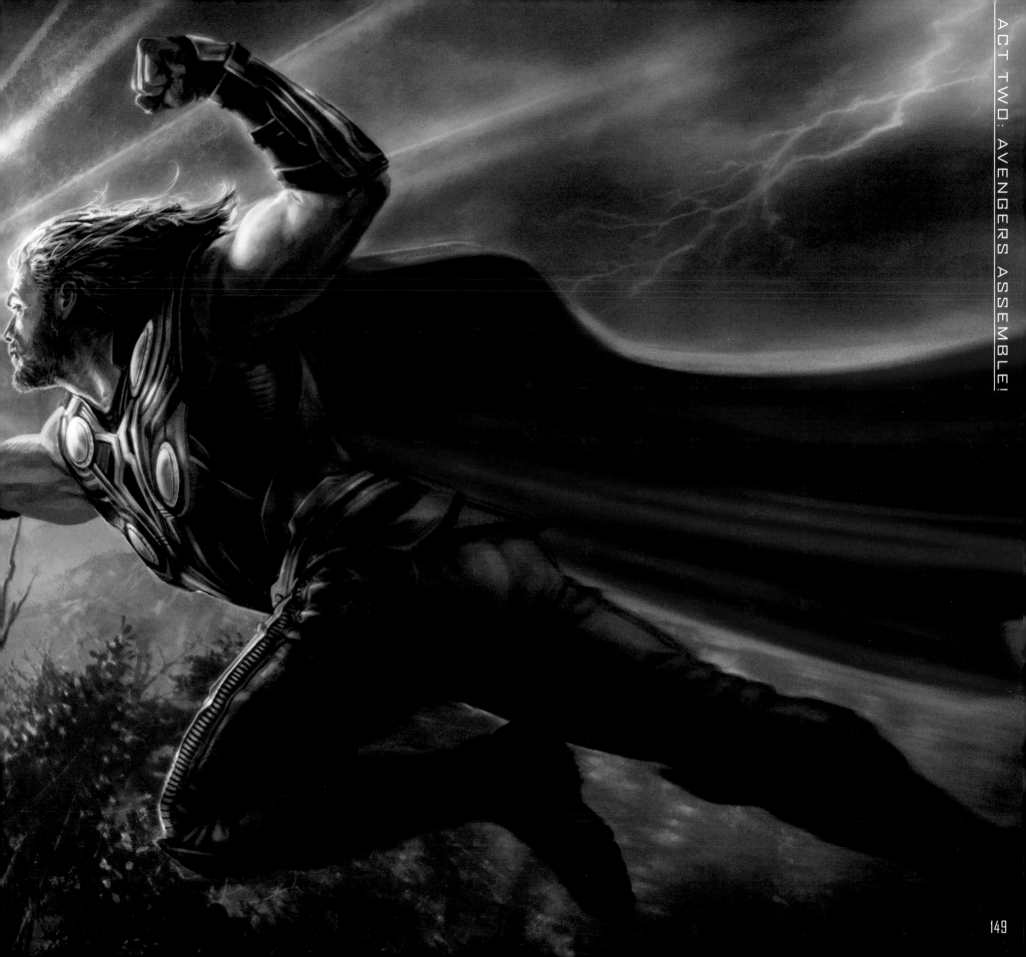

MB1420

MB1440

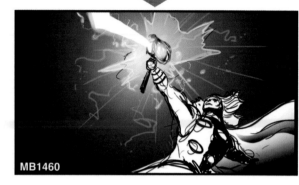

MB1460

GHMountaintop Battle Shot 1460

MB1500

GHMountaintop Battle Shot 1500

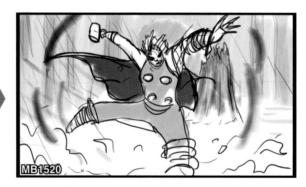

MB1520

GHMountaintop Battle Shot 1520

MB1540

GHMountaintop Battle Shot 1540

MB1580

GHMountaintop Battle Shot 1580

MB1620

GHMountaintop Battle Shot 1620

MB1640

GHMountaintop Battle Shot 1640

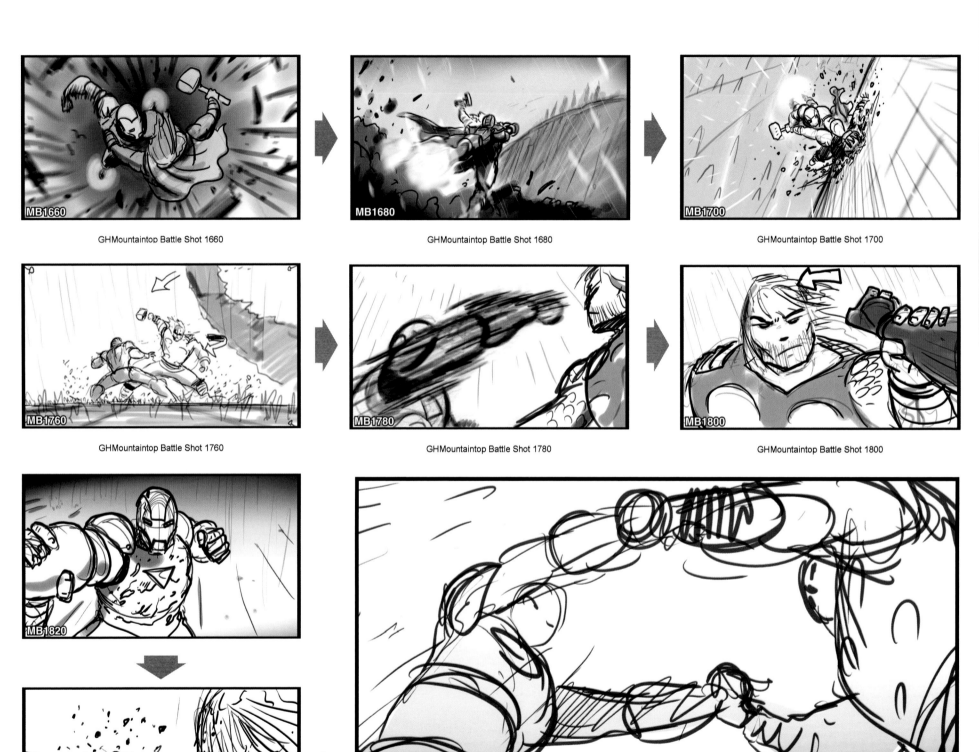

GHMountaintop Battle Shot 1660

GHMountaintop Battle Shot 1680

GHMountaintop Battle Shot 1700

GHMountaintop Battle Shot 1760

GHMountaintop Battle Shot 1780

GHMountaintop Battle Shot 1800

GHMountaintop Battle Shot 1840

Andrews: "A Marvel hero fighting another Marvel hero because of some kind of misunderstanding is such a classic element from the comics. What kid hasn't asked the question, 'Who would beat who in a fight?' It was terrific to be able to work with Joss and sink my teeth into that question in regards to Thor and Iron Man. It seemed clear that Thor could truly destroy Iron Man if he really wanted to. So coming up with stuff that could keep Tony in the fight was important. He needed to fight savvy — move around a lot, use his unique abilities to get him out of trouble and prolong the inevitable. The beauty is that Thor can take so much damage that it created the opportunity for Iron Man to really brutalize him."

GHMountaintop Battle Shot 2040

GHMountaintop Battle Shot 2060

GHMountaintop Battle Shot 2080

GHMountaintop Battle Shot 2100

GHMountaintop Battle Shot 2120

GHMountaintop Battle Shot 2140

GHMountaintop Battle Shot 2160

GHMountaintop Battle Shot 2200

GHMountaintop Battle Shot 2220

GHMountaintop Battle Shot 2240

GHMountaintop Battle Shot 2260

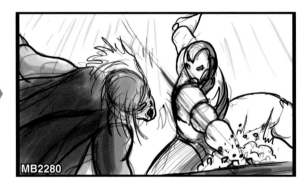

GHMountaintop Battle Shot 2280

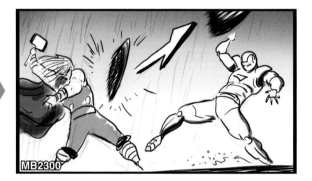

GHMountaintop Battle Shot 2300

GHMountaintop Battle Shot 2360

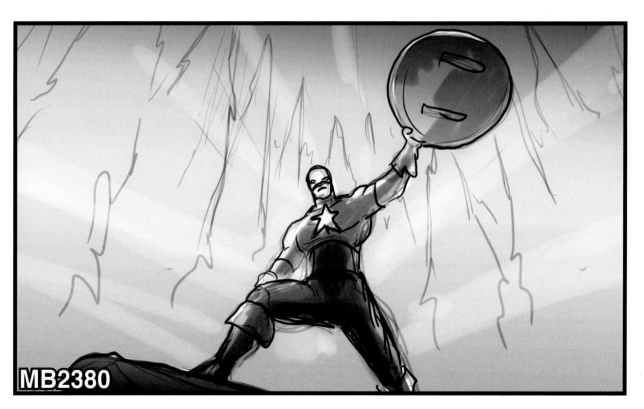

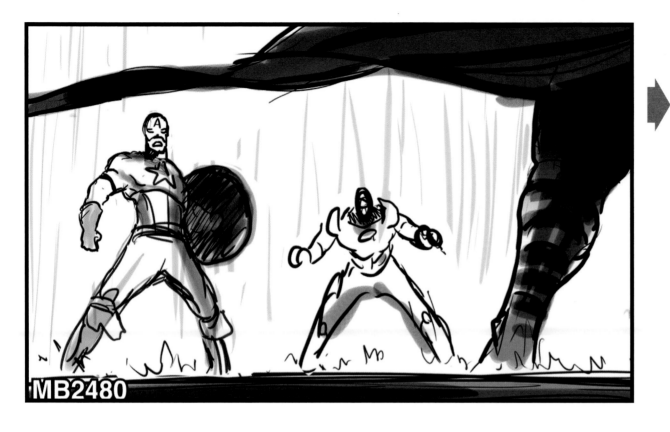

MB2480

MB2500

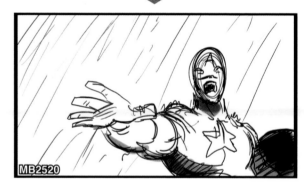

MB2520

GHMountaintop Battle Shot 2520

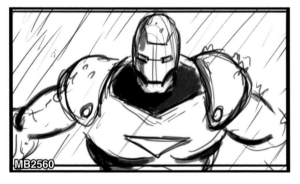

MB2560

GHMountaintop Battle Shot 2560

MB2580

GHMountaintop Battle Shot 2580

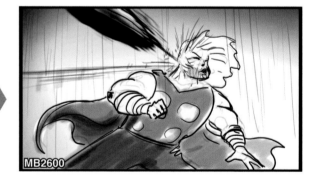

MB2600

GHMountaintop Battle Shot 2600

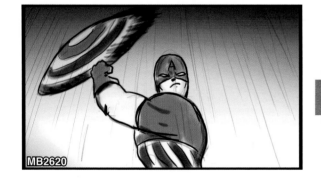

MB2620

GHMountaintop Battle Shot 2620

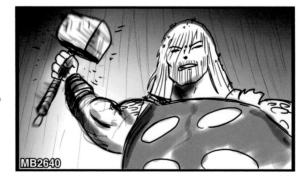

MB2640

GHMountaintop Battle Shot 2640

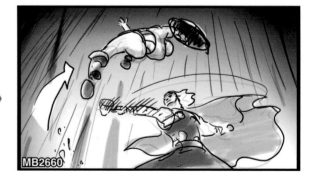

MB2660

GHMountaintop Battle Shot 2660

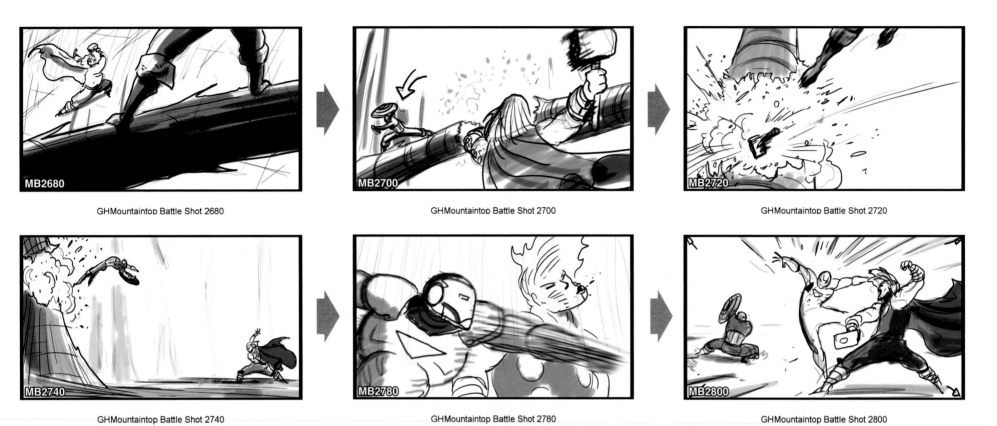

GHMountaintop Battle Shot 2680

GHMountaintop Battle Shot 2700

GHMountaintop Battle Shot 2720

GHMountaintop Battle Shot 2740

GHMountaintop Battle Shot 2780

GHMountaintop Battle Shot 2800

"This moment was important in Joss' mind because it was the meeting of two of the biggest icons in the Marvel Universe: Mjolnir and Cap's shield," Ryan Meinerding said. "Thor's strength has been pretty well-established in the audience's mind from his own movie, but Cap's stance needed to communicate a sense of strength despite using a shield to protect himself. The moment is really powerful in the film, Joss totally nailed it."

Ryan Meinerding keyframe.

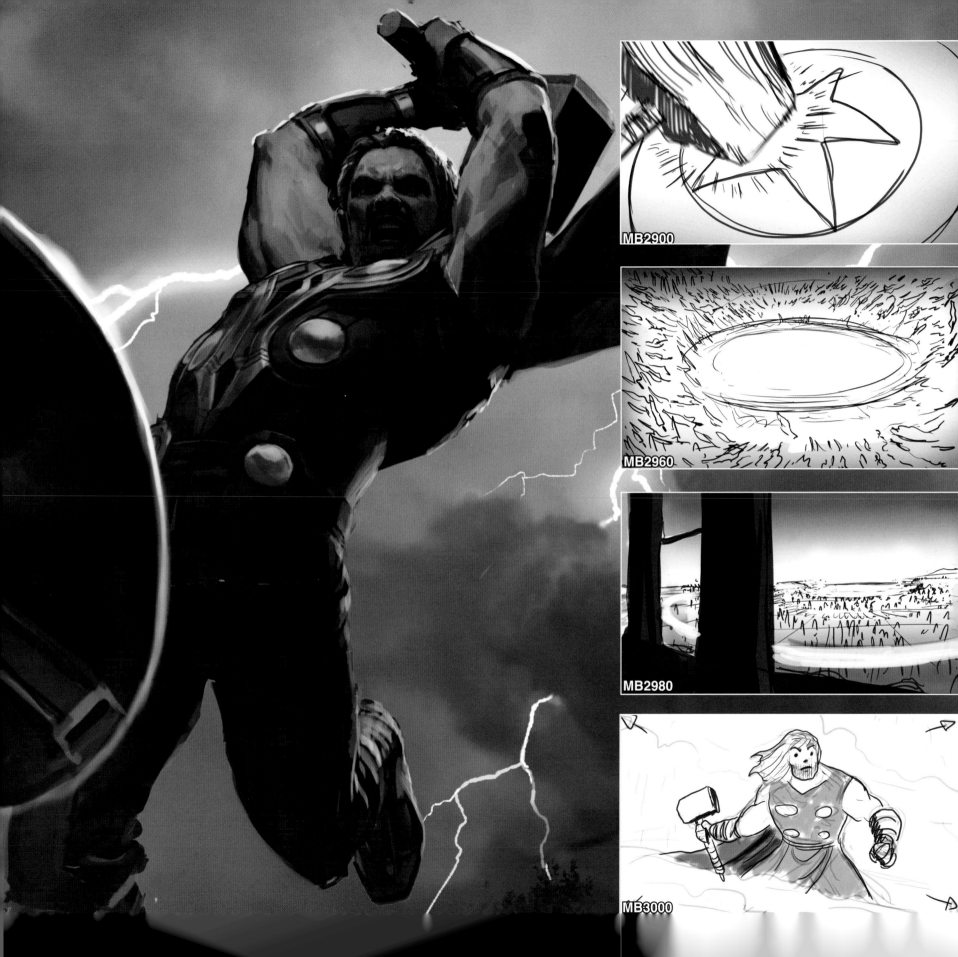

MB2900

MB2960

MB2980

MB3000

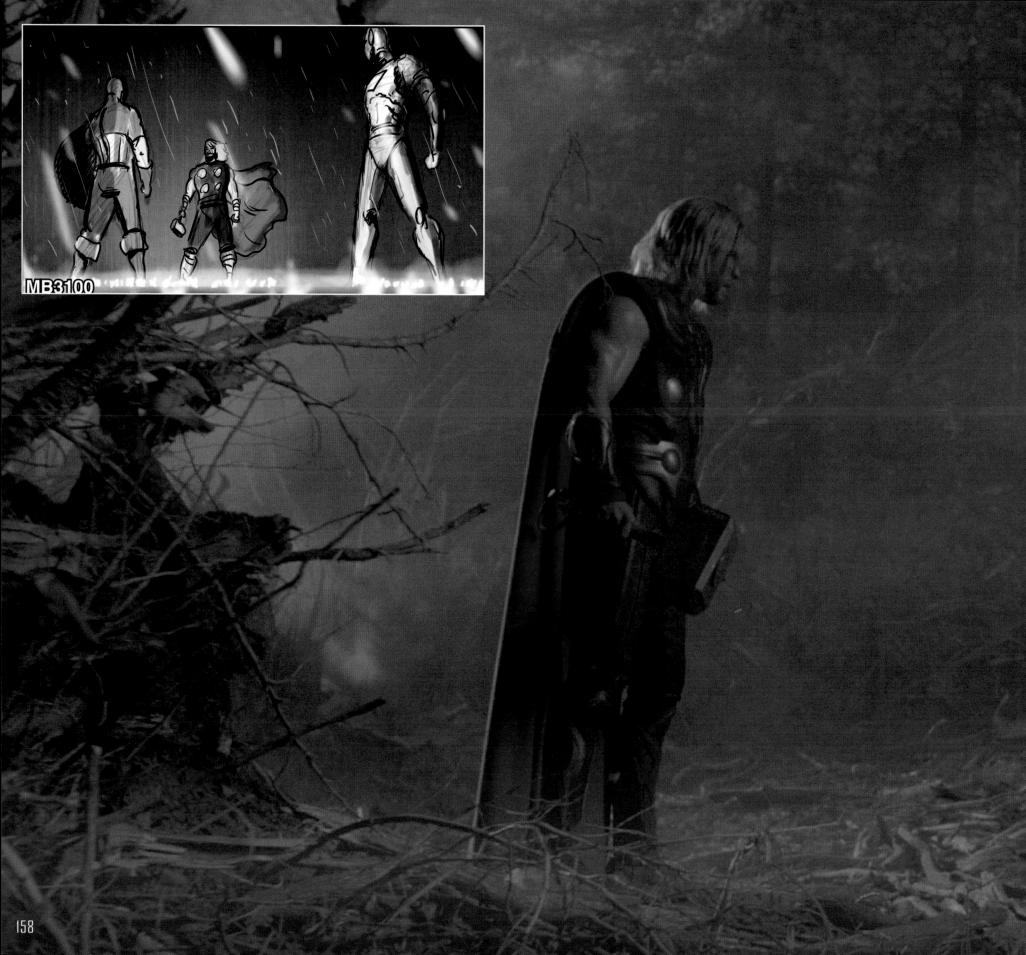

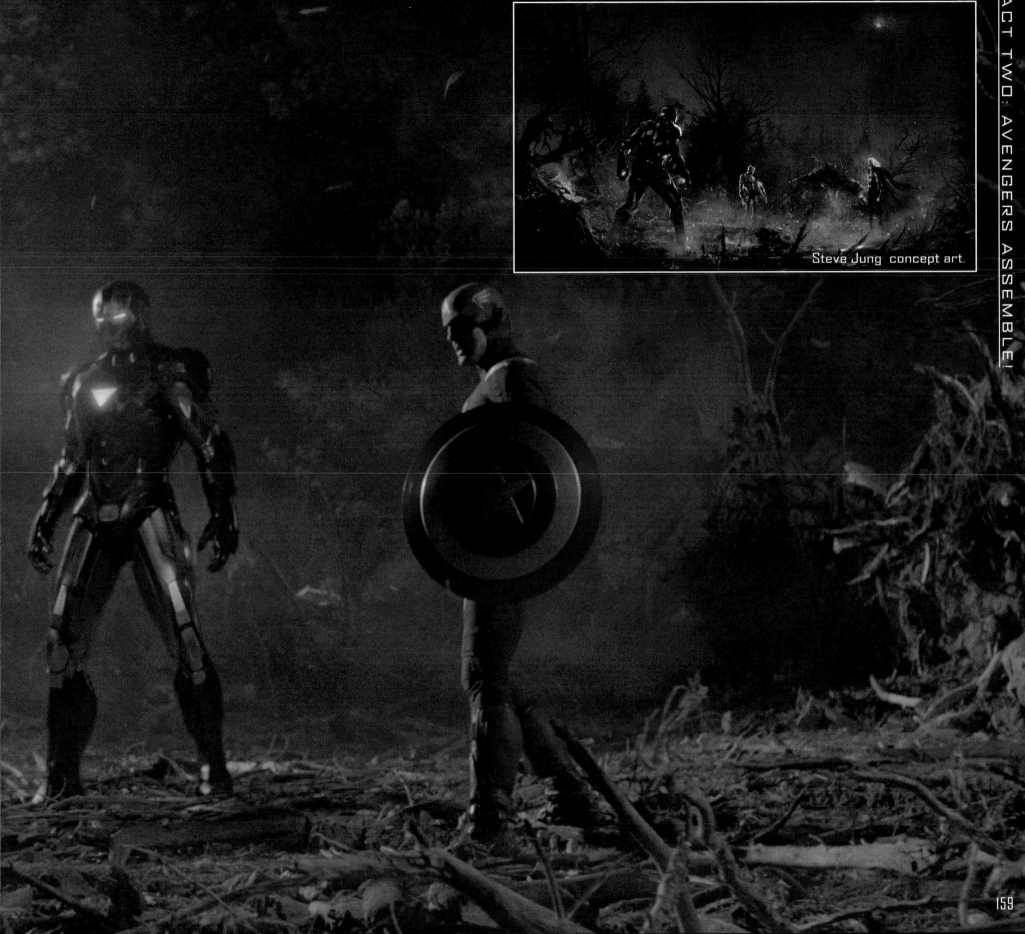

Steve Jung concept art.

LOKI'S CELL

Once safely aboard the S.H.I.E.L.D. Helicarrier, Loki quickly finds himself incarcerated in a rather unique prison cell: a tube of impenetrable glass and steel that can be ejected with the touch of a button, sending the prisoner "30,000 feet straight down in a steel trap," as an understandably testy Nick Fury points out to his Asgardian prisoner. Loki has no hope whatsoever of breaking out of this particular cage, and for good reason: It was built to contain the Hulk in the event of an onboard incident.

Fury is on hand to welcome Loki aboard the Helicarrier, and their subsequent confrontation is one of the film's highlights — and a chance for both actors to subtly nibble on some scenery as they state their positions.

"Loki's cell is essentially a quarantine zone in the ship: a highly secured isolation chamber that could be ejected through a port in the hull of the ship," Nathan Schroeder said. "While much of the rest of the ship's interior is unique to the film, the cylindrical inner cell had its origins in *The Ultimates* comic-book series. Production Designer James Chinlund felt that fans of the series would appreciate our nod to the historical reference."

Nathan Schroeder concept art; **insets:** Jeff Markwith computer models.

"As we were exploring the layouts of the various spaces on the Helicarrier, we came across some artwork from *The Ultimates* of a containment cell designed for Bruce Banner that was built in the Triskelion," James Chinlund said. "I was excited about trying to incorporate this idea into the architecture of the ship. The glass pod allowed us to create a much more dynamic space than your typical cell, and the threat of ejection created a constant tension. It was a great example of the dynamics of the set becoming a character in the film.

"Holding the cell in its cradle within the containment space also allowed us to reveal another layer of the architecture of the ship showing a utility level and more grit and texture," Chinlund continued. "We were excited about the idea that the pod was a lamp — glowing in the darkness, creating opportunities for silhouettes and multiple reflections. And working closely with Concept Artist Nathan Schroeder, we were able to bring this form to life. Construction Coordinator John Hoskins and his team did superhuman work tackling the engineering challenges this set provided. In the end, we wound up with a cell that was capable of starting the sudden drop as the cell ejects — practically, on camera — which was an incredible feat considering the weight of the cell and the fragility of the glass."

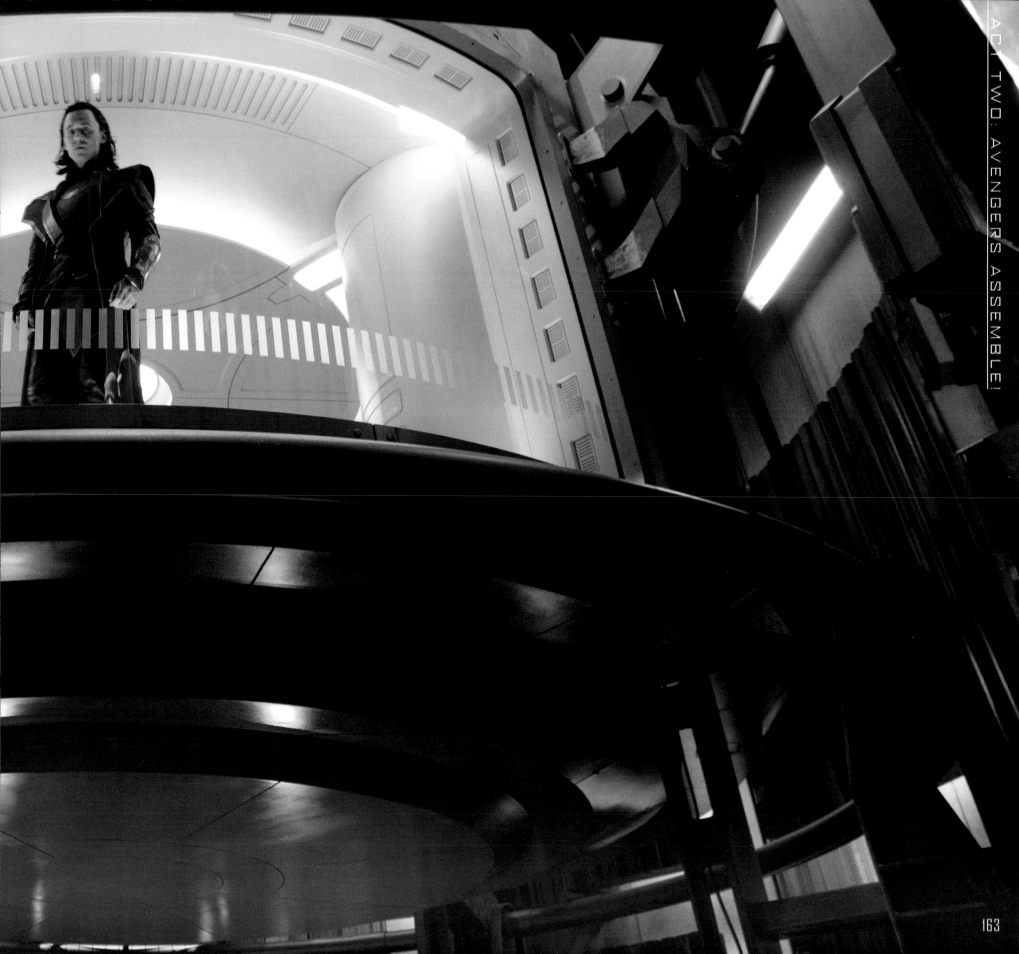

WISHBONE LAB

Mark Goerner concept rendering of the Wishbone Lab, so named for its position between the two "legs" at the aft end of the Helicarrier; **top inset:** Nick Cross computer diagram; **middle, bottom insets:** Nathan

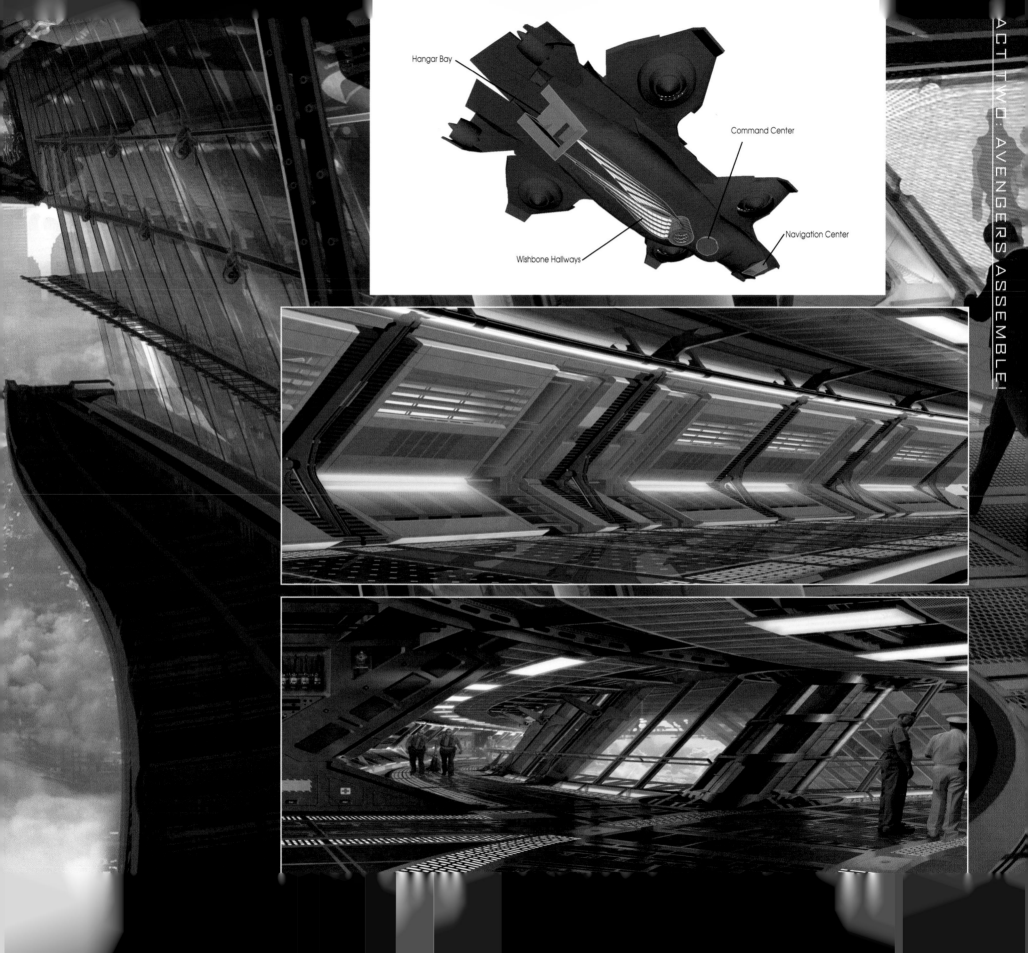

Hangar Bay

Command Center

Navigation Center

Wishbone Hallways

"The Medlab is a beautiful set from many angles and was really a pleasure to illustrate," Nathan Schroeder said. "It sits strategically at the hub of the grand wishbone hallway, affording a spectacular view, but also leaves it vulnerable to attack. My job was to envision the set before and after a fierce battle, which allowed me to tap into the destructive side of my personality. Just as I enjoy imagining how things are put together, I also enjoy the challenge of figuring out what happens when they become damaged due to impact, fire, explosion, etc."

Nathan Schroeder concept art.

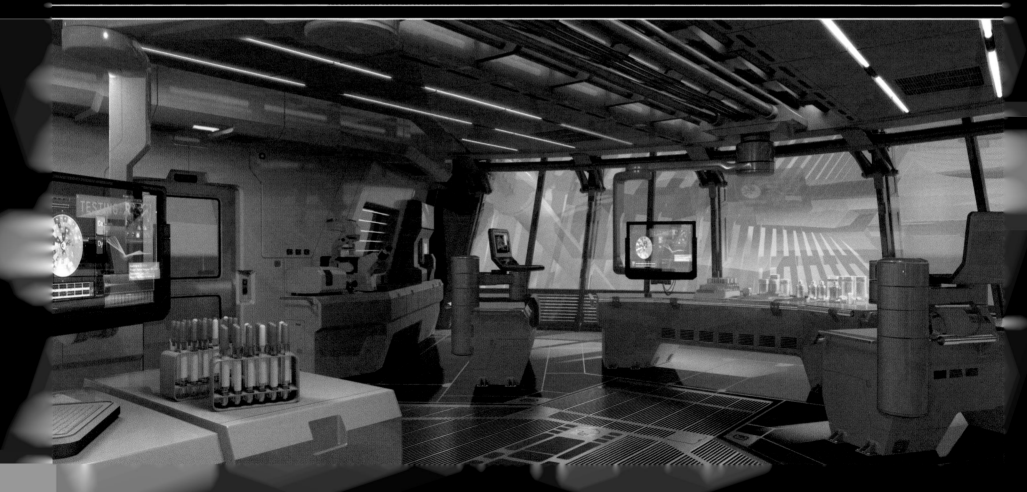

ASSAULT ON THE HELICARRIER

The assault on the Helicarrier was just one of the action-packed sequences that required Scarlett Johansson to stay in top shape throughout the production. "Stunts and fights are a huge part of my work on this film, and being able to have a fighting style that audiences remember from *Iron Man 2* is awesome," Johansson said. "(Fight Choreographer) Jonathan Eusebio created and choreographed the style and look of the movements. And Heidi Moneymaker, my stunt double, helped me learn them. What they both did for me is so important because it is just as much a creation of the character as whatever dramatic work I put into the job."

"We wanted to make Black Widow very fluid and acrobatic," Eusebio said. "The Wushu fighting style works well for her body mechanics. It's very graceful, but it also requires a lot of flexibility for the long circular movements. You're also going to see Black Widow doing a lot more body-weight throws and using weapons, which changed the game up quite a bit. It's like learning something entirely new, and for her to learn a long weapon like the one we gave her is pretty difficult. She trained hard for it and really pulled it off."

"Scarlett worked so hard on the film to keep in great shape, and that's not easy when you have to go to the gym at 4 a.m. so you can be in makeup at 5 a.m.," Executive Producer Patty Whitcher said. "On other days, she would go straight from the gym to stunt training, and then go work a full day. So it's not all glamorous like people think. It's really hard work to pull off these kinds of moves in a convincing fashion so that the audience sees it's really Scarlett in there fighting."

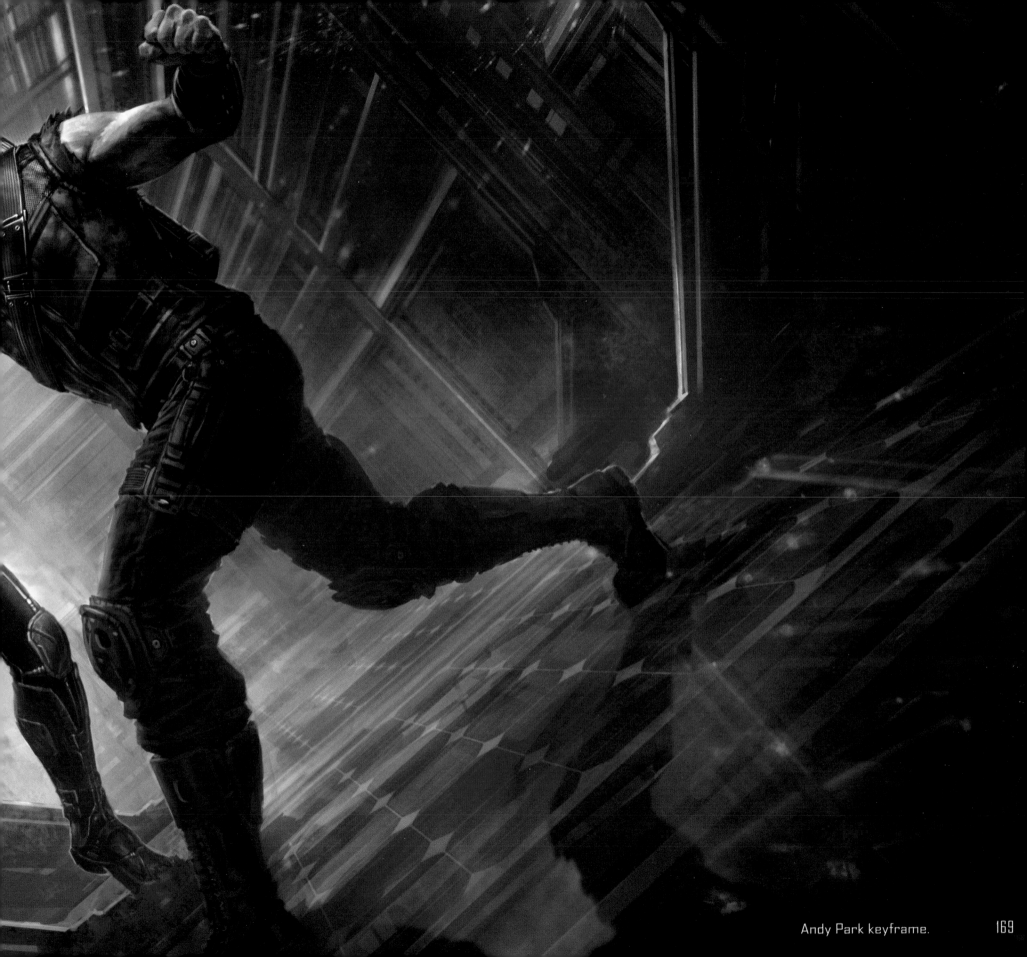

Andy Park keyframe. 169

RETURN OF THE BEAST

Marvel's The Avengers marks the first big-screen appearance of the green goliath since *The Incredible Hulk* in 2008. The film also features a new actor in the dual role of Dr. Bruce Banner and his gamma-infused alter ego, Mark Ruffalo, and a new way of approaching that computer-generated duality. The title character in both *Hulk* (2003) and *The Incredible Hulk* was completely computer-animated, with no visual connection to the actors who played Banner. Joss Whedon and the Marvel creative team were determined to do things differently.

"We wanted to create a Hulk that had never been done before," Whedon said. "In the comics, Bruce Banner and the Hulk didn't look the same. On the television show, they were different actors. And they've always been an actor and a CGI creature in the films. But now, with the advancements of motion-capture technology, we wanted Mark Ruffalo to play both sides of the character.

"Very early on we decided to build the Hulk's face off of Mark's, not just in terms of what he was going to do movement-wise in playing the character, but also the actual physicality of it — including the bone structure, and contours of the eyes and mouth," Whedon continued. "We really wanted to bridge the gap between the characters so that when he turns into the Hulk, you go, 'Oh my god, that's Bruce Banner — only he is big and green and very angry."

There was another key difference between Mark Ruffalo's Hulk and those of his cinematic predecessors. "In a lot of the other versions of the character, the Hulk grew in size drastically — but in *The Avengers*, he is always going to be about eight-and-a-half feet tall," Ruffalo said. "He gets stronger as he gets angrier, but he doesn't really grow too much taller."

The Hulk, as seen in *The Incredible Hulk* (2008).

"We wanted to incorporate more of the actor than ever before so that the face and mannerisms of the Hulk come from Mark Ruffalo's face," Kevin Feige said. "We have never done this before, but it was a tremendous help in making audiences feel Bruce Banner and the Hulk were one in the same. When he turns into the Hulk, all of the goodwill we get from a very likeable Bruce Banner goes into him — and you get more expression, more character and more emotion than we have ever gotten out of the character."

"When I found out there was a whole new arena of technology that would allow an actor to play what has always been a CGI character, I thought it could be something very cool," Ruffalo said. "It's a huge game changer for the Hulk because it's hard to capture real anger in a CGI character. Anger is something that's deep and primordial. There are so many subtleties and variations to it — so this idea of bringing a darker, more humanistic Hulk was really exciting and compelling."

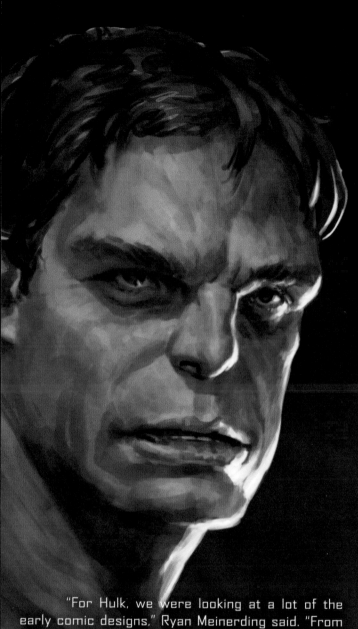

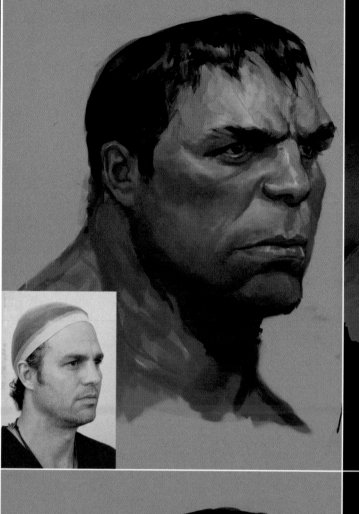

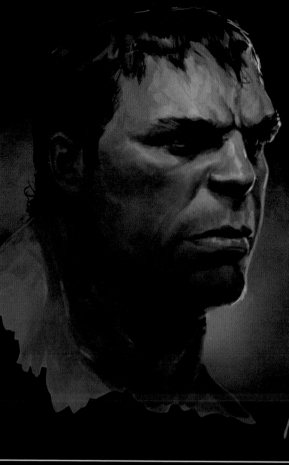

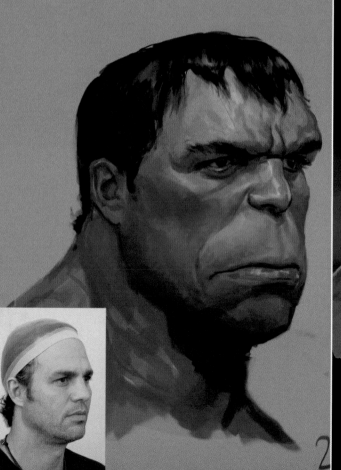

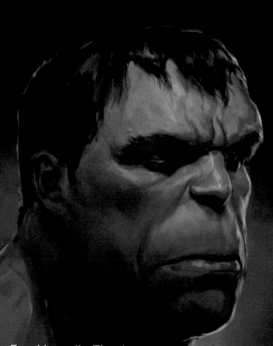

"For Hulk, we were looking at a lot of the early comic designs," Ryan Meinerding said. "From the early Kirby designs up until around the '80s, the Hulk was sort of a combination of Frankenstein, a gorilla and a turn-of-the-century strongman. We were definitely trying to get the tone of that Hulk and stay away from the more modern versions, where he is more classically heroic and honestly looks like a bodybuilder. I was very interested in exploring the Hulk as a monster and less of a hero. Joss really pushed us to take some of the cues from those early Hulks and combine them with Mark Ruffalo's features. At first, we couldn't see how that would work — but he was dead-on in that direction. Mark's face really lends itself to hulking out, and we affectionately called the design the 'Hulkalo.'"

For *Marvel's The Avengers*, the filmmakers sought to capture both the likeness and performance of the actor portraying the Hulk — as seen in this series of Ryan Meinerding character designs based directly on the new Bruce Banner, Mark Ruffalo.

"Our biggest challenge was maintaining the integrity of the comics and the strength of the Hulk, but also to make sure Mark Ruffalo was embodied in this new Hulk." Executive Producer Victoria Alonso said. "The obvious challenge is to make a big muscular green beast look photoreal. And I think through countless iterations, we were able to accomplish a look we were all happy with."

Charlie Wen character design.

173

Charlie Wen character designs.

"Joss is a great guy to work for," Meinerding said. "He really seemed to enjoy the concept-design phase of the preproduction, and we really loved working for him. He has very definitive ideas about each of his characters, and the heroes are so well fleshed out in the script that developing the visuals was a joy. We were on a very tight timeline for this project, and we would've had a hard time meeting our deadlines without the clarity of direction that Joss provided. The look of Cap's costume and the design of the Hulk are directly out of Joss' head. He was very passionate about the Hulk and was involved in his creation from our first sketch to the last frame of the movie rendered by ILM."

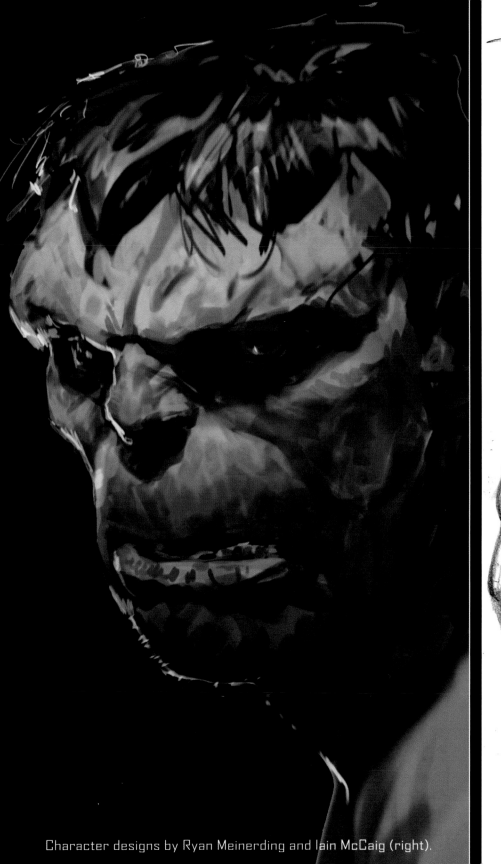

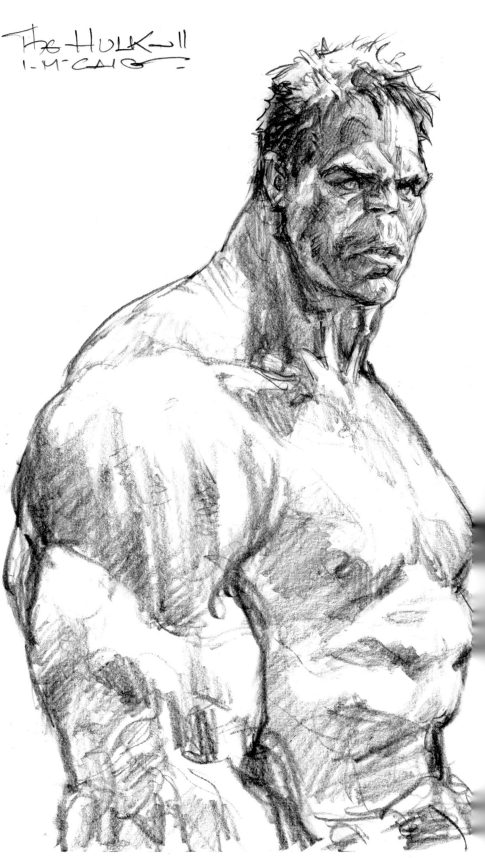

The HULK II
I. M-CAIG

Character designs by Ryan Meinerding and Iain McCaig (right).

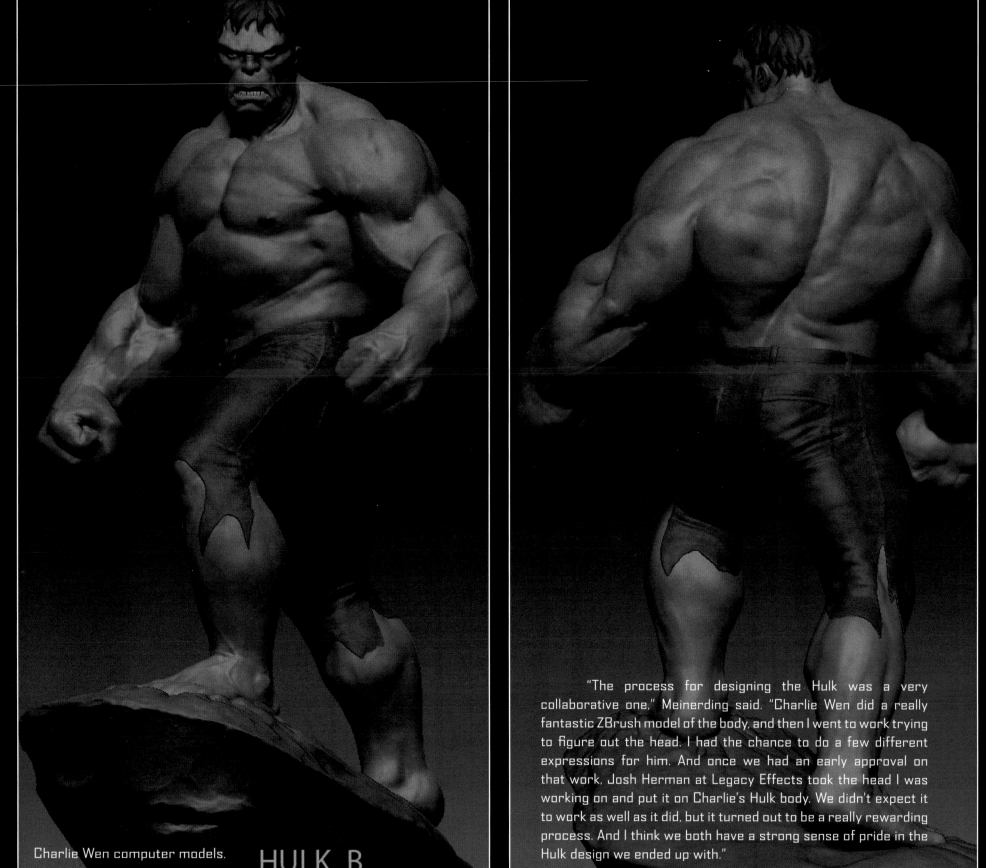

Charlie Wen computer models.

HULK B

"The process for designing the Hulk was a very collaborative one," Meinerding said. "Charlie Wen did a really fantastic ZBrush model of the body, and then I went to work trying to figure out the head. I had the chance to do a few different expressions for him. And once we had an early approval on that work, Josh Herman at Legacy Effects took the head I was working on and put it on Charlie's Hulk body. We didn't expect it to work as well as it did, but it turned out to be a really rewarding process. And I think we both have a strong sense of pride in the Hulk design we ended up with."

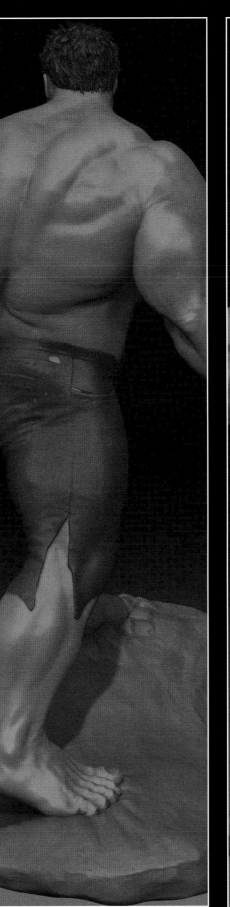

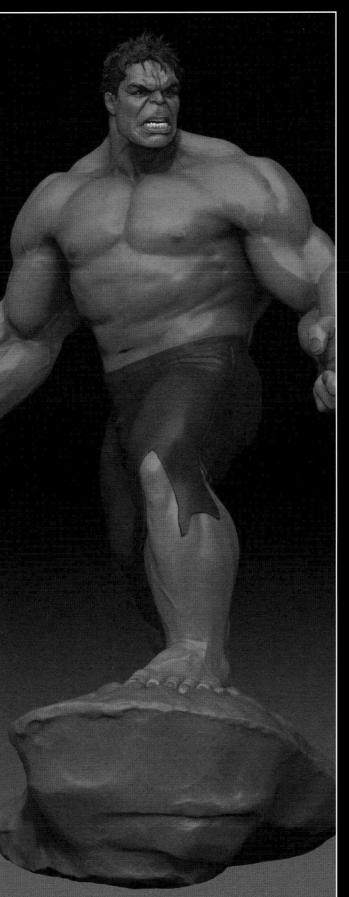

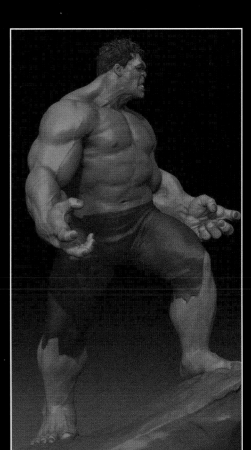

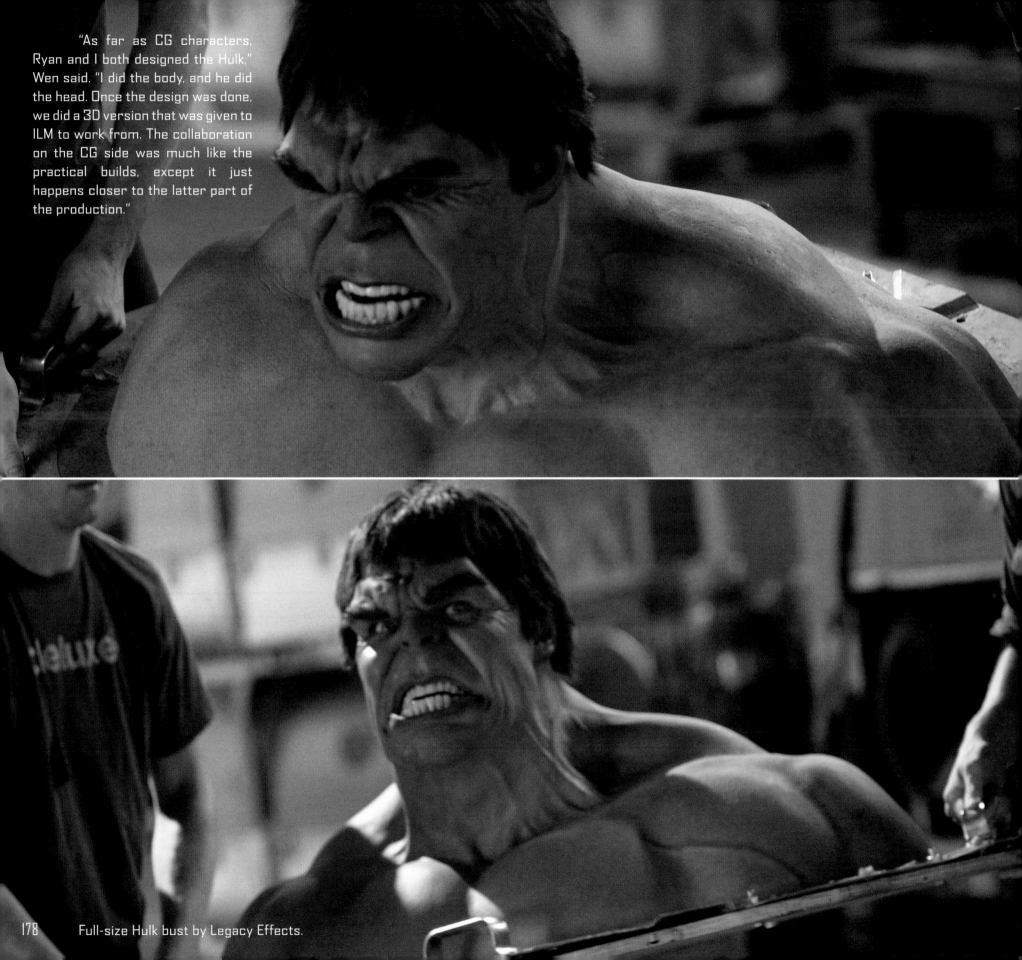

"As far as CG characters, Ryan and I both designed the Hulk," Wen said. "I did the body, and he did the head. Once the design was done, we did a 3D version that was given to ILM to work from. The collaboration on the CG side was much like the practical builds, except it just happens closer to the latter part of the production."

Full-size Hulk bust by Legacy Effects.

Legacy Effects maquette.

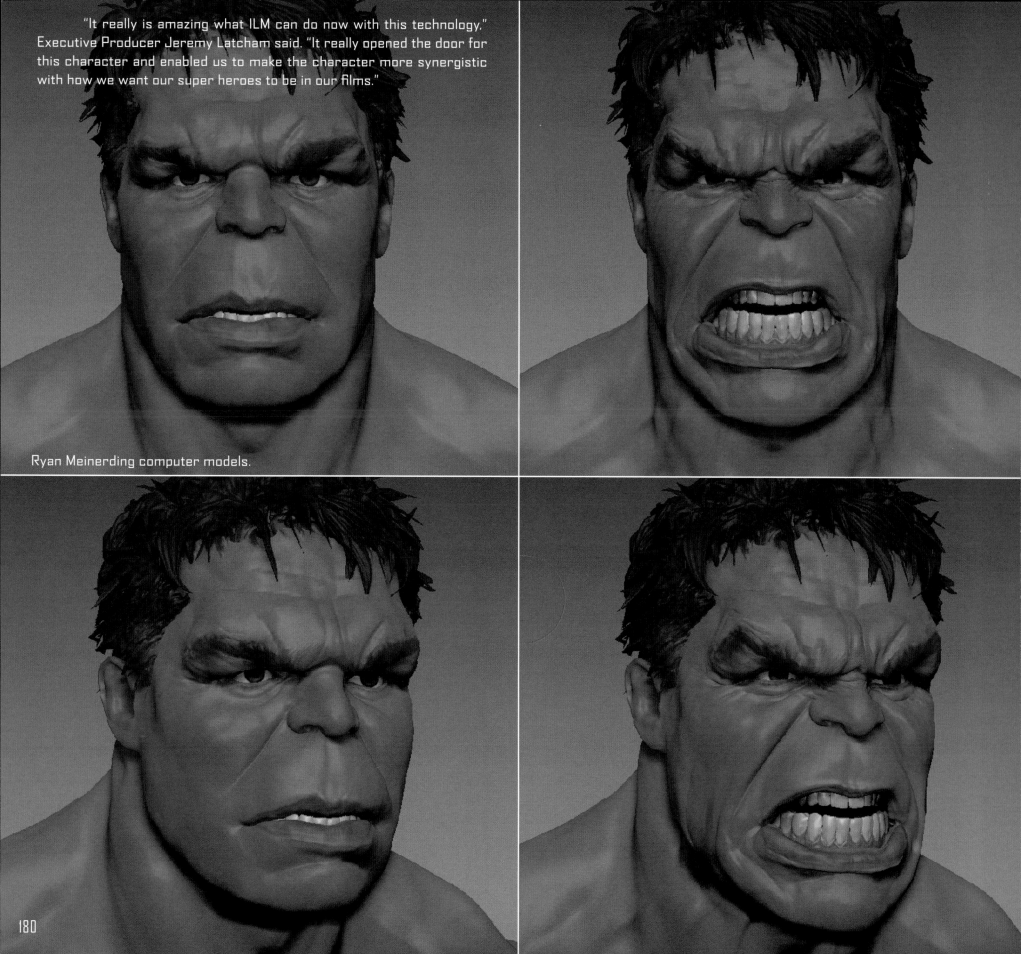

"It really is amazing what ILM can do now with this technology," Executive Producer Jeremy Latcham said. "It really opened the door for this character and enabled us to make the character more synergistic with how we want our super heroes to be in our films."

Ryan Meinerding computer models.

Mark Ruffalo "Hulks out" for the first time on-screen.

"There's a million things we can build off of from Mark," VFX Supervisor Janek Sirrs said. "But at the end of the day, the CGI Hulk needed to feel like flesh and blood, but at the same time had to express everything more dramatically than a human being is going to. So there have been times when ILM is building off Mark's performance, and I see it and say, 'We need to take this further. His mouth needs to be opened wider; his head needs to snap quicker.' All these things had to be augmented in order for them to read as pure Hulk, but they had to come from the basis of reality."

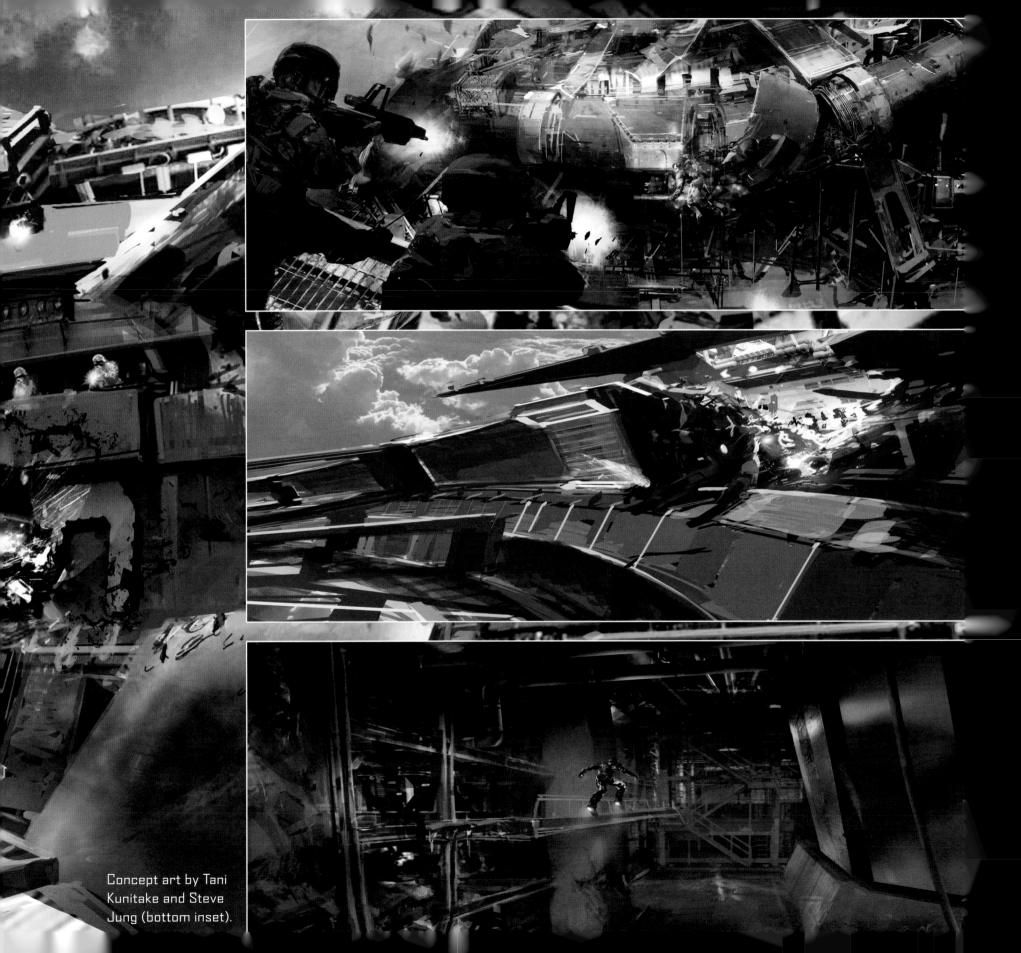

Concept art by Tani Kunitake and Steve Jung (bottom inset).

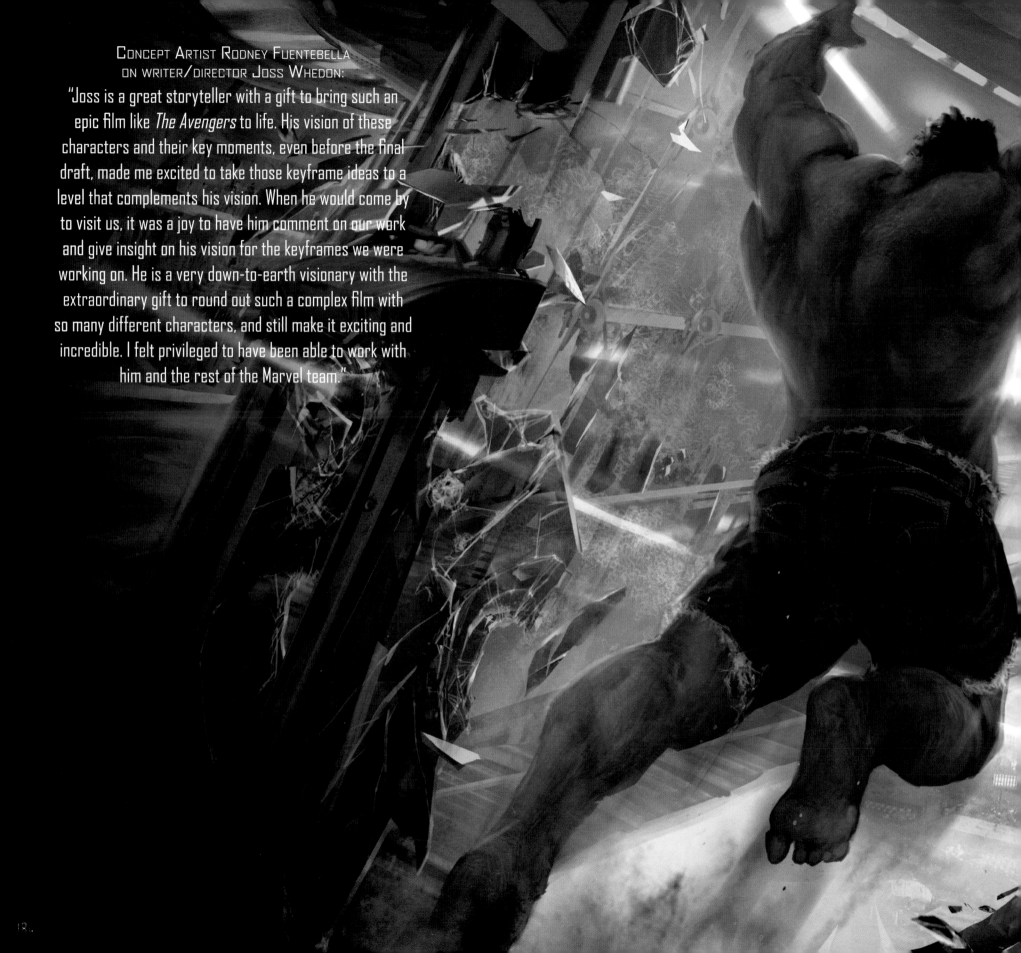

Concept Artist Rodney Fuentebella on writer/director Joss Whedon:

"Joss is a great storyteller with a gift to bring such an epic film like *The Avengers* to life. His vision of these characters and their key moments, even before the final draft, made me excited to take those keyframe ideas to a level that complements his vision. When he would come by to visit us, it was a joy to have him comment on our work and give insight on his vision for the keyframes we were working on. He is a very down-to-earth visionary with the extraordinary gift to round out such a complex film with so many different characters, and still make it exciting and incredible. I felt privileged to have been able to work with him and the rest of the Marvel team."

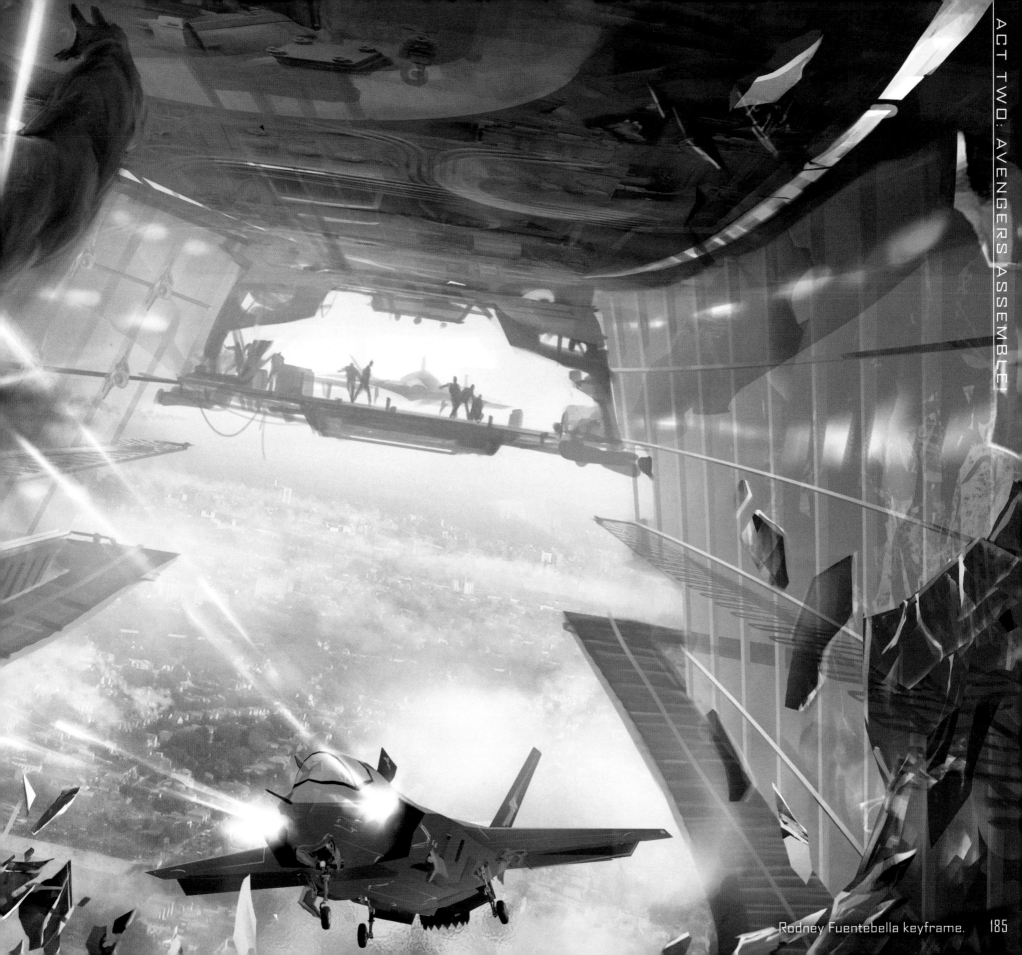

Rodney Fuentebella keyframe.

ABANDONED SHIPYARD

A dazed and disoriented Bruce Banner awakens to find himself in a New Jersey shipyard, having used several floors of an abandoned warehouse to break his fall following the Hulk's midair skirmish with a S.H.I.E.L.D. fighter jet. It's a pivotal moment for Banner. Should he go back to life on the run and again try to contain the beast, or should he return to his newfound allies and unleash the monster in the final battle for New York City?

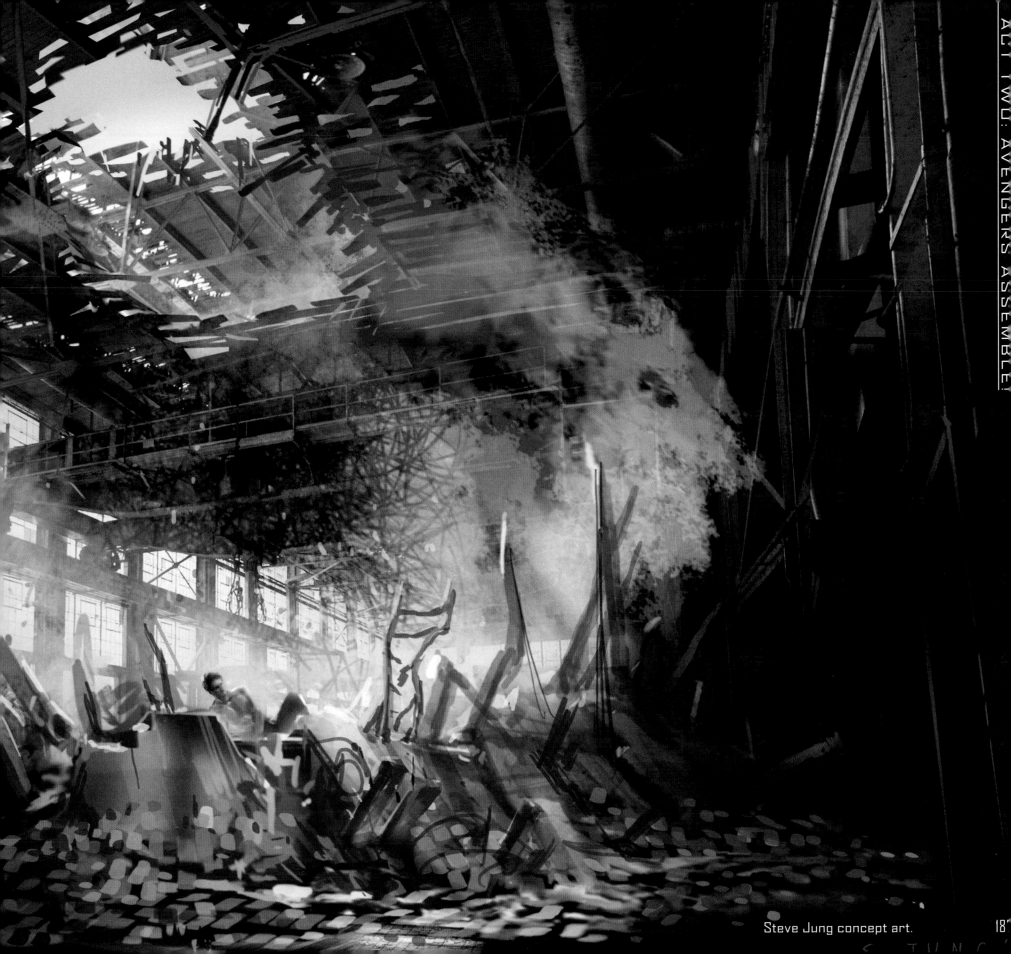

Steve Jung concept art.

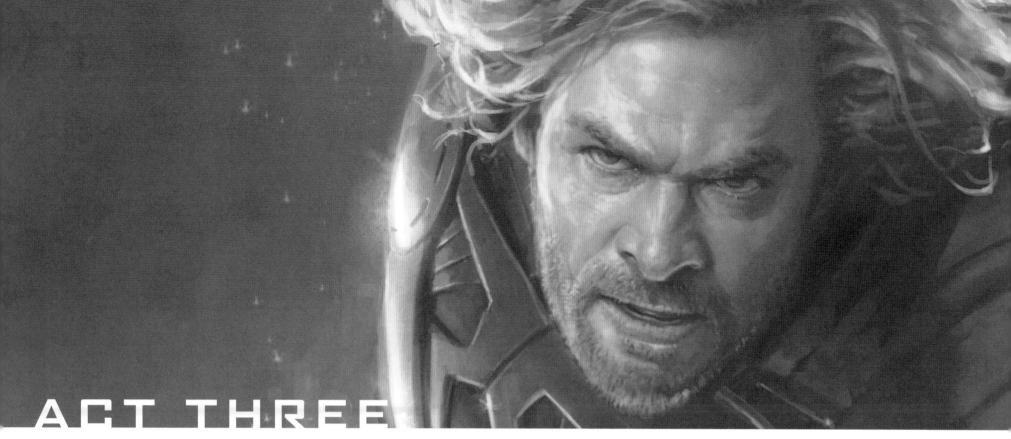

A COMMON THREAT

Art by Charlie Wen.

STARK TOWER – TONY'S APARTMENT, TONY VS. LOKI

"In the design of the interior, it was important to us that we feel familiar to the Stark aesthetic developed in the first two *Iron Man* films," Production Designer James Chinlund said. "We tried to incorporate the sweeping curves and glass from Tony's Malibu home and bring that to his home in NYC, hopefully raising the bar in terms of the spectacular setting. Having lived in New York for so much of my life, I am familiar with the need to be as efficient with the use of space as possible. Now, when discussing Tony Stark, it may seem dissonant to talk about efficient use when dealing with a billionaire — but it felt right to create as much built-in function as possible."

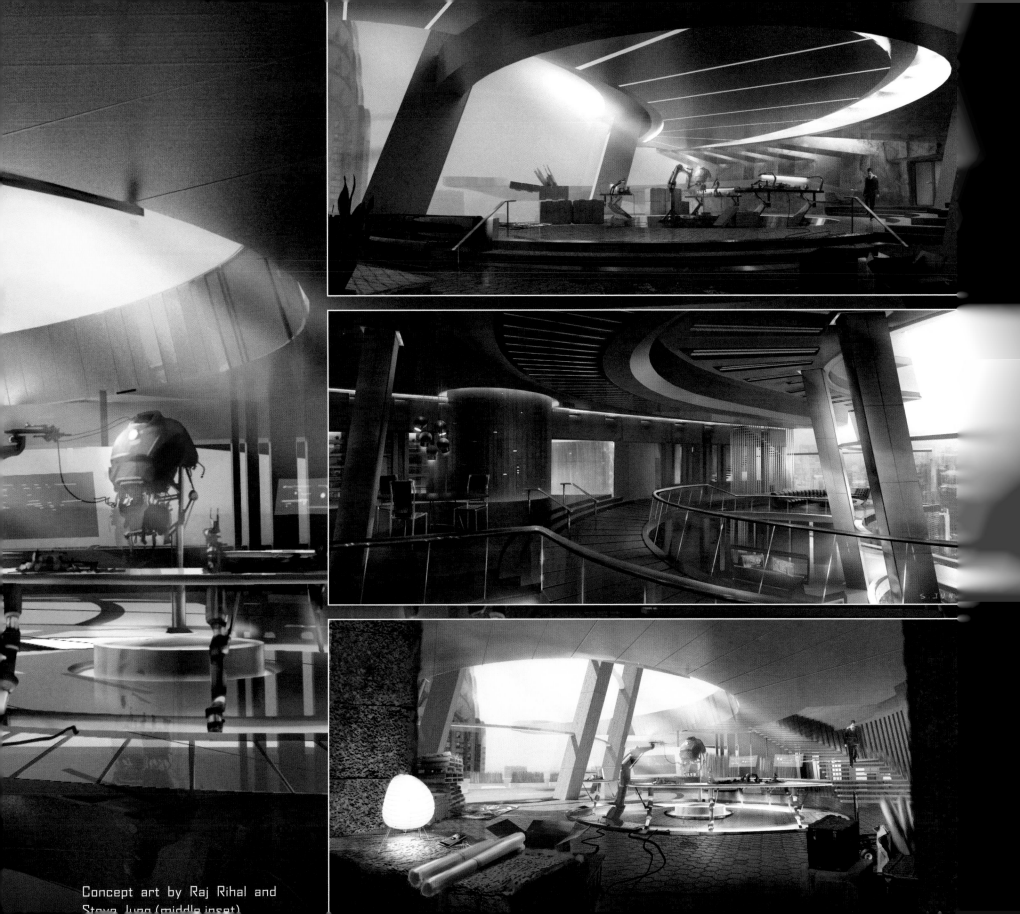

Concept art by Raj Rihal and
Steve Jung (middle inset)

designs begin with the script, Concept Artist Phil Saunders said, and Iron Man's Mark VII armor was no exception. "There were esse
ments for the suit: First, we needed to make a more powerful, heavily weaponized suit so Tony would be equipped to take on an arm
king it to the tank-like proportions of War Machine. He still had to feel like Iron Man. So we went back to a couple of ideas we had play
nal ending of *Iron Man* — where the weaponized Iron Man would be modular, and have various ammo and weapons packs that would
he script also required a booster that would allow Tony to outrun and intercept a nuclear missile, and fly it through the dimensional p
e 'rocket backpack' element of the suit. Ultimately, the whole suit needed to be packaged in a more streamlined form in keeping with To
g-influenced aesthetics. The touchstone I kept in mind throughout the design process was to keep it looking like a 'wearable Ferrari.'"

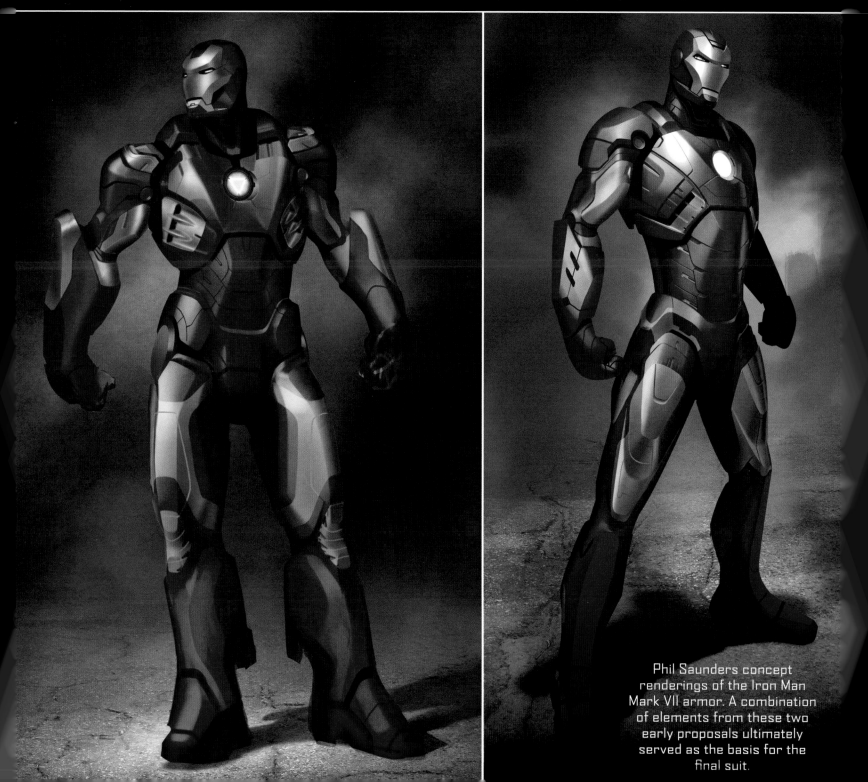

Phil Saunders concept
renderings of the Iron Man
Mark VII armor. A combination
of elements from these two
early proposals ultimately
served as the basis for the
final suit.

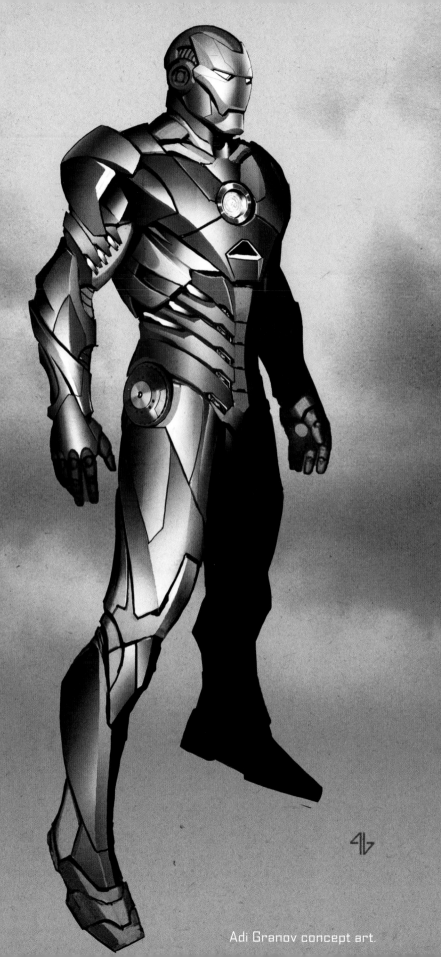

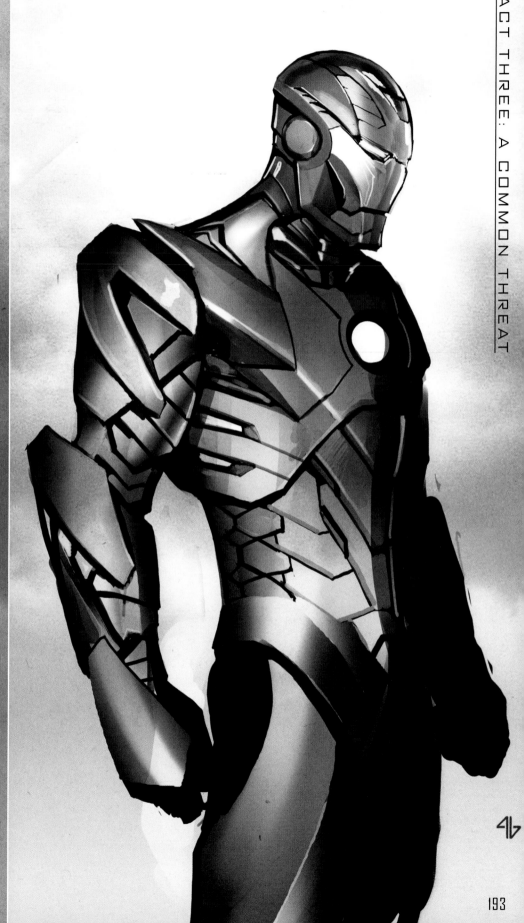

Adi Granov concept art.

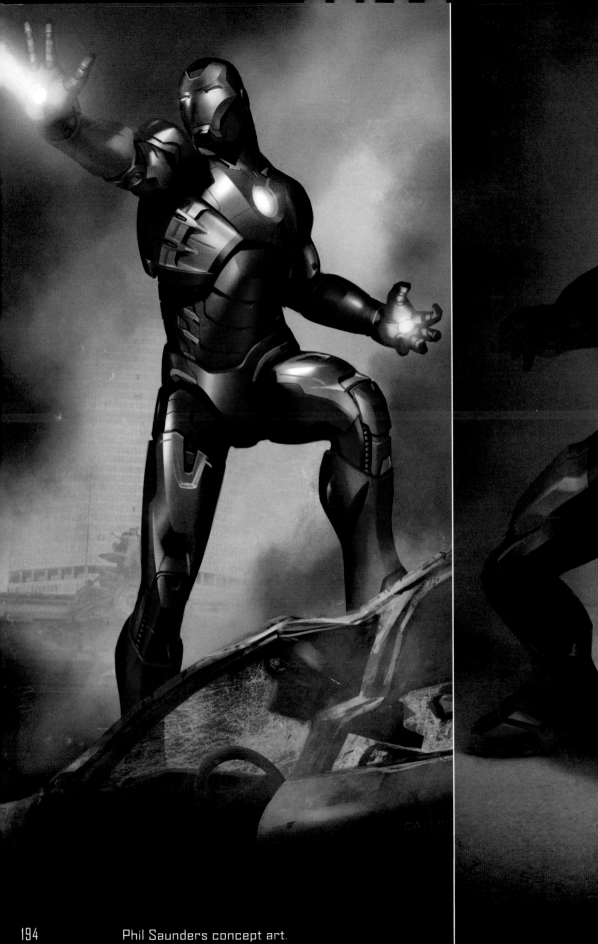
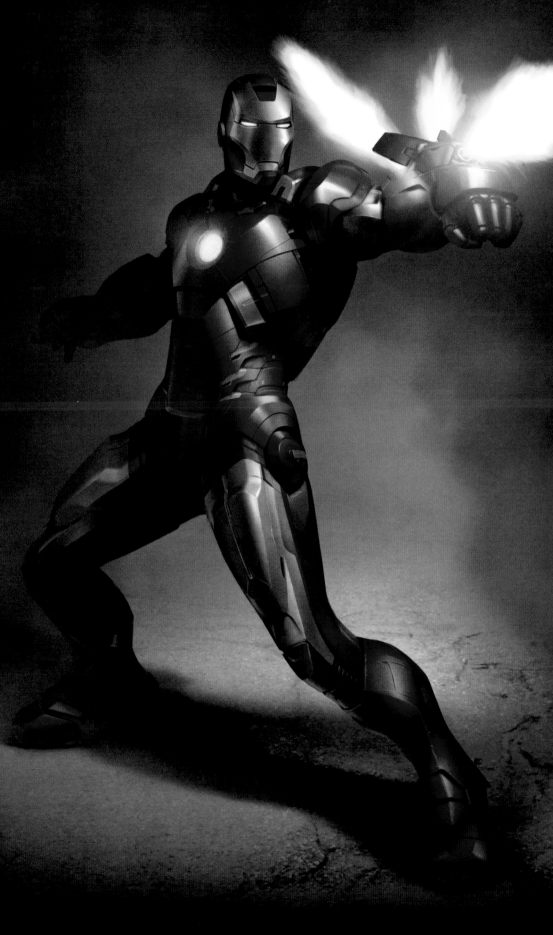

Phil Saunders concept art.

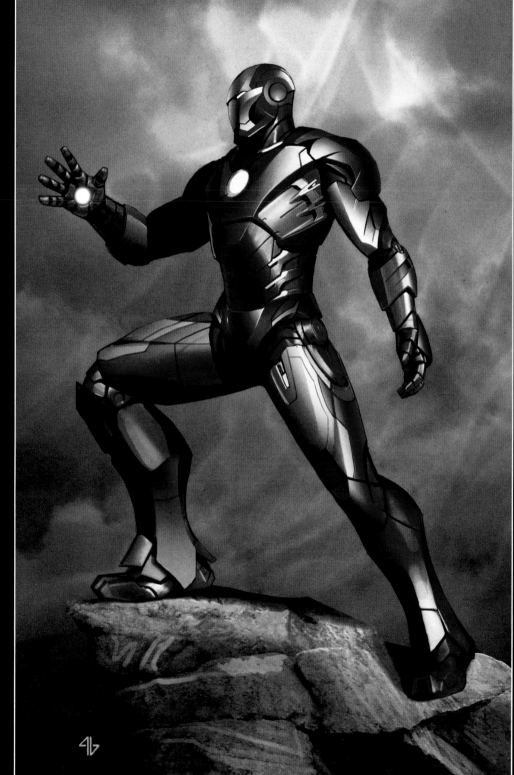

..nt, I didn't tackle that until the suit was designed and modeled so that it wouldn't compromise the ultimate design of our hero. ...ering, I was able to take Josh Herman's amazing digital model, import it into Luxology Modo, break it into components and figure ou... ... it to collapse into a missile-like shape. With a basic animation and a final collapsed silhouette, I added panels to streamline the ...ual suit surfaces as possible so as to hint at what the mysterious package would eventually become. Those panels would ultima... ...on an ICBM before the suit unfolds, adding another dynamic element to the sequence."

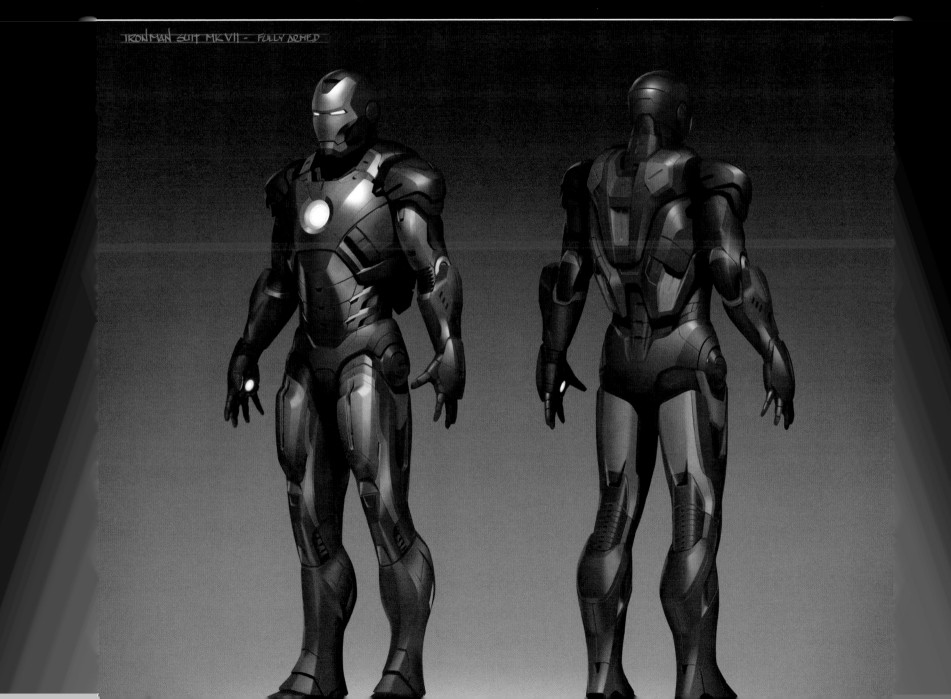

IRON MAN SUIT MK VII - FULLY ARMED

Phil Saunders concept art.

"I painted the front and rear three-quarter views and elevations over renders of the Mark IV to maintain accurate reference proportions for Josh Herman's final model," Saunders said.

SAUNDERS
1·20·11

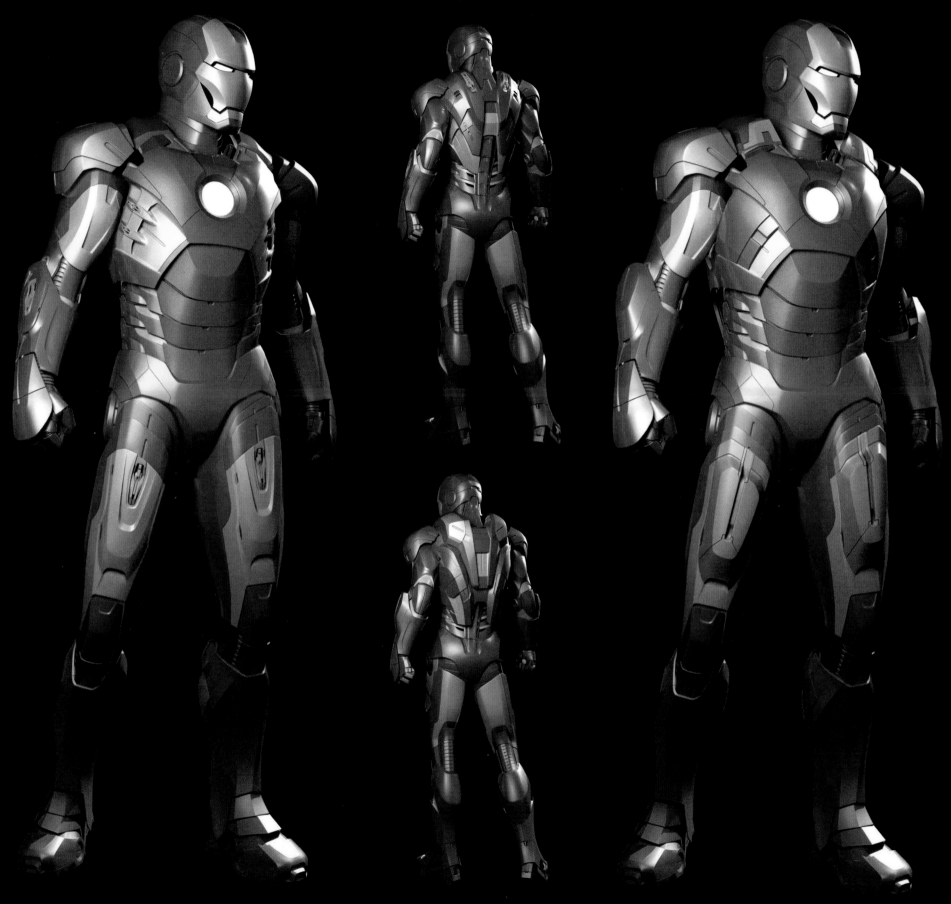

Final Mark VII digital model by Josh Herman with additional details by Gregory Smith.

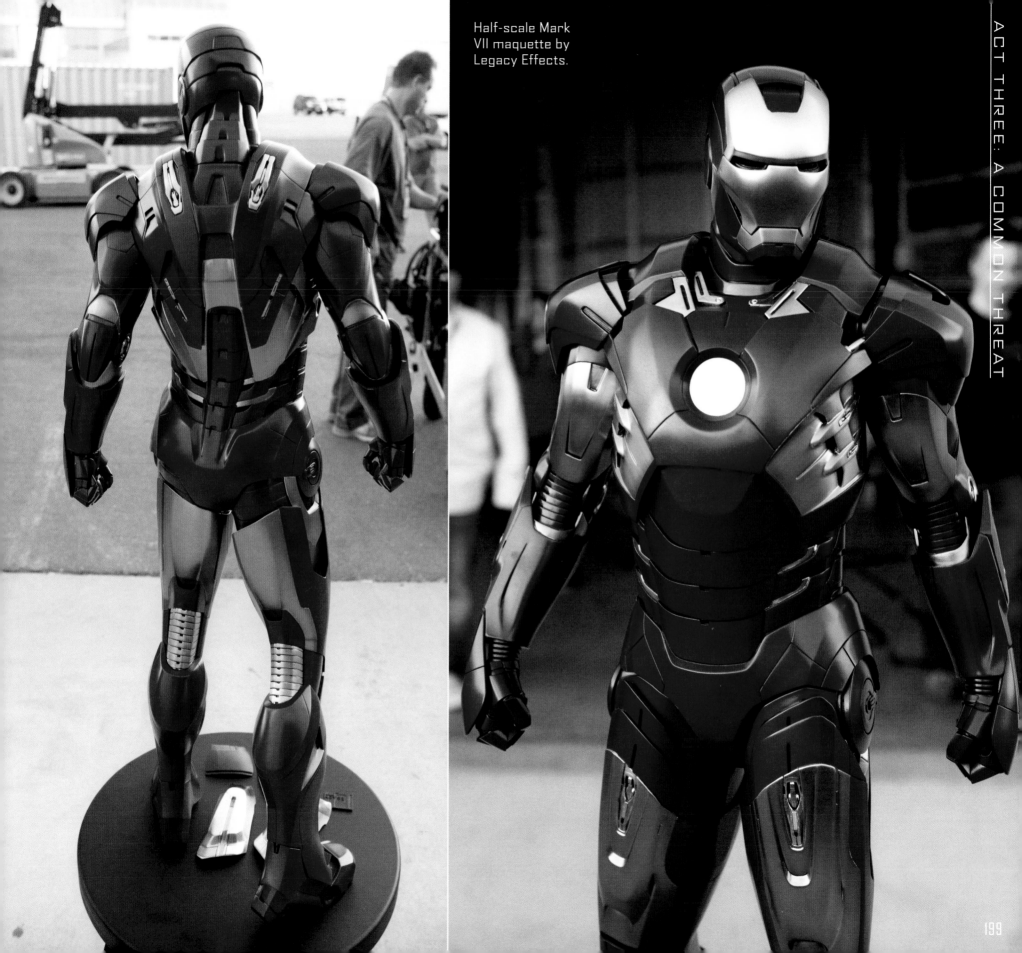

Half-scale Mark VII maquette by Legacy Effects.

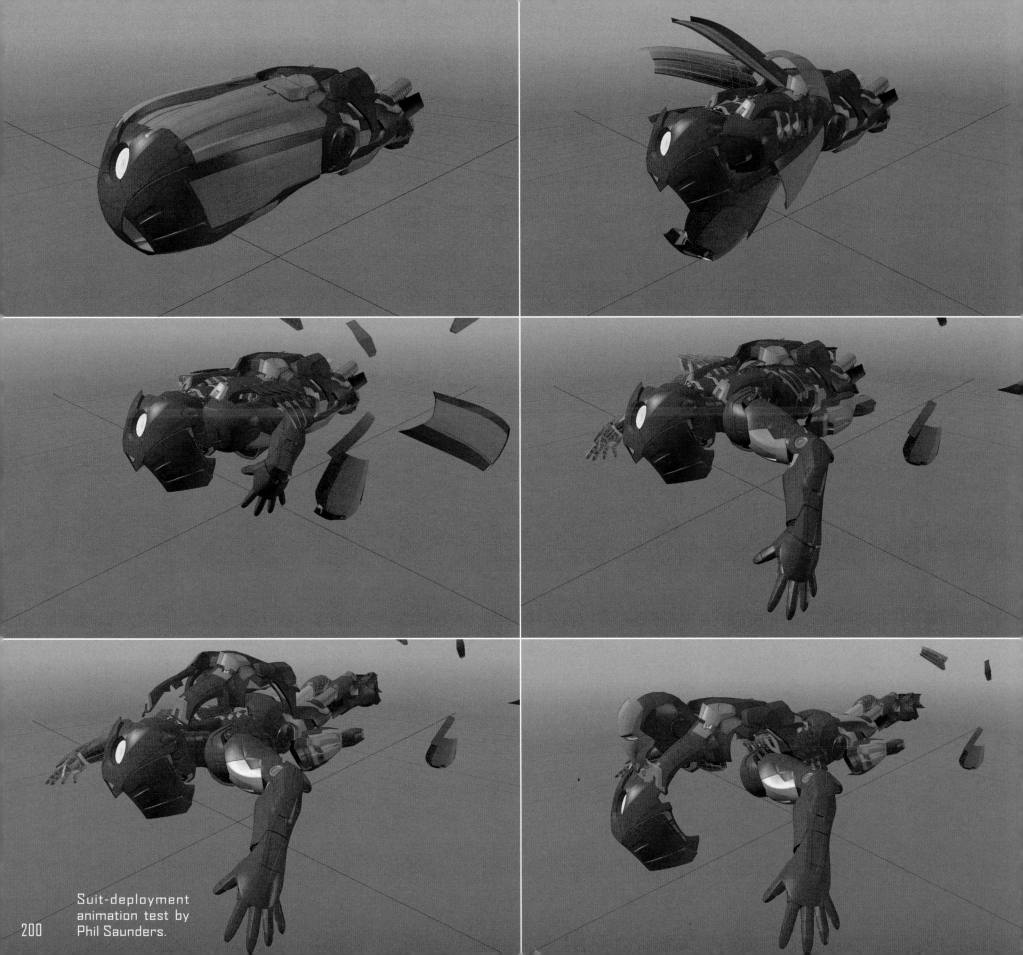

Suit-deployment
animation test by
Phil Saunders.

200

"My painting of Tony falling in mid-air whilst suiting up for the first time in the Mark VII is my favorite keyframe," Concept Artist Rodney Fuentebella said. "This was one of the first things I did on *The Avengers* — so it has sentimental value, as well as being a very awesome scene. When I saw the designs of the Mark VII, I got really pumped. So when I was given the opportunity to do a keyframe for the new suit, I had to make the Mark VII's reveal exciting. I did a rendered sequence of the suit blasting through the building, locking on to Tony and eventually going on him before even starting the keyframe. There are a lot of great scenes in this film that I had the privilege to work on, but this one marks a very exciting moment in the film that I am sure the audience is going to love."

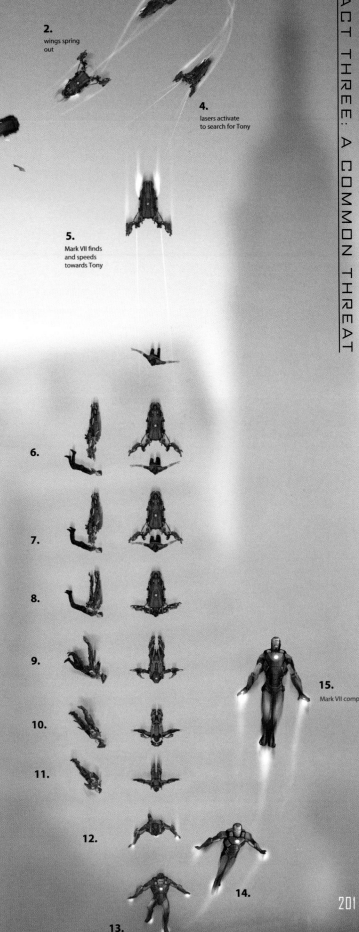

1.

2.
wings spring out

3.

4.
lasers activate to search for Tony

5.
Mark VII finds and speeds towards Tony

6.

7.

8.

9.

10.

11.

12.

13.

14.

15.
Mark VII comple

Rodney Fuentebella keyframe **right**: Fuentebella's concept rendering of the entire sequence of events, from Jarvis' activation of the Mark VII to its deployment.

201

STARK TOWER – THE PORTAL

Loki seeks not just to take over the world, but also to do so in the most dramatic, high-profile way imaginable. And there's no better place to do that than the new, clean-burning, self-sustaining Stark Tower in Midtown Manhattan — as Tony Stark himself realizes all too late. Dr. Erik Selvig has tapped into the virtually unlimited energy of the building's Arc Reactor to power a newly constructed device that will enable the Tesseract to open a much larger portal to another dimension — and allow Loki's Chitauri invasion force to pass through into our world.

Yanick Dusseault concept art.

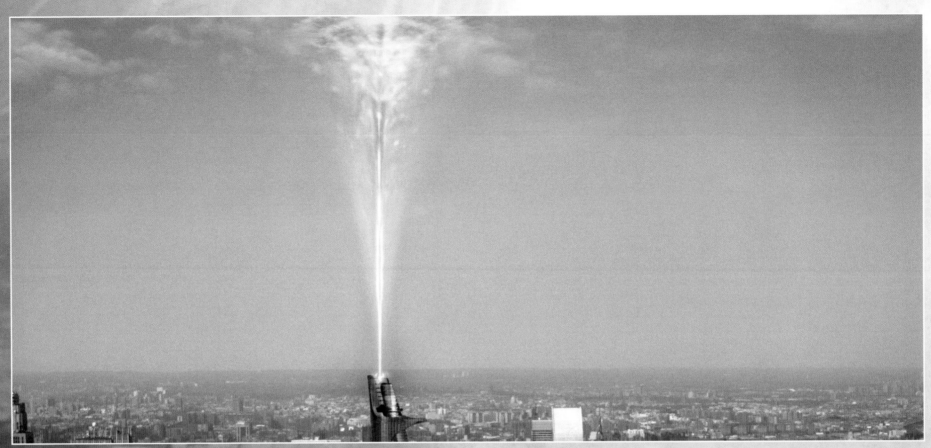

Top: John Giang paintover of the Tesseract's dark energy opening a new, larger portal from its position within a device attached to the tip of Stark Tower; **bottom:** Yanick Dusseault concept rendering of Thor using the Chrysler building as a lightning rod to summon a massive, sustained burst of lightning with which he attempts to close the portal.

203

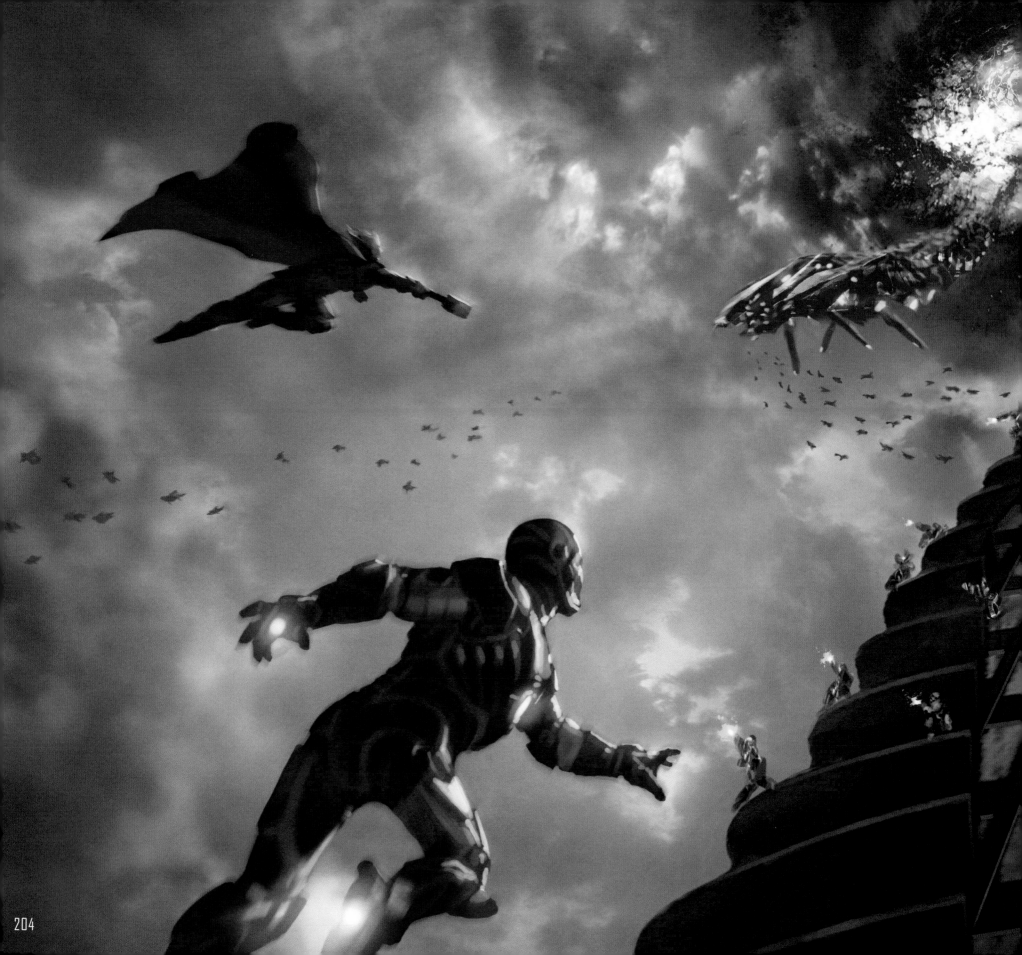

ANGLE ON: THE PORTAL

A LEVIATHAN — a beast, enormous, scaled, semi-mechanical — a
monster the width of a whale and the length of a jumbo jet —
breaches the portal and barrels towards —

EXT. STARK TOWER

Rumbling by as Thor and Loki fight on a balcony, heading
straight down towards the —

EXT. PARK AVE RAMP

As Cap, Natasha and Hawkeye look skywards to see the beast
fill the sky above them, the "scales" on the Leviathan's side
moving — and suddenly springing out, revealed to be a platoon
of foot soldiers. They hit the walls of the building and
cling, then begin sliding down.

Andy Park keyframe.

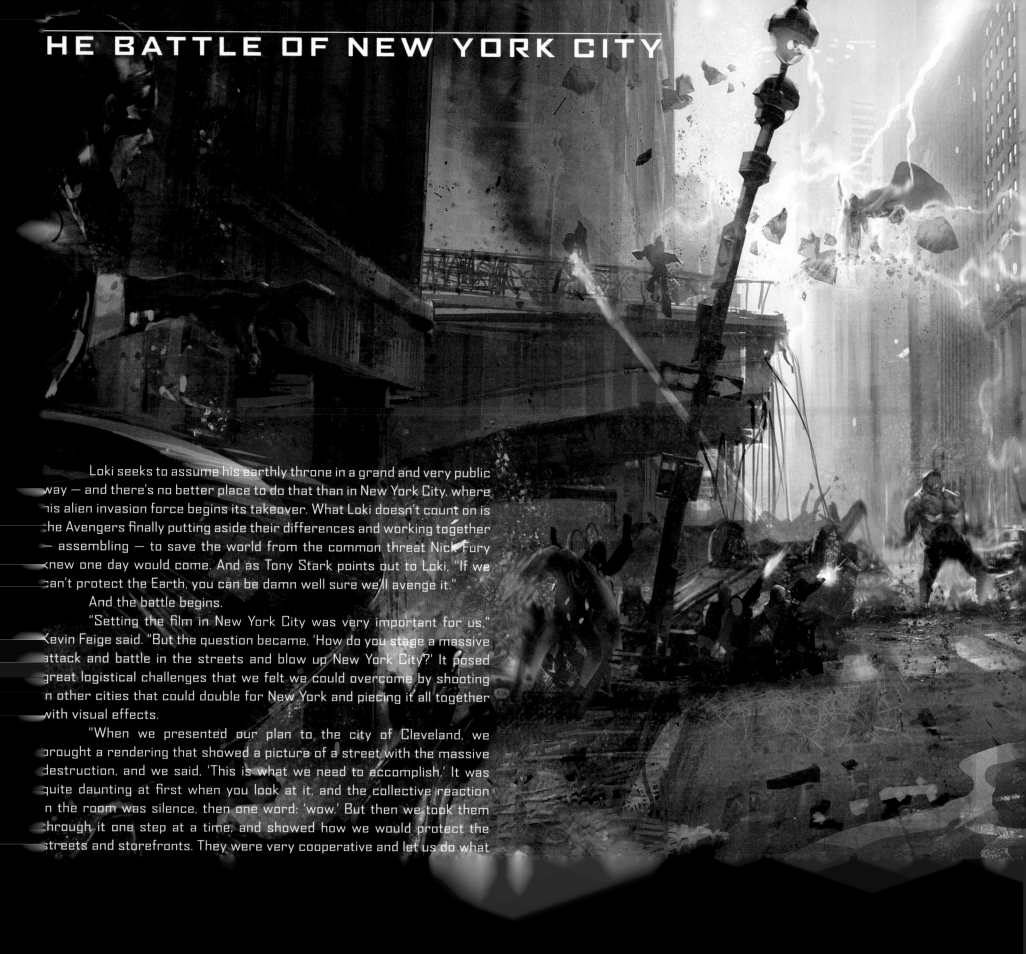

HE BATTLE OF NEW YORK CITY

Loki seeks to assume his earthly throne in a grand and very public way — and there's no better place to do that than in New York City, where his alien invasion force begins its takeover. What Loki doesn't count on is the Avengers finally putting aside their differences and working together — assembling — to save the world from the common threat Nick Fury knew one day would come. And as Tony Stark points out to Loki, "If we can't protect the Earth, you can be damn well sure we'll avenge it."

And the battle begins.

"Setting the film in New York City was very important for us," Kevin Feige said. "But the question became, 'How do you stage a massive attack and battle in the streets and blow up New York City?' It posed great logistical challenges that we felt we could overcome by shooting in other cities that could double for New York and piecing it all together with visual effects.

"When we presented our plan to the city of Cleveland, we brought a rendering that showed a picture of a street with the massive destruction, and we said, 'This is what we need to accomplish.' It was quite daunting at first when you look at it, and the collective reaction in the room was silence, then one word: 'wow.' But then we took them through it one step at a time, and showed how we would protect the streets and storefronts. They were very cooperative and let us do what

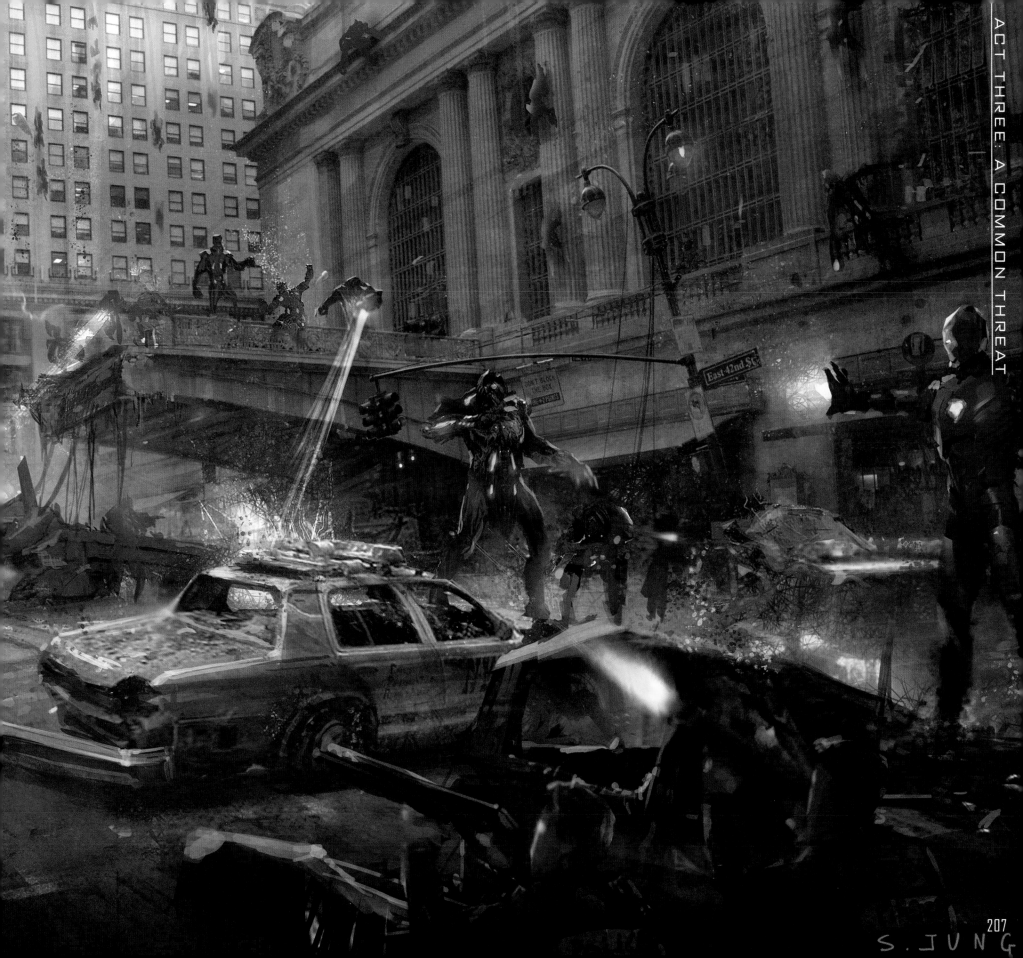

207

S.JUNG

THE CHITAURI

The alien race with which Loki forges his dark alliance is the Chitauri — which takes its name from the shape-shifting alien species that appeared in *The Ultimates*, the popular reimagining of the Avengers first published in 2002 as part of the Ultimate Marvel imprint. In the comics, the Chitauri allegedly come from the fourth dimension and are revealed to have financed the Nazi regime in their initial attempt to conquer Earth. The film version of the Chitauri share only a name with their comic-book predecessors. They are not shape-shifters and primarily serve as alien muscle for Loki.

"The aliens were an interesting challenge," Visual Development Supervisor Ryan Meinerding said. "We were tasked with creating a new alien race that wasn't necessarily from the comics — so the first week we worked on them, our team just generated a huge amount of rough concepts. We just kept trying new things and seeing what everyone was responding to. The direction ended up going to a place where there was a sense of regality in the aliens, that they almost thought that taking over the world would be an easy task for them."

Joss Whedon advocated a fresh take on the film's alien menace.

"We didn't want the aliens to be mistaken for one of the Marvel stalwarts such as the Kree or the Skrulls," Whedon said. "They didn't need any kind of explanation. They just needed to show up and kick ass."

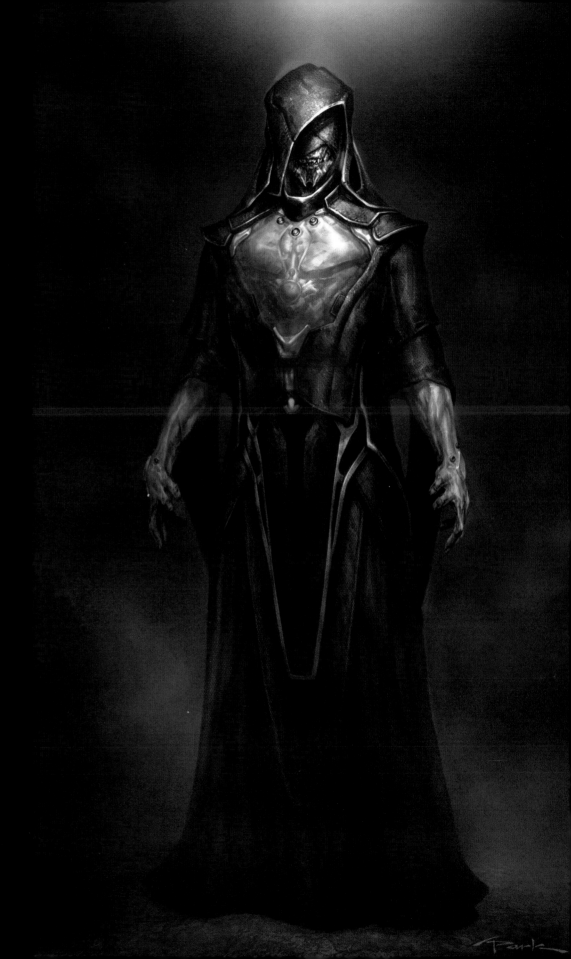

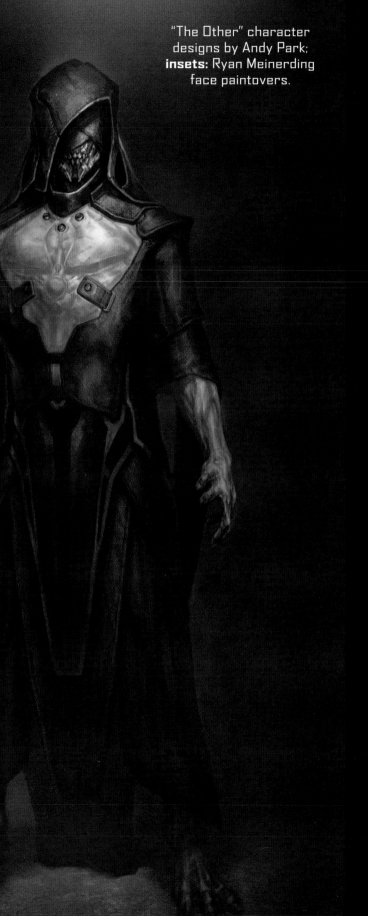

"The Other" character designs by Andy Park; **insets:** Ryan Meinerding face paintovers.

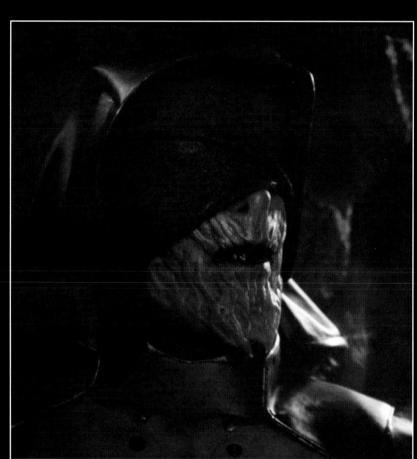

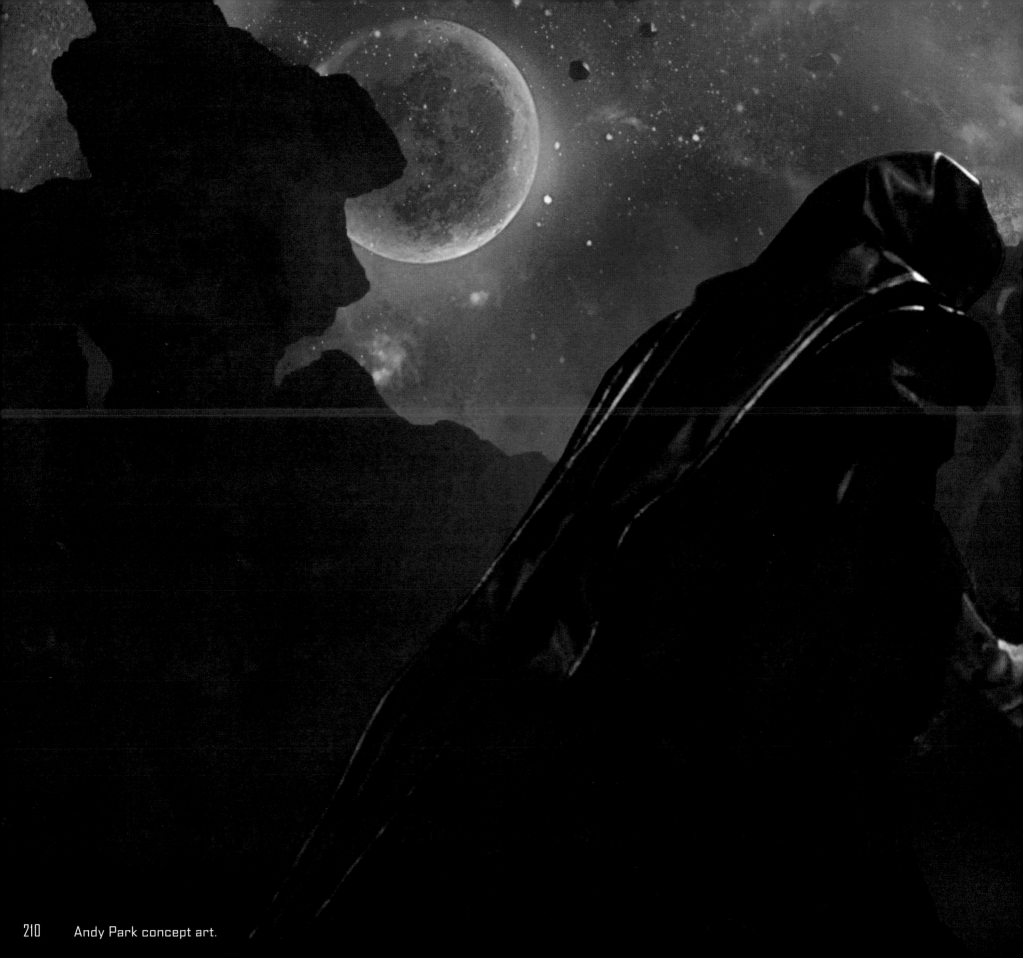

Andy Park concept art.

Throughout the design process, the Chitauri foot soldiers were consistently depicted as humanoid and slightly reptilian in appearance, as seen in these early concept renderings, with most of the variations occurring in the body armor and weaponry.

Concept art by Adi Granov (top row) and Justin Sweet (bottom row).

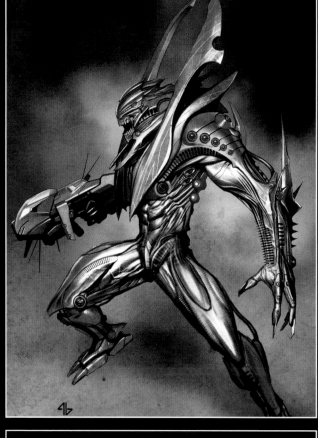

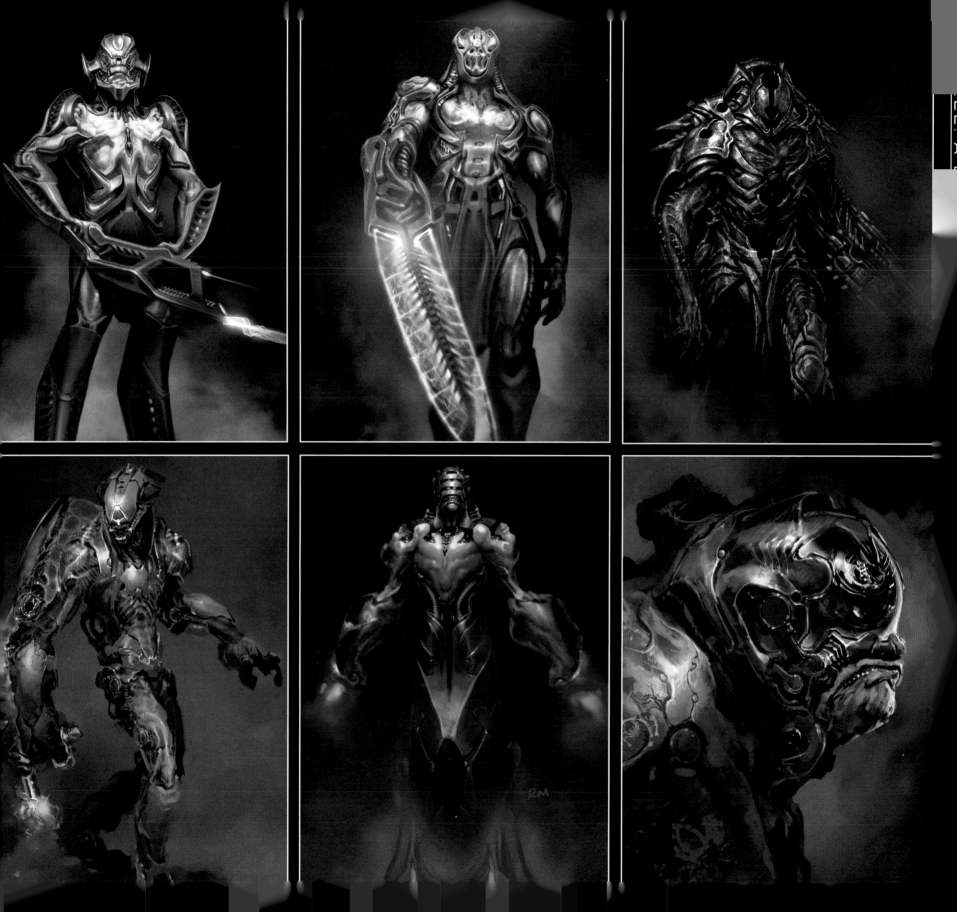

"Justin Sweet and I worked on a few concepts — and then with a sketch from Iain McCaig to figure out their heads, I did an early 3D model for the infantry and for the chariots," Meinerding said. "I really loved the idea of these sort of gross creatures that were all snowy white and covered in golden armor — basically creating this contrast between a battle-hardened army and the imperial, colonial majesty they represent."

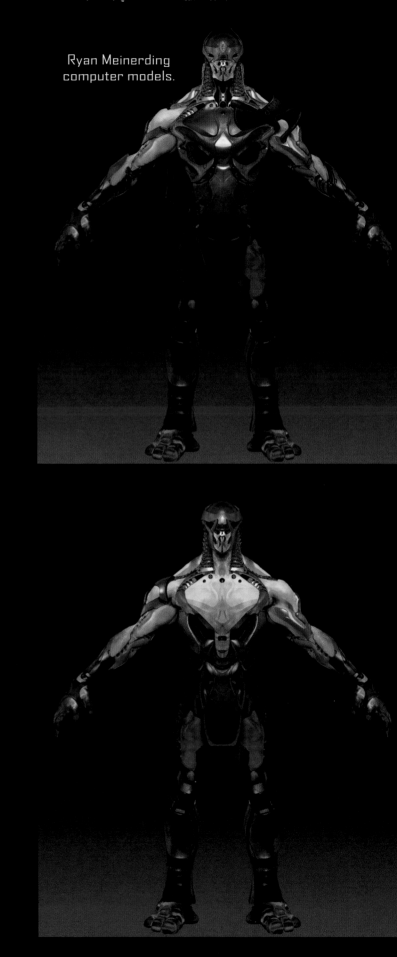

Ryan Meinerding computer models.

Iain McCaig sketch.

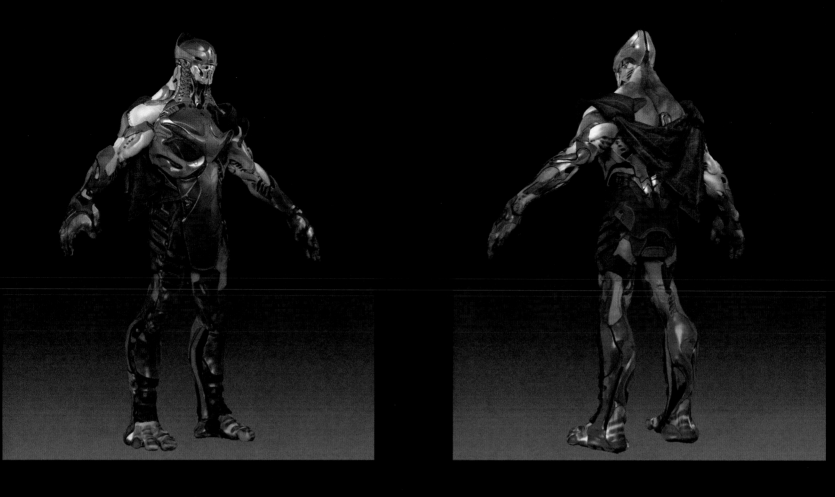

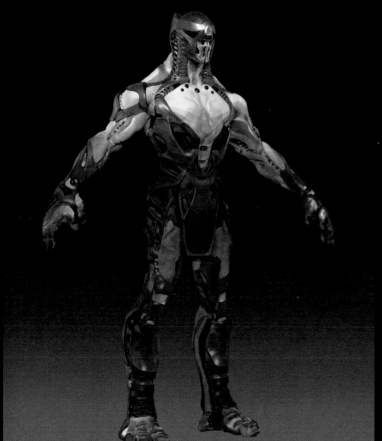

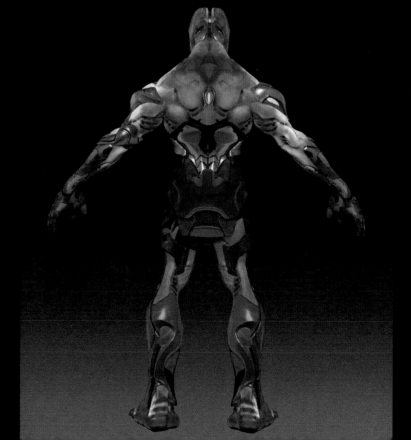

215

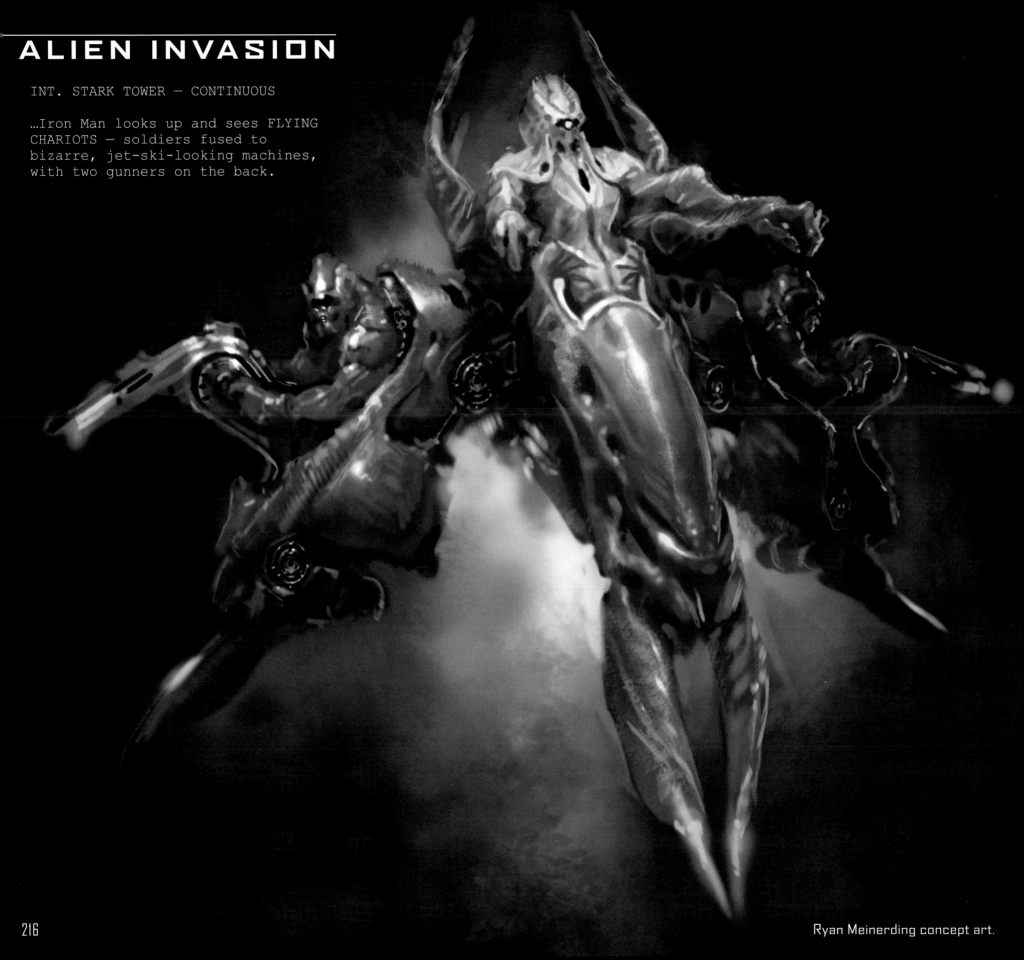

ALIEN INVASION

INT. STARK TOWER — CONTINUOUS

...Iron Man looks up and sees FLYING
CHARIOTS — soldiers fused to
bizarre, jet-ski-looking machines,
with two gunners on the back.

Ryan Meinerding concept art.

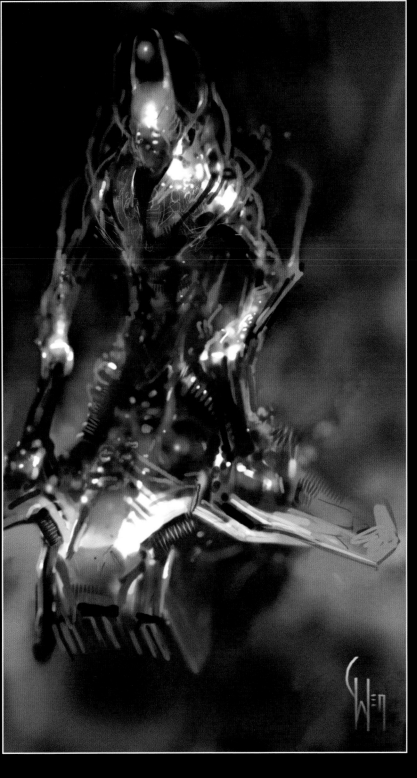

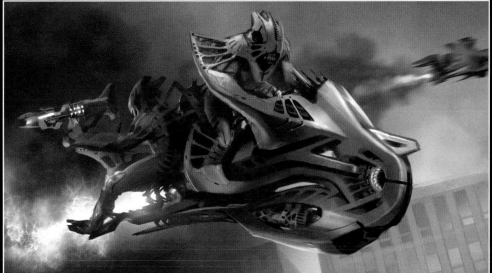

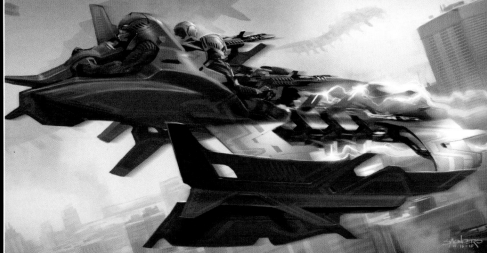

Concept art by Charlie Wen (left), Phil Saunders (top right, center) and Ryan Meinerding (bottom right).

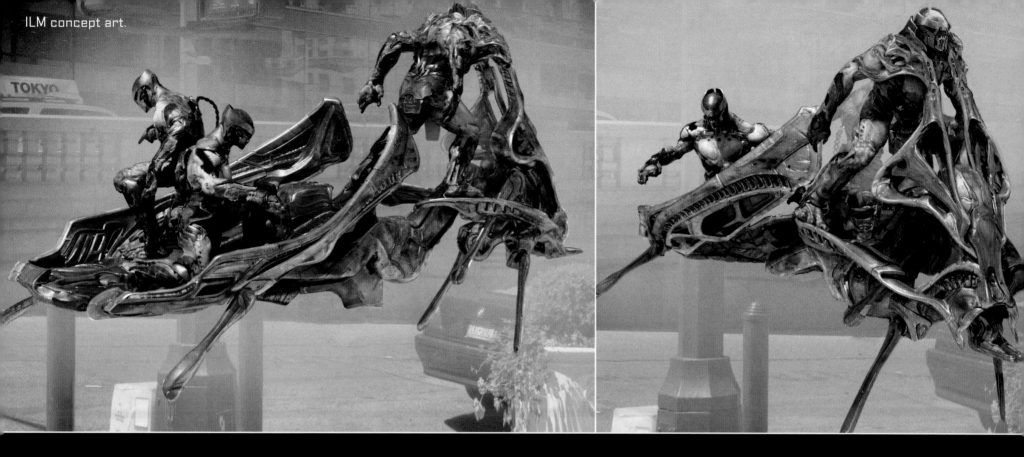

ILM concept art.

Ryan Meinerding concept art.

218

Ryan Meinerding concept rendering of a Chitauri and its staff;
right: Tani Kunitake concept renderings of a Chitauri staff.

219

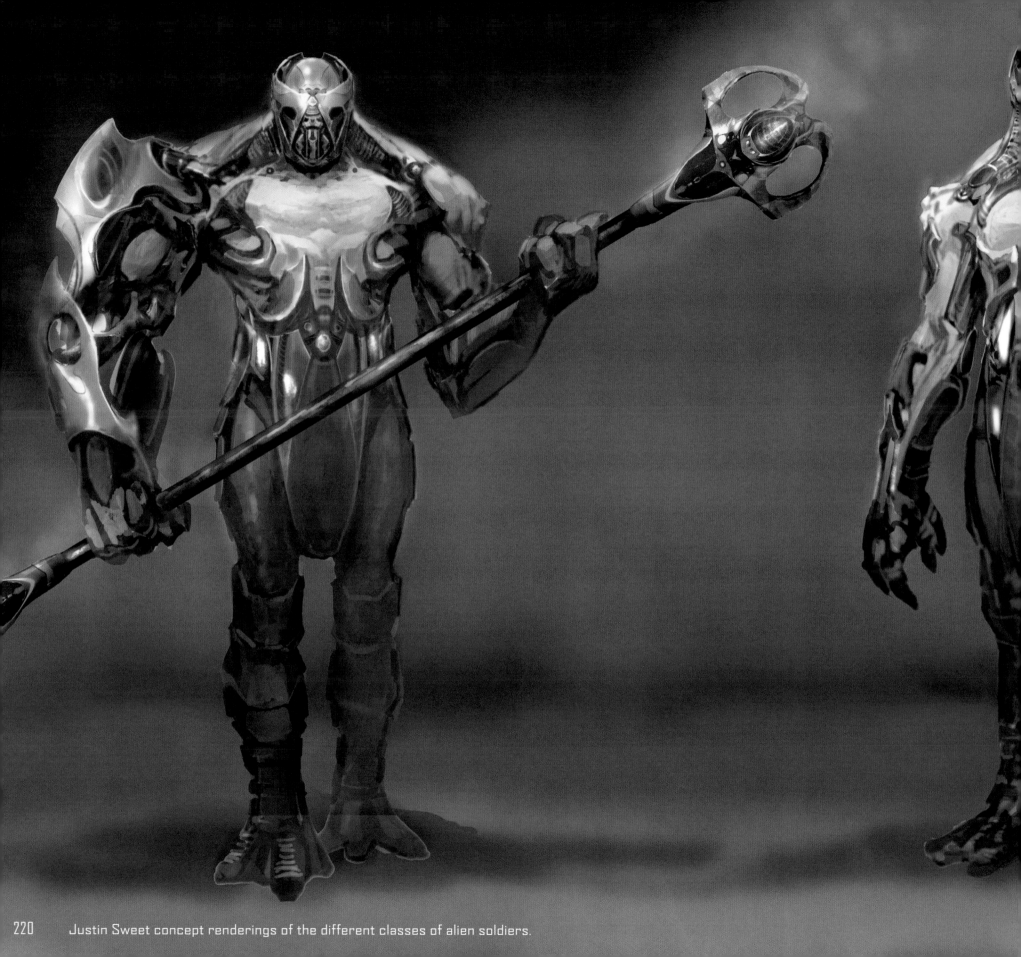

Justin Sweet concept renderings of the different classes of alien soldiers.

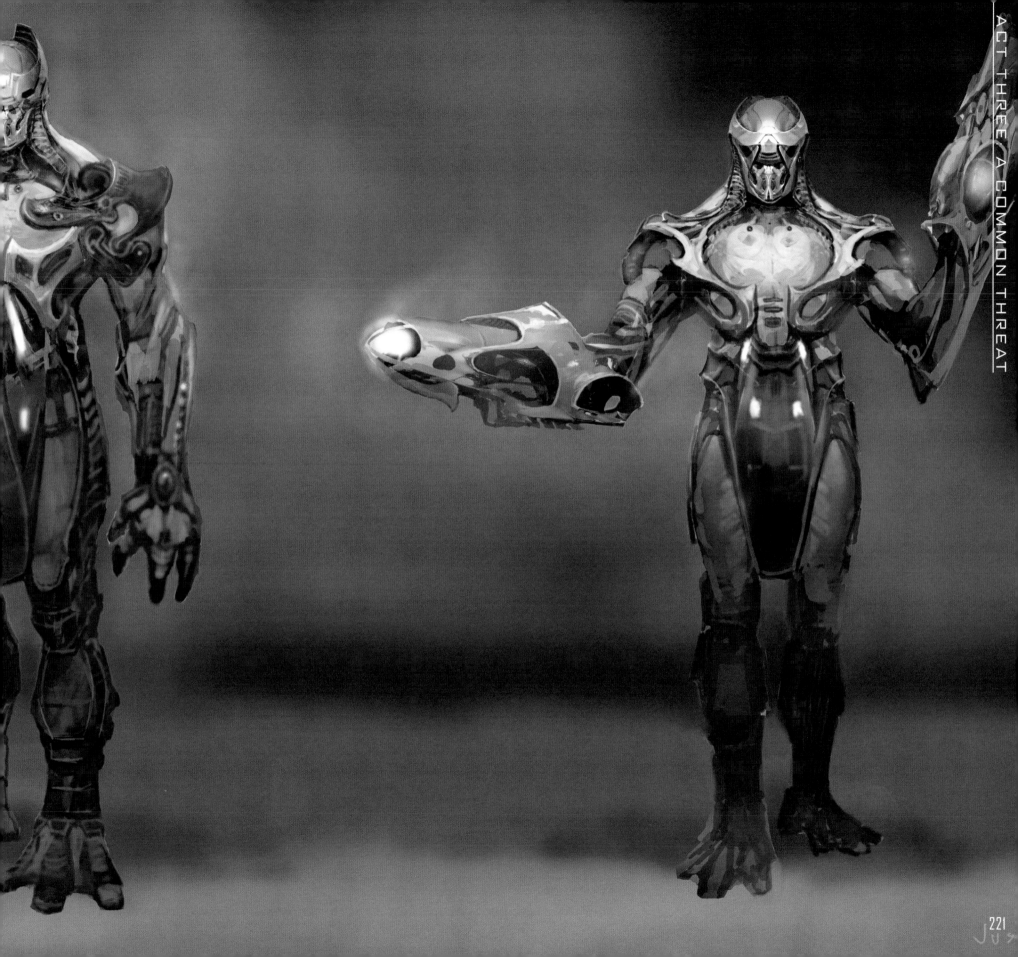

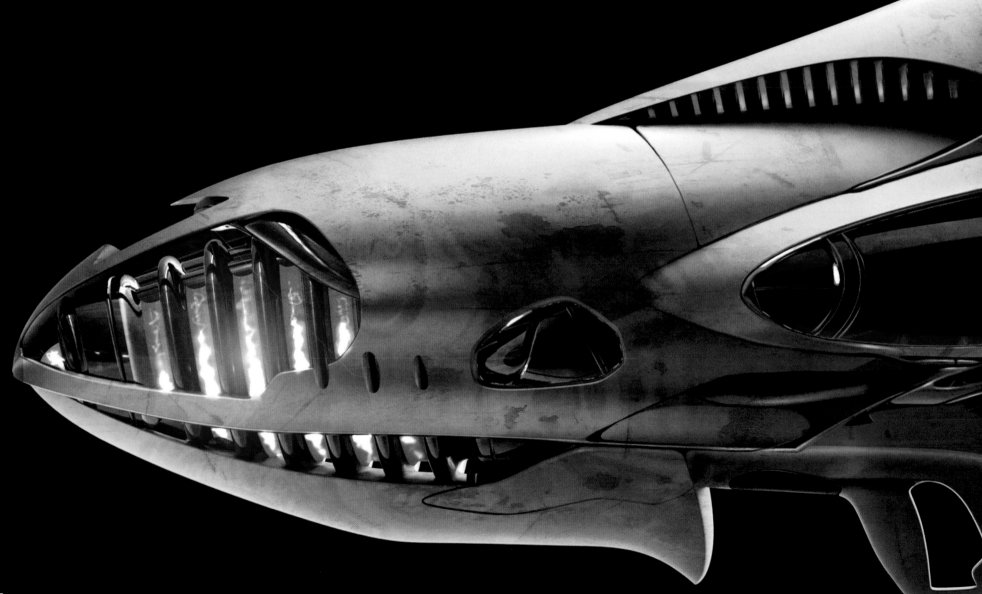

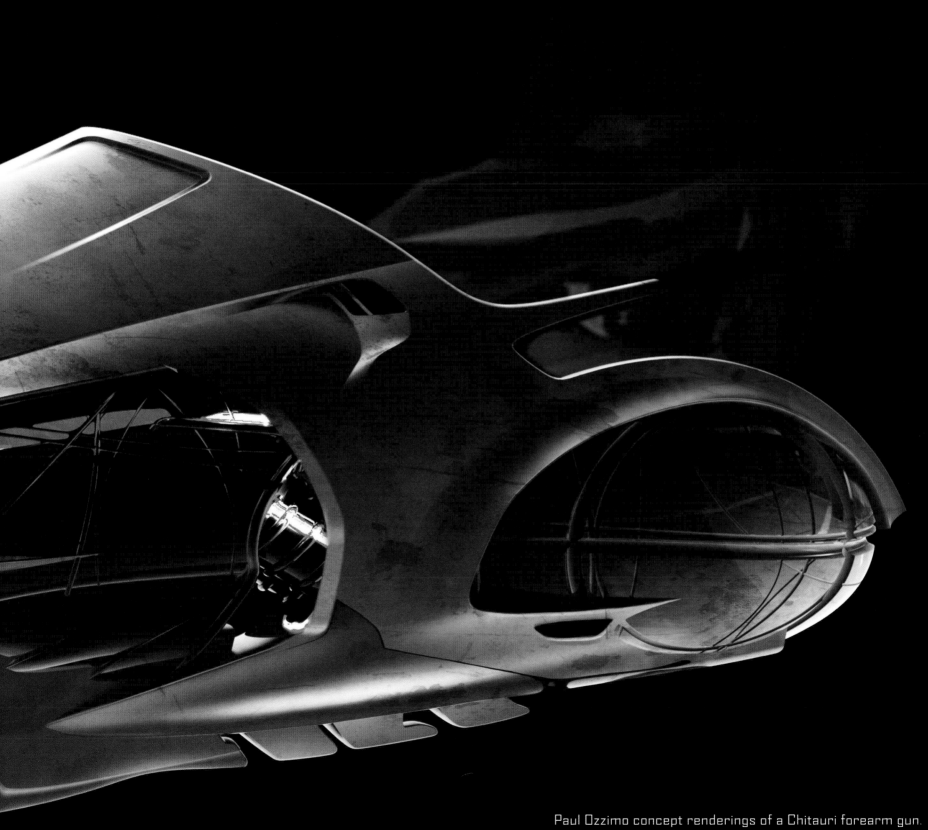

Paul Ozzimo concept renderings of a Chitauri forearm gun.

LOKI'S CHARIOT

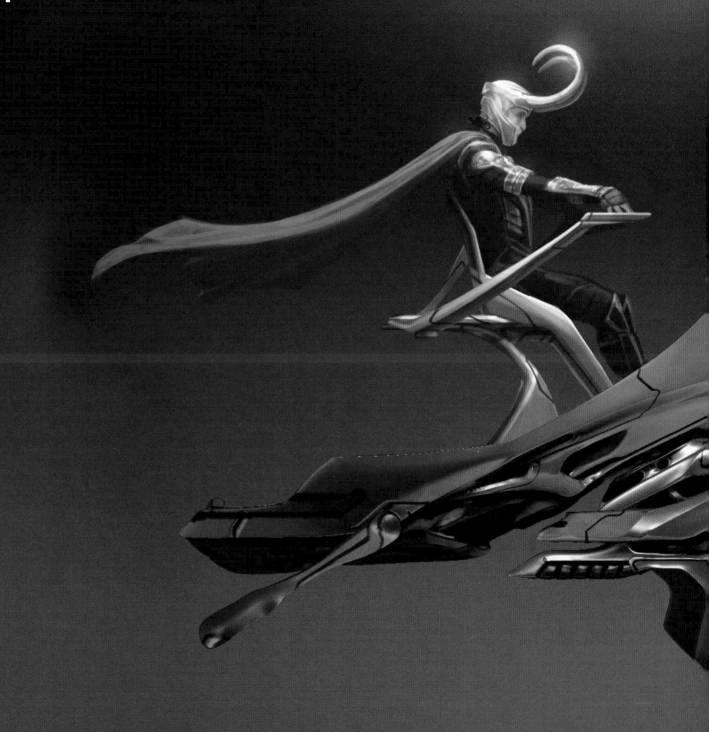

Concept art by Ryan Meinerding (computer model) and Andy Park (Loki paintover)

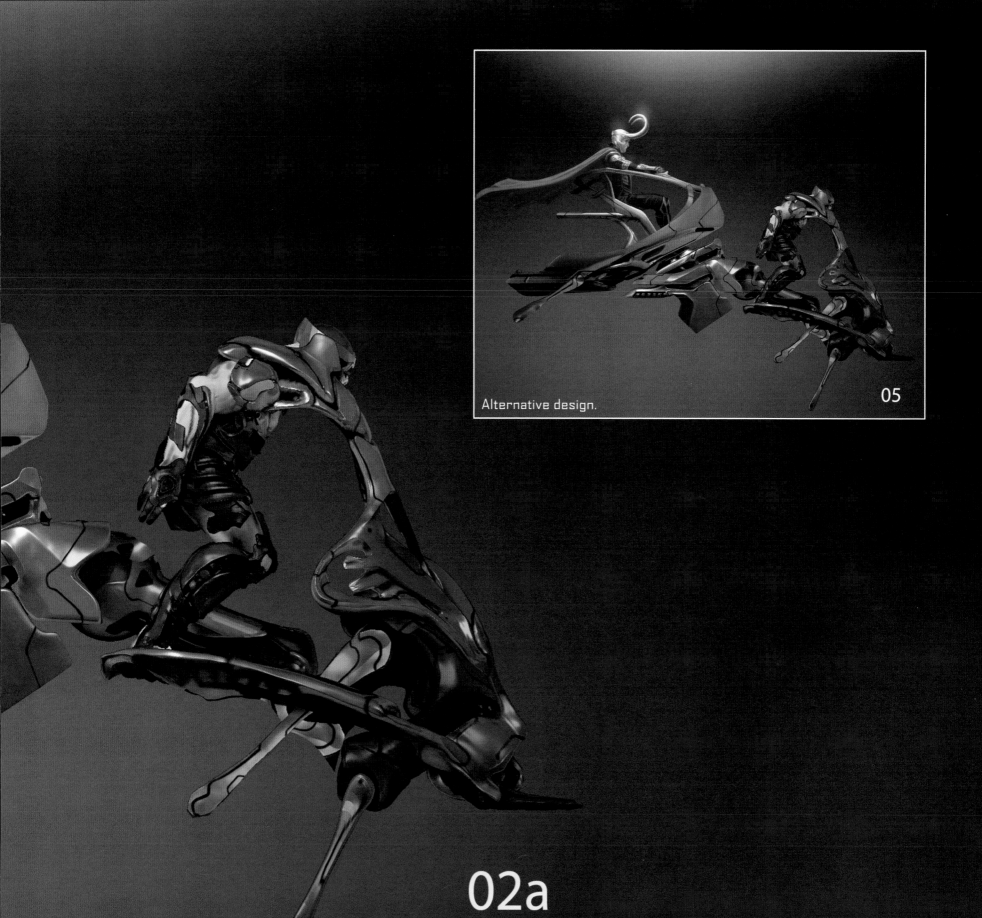

Alternative design.

05

02a

LEVIATHANS

The Chitauri's secret weapon is a squadron of Leviathans, giant armored space creatures serving as interdimensional troop transports for legions of foot soldiers who emerge from the scaled sides of these biomechanical beings to wreak havoc on New York City. The Hulk smashes the first Leviathan square in the face — causing the creature to accordion in on itself and expose enough of its fleshy interior for Iron Man to blast it to pieces, showering Manhattan with its alien insides. But that Leviathan is only the first of many, and Earth's Mightiest Heroes must work together to take out the rest — including one Iron Man destroys from the inside out.

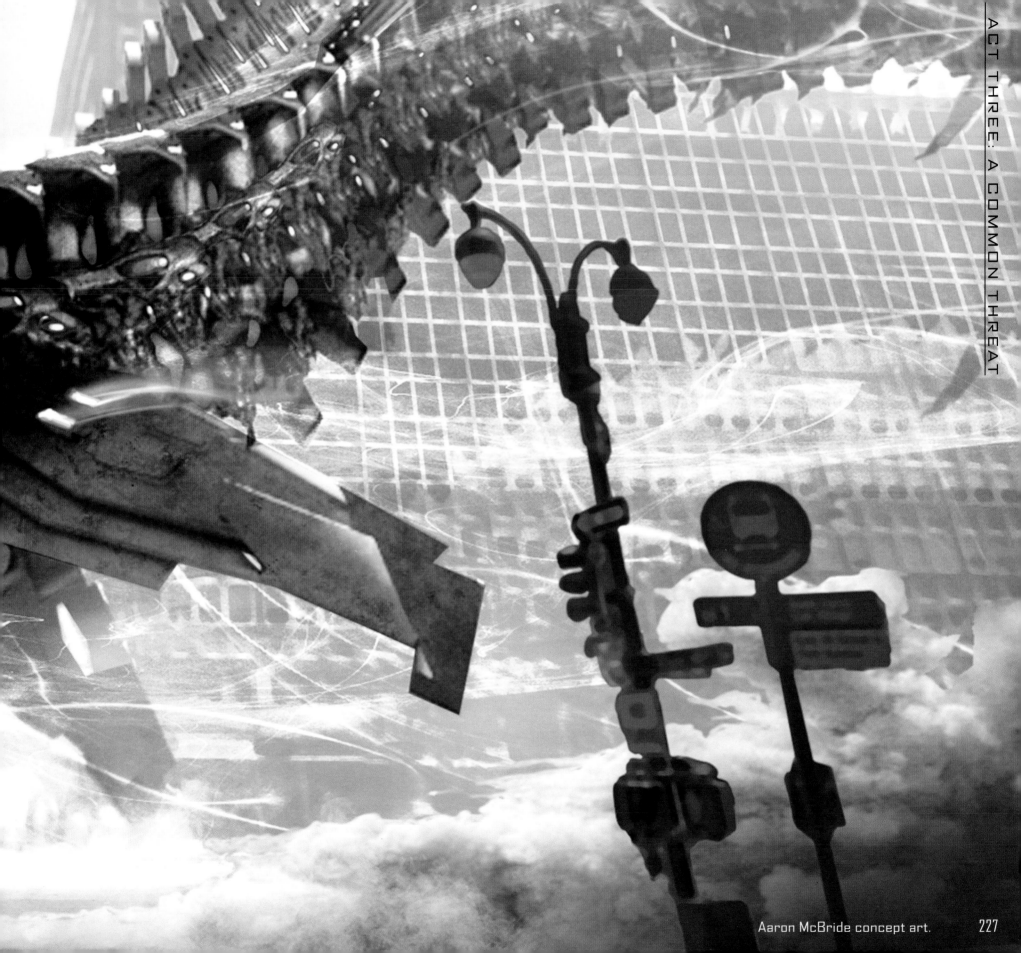

Aaron McBride concept art.

Aaron McBride concept art

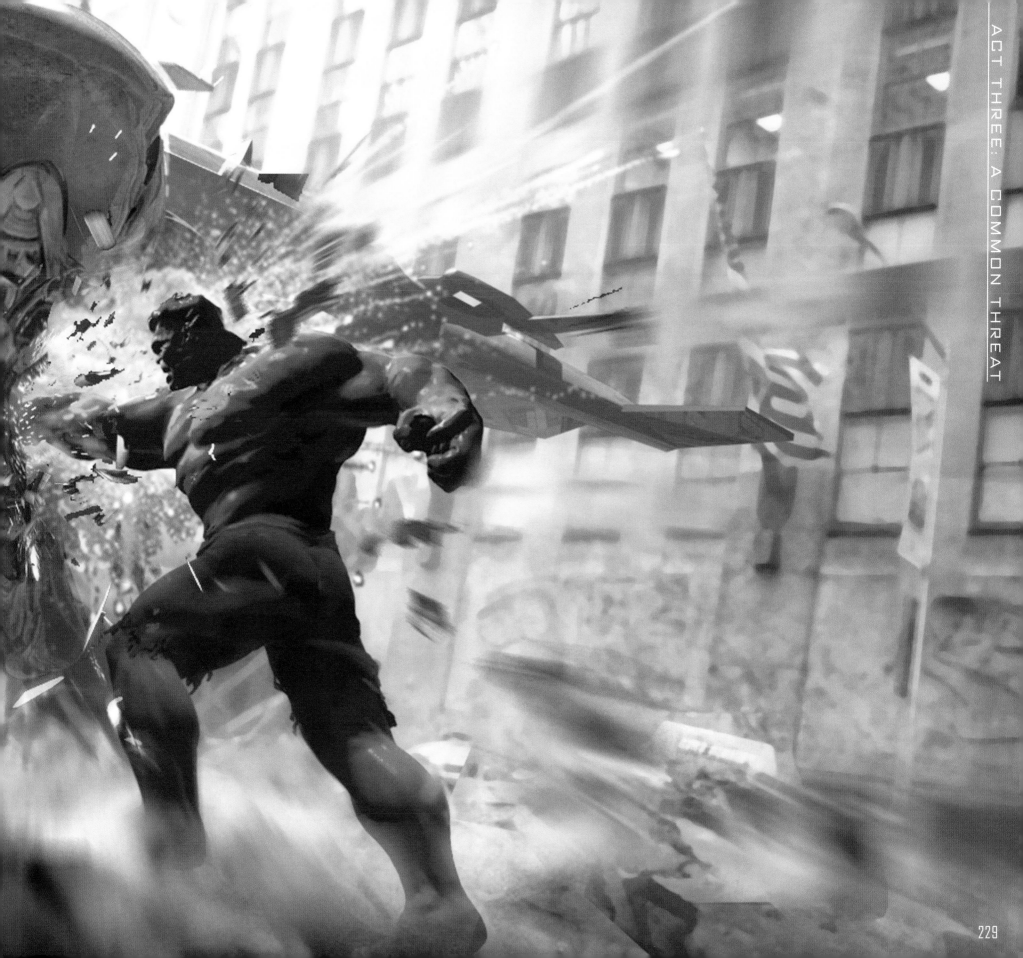

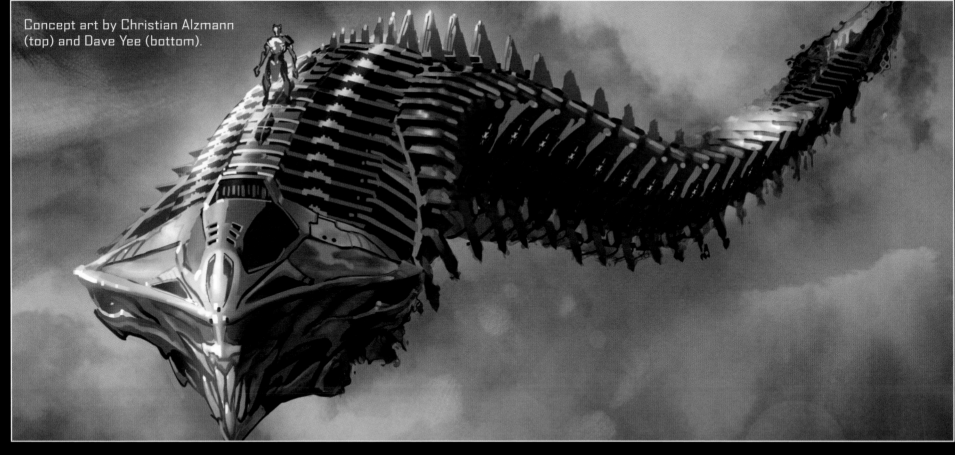

Concept art by Christian Alzmann (top) and Dave Yee (bottom).

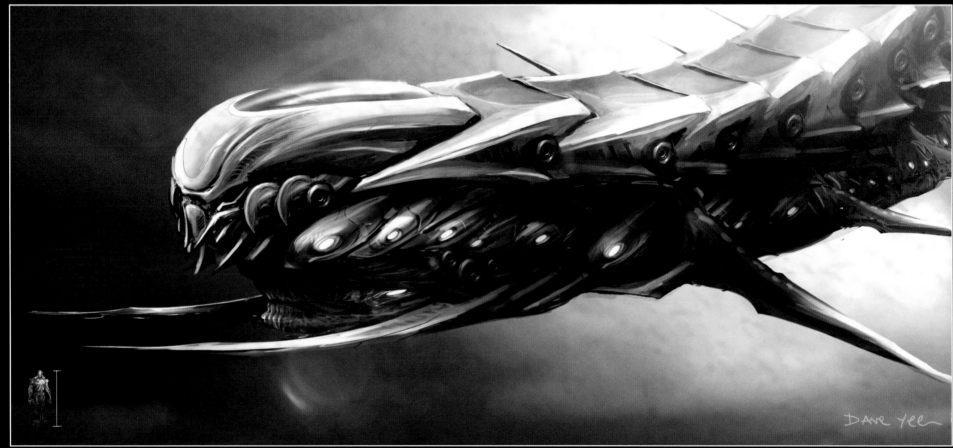

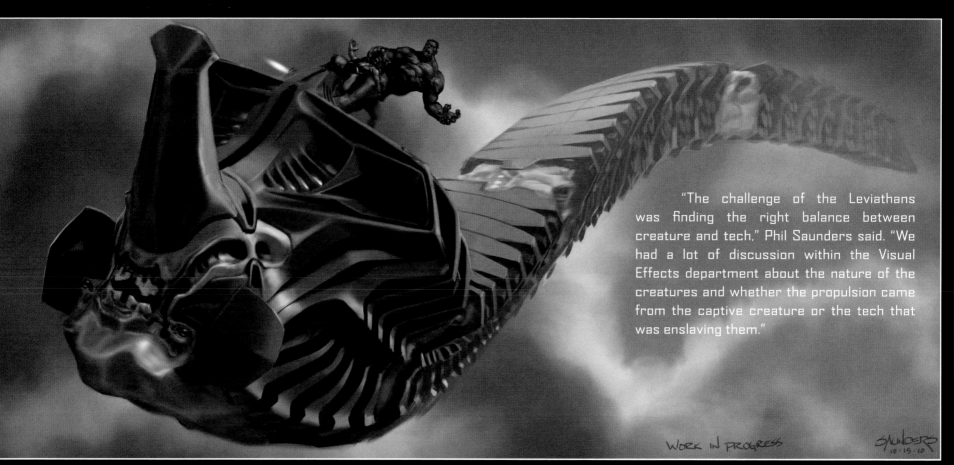

"The challenge of the Leviathans was finding the right balance between creature and tech," Phil Saunders said. "We had a lot of discussion within the Visual Effects department about the nature of the creatures and whether the propulsion came from the captive creature or the tech that was enslaving them."

WORK IN PROGRESS

SAUNDERS
10·15·10

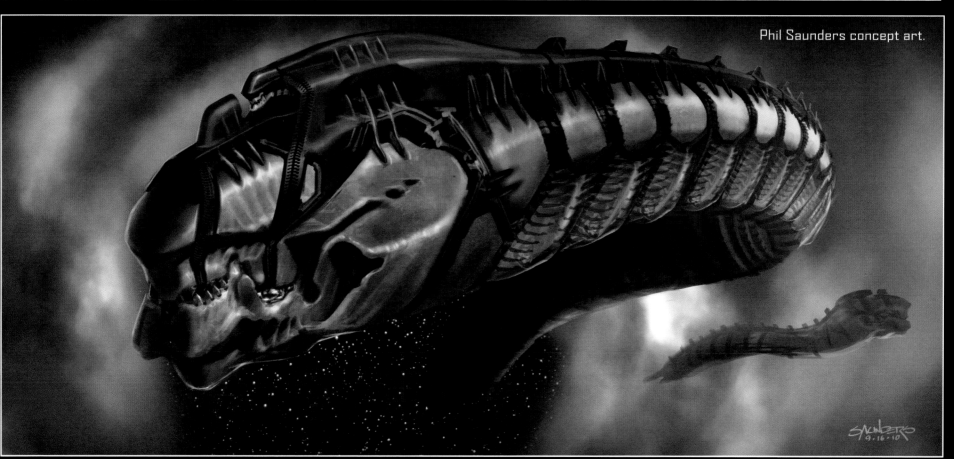

Phil Saunders concept art.

SAUNDERS
9·16·10

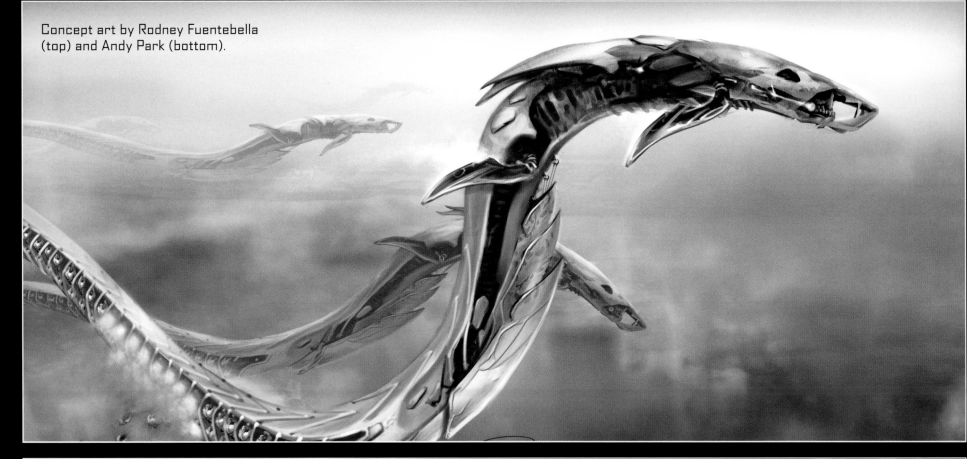

Concept art by Rodney Fuentebella
(top) and Andy Park (bottom).

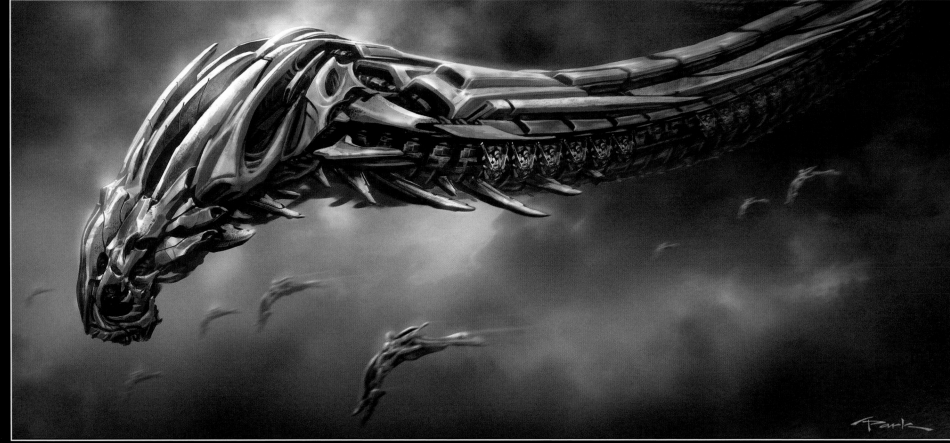

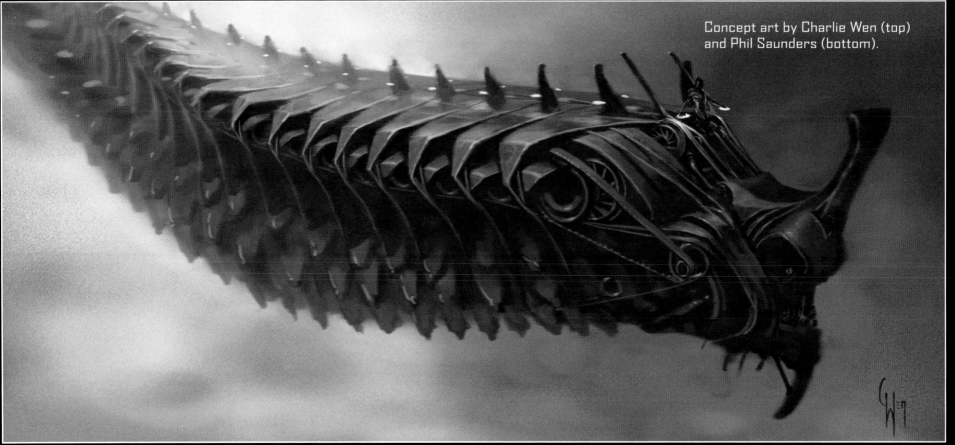

Concept art by Charlie Wen (top)
and Phil Saunders (bottom).

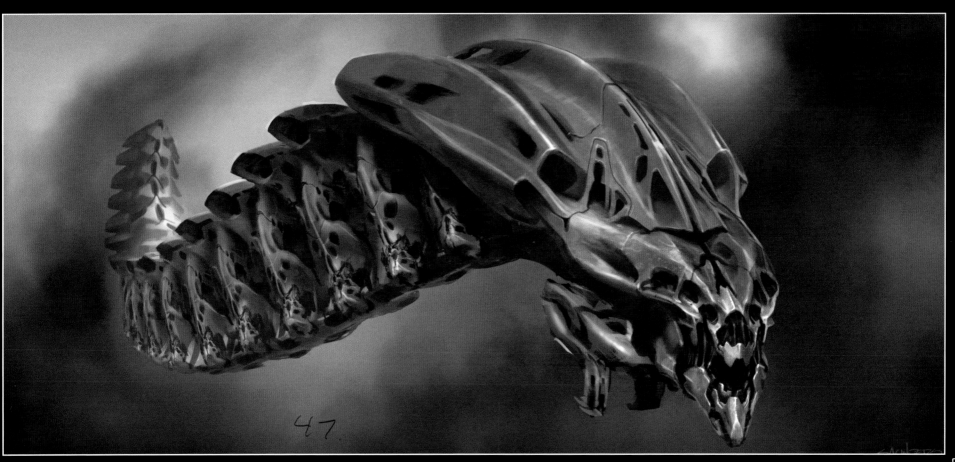

47.

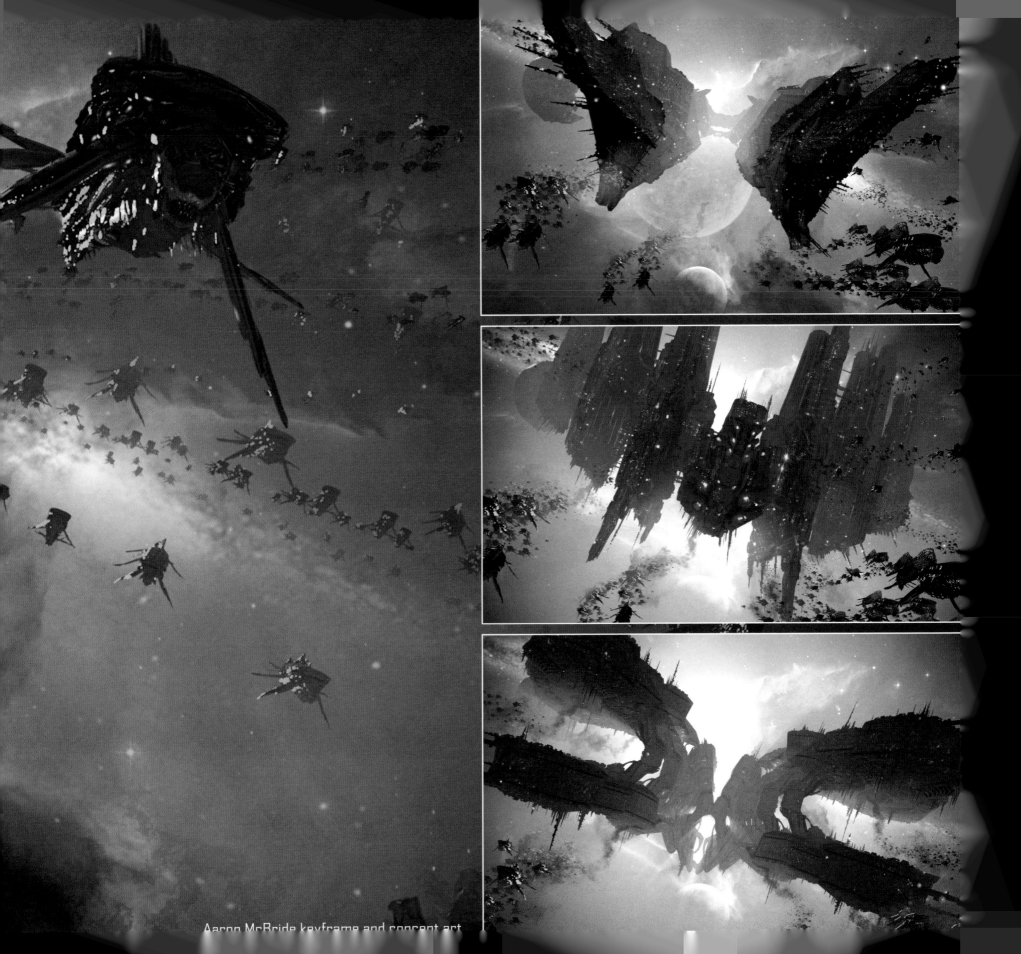

Aaron McBride keyframe and concept art

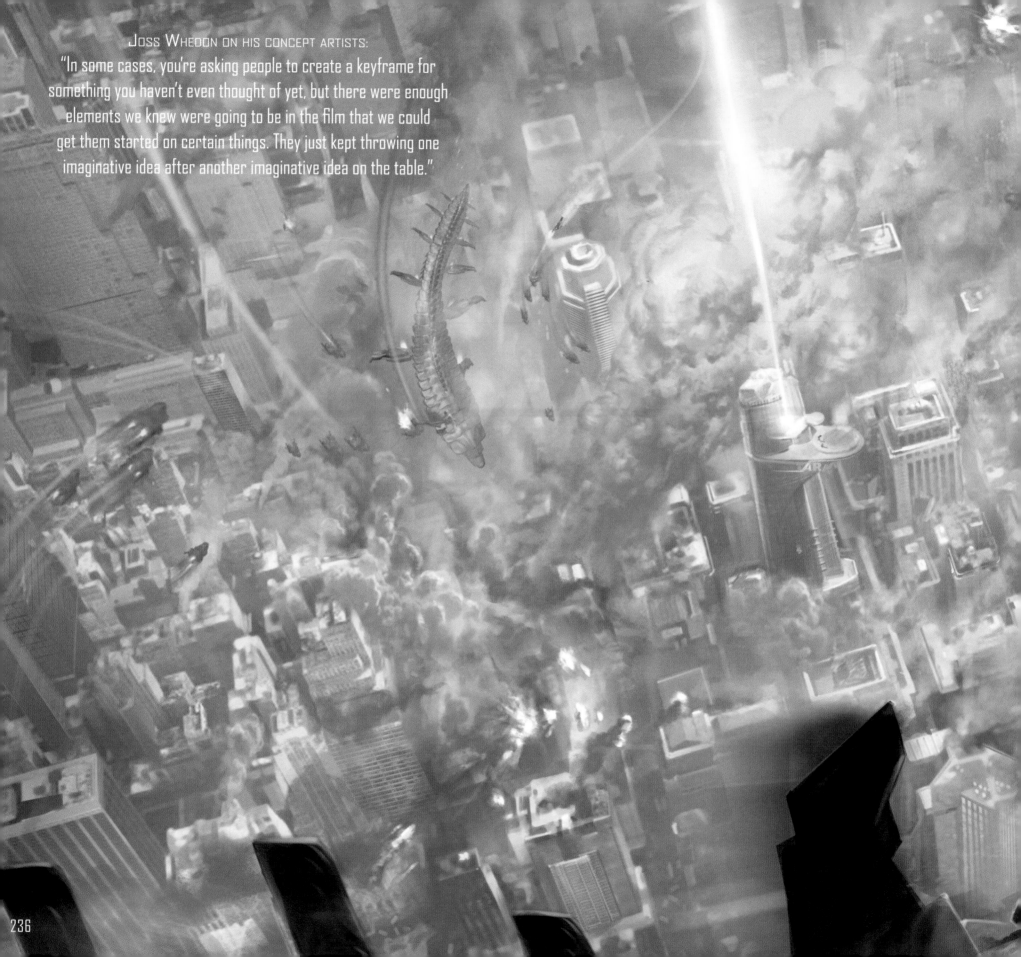

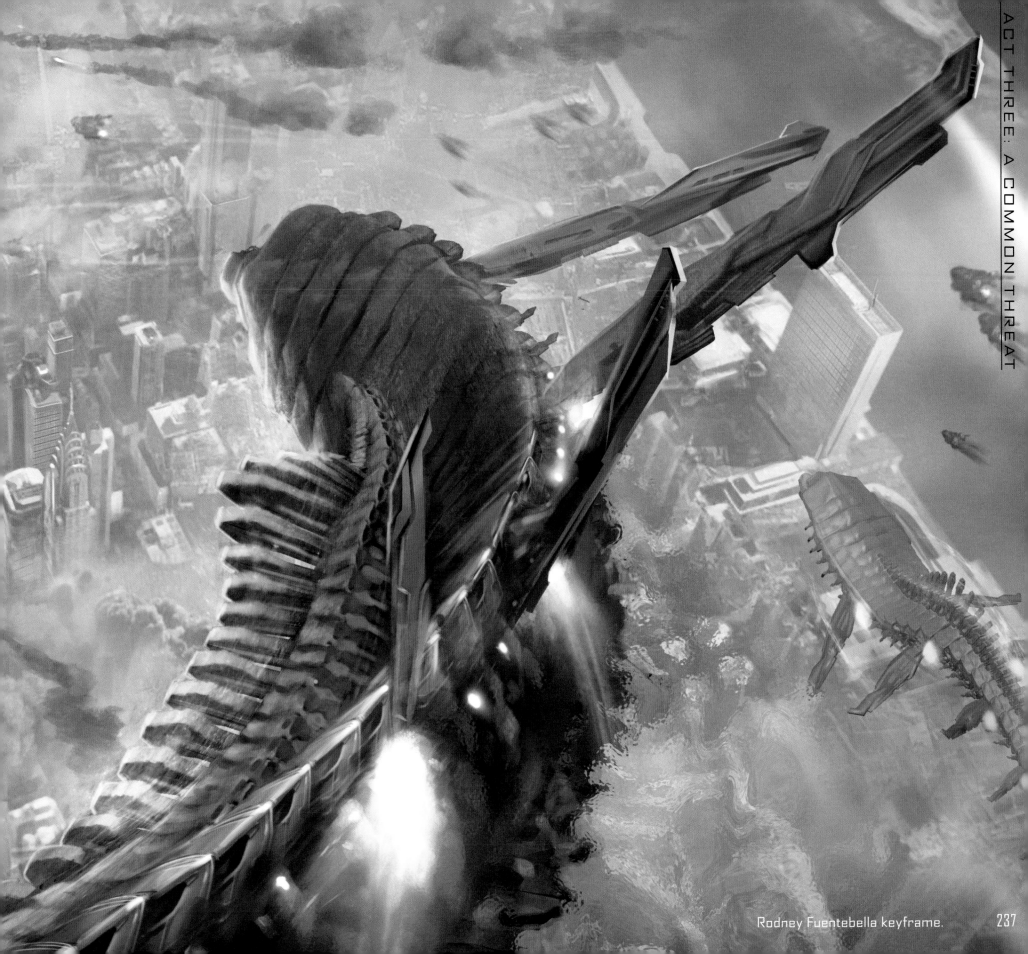

Rodney Fuentebella keyframe.

237

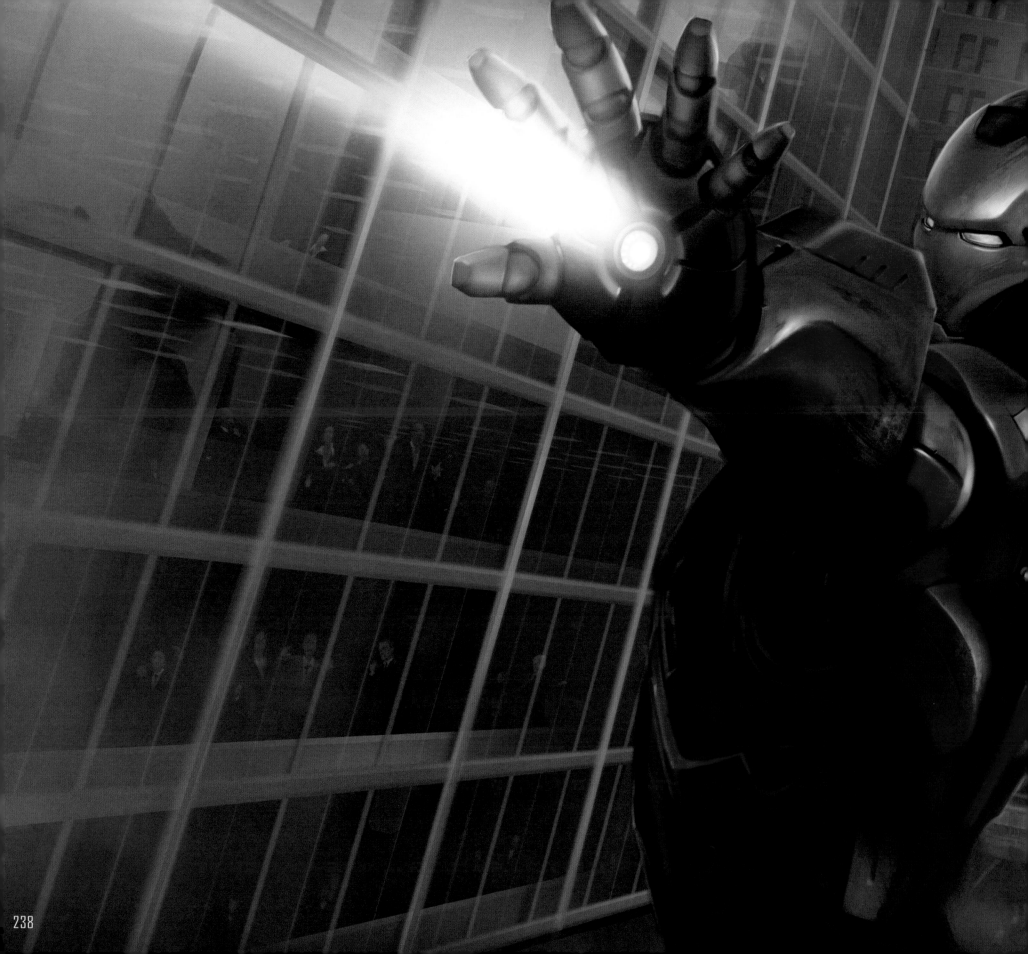

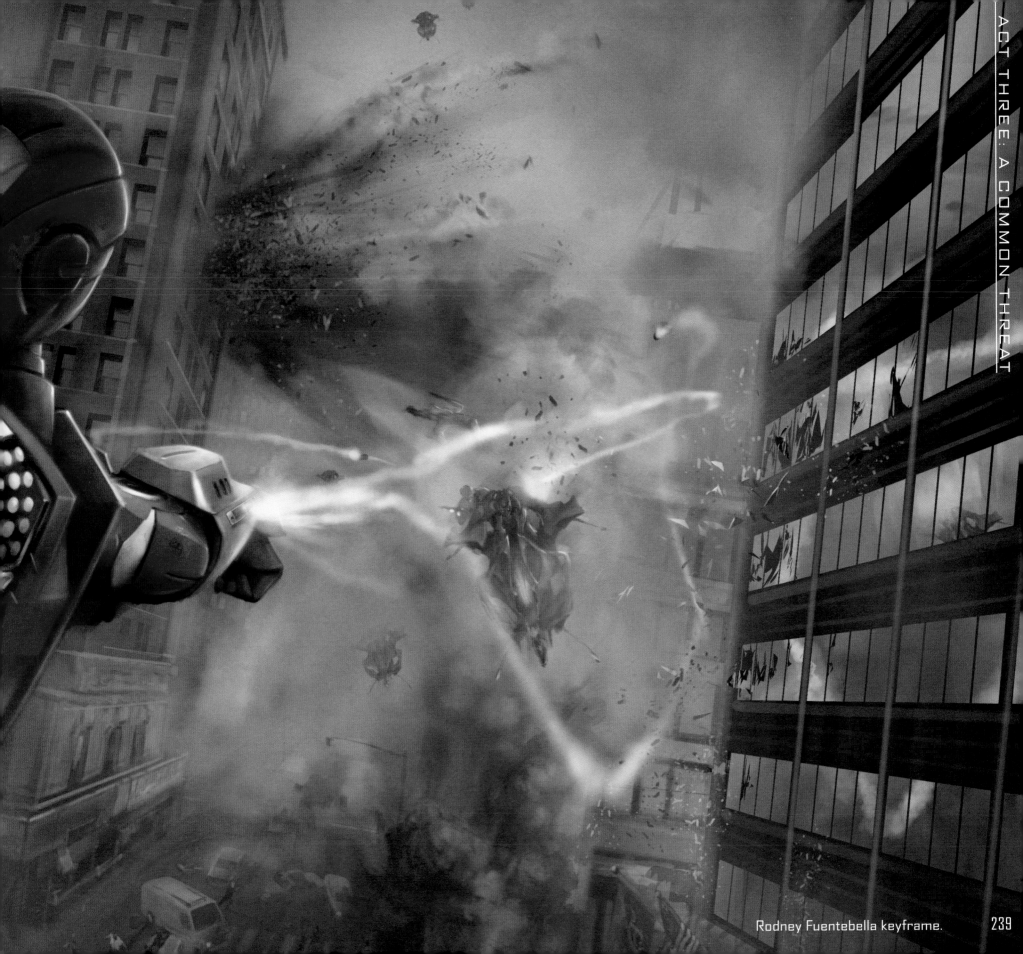

Rodney Fuentebella keyframe.

"Some of their keyframes are essentially in the film as is," Whedon said "Some of the guys have gags in the film exactly as they drew them, whether they were keyframes or storyboards. When something is right, you put it in the movie. Don't fix it if it doesn't need to be fixed."

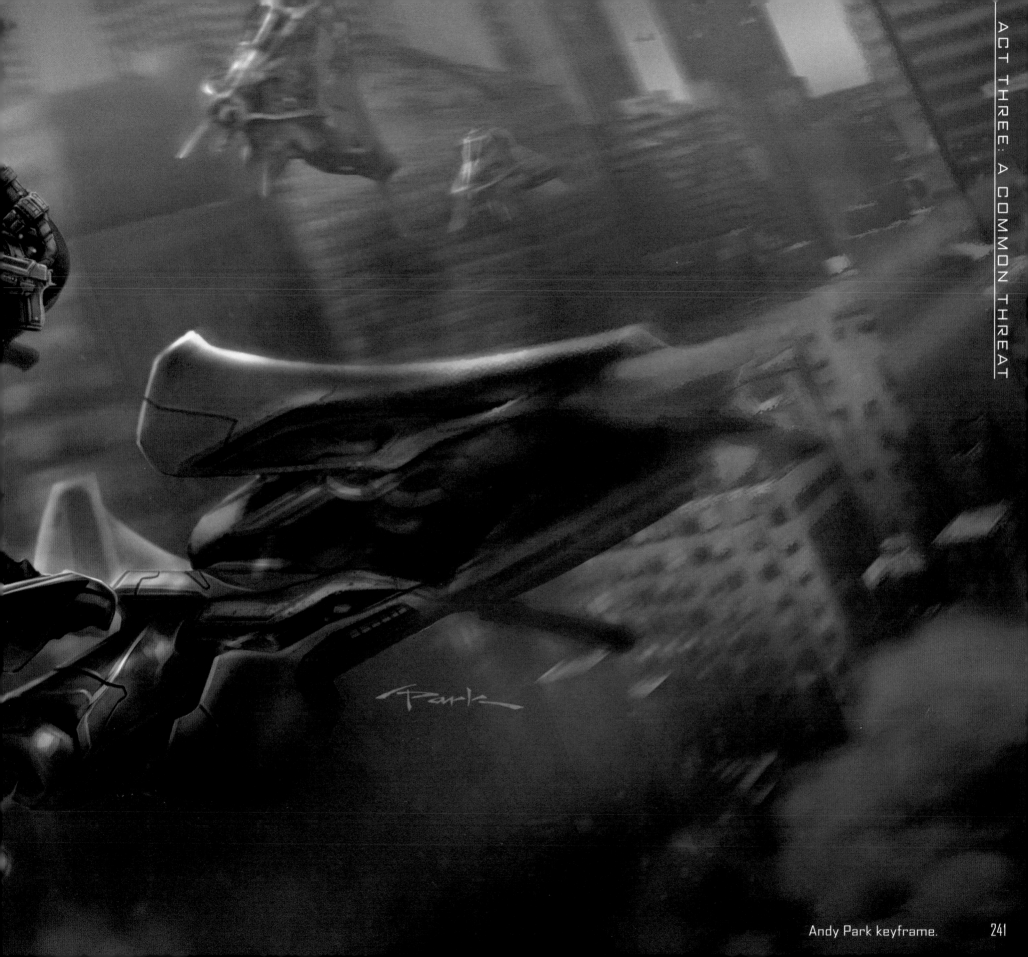

Andy Park keyframe.

FINAL BATTLE: SCRIPT AND STORYBOARDS

EXT. PARK AVE RAMP

ANGLE: THE PORTAL -- as a second wave of Leviathans appear.

> CAPTAIN AMERICA
> Listen up. Until we can close that
> portal, our priority is
> containment. Hawkeye's on that
> roof. Eyes on everything -- call
> out patterns, strays --
> (Hawkeye nods)
> Iron Man, you've got the perimeter.
> Anything gets more than three
> blocks out, turn it back or turn it
> to ash.

> HAWKEYE
> (to Iron Man)
> Give me a lift?

> IRON MAN
> Better clench up Legolas.

As Iron Man grabs Hawkeye and fires skyward.

> CAPTAIN AMERICA
> Thor, you got to try to bottleneck
> that portal, slow 'em down. You've
> got the lightning -- light the
> bastards up.

Thor swings his hammer for take-off as Cap turns to Widow.

> CAPTAIN AMERICA (CONT'D)
> You're with me on the ground. Keep
> at 'em -- Keep the fighting here.
> And Hulk... Smash.

The Hulk smiles -- and boom! -- he's in the air, grabbing
every alien he can, leaping from building to building, then
jumping onto an approaching chariot and smashing it out of
the sky.

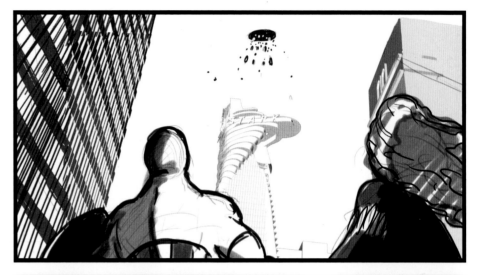

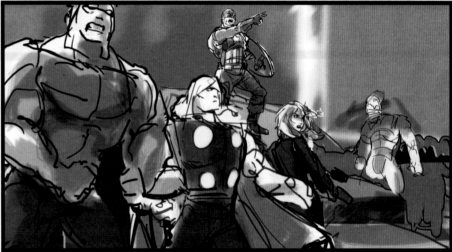

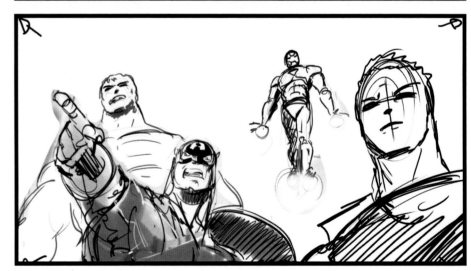

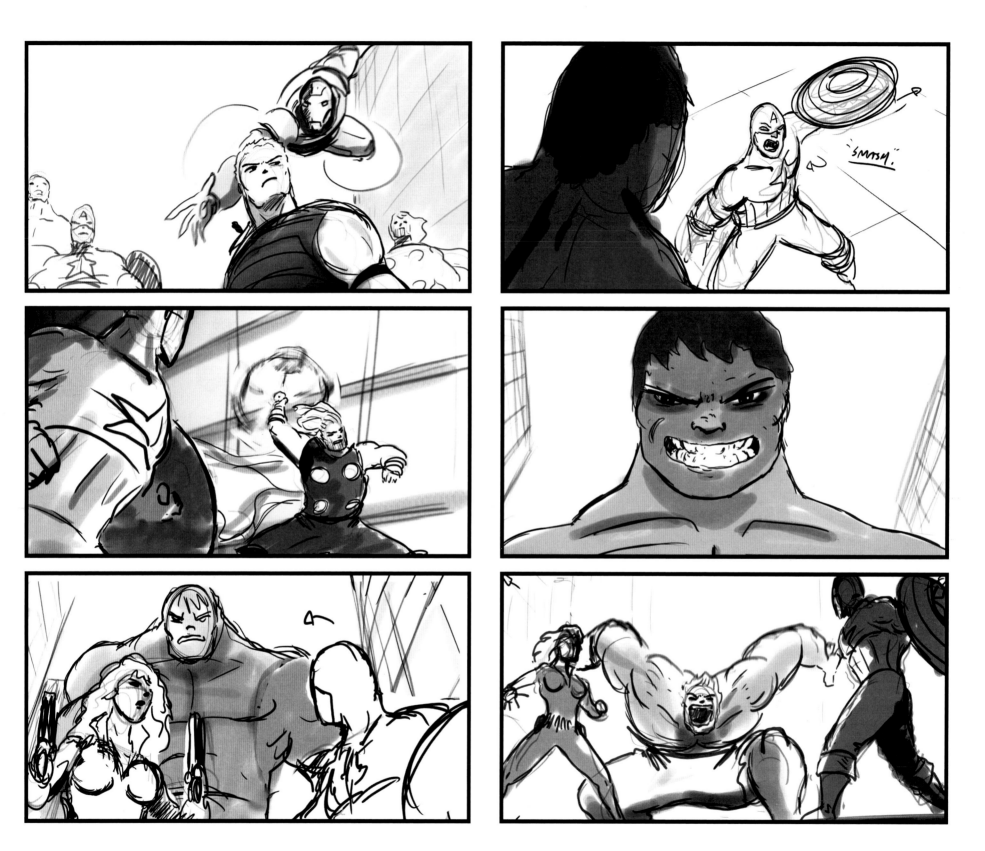

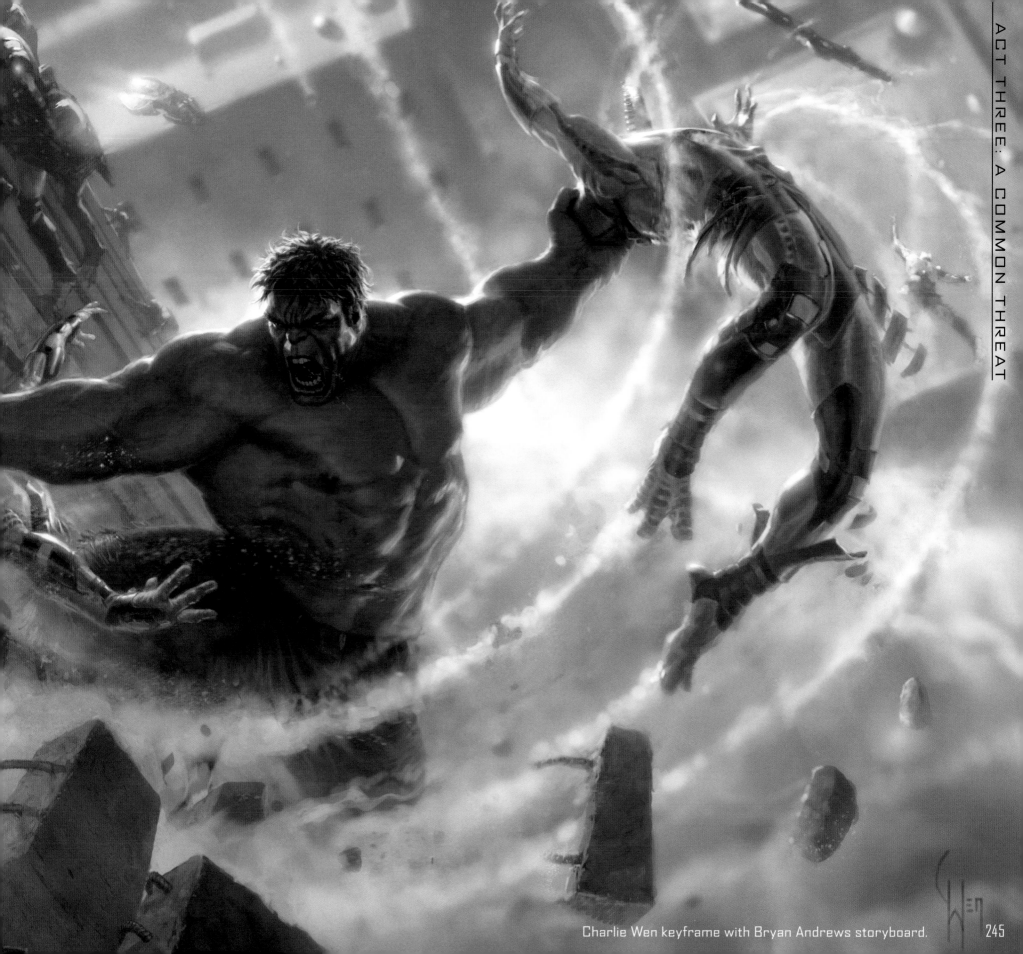

Charlie Wen keyframe with Bryan Andrews storyboard.

"One of my favorite pieces I created for the film is the keyframe depicting Hawkeye shooting his arrows during the final alien battle going on in the background," Concept Artist Andy Park said. "I like the Hawkeye keyframe illustration because it shows Hawkeye doing what he does best while showing a glimpse of the global threat that has united each of these characters to form the Avengers. It's the culmination of all the previous films and the

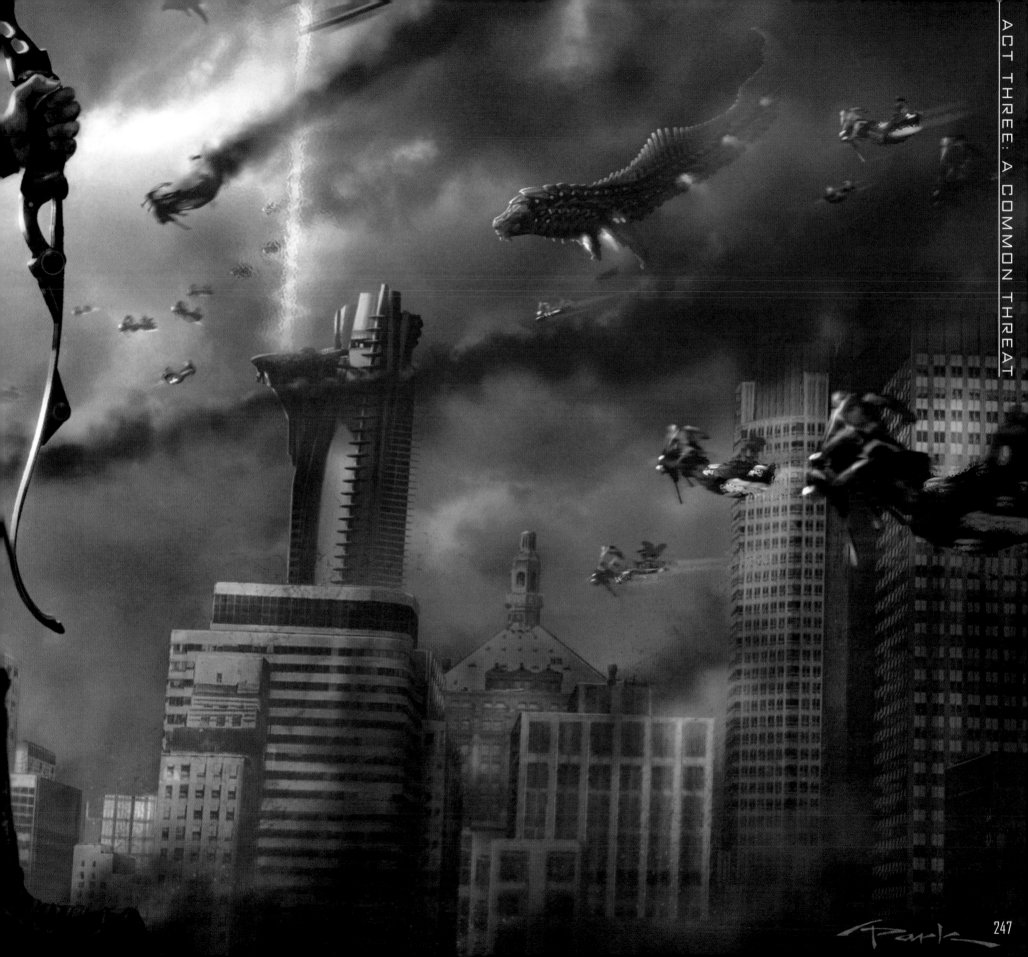

John Giang paintover.

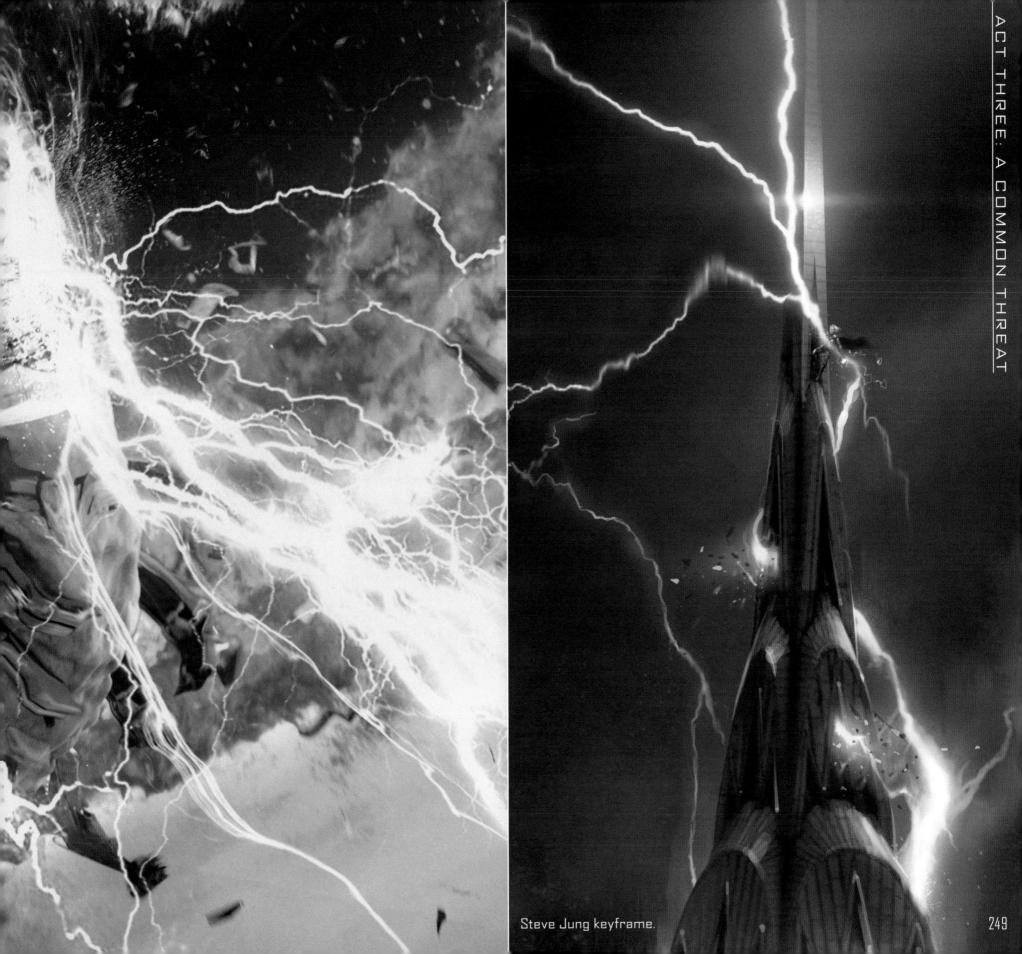

Steve Jung keyframe.

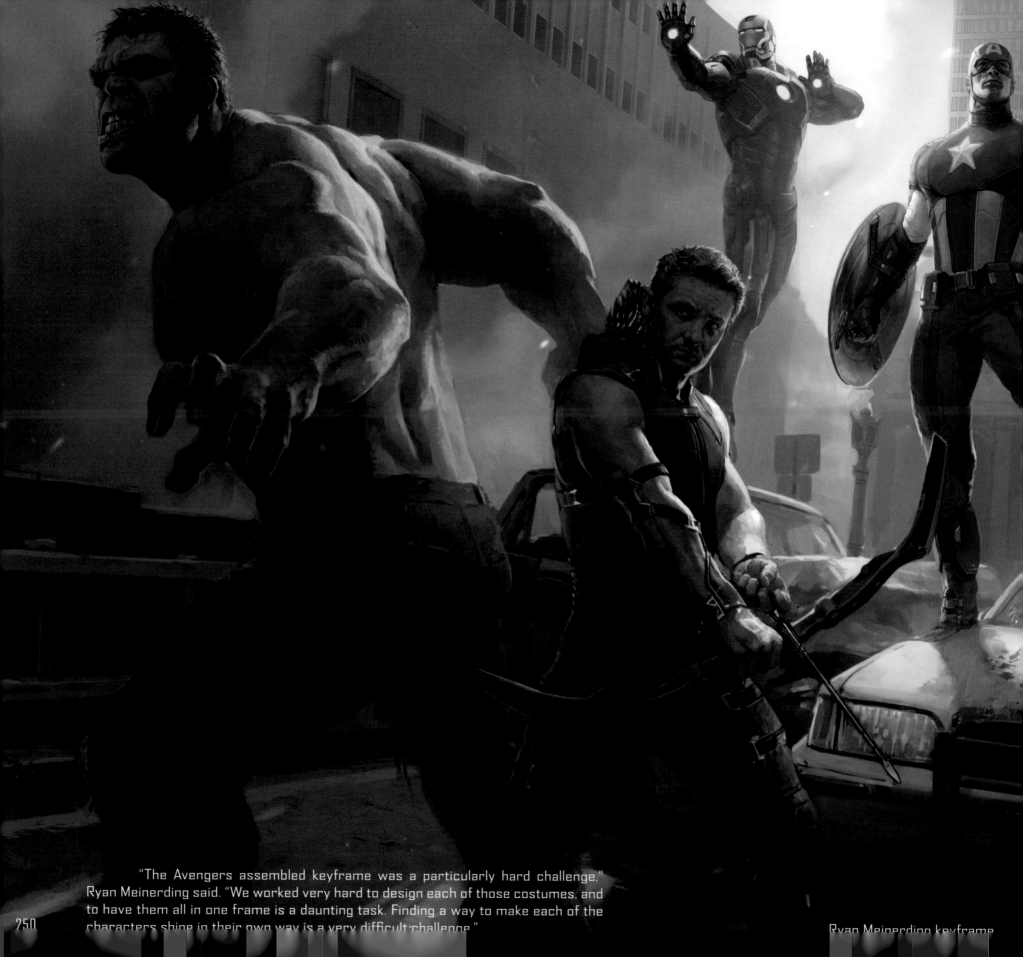

"The Avengers assembled keyframe was a particularly hard challenge,"
Ryan Meinerding said. "We worked very hard to design each of those costumes, and
to have them all in one frame is a daunting task. Finding a way to make each of the
characters shine in their own way is a very difficult challenge."

Ryan Meinerding keyframe

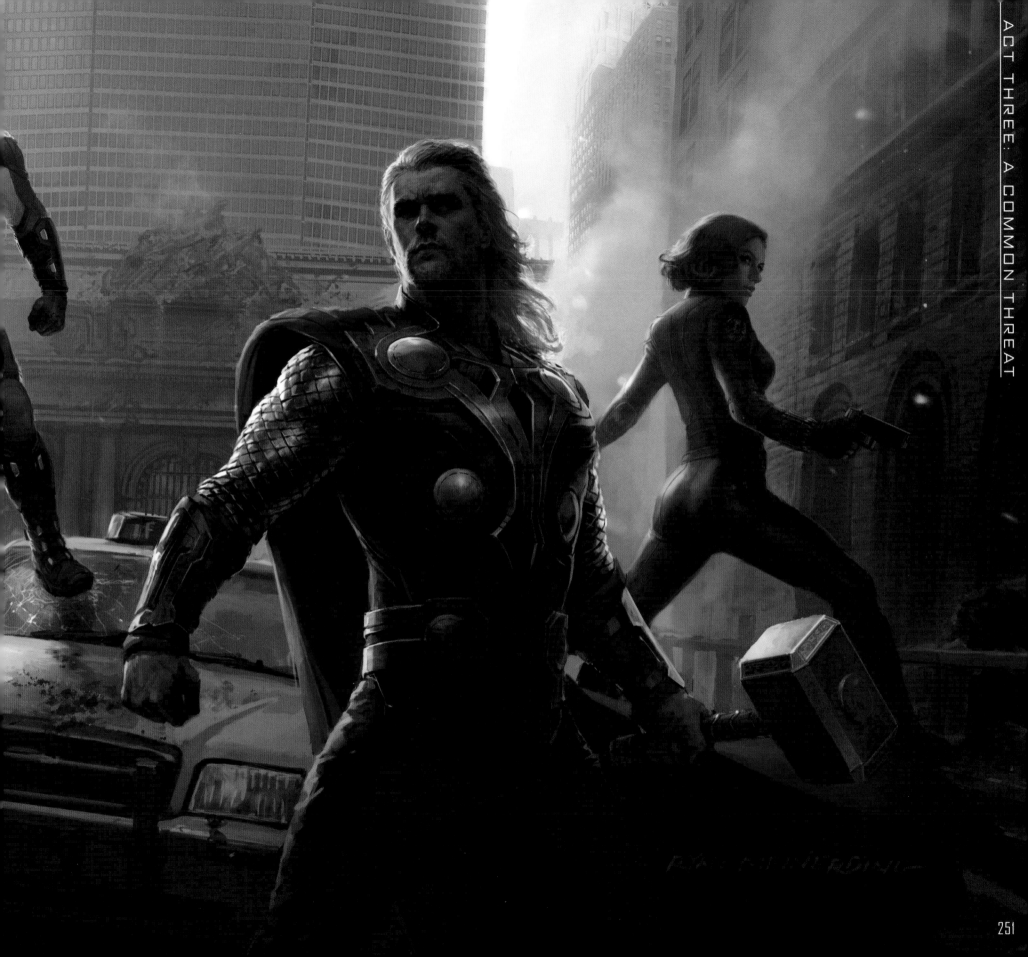

251

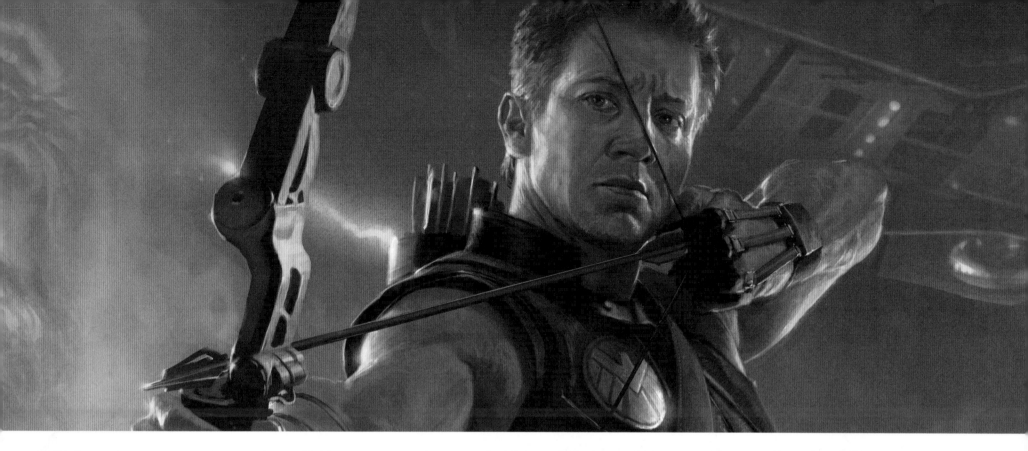

SOME ASSEMBLY REQUIRED

MARKETING EARTH'S MIGHTIEST HEROES

Event films have courted the faithful at the San Diego Comic-Con since fans got their first glimpse of a little film called *Star Wars* back in 1976. During the decades since, any genre film worth its salted popcorn has treated the Con faithful to first looks, surprise celebrity appearances and exclusive giveaways. The films of the Marvel Cinematic Universe are no exception.

Marvel Studios dove right into the deep end in the summer of 2007, when director Jon Favreau shocked and awed the Comic-Con crowd with ten minutes of rough footage from *Iron Man*. The crowd was sold, and the rest is history. The film went on to become a blockbuster hit upon its release the following May, Robert Downey Jr. became an instant action hero, and the Marvel Cinematic Universe was born in a big bang.

Marvel Studios has returned to Comic-Con to preview each of its subsequent releases, and *Marvel's The Avengers* was no exception. In one of the highlights of the 2010 Con, the Avengers assembled live onstage to a positively rapturous response. One of the 2011 event's most sought-after takeaways was a series of seven collectible posters created by Marvel visual development supervisors Ryan Meinerding and Charlie Wen. Each poster is a work of art unto itself, but the individual images form the proverbial big picture of the Avengers assembled when put together. Carrying on a Marvel Studios tradition that had begun four years earlier with *Iron Man*, the fans were sold — and May 4, 2012, couldn't come fast enough.

The posters were just as meaningful to the artists who created them, and they have their visionary writer/director to thank for the experience. "My favorite piece for the movie was the Comi-Con posters that our team collaborated on," Meinerding said. "Charlie Wen, Andy Park and I painted the whole team together, and that has to be one of the most rewarding projects in my time at Marvel. Our design team was created to accomplish *The Avengers*, and it was a fantastic experience to work with such amazing artists to assemble all of the characters into one image."

"Joss' biggest influence on my designs came from his amazing script, and *The Avengers* was one of the best scripts I've read," Wen added. "My favorite piece that I did for the film was probably the Comic-Con poster because I love storytelling so much."

Perhaps the artists' biggest fan is the director himself. "Ryan and Charlie are painting something that is so photo-real you can practically see the fabric," Whedon said. "They have an amazing understanding of the needs of the other creative departments, like costume and production design."

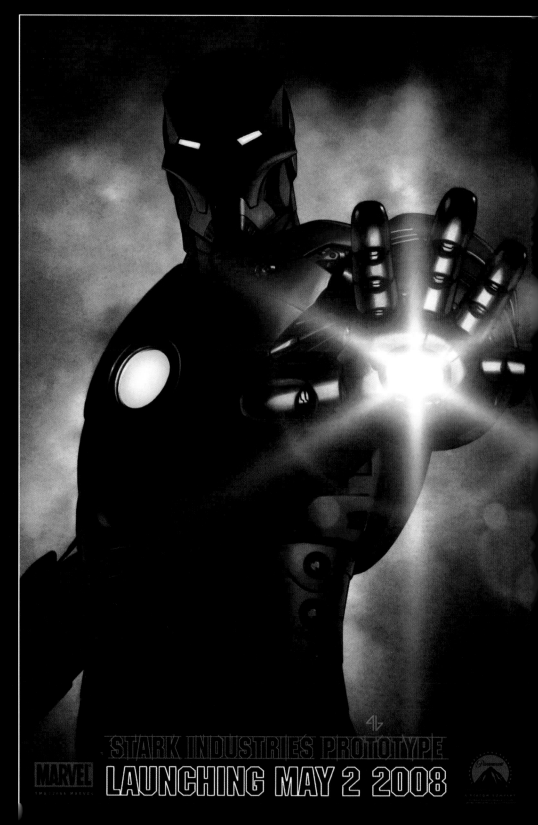

STARK INDUSTRIES PROTOTYPE
LAUNCHING MAY 2 2008

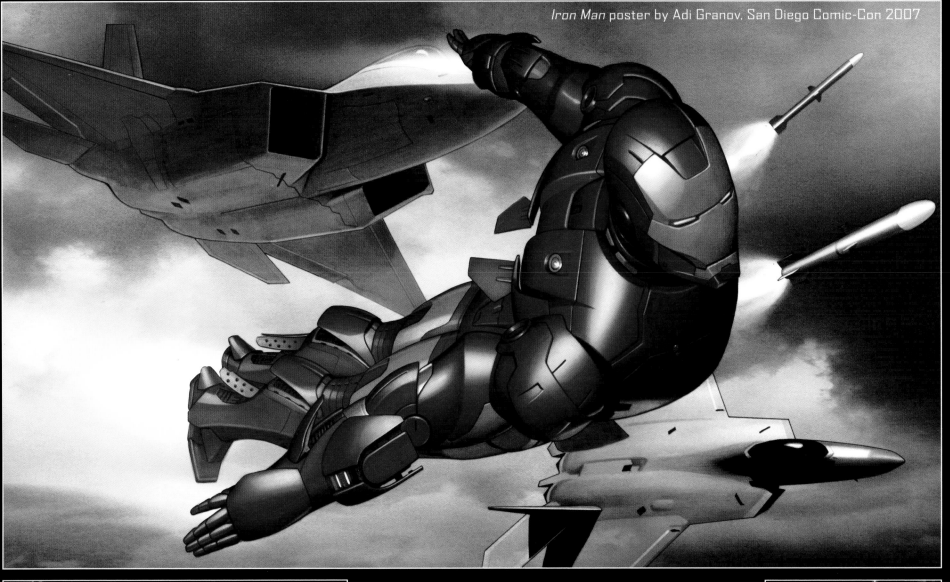

Iron Man poster by Adi Granov, San Diego Comic-Con 2007

MARK 1 MARK 2 MARK 3

IRON MAN

Iron Man "Three Heads" poster WonderCon 2009

KAY BAKER
RECRUITER

STARK INDUSTRIES, INC.

TEL: 310-555-5555
E-Mail: kbaker@starkindustriesnow.com

STARK INDUSTRIES

STARKINDUSTRIESNOW.COM

Stark Industries business card, San Diego Comic-Con 2010

Black Widow mini-poster
WonderCon 2010

MARK I MARK II MARK III MARK IV

COMIC CON **EXCLUSIVE**

05.07.10

MARVEL IRONMANMOVIE.COM

STARK INDUSTRIES

Hall of Armor poster, San Diego Comic-Con 2008

San Diego Comic-Con takeaway for 2010 promoting *Thor*.

San Diego Comic-Con takeaway for 2010 promoting
Captain America: The First Avenger.

Collectible T-shirts promoting *Marvel's The Avengers*, given to fans at the New York Comic-Con in October 2011.

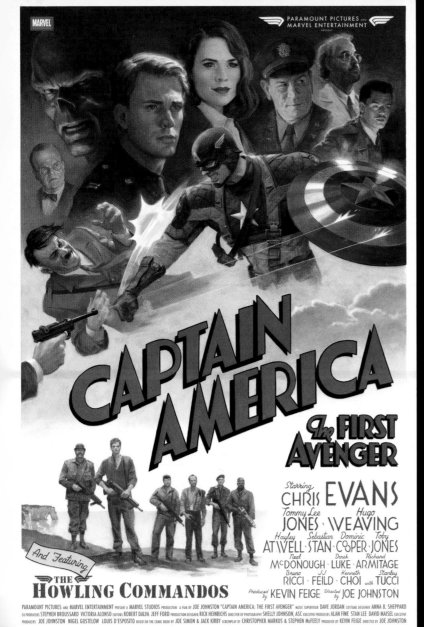

Captain America: The First Avenger crew gift by Paolo Rivera.

Thor crew gift by Olly Moss.

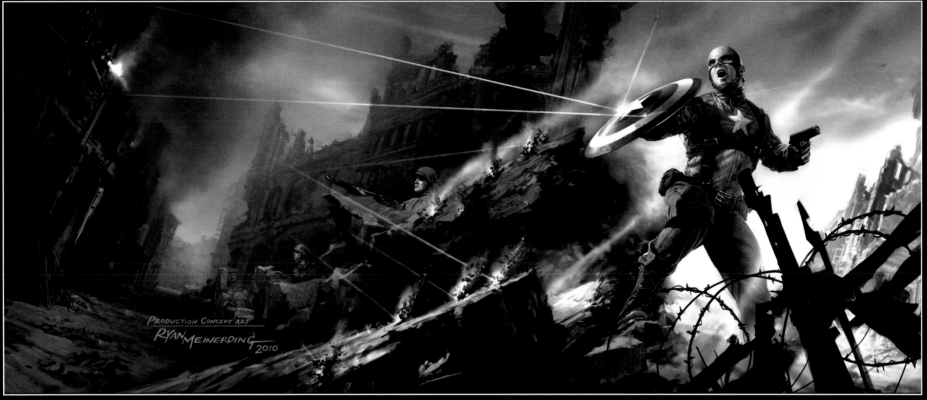

Captain America: The First Avenger limited-editon concept art by Ryan Meinderding, San Diego Comic-Con 2010

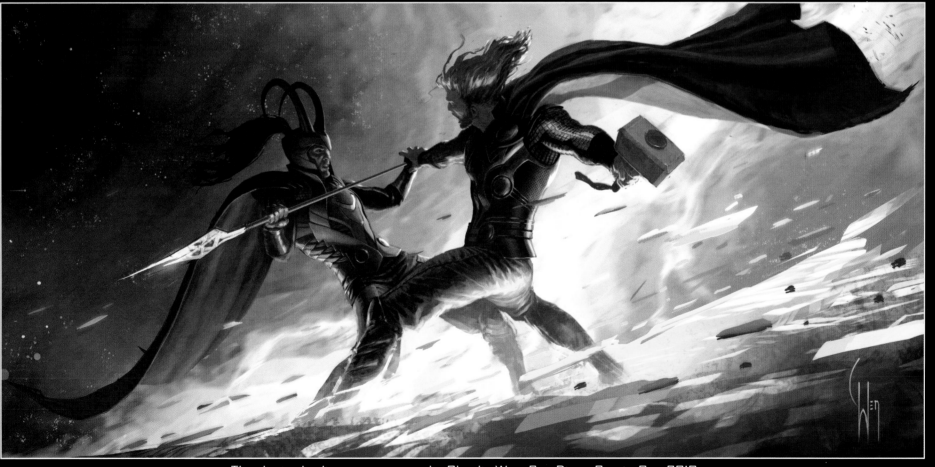

Thor limited-editon concept art by Charlie Wen, San Diego Comic-Con 2010

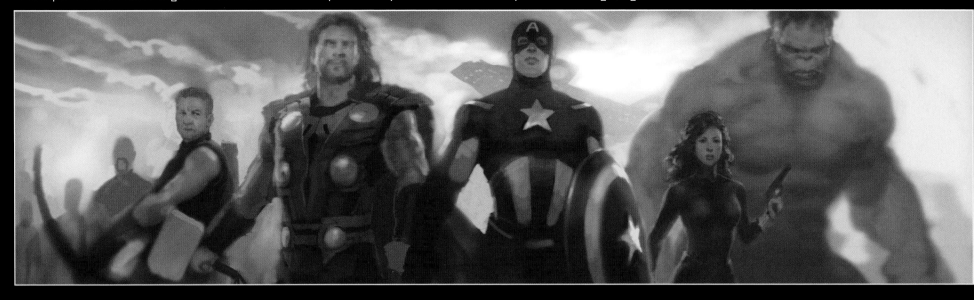

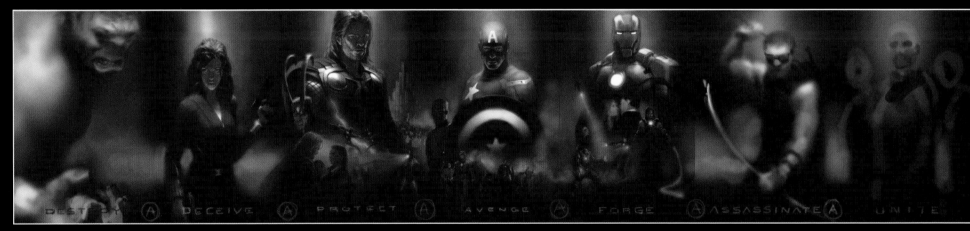

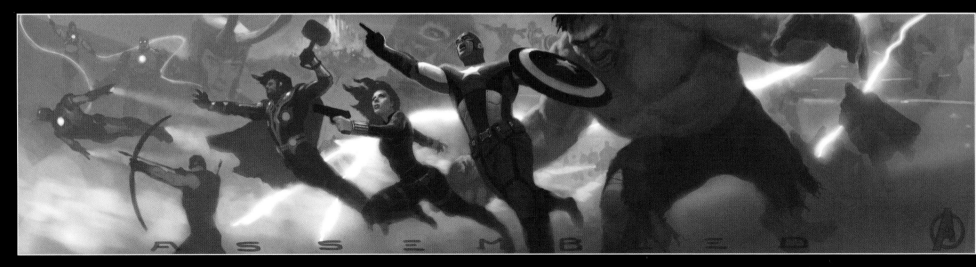

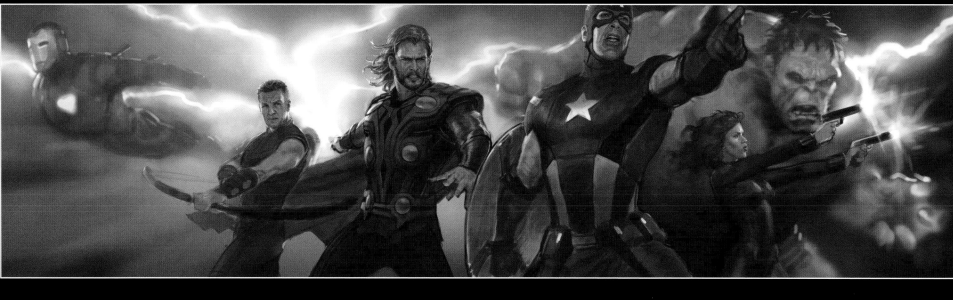

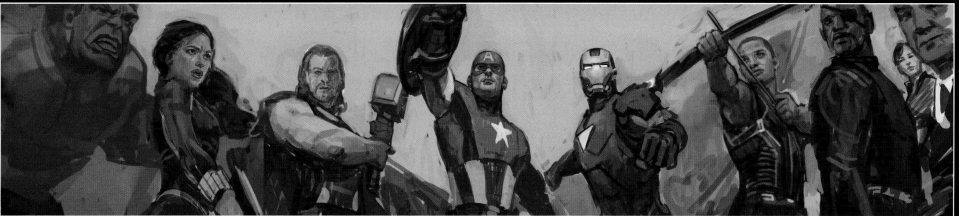

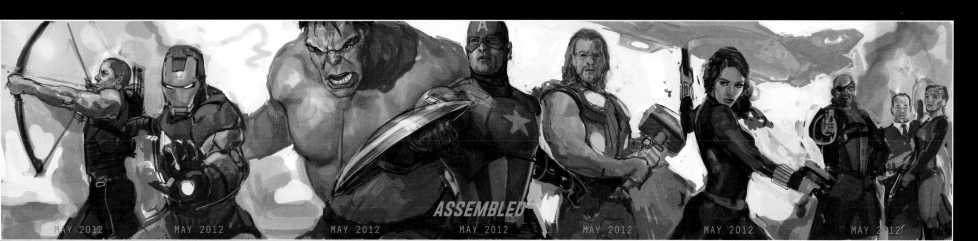

ASSEMBLED

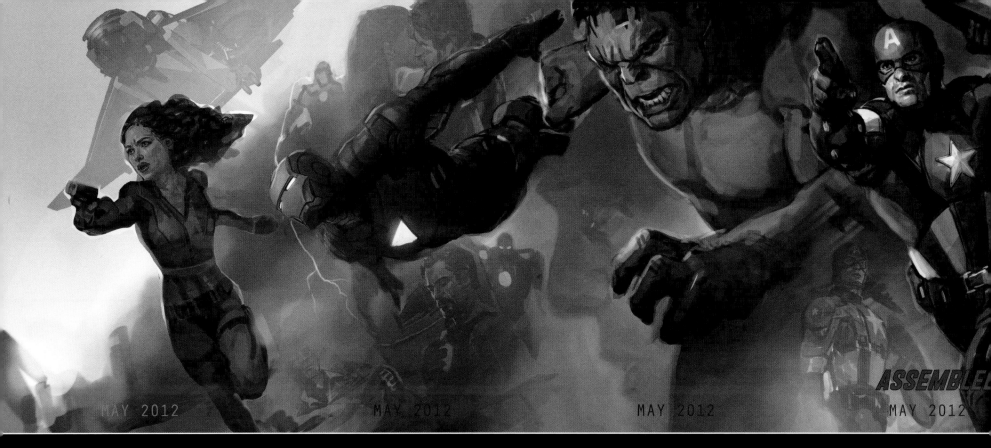
ASSEMBLE

MAY 2012 MAY 2012 MAY 2012 MAY 2012

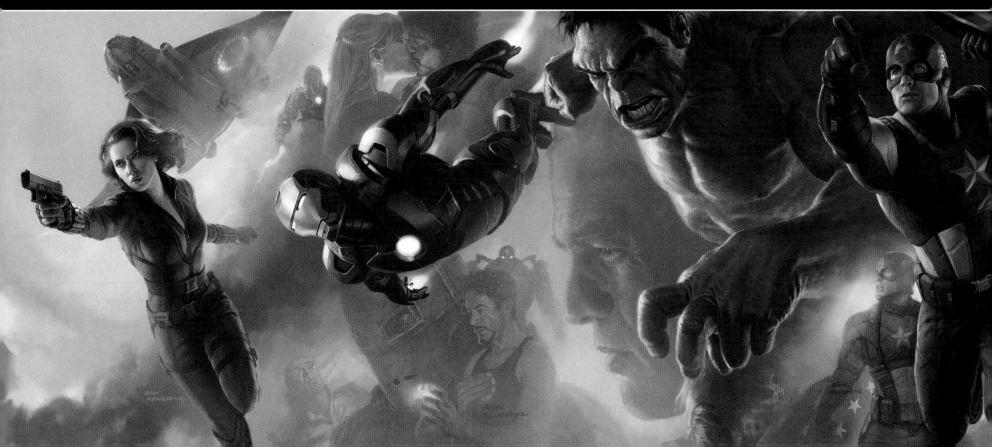

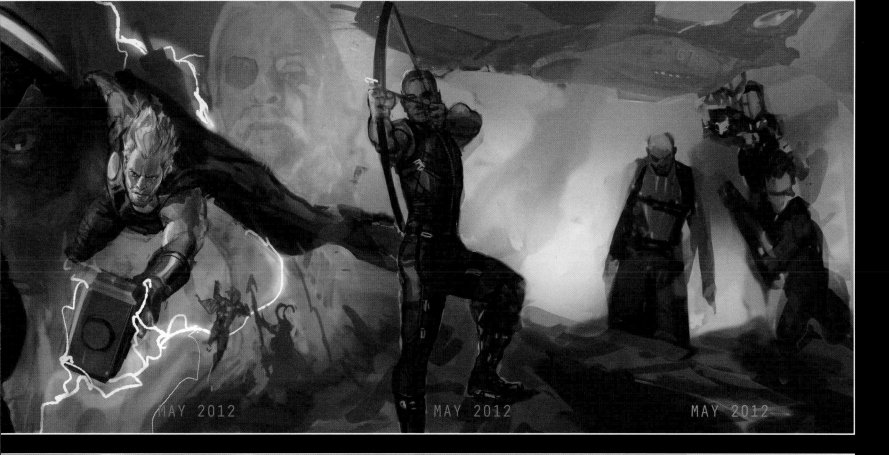

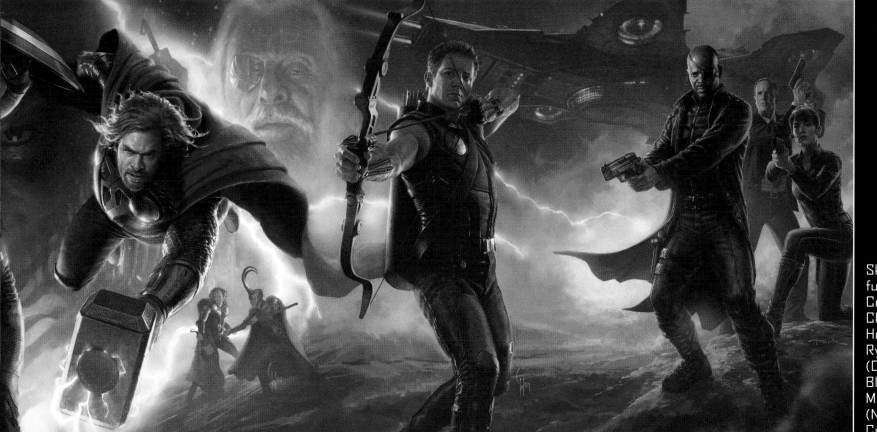

Sketch and final, full-color San Diego Comic-Con poster by Charlie Wen (Thor, Hulk, Hawkeye), Ryan Meinderding (Captain America, Black Widow, Iron Man) and Andy Park (Nick Fury, Phil Coulson, Maria Hill).

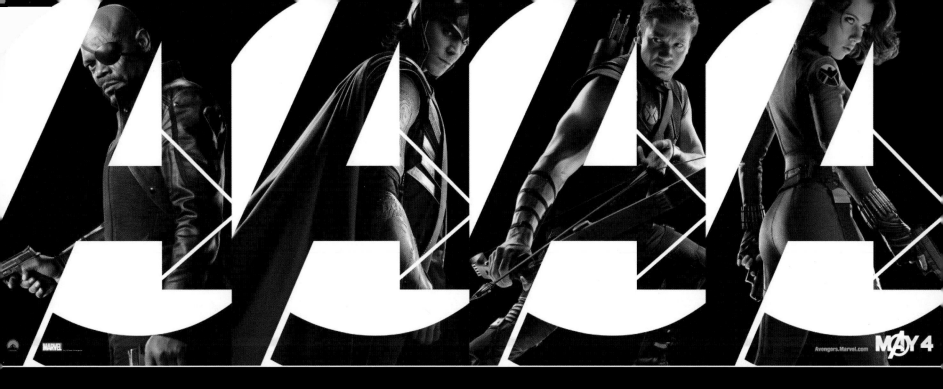

Much like the San Diego Comic-Con piece, the individual teaser posters for *Marvel's The Avengers* collectively form a banner teasing the imminent assembly of Earth's Mightiest Heroes.

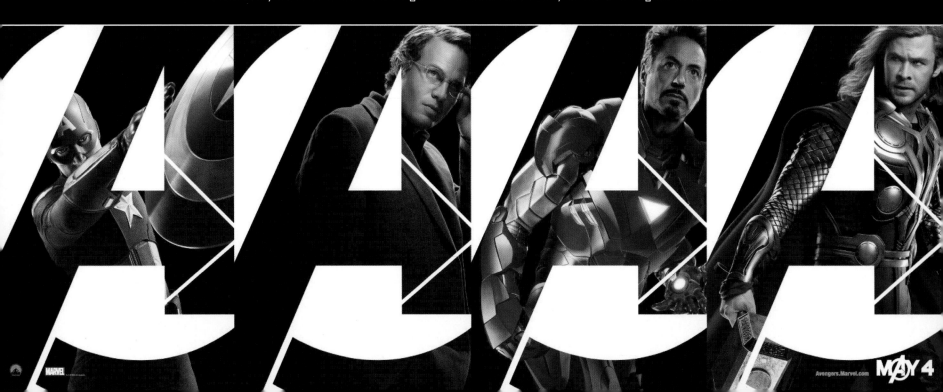

Marvel's The Avengers teaser poster.

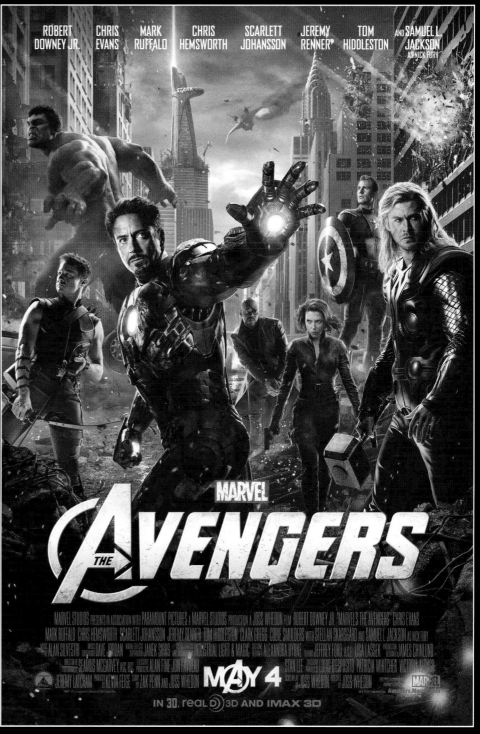

Marvel's The Avengers final theatrical poster.

Writer/producer/director **Joss Whedon** is a veteran of film, television and comics renowned for his witty dialogue, genre-blending sensibilities and strong female characters. An Emmy-nominated, third-generation talent whose father and grandfather both wrote for television, Whedon got his start as a writer on the *Roseanne* sitcom in 1989 and soon moved into film where his writing credits included *Buffy the Vampire Slayer, Alien: Resurrection* and the Oscar-nominated *Toy Story*. Whedon moved back to television, where he converted 1992's lackluster *Buffy* film into the critically acclaimed *Buffy the Vampire Slayer* TV series (1997-2003) and its vampire-hero spin-off series, *Angel* (1999-2004). Whedon's sci-fi Western series *Firefly* (2002) was short-lived, but its popularity on DVD led to Whedon writing and directing a Universal feature film based on its characters, *Serenity* (2005). Whedon returned to television in 2009 with *Dollhouse* and explores terror in the 2010 feature film *Cabin in the Woods*. A lifelong comics fan, he entered the business with the 2001 Dark Horse mini-series *Fray*, featuring the Slayer of a dystopian future. He later co-wrote a Serenity mini-series for Dark Horse (with sequels to follow), helped plot IDW Publishing's *Angel: After the Fall* series picking up where the Angel TV show left off, and serves as co-writer and "executive producer" of Dark Horse's *Buffy The Vampire Slayer Season Eight* series, a canonical continuation of the TV heroine's adventures. At Marvel, Whedon is best known for teaming with John Cassaday on a popular *Astonishing X-Men* run (2004-2008) and taking over *Runaways* after series creator Brian K. Vaughan left the book. Whedon's other Marvel credits include *Giant-Size X-Men #3* (2005) and *Stan Lee Meets Spider-Man #1* (2006).

Producer and Marvel Studios President **Kevin Feige** has guided the studio through more than a decade of films and was instrumental in starting up the current era of movies produced directly by the studio. Feige serves as producer for the studio's entire slate of films — including *Iron Man, Iron Man 2, The Incredible Hulk, Thor, Captain America: The First Avenger* and *Marvel's The Avengers*. In that role, it falls to him to coordinate the emergent Marvel Cinematic Universe between the different productions — drawing together a talented pool of directors, producers, actors and artists to create a coherent film world, the likes of which Hollywood has never attempted.

Executive Producer and Marvel Studios Co-President **Louis D'Esposito** has served as executive producer on the blockbuster hits *Iron Man, Iron Man 2, Thor, Captain America: The First Avenger* and *Marvel's The Avengers*. As co-president of the studio and executive producer on all Marvel films, D'Esposito balances running the studio with overseeing each film from development through distribution. D'Esposito began his tenure at Marvel Studios in 2006. D'Esposito's executive-producing credits prior to Marvel include the 2006 hit *The Pursuit of Happyness*, starring Will Smith; *Zathura: A Space Adventure*; and the 2003 hit *S.W.A.T.*, starring Samuel L. Jackson and Colin Farrell.

Executive Producer **Victoria Alonso** previously served as co-producer on Jon Favreau's *Iron Man* and *Iron Man 2*, Kenneth Branagh's *Thor* and Joe Johnston's *Captain America: The First Avenger*. Alonso's career began at the infancy of the visual-effects industry, when she served as a commercial VFX producer. From there, she VFX-produced numerous feature films — working with such directors as Ridley Scott (*Kingdom of Heaven*), Tim Burton (*Big Fish*) and Andrew Adamson (*Shrek*), to name a few. Alonso is the executive vice president of visual effects and post production for Marvel Studios. Her future projects with Marvel include *Iron Man 3* and *Thor 2*.

Executive Producer **Patricia Whitcher** previously served as an executive producer on Marvel Studios' *Thor*. Whitcher has enjoyed a storied career — from her time as a production coordinator on the fondly remembered *Bill & Ted's Excellent Adventure* to serving as one of the unit production managers on *True Lies* to working as an executive producer on *My Best Friend's Wedding, The Terminal, Memoirs of a Geisha, Dreamgirls* and *The Soloist*.

Executive Producer **Jeremy Latcham** is the senior vice president of production and development at Marvel Studios. Latcham served as an associate producer on the 2008 blockbuster *Iron Man* and a co-producer on its successful 2010 follow-up *Iron Man 2*. A graduate of Northwestern University, Latcham began his career at Miramax and Dimension Films; he also worked at the Endeavor Agency. In 2004, he joined Marvel Studios, where he has also held the titles of vice president and creative executive. In 2011, Latcham was featured as one of "Hollywood's New Leaders" by *Variety*.

Production Designer **James Chinlund**, a New York City native, has been designing for film since the early nineties. With a background in fine art, having studied at CalArts in Los Angeles, Chinlund cut his teeth designing music videos and independent films. During this period, he joined forces with frequent collaborator Darren Aronofsky (*Requiem for a Dream, The Fountain*) in addition to many other icons of the New York independent scene — including Todd Solondz (*Storytelling*), Paul Schrader (*Auto Focus*) and Spike Lee (*25th Hour*). In recent years, Chinlund has been active in the worlds of commercials and fashion, working with some of the top names in the field (Inez and Vinoodh, Rupert Sanders, Spike Jonze, Fredrik Bond, Gus Van Sant, Lance Acord, Harmony Korine). In 2010, he won both the Art Director's Guild and the AICP awards for a commercial collaboration with director Rupert Sanders. Having completed work on *Marvel's The Avengers*, Chinlund is looking forward to continuing to push and explore the boundaries of his craft at all levels of production. In the late 1970s,

Costume Designer **Alexandra Byrne** trained as an architect at Bristol University before studying Theatre Design on the Motley Course at the English National Opera under the legendary Margaret Harris. She has worked extensively in television and theater, both as a set and costume designer. Her television credits include Roger Michell's *Persuasion*, for which she received the BAFTA Award for Best Costume Design, and *The Buddha of Suburbia*, for which she received a BAFTA nomination and RTS award. In theater, Alexandra received a Tony nomination for Best Set Design for *Some Americans Abroad*, which transferred from the Royal Shakespeare Company to the Lincoln Center in New York. Following on from her work in theater, Alexandra designed the costumes for Kenneth Branagh's *Hamlet*, for which she gained her first Oscar nomination. Other credits include *Phantom of the Opera, Sleuth* and *The Garden of Eden*. She received two further Oscar nominations for her costumes in *Elizabeth* and *Finding Neverland*. *Elizabeth: The Golden Age* finally won her the Oscar. Alexandra is married to the actor Simon Shepherd, and they have four children.

Director of Photography **Seamus McGarvey** ASC, BSC, was born June 29, 1967, in Armagh, Northern Ireland. He began his career as a still photographer before attending film school at the University of Westminster in London. Upon graduating in 1988, he began shooting short films and documentaries — including *Skin*, which was nominated for a Royal Television Society Cinematography Award; and *Atlantic*, directed by Sam Taylor-Wood, which was nominated for the 1998 Turner Prize. He also photographed and directed more than 100 music videos for such artists as U2, the Rolling Stones, PJ Harvey, Robbie Williams, Sir Paul McCartney, Dusty Springfield and Coldplay. In 1998, the British Society of Cinematographers invited McGarvey to join. In 2004, he was awarded the Royal Photographic Society's prestigious Lumiere medal for contributions to the art of cinematography. His credits as a cinematographer include Oliver Stone's *World Trade Center*, starring Nicolas Cage; *The Hours*, directed by Stephen Daldry and starring Nicole Kidman, Meryl Streep and Julianne Moore, for which he earned the Evening Standard British Film Award for Best Technical/Artistic Achievement; the action-adventure film *Sahara*, starring Matthew McConaughey and Penelope Cruz, for which he won the Irish Film and Television Award for Best Cinematography; *Along Came Polly*, starring Ben Stiller and Jennifer Aniston; *High Fidelity*, directed by Stephen Frears and starring John Cusack; *Wit*, starring Emma Thompson and directed by Mike Nichols; *Enigma*, directed by Michael Apted; *The War Zone*; *Butterfly Kiss*; *The Winter Guest*; *The Actors*; *A Map of the World*; *Charlotte's*

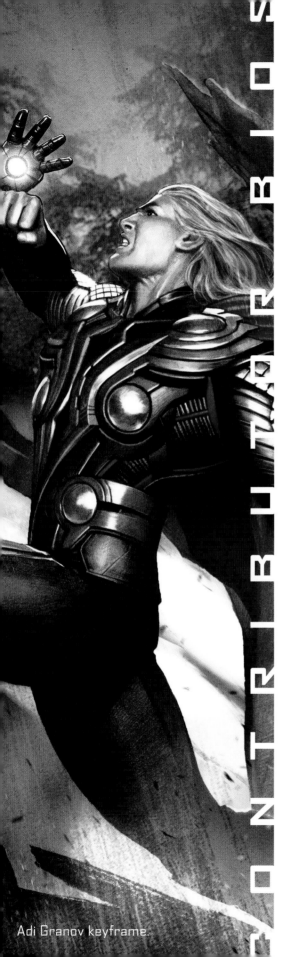

Adi Granov keyframe.

Web; Atonement, for which he received an Academy Award nomination (2008), a BAFTA nomination (2008), the Technical Achievement Award in the Evening Standard British Film Awards for 2007, and the 2008 Irish Film and Television Award for Best Cinematography; a 2007 television advertisement for Chanel's Coco Mademoiselle campaign; and *The No. 1 Ladies' Detective Agency*, directed by Anthony Minghella. In 2008, he shot *The Soloist* for director Joe Wright in Los Angeles. He subsequently shot *Nowhere Boy* for director Sam Taylor-Wood; reunited with director Joe Wright for the short film *Cut*; and shot the acclaimed Lynne Ramsay's *We Need to Talk About Kevin*, starring Tilda Swinton, in New York and Connecticut, for which he won the Irish Film and Television Award for Best Cinematography. He recently wrapped on *Anna Karenina* for director Joe Wright.

Visual Development Supervisor **Ryan Meinerding** has only been a freelance concept artist and illustrator in the film business since 2005, but his work is already drawing the kind of raves reserved for veterans of the industry. After earning a degree in industrial design from Notre Dame, he eventually transitioned to Hollywood and worked on *Outlander*. Subsequent to *Iron Man*, he worked on *Transformers: Revenge of the Fallen* and helped coordinate wardrobe for *Watchmen*. While working on *Iron Man 2*, Meinerding contributed the design for the new Iron Man armor in the comic-book series *Invincible Iron Man*, continuing to cement the strong bonds between Marvel Studios and Marvel Comics. He was part of the *Iron Man* crew nominated for the 2009 Art Directors Guild Excellence in Production Design Award for Fantasy Films, was one of the main concept designers for *Thor*, and served as visual development co-supervisor on *Captain America: The First Avenger* and *Marvel's The Avengers*.

Visual Development Supervisor **Charlie Wen** has held a variety of positions in the entertainment industry, ranging from concept designer to art director, on everything from feature films to video games and commercials. Wen's client list reads as a virtual who's who of the industry, including Digital Domain, Disney, Dreamworks, Legendary Pictures, Marvel Studios, Darkhorse, Rhythm and Hues, Imagi Studios, Wizards of the Coast, and Sony Computer Entertainment of America. In 2005, he created Kratos and helped establish *God of War* as a monolithic action-adventure title for Sony PlayStation. Outside of the production environment, Charlie has given lectures on figure drawing and character design at many distinguished studios and universities. After helping to establish the main character designs in *Thor*, he holds the title of visual development co-supervisor at Marvel Studios, working on *Captain America: The First Avenger* and *Marvel's The Avengers*.

Physical Suit Effects Supervisor **Shane Mahan** worked at Stan Winston Studio from 1983 until the founding of Legacy Effects, following Stan Winston's death in 2008. Mahan has taken a lead role on dozens of films as physical effects supervisor. He has managed creature effects for science-fiction movies like *Predator, Predator 2, Aliens*, and *Leviathan*; headed up the art department for *Terminator 2: Judgment Day*; and supervised animatronics for *Zathura* and *Eight Below*. As physical suit supervisor on *Iron Man*, he shepherded the development of the Iron Man armor from concept to fully functioning suit. His efforts garnered him an Academy Award nomination for Best Achievement in Visual Effects (joined by John Nelson, Ben Snow, and Daniel Sudick) in 2009. Mahan contributed to *Indiana Jones and the Kingdom of the Crystal Skull* and *G.I. Joe: The Rise of Cobra* before returning for *Iron Man 2* and *Marvel's The Avengers*

Prop Master **Drew Petrotta**, a Los Angeles native, is a third-generation property master — following in the footsteps of his grandfather, uncle and father. Prior to *Marvel's The Avengers*, Petrotta worked on genre films *Green Lantern* (2011) as prop master, and *Hulk* (2003) and *Batman Returns* (1992) as assistant prop master. He has been prop master on *Red Dawn* (2012), *The Rum Diary* (2011), *The Men Who Stare at Goats* (2009), *Transformers: Revenge of the Fallen* (2009), *Che: Part One* (2008), *Che: Part Two* (2008), *Leatherheads* (2008), *Transformers* (2007), *The Reaping* (2007), *Jarhead* (2005) and *The Chumscrubber* (2005). As an assistant prop master, his credits include *Lemony Snicket's A Series of Unfortunate Events* (2004), *Big Fish* (2003), *Hulk* (2003), *Star Trek: Nemesis* (2002), *Minority Report* (2002), *A.I. Artificial Intelligence* (2001), *My First Mister* (2001), *Galaxy Quest* (1999), *Deep Blue Sea* (1999), *Small Soldiers* (1998), *Amistad* (1997), *The Lost World: Jurassic Park* (1997), *Mars Attacks!* (1996), *The Nutty Professor* (1996), *Congo* (1995), *A Little Princess* (1995) and *Diggstown* (1992). Petrotta is a recipient of Movieline magazine's Hamilton Behind the Camera Award, recognizing the achievements of below-the-line craftsmen and crew members.

Set Decorator **Victor J. Zolfo** celebrated 25 years in the motion-picture industry in 2011. For the past fifteen years, he has been the set decorator for more than a dozen genre-spanning films — highlights of which include *Godzilla* (1998), *The Patriot* (2000), *The Time Machine* (2002), *The Day After Tomorrow* (2004), *Mr. & Mrs. Smith* (2005), *Zodiac* (2007), *Terminator Salvation* (2009) *The Social Network* (2010) and *Real Steel* (2011). In 2009, Zolfo's collaboration with Production Designer Donald Graham Burt on David Fincher's *The Curious Case of Benjamin Button* swept the industry's three major design awards — the Academy Award, the British Academy Award and the Art Directors Guild Award — which few set decorators have achieved for any one movie. A graduate of New York University's Tisch School of the Arts in 1985, Zolfo began his film career as an art department production assistant. His entry into the world of big-budget filmmaking came in 1990 with Michael Mann's opus *The Last of the Mohicans*. It was on this job he first worked for Academy Award nominee Jim Erickson, who would become his mentor and friend. The two went on to work together on a string of location films that were instrumental in shaping Zolfo's career. They included *This Boy's Life, Stargate* and *Independence Day*, as well as international projects such as *Operation Dumbo Drop* and *Seven Years in Tibet*.

Visual Effects Supervisor **Janek Sirrs** came west in 1993 to help establish Los Angeles offices for the London-based VFX company The Computer Film Company. Since then, he has worked independently as a visual effects supervisor on such films as *I Am Legend* with director Frances Lawrence, *Batman Begins* with Christopher Nolan, *The Big Lebowksi* with the Coen Brothers and *Iron Man 2* with Jon Favreau. Sirrs won an Academy Award and a BAFTA for his work on *The Matrix* with the Wachowski Brothers in 1999, and was nominated for a second Oscar for *Iron Man 2*. Sirrs served as visual effects supervisor on *Marvel's The Avengers* with writer/director Joss Whedon.

Concept Artist **Andy Park** began his career as a comic-book artist illustrating such titles as *Tomb Raider* and *Uncanny X-Men* for companies like Marvel, DC and Image. Switching careers in 2004, he has worked as a concept artist on video games, commercials and TV series. Notably, he helped create the worlds of the *God of War* franchise for Sony Computer Entertainment of America. Park has since joined the team at Marvel Studios as a visual development illustrator designing characters and key-art illustrations for *Captain America: The First Avenger, Marvel's The Avengers* and several upcoming films.

Storyboard Artist **Bryan Andrews**, known in the industry for his uncanny ability to board scenes of high drama with uniquely inspiring takes on action storytelling, has been impressing science-fiction action fans for almost a decade since his Emmy Award-winning contributions to animated series *Star Wars: Clone Wars* and *Samurai Jack* ("The Four Seasons of Death"). Citing influences that range from Steven Spielberg, Ray Harryhausen and Akira Kurosawa to Frank Frazetta, Gatchaman and Macross — and an avid student of not only the visual language of cinema, but also of rapier fencing, and such Chinese martial arts as Wushu and Wing Chun — Andrews has brought his trademark flair for dramatic action storytelling to both the small and silver screens.

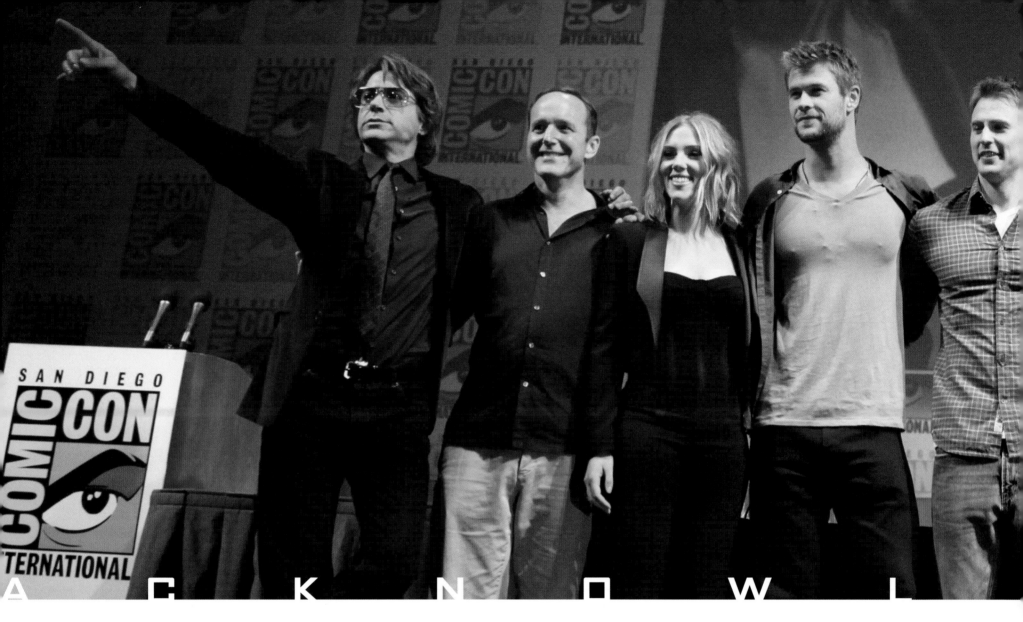

ACKNOWL

Victoria Alonso	Robert Downey Jr.	Clark Gregg	Steve Jung
Christian Alzmann	Yanick Dusseault	Chris Hemsworth	Jack Kirby
Bryan Andrews	Ben Edelberg	Josh Herman	Tani Kunitake
Stephen Broussard	Jonathan Eusebio	Tom Hiddleston	Theodore W. Kutt
Rick Buoen	Chris Evans	Bryan Hitch	Craig Kyle
Alexandra Byrne	Kevin Feige	Amanda Hunter	Fabian Lacey
James Chinlund	Rodney Fuentebella	Industrial Light & Magic	Jeremy Latcham
Nick Cross	John Giang	Samuel L. Jackson	Legacy Effects
Louis D'Esposito	Mark Goerner	Scarlett Johansson	Shane Mahan
Michael Dillon	Adi Granov	Jacob Johnston	Jeff Markwith

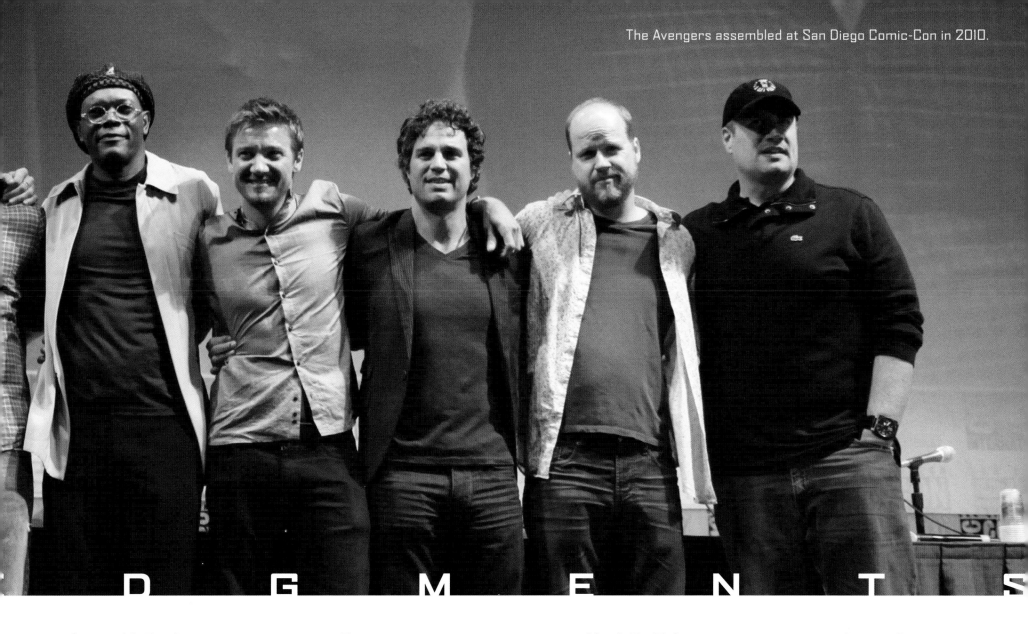

The Avengers assembled at San Diego Comic-Con in 2010.

Aaron McBride
Iain McCaig
Seamus McGarvey
Ryan Meinerding
Michael Meyers
Jim Mitchell
Olly Moss
Paul Ozzimo
Andy Park

Perception
Drew Petrotta
Plasticgod
Jeremy Renner
Raj Rihal
Paolo Rivera
Taylor Rockwell
Zade Rosenthal
Christopher Ross

Mark Ruffalo
Ari Sachter-Zeltzer
Phil Saunders
Nathan Schroeder
Jonathan Schwartz
Joe Simon
Janek Sirrs
Gregory Smith
Cobie Smulders

Justin Sweet
Jackson Sze
Jen Underdahl
Charlie Wen
Joss Whedon
Patricia Whitcher
Dave Yee
Victor Zolfo

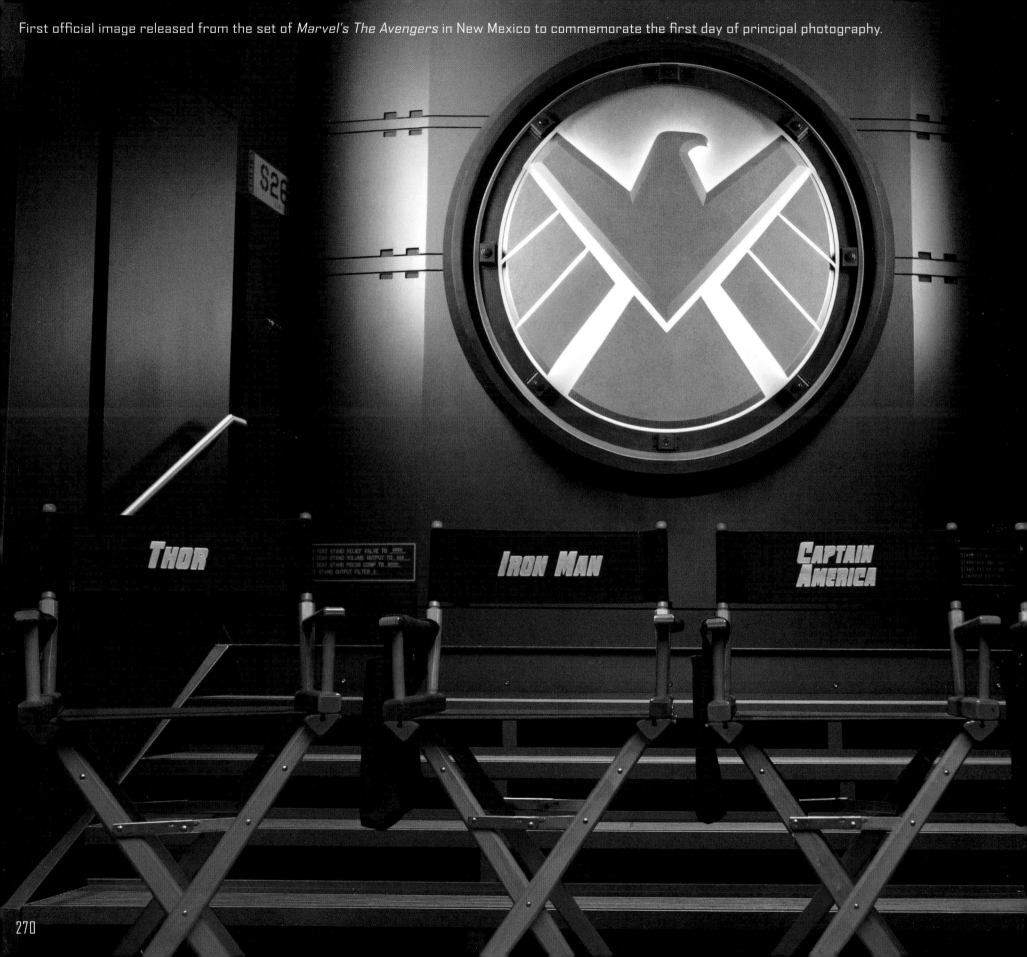

First official image released from the set of *Marvel's The Avengers* in New Mexico to commemorate the first day of principal photography.

ARTIST CREDITS

Script excerpts on pages 22, 82, 88,
141, 205, 216 and 242 are from the
story by **Zak Penn** and **Joss Whedon**,
and screenplay by **Joss Whedon**.

Still photographs by **Zade Rosenthal**.

MARVEL STUDIOS PRESENTS IN ASSOCIATION WITH PARAMOUNT PICTURES A MARVEL STUDIOS PRODUCTION A JOSS WHEDON FILM ROBERT DOWNEY JR. "MARVEL'S THE AVENGERS" CHRIS EVANS MARK RUFFALO CHRIS HEMSWORTH SCARLETT JOHANSSON JEREMY RENNER TOM HIDDLESTON CLARK GREGG COBIE SMULDERS WITH STELLAN SKARSGÅRD AND SAMUEL L. JACKSON AS NICK FURY MUSIC BY ALAN SILVESTRI MUSIC SUPERVISOR DAVE JORDAN VISUAL EFFECTS SUPERVISOR JANEK SIRRS VISUAL EFFECTS AND ANIMATION BY INDUSTRIAL LIGHT & MAGIC COSTUME DESIGNER ALEXANDRA BYRNE EDITORS JEFFREY FORD, A.C.E. LISA LASSEK PRODUCTION DESIGNER JAMES CHINLUND DIRECTOR OF PHOTOGRAPHY SEAMUS MCGARVEY, ASC, BSC EXECUTIVE PRODUCERS ALAN FINE JON FAVREAU STAN LEE EXECUTIVE PRODUCERS LOUIS D'ESPOSITO PATRICIA WHITCHER VICTORIA ALONSO JEREMY LATCHAM PRODUCED BY KEVIN FEIGE STORY BY ZAK PENN AND JOSS WHEDON SCREENPLAY BY JOSS WHEDON DIRECTED BY JOSS WHEDON

TM & © 2017 Marvel & Subs. Avengers.Marvel.com